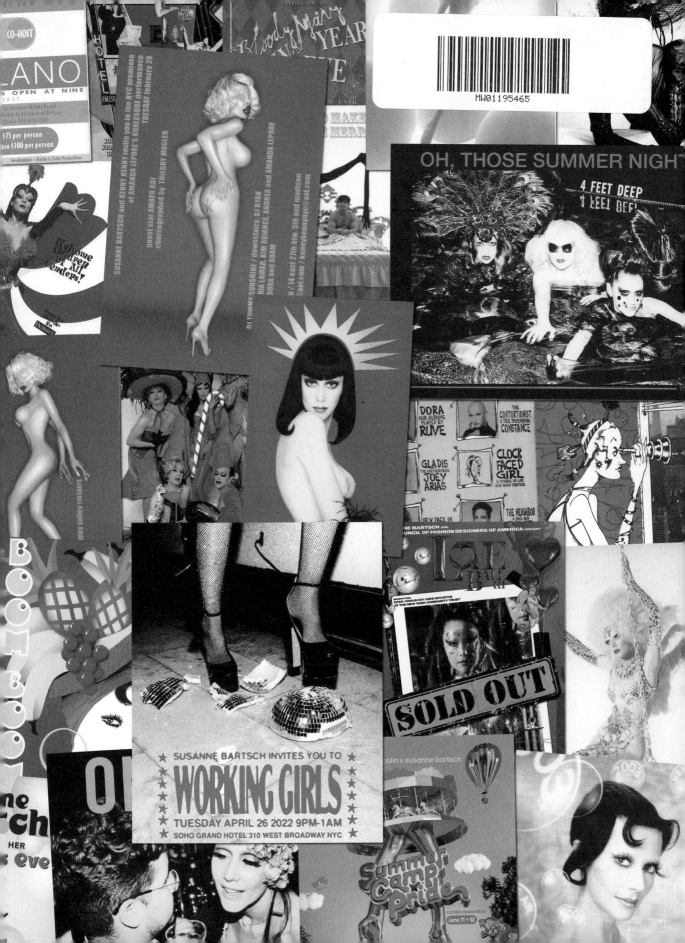

BARTSCHLAND

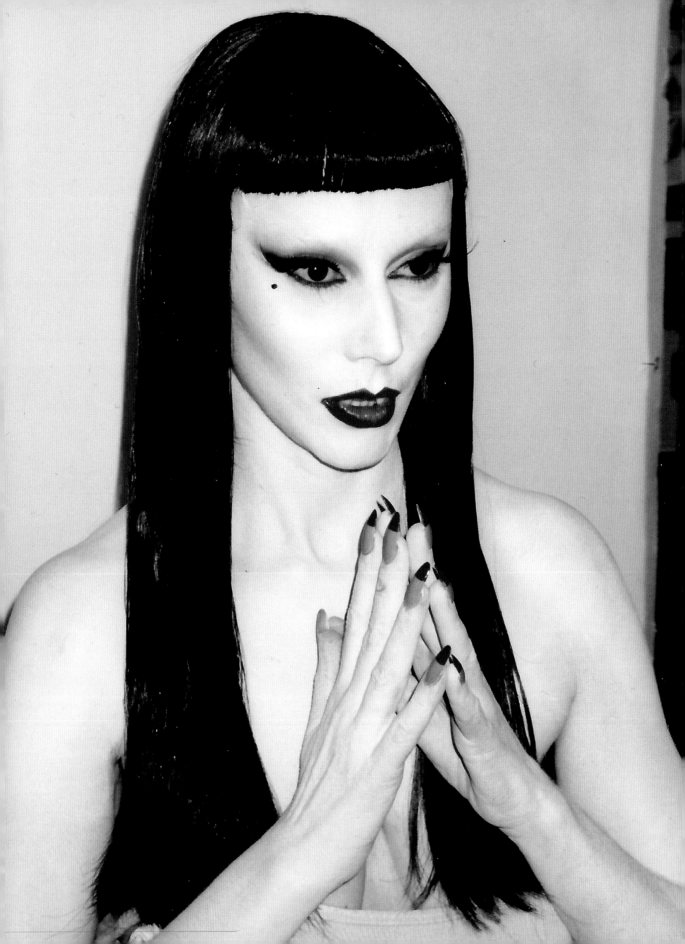

SUSANNE BARTSCH

PRESENTS

BARTSCHLAND

TALES OF NEW YORK CITY NIGHTLIFE

FOREWORD BY RUPAUL

CERNUNNOS

*I would like to dedicate this book to my mom
and dad, Mina Enz and Werner Bartsch,
for planting the seed of love in my life and for
teaching me that it's not whether you win or
lose, it's how you play the game that counts.*

CONTENTS

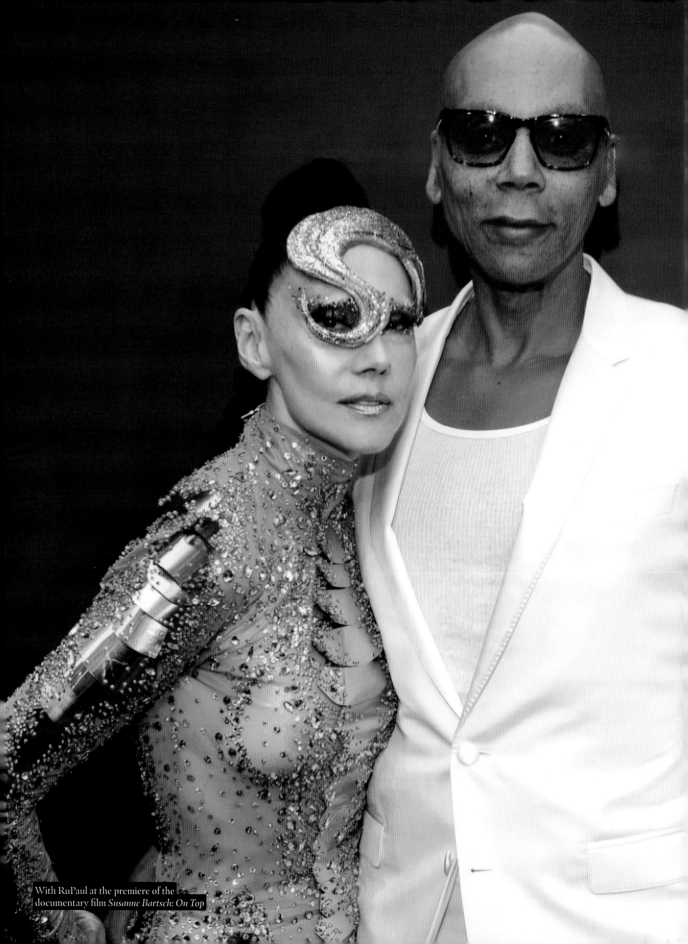

With RuPaul at the premiere of the documentary film *Susanne Bartsch: On Top*

FOREWORD

BY RuPaul

Susanne Bartsch is a fabulous friend, devoted mother, entrepreneur, and muse. She's also an amazing connector. She connects continents, cities, and boroughs. She connects ideas, energy, and people. A natural-born conduit with an impeccable reputation, she aligns people with unexpected happenings that they may have never had the chance to experience without her influence. She thrives on creating the ultimate shared experience, and giving people opportunities to make lifelong connections. How very fabulous of Susanne to find her calling so early in life.

We first met in New York, when I was hired as a go-go dancer at her Tuesday night party called Savage. When she entered the room, she hovered over the crowd like a magical fairy, sprinkling excitement on everyone in the club. It was magical. By the time she made it over to me, her first words were, "You're a popstar." I was thrilled and honored that the Queen of the Night had dubbed me the very thing I had come to Manhattan to be.

She continued to hire me over the next two years, adding me to her roster of gorgeous, outrageous downtown creatures who decorated her lavish charity events and spectacular, one-of-a-kind blowout parties. We also traveled the world as part of her nightclub revue. In fact, the first time I saw Paris, Zurich, and Tokyo was on one of those many tours.

For so many of us who came to New York to follow our Warhol dreams and fulfill the promise of a David Bowie future, Susanne became the Wizard of Fantasy. The one person who could get us closer to the dream we had all envisioned. Till this day, Susanne is the person that so many young dreamers count on to color their world. I love Susanne, endlessly.

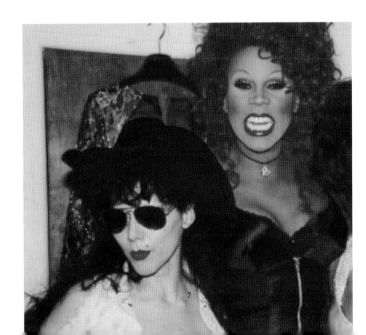

"Imagine leaving your apartment and stepping into a magical world filled with joy, pleasure, inclusion, and celebration. This is what Susanne does so effortlessly, not much different than Alice in Wonderland coming to life. There is no space like it and no place I'd rather be. She truly is a world treasure and we're all fortunate to say that we have lived and loved in the time of Bartschland."

—JEREMY KOST

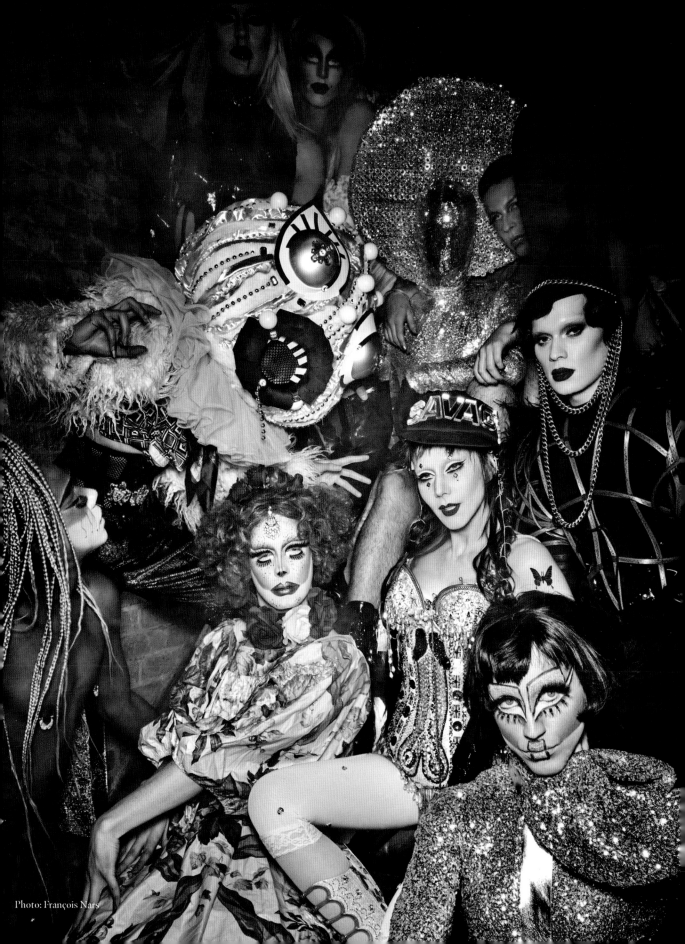

Photo: François Nars

Hudson
River

→

MESSIAH
IS HERE!

NO PARKING
Anytime

←

ONLY | ONLY

ONE WAY

TSIDE M RKET

Photo: Steven Menendez

WELCOME TO BARTSCHLAND

I did not know what "Thanksgiving" was when I first moved to New York. Undeterred, I threw an annual Thanksgiving dinner here in my apartment at the Chelsea for many years. This dinner was not only for my friends, but really for anyone who had nowhere else to go. Many of the people who came to these dinners had been ostracized by their families for simply being themselves. Some of them worked at my SoHo boutique and were gay, trans, or drag queens. I made a point to compliment and encourage their unique gifts and eccentricities, as those were what made them special. Seeking to uplift people from all walks of life, I found myself becoming an anchor in my community. The electrifying energy that came from bringing people together is why I began throwing parties in the first place. It is that same energy that keeps me going to this day.

In our current era of social media, we are inundated with images from parties. At the same time, they are fleeting moments that capture our attention for milliseconds before we move on to the next thing. By contrast, the slow process of digging though bags of old photos tucked away in a closet and curating them to create glimpses into my world is not dissimilar to getting ready to go to a party. Putting together a look is often a lengthy process of trying things on, taking them off, and pairing different pieces to find what works best. It takes time, effort, and meticulous orchestration to put together a fabulous look and march onto the dancefloor. It's much easier to sit on the couch and send a text message. Yet there is no substitute for the connections that can be made on the dancefloor. It is a place to be truly in the moment. My hope is that this book is something that you will take

time to connect with, as it was a labor of love to chronicle my journey through four decades of nightlife.

There is an old saying about New York City: "Every Monday there's a million-dollar deal. Come Friday its fallen through, but there's always another Monday." My life in this city has certainly not been without its fair share of ups and downs. As I sit here now, I am reminded of the time my ex-boyfriend's fiancée covered everything in this apartment in glue! The week before she was jilted at the altar because he was still in love with me. When all this happened, I had already moved on, and he had returned to London, leaving me the apartment we once shared. When I returned to the apartment that day, I opened the door to a sight that I will never forget. The toilet seat was glued to the toilet, the pillow was glued to the bed, a dead mouse was glued to the floor. There was nothing that wasn't glued in place. In retrospect, it was kind of a fabulous art installation. My adventures in New York have made me who I am. Without New York City, there is no Susanne Bartsch.

This book is just as much my story as it is that of the countless individuals who have been part of my journey. Many are featured in this book, and, regretfully, many are not. The transformers, the shapeshifters, the artists, the queens, and so many more: they possess the understanding that nightlife is a powerful tool for connection and self-expression. This book is the story of people from all backgrounds, ages, races, genders, and sexual orientations that come together at my events. The people I am endlessly blessed to call my chosen family.

I am nothing without you!

Susanne Bartsch xx

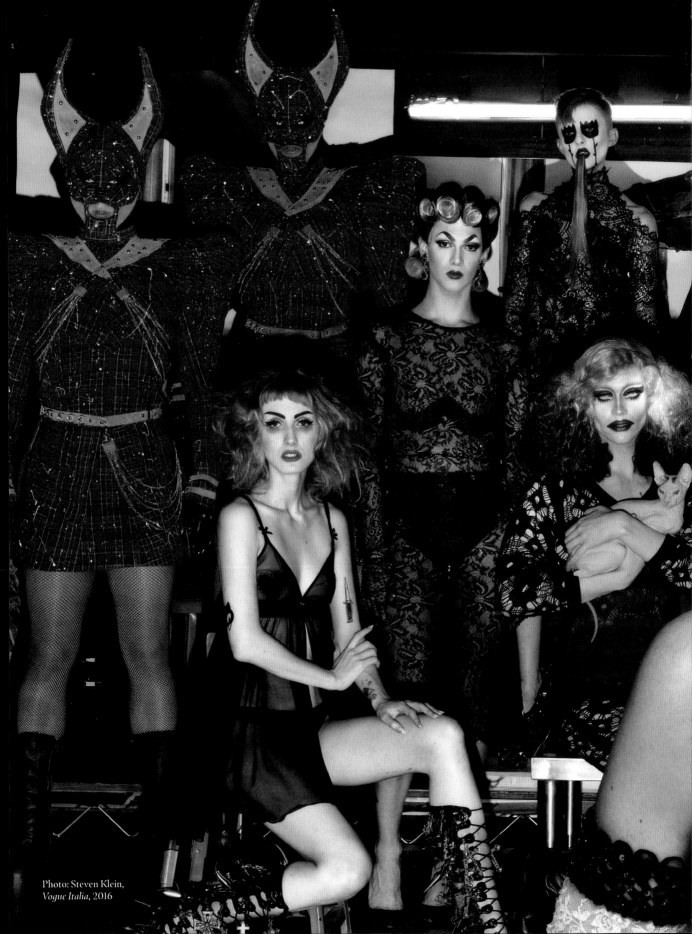

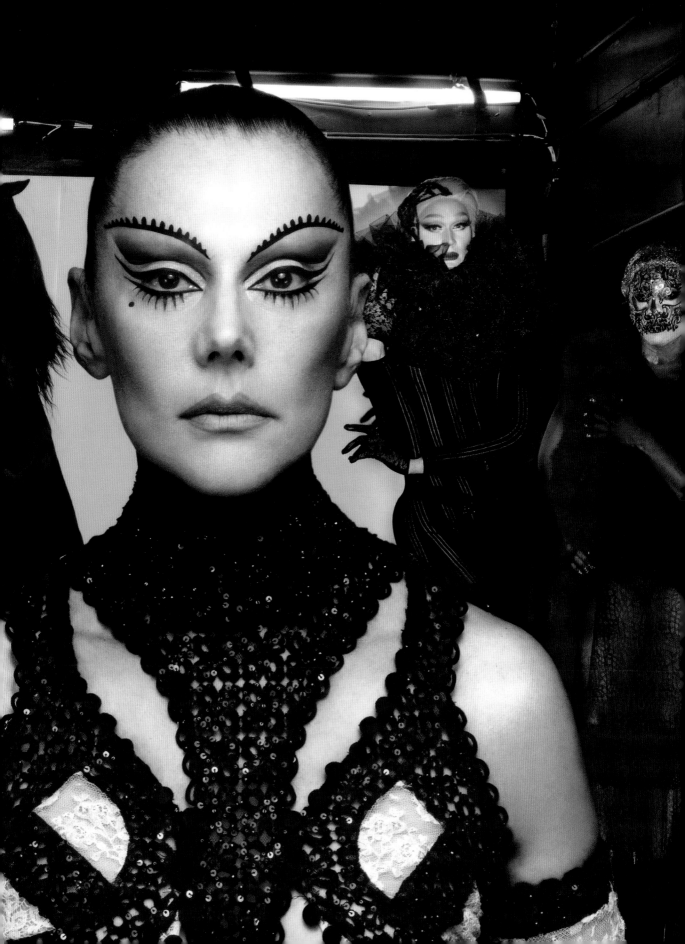

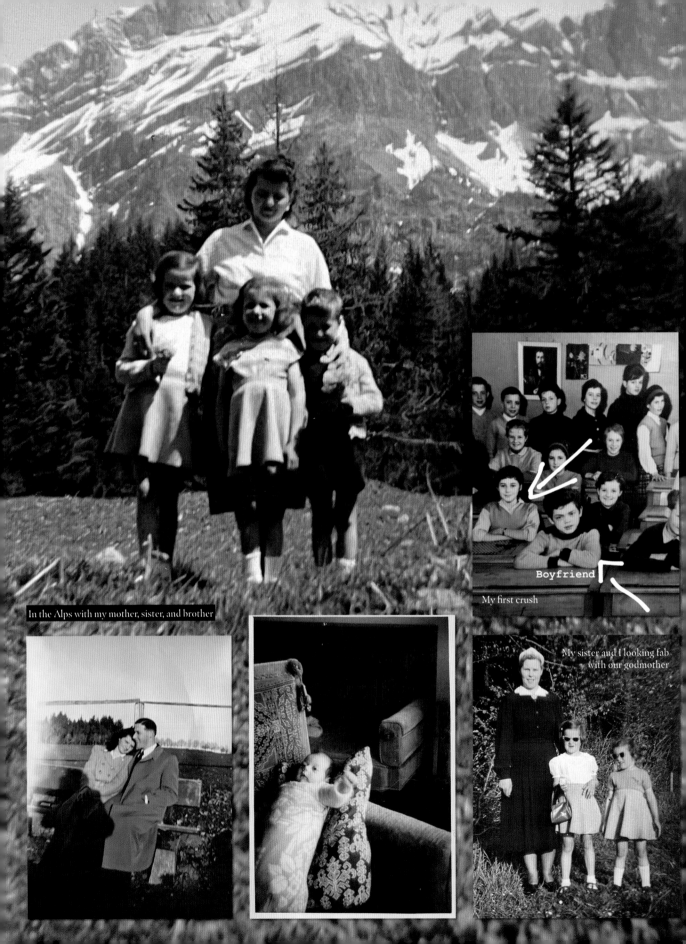

In the Alps with my mother, sister, and brother

My first crush

Boyfriend

My sister and I looking fab
with our godmother

Kindergarten with Jacob, my fav doll

SWISS MISS

I was born and raised in Bern, the capital of Switzerland. In a way my whole life has been a reaction against my Swiss heritage. It's a cliché, but it's true: in those days, the Swiss were like clockwork. Everything was very regimented, conventional. You were supposed to grow up and marry a banker, have three kids, and live in a house with a white picket fence. As much as I love Switzerland, I always knew that wasn't the life I wanted.

From a very young age, I was interested in expressing myself through dressing up. I can vividly remember being in kindergarten and putting together this outfit of an orange skirt with strawberries on it and a peasant blouse—a kind of Sunday look one might wear for a special occasion—and pairing it with hiking boots and chunky knee socks. It was totally unconventional, but my parents were supportive. I was lucky, they always encouraged me to be myself. My mother's motto was "Win or lose, what matters is that you play the game."

The only time I can remember my mom protesting was when I was in my teens. I had used Crayolas to draw rainbows on my eyelids and was wearing little hot pants to go to the candy store with her. She was nice about it but said she couldn't go out with me dressed like that, especially in those tiny little hot pants. She let me keep the rainbows though, and, as she probably expected, the salesgirl at the store couldn't handle them— she freaked out when she saw me. I was like, "Okay great, then I'll just help myself."

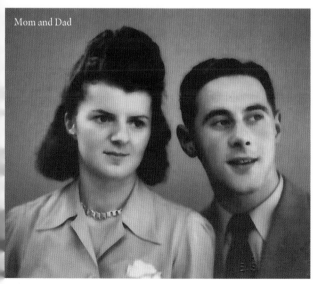

Mom and Dad

At school

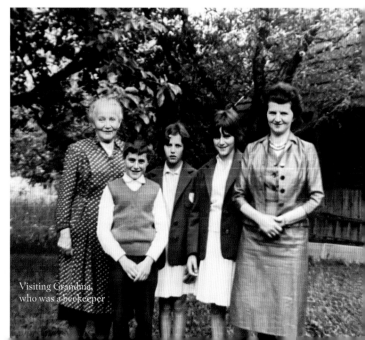

Visiting Grandma, who was a bookkeeper

LONDON CALLING

When I was about eight years old, I told my mom that I was going to leave Switzerland by the time I was sixteen. Sure enough, that's what happened. I managed to convince my parents to let me move to London under the guise of learning English. I was supposed to go to school but barely went; when my parents found out and stopped sending me money, I refused to go home. I knew I had to get a job. I also knew that if you worked at the Swiss center for four weeks, you could get a work visa. So that's what I did—I got a gig cutting cheese, and, after I got my visa, I called it quits. That's the only time I ever really did the nine-to-five schtick, which was never my thing.

One day around this time, I was walking up Kensington High Street, and I saw the most gorgeous girl. She had this fantastic eyeshadow and blonde streaks in her hair, and nobody was doing that at the time. I stopped to compliment her, and that's how I met Linda Powell, who would become one of my best girlfriends. I told her I needed a job, so she brought me to the shop where she worked, and her boss hired me on the spot. He was opening a new location on Kings Road and sent us two to run it. It was nothing fancy—just racks of clothes in a little stall with a counter we'd push out onto the pavement—but the two of us, standing outside vamping, were like magnets. I got a reputation for being the best salesgirl on Kings Road, and Tommy Roberts—who owned Mr. Freedom, which was the coolest, most avant-garde boutique—hired me to work for him on the weekends.

It was there that I met Paul Reeves, who'd be my boyfriend for the next five years. He was a designer and made the most fabulous clothes—he introduced satin and velvet pants, and Liberty floral-print shirts for men. All the rock stars—David Bowie, Freddie Mercury, Jimmy Page—wore his stuff, and I became friends with them all. I also started my own knitwear business, with housewives from Clapham to Herne Hill knitting sweaters for me, and sold them to all the rockers. I fell in with Ossie Clark, Celia Birtwell, David Hockney, Manolo Blahnik, Stephen Jones, Vivienne Westwood—it was an incredibly creative moment to be living in London. At one point, I took off to Italy for a love affair with a boy named Giovanni from Como. We practically lived in a four-door Ferrari, driving up and down Italy, hanging out with the fashion genius Fiorucci. It was totally spontaneous and wildly romantic, until it wasn't. I headed home to London after two years.

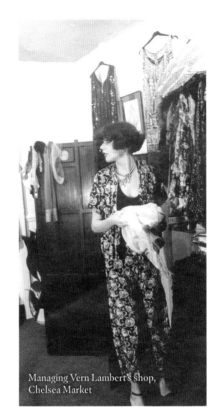

Managing Vern Lambert's shop, Chelsea Market

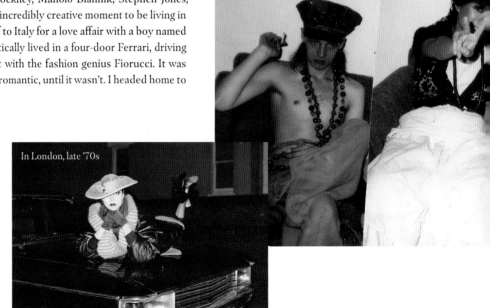

With Trojan, Gerlinde Costiff, Leigh Bowery in London, photo: Michael Costiff

With Jimmy Page

In London, late '70s

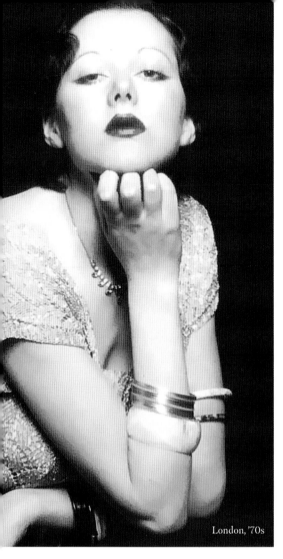

London, '70s

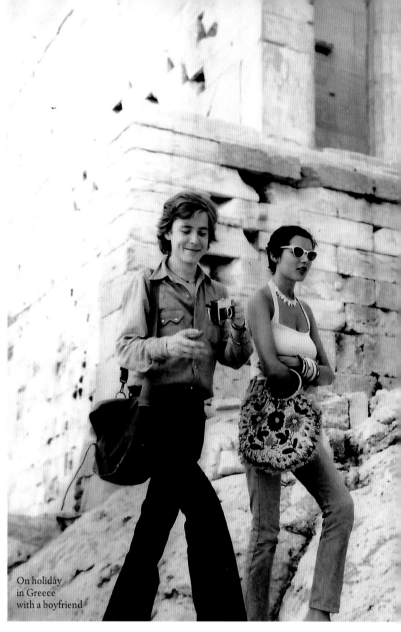

On holiday
in Greece
with a boyfriend

Later in the '70s, I was running Vern Lambert's antique shop at Chelsea Market, dealing vintage clothes and objects. He eventually sold me the shop, and overnight I became a business owner. I had no idea what I was doing, but, like everything in my life, I decided to just go for it. I was waking up at dawn to go to the markets and bought whatever caught my eye—'20s chiffon dresses and crepe pajamas, Art Deco tchotchkes, '40s Bakelite jewelry. That's a lot of what I was wearing at the time. In those days, I was less about doing a *look* and more about wearing something unusual that people hadn't seen. It was around this time that I started going to the parties at the Blitz in Covent Garden. People there would do amazing looks, and every week it was something different: punk, new romantic, glam rock. You could say that this was when I got my first taste of the magic of nightlife.

A BITE OF THE BIG APPLE

The first time I came to New York, I wasn't loving it. It was 1977—coincidentally, I was in town for the opening of Studio 54—and I was there for a month. I thought the heat was unbearable, and the city was kind of scary. I remember getting decked out in all this fake gold jewelry and people told me that if I went out like that, I'd get mugged. Little did they know it was all costume pieces.

After going back to London, I met the artist Patrick Hughes, and, like most loves in my life, we fell for each other hard and fast. He was an incredible influence on me—as was Paul Reeves and my husband, David Barton. They all really encouraged me to think bigger and to create my own life. Patrick lived between London and New York, and I flew over to stay at his place at the Chelsea Hotel on Valentine's Day in 1981. I was meant to stay for two weeks but have been here ever since. The Chelsea was totally dingy; the glamorous rocker days had passed, and it had become mostly just a sleazy hotel filled with misfits. But even so, there was something magical about it. It still had that aura, like, "Wow, I'm living at *the* Chelsea Hotel." It's probably the longest love affair I've ever had—I'm still living in that same apartment today.

After a few months of living in New York, I was missing London. New York at that time just didn't have the same creative energy. No one was dressing up or doing looks. One night, Patrick and I went to the opera, and I did a sort of demi-drag look—a David Holah floor-length, cocoon-style chemise topped off with a Stephen Jones creation. The photographer Bill Cunningham was enamored and took my picture. He was like, "Who are *you*?" I said, "I'm Susanne, from Switzerland." That's when Bill dubbed me the Swiss Miss; he was a great friend and supporter throughout my career.

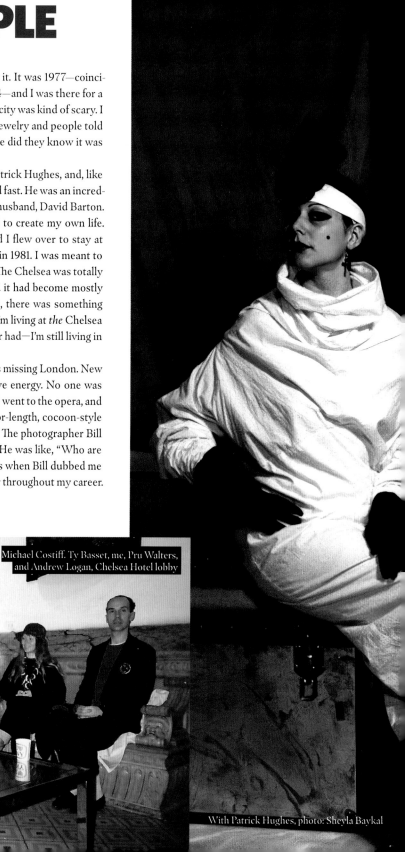

Michael Costiff, Ty Basset, me, Pru Walters, and Andrew Logan, Chelsea Hotel lobby

With Patrick Hughes, photo: Sheyla Baykal

Eleanor Don
way to make
Canal Street
back to Engl
flamboyant S
now it's all an
I was the firs
'bobtails' wo
Antenna in I
lengthen you
is thick and h
your own you

Andrea Tho
Madison Ave
just came fro
don't wear a
one of the gu

Lisa Revelle
rendezvousi
Avenue and
the week I d
but on week

Starting to get noticed for my looks

Sus... "finery" shop on Thompson Street. "This hat comes with a veil. Veils are gorgeous wearing one today. Then no one would be able to tell that I haven't slept."

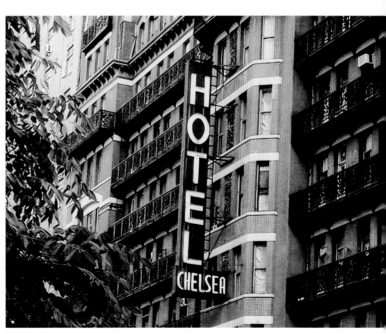

I was having fun, but New York just wasn't exciting me after all the brilliance I'd seen in London. People dressed well, but hardly anyone was dressing *up*. In New York, putting a flower in your hair was making a statement—child's play by London standards. It was Patrick who asked me, "Why not import what you miss?"

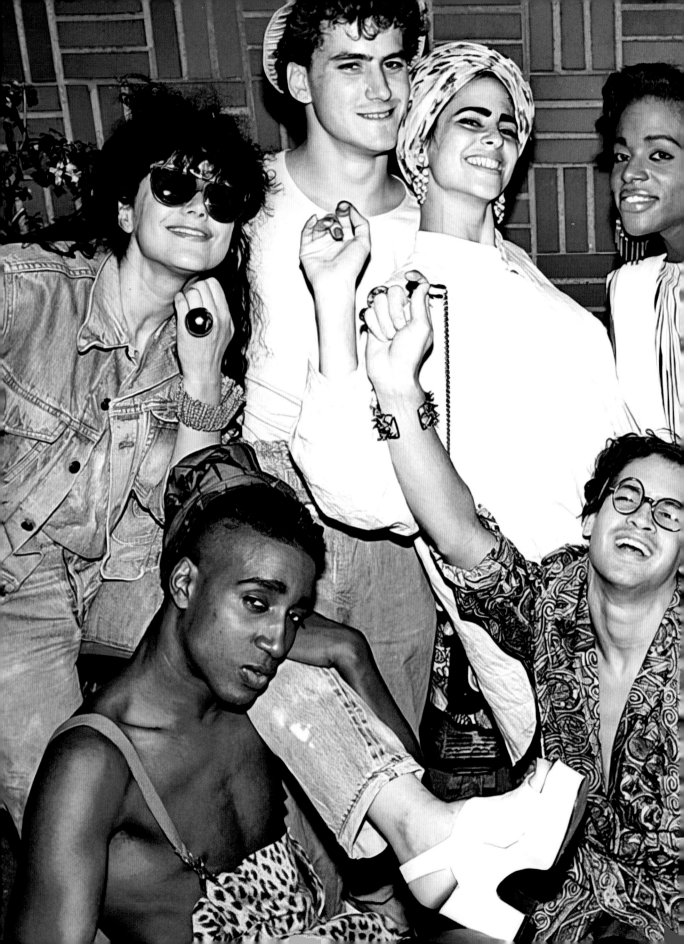

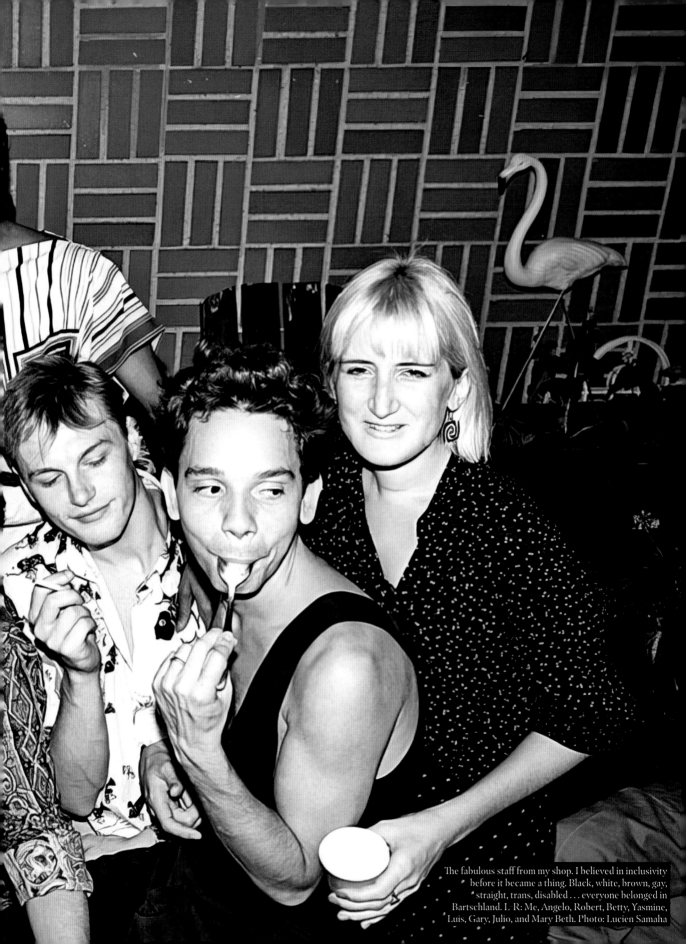

The fabulous staff from my shop. I believed in inclusivity before it became a thing. Black, white, brown, gay, straight, trans, disabled … everyone belonged in Bartschland. L–R: Me, Angelo, Robert, Betty, Yasmine, Luis, Gary, Julio, and Mary Beth. Photo: Lucien Samaha

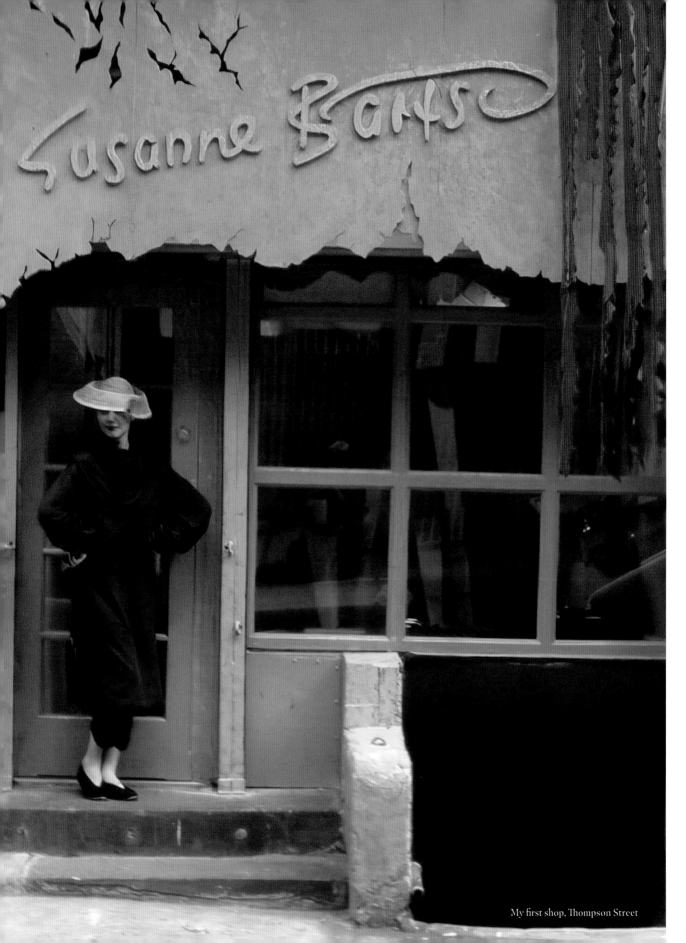

My first shop, Thompson Street

SETTING UP SHOP

For better or worse, I never make plans. But for most of my life, leaving myself open to the unexpected has worked in my favor. A prime example is when I stumbled upon a little storefront on Thompson Street in SoHo. It was the summer of '81, and I'd been thinking about how I could bring a bit of London's edge to New York. As luck would have it, I met the landlord, and he gave me a great deal. And just like that, it was decided: I was going to open a store.

I went back to London and visited all of my friends, consigning stock to sell: Stephen Jones hats, Andrew Logan jewelry, David Holah's BodyMap clothes, pieces made by John Galliano while he was still in school, with vintage bits and bobs peppered throughout. It was really a reflection of what I loved and how I dressed—a mishmash of fabulousness, old and new. I enlisted my friend Michael Costiff to design the store interior, and he made magic on my shoestring budget, fashioning cheap paper and plywood into a fantastical set piece. While today SoHo is a fashion mecca, in those days it was a no-man's-land. There was only a Shiseido and a Robert Lee Morris jewelry store, so I was really a pioneer in transforming the neighborhood into the shopping destination it eventually became.

People began to notice what we were up to, and before I'd even opened, John Duka—a fashion reporter for the *New York Times*—dropped in for a preview. I gave him a tour and explained my vision, and the day before I officially launched in late August of '81, he gave me a full-page write-up in the Style section (which was pretty much unheard of at that time). Soon, all of the city's most adventurous dressers were making their way to Thompson Street. Everyone from designers like Donna Karan and Norma Kamali to Harlem drag queens were shopping at Susanne Bartsch.

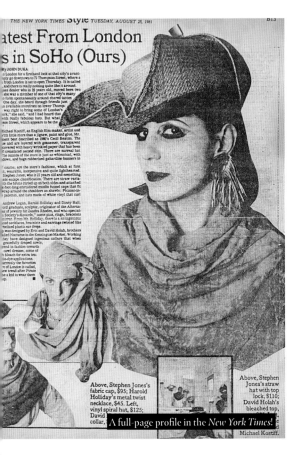

THE NEW YORK TIMES Style TUESDAY, AUGUST 25, 1981 B13

atest From London s in SoHo (Ours)

By JOHN DUKA

A full-page profile in the *New York Times*!

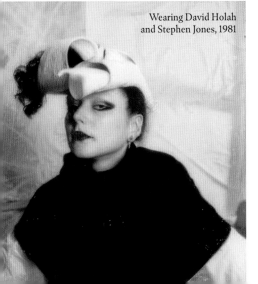

Wearing David Holah and Stephen Jones, 1981

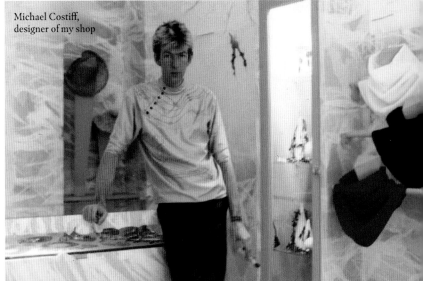

Michael Costiff, designer of my shop

After I outgrew the Thompson Street shop,
I moved to a big store on West Broadway

Wearing Vivienne Westwood

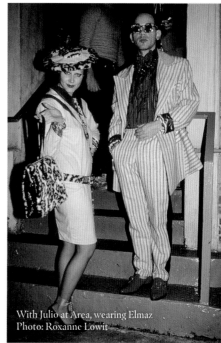

With Julio at Area, wearing Elmaz
Photo: Roxanne Lowit

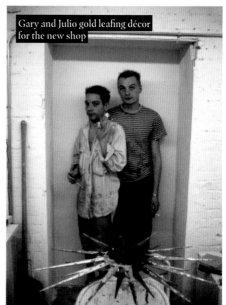

Gary and Julio gold leafing décor
for the new shop

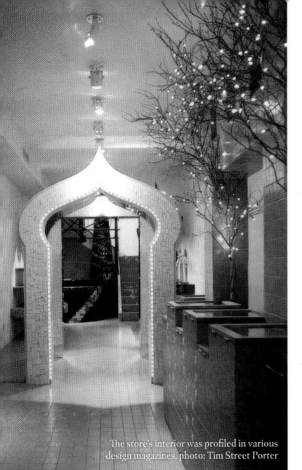

The store's interior was profiled in various design magazines, photo: Tim Street Porter

MOVING ON UP

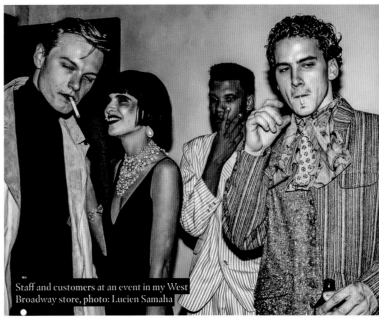

Staff and customers at an event in my West Broadway store, photo: Lucien Samaha

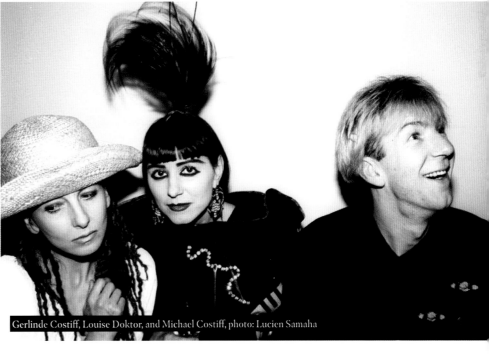

Gerlinde Costiff, Louise Doktor, and Michael Costiff, photo: Lucien Samaha

SUSANNE BARTSCH
New London, New York

DON'T
SMOKE
IN
BED

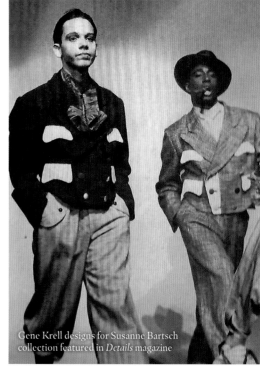

Gene Krell designs for Susanne Bartsch
collection featured in *Details* magazine

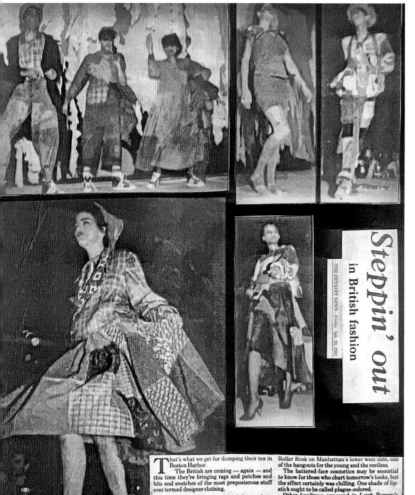

Steppin' out
in British fashion

THE DETROIT NEWS—Friday, Apr. 20, 1984

Cue magazine

May 1984

That's what we get for dumping their tea in Boston Harbor.

The British are coming — again — and this time they're bringing rags and patches and bits and snatches of the most preposterous stuff ever termed designer clothing.

Some of it, in truth, looks like leftovers from the American Revolution, a decided contrast to the conservative approach of the New York fashion establishment now.

Susanne Bartsch, a hat creator with a shop in New York's Soho district, put together the evening featuring outfits from several young Brit-

Roller Rink on Manhattan's lower west side, one of the hangouts for the young and the restless.

The battered-face cosmetics may be essential to know for those who chart tomorrow's looks, but the effect certainly was chilling. One shade of lipstick ought to be called plague-colored.

Other loveliness appeared in Leigh Bowery's drop-seated jumpsuit (much applause from the audience) and dirty clothing ("... took a nice coat and screwed it up," mumbled someone in the next row). Dirt is *in* with this bunch. Vivienne Westwood is using the shade now, she said with utter seriousness, because it's the way poor people look after they've worn the same thing for a year. Her

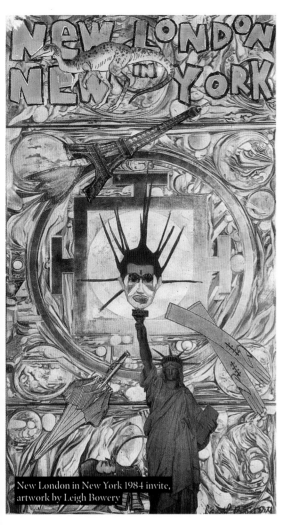

New London in New York 1984 invite, artwork by Leigh Bowery

NEW LONDON IN NEW YORK

The shop was a hit—almost too big of a hit. Without any real strategy on my part, I set off a craze for British fashion. In those days, there was no proper London Fashion Week, so my shop was the only place for people to discover young English designers. Soon all the big stores—Saks, Bloomingdale's, Maxfield, you name it—were sending buyers to London to get in on the trend. I was basically a one-woman show, and I began to panic because there was no way I could compete with the big guys.

I was freaking out that I was going to lose all the momentum I'd built, and I thought, if I can't compete with these stores, why not get in on the action? I decided I'd represent the brands I was carrying and be their US agent. I flew to London to meet with all the designers—Leigh Bowery, Rachel Auburn, BodyMap, John Richmond, Maria Cornejo, etc.—and said, "I'm going to represent you. I'm doing a show—you'll have ten minutes on stage, you can do whatever you want," and everyone agreed. I had no idea what I was doing; I'd never produced a fashion show, much less been a wholesale agent, but I just ran with it. I called it "New London in New York."

I got the Roxy roller rink as a venue and set up what I thought was a perfect runway. In reality, it was a mess. There was just a piece of fabric separating the backstage from the audience, so, once the show started and music was blasting, no one could hear anything backstage. Everyone wound up losing their voice because we had to scream to hear one another. I was totally oblivious to the politics of fashion, so I sat Barneys next to Bergdorf and all these other competitors. It was chaotic but, in the end, that's what made it so special.

It was the first time I'd ever organized anything like that: bringing people together to experience this moment. I'll never forget, as I was pulling up to the Roxy the day of the show, I could see that there was already a line going down the block and doubling around. It was the ultimate high seeing all these people show up, excited about this thing that I'd created. Feeling their energy made me even more excited about what we were doing. After that, I was hooked.

The British Fashion Council was hugely grateful for what I was doing and offered to help support me. I went on to produce two more New London in New York shows at the Limelight, adding designers like Westwood and Galliano. *Women's Wear Daily* in Japan contacted me about bringing the show there, so about six months later, I produced my first international event: London Goes to Tokyo.

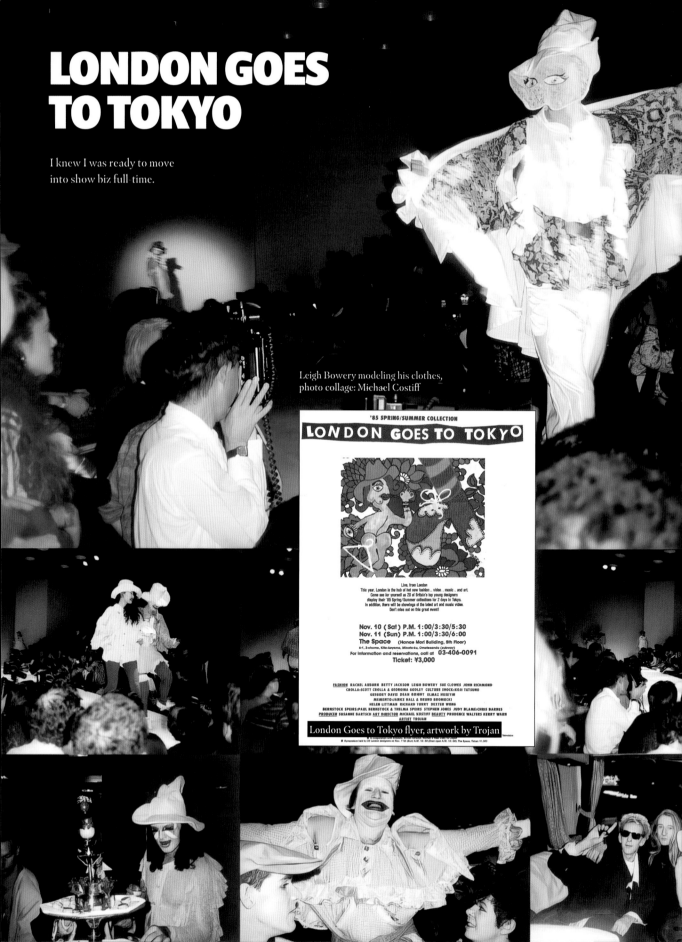

LONDON GOES TO TOKYO

I knew I was ready to move
into show biz full-time.

Leigh Bowery modeling his clothes,
photo collage: Michael Costiff

London Goes to Tokyo flyer, artwork by Trojan

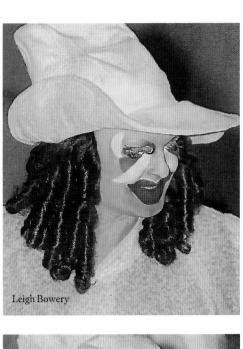

Leigh Bowery

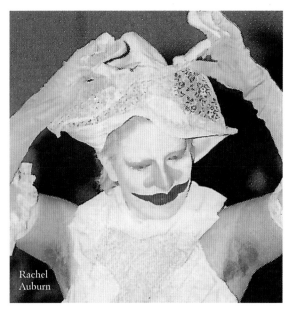

Rachel Auburn

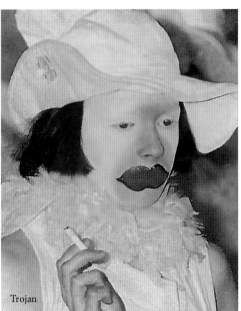

Trojan

Judy Blame

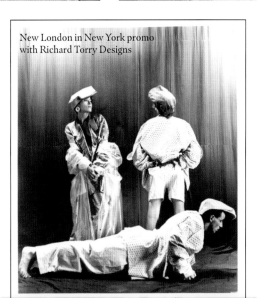

New London in New York promo with Richard Torry Designs

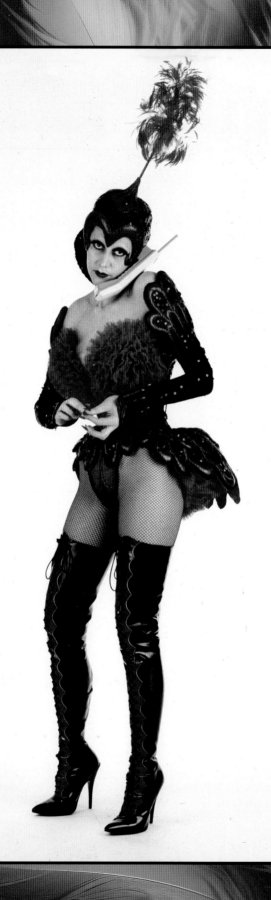

Photo: Todd Eberle

PARTY GIRL

The fashion shows I produced were the first large events of any kind that I organized, except for an incredible party I threw at the Top of the Rock in Rockefeller Center. The investor for my shop was a finance guy and had his offices there, so I decided to have my birthday party there. Everyone from Andy Warhol to Basquiat to Margaux Hemingway to Andre Walker to Joey Arias showed up. But in the end, the magic I experienced at that first show at the Roxy, with all its mishaps and chaos, was the transformative moment in my life. Up until that point, I'd done a lot of dabbling in different arenas—fashion, retail, design—but none of that work tapped into what I've come to know is what I do best: bringing people together.

Fashion shows are fabulous in their own way, but they're a bit limiting. Even if my shows went against the grain—they were very anti the prim-and-proper *défilés* that were in vogue at the time—there was still a formula: the audience comes to sit and watch models parade down a runway. I've never been one for the conventional, and, no matter how gorgeous the models were, I was usually more interested in the people sitting in the audience than the professional beauties on the catwalk.

I wanted to find a way to replicate that incredible energy I'd felt at my shows—the creativity, the excitement, the sense of seeing and being seen—but do it in a way that let everyone in on the fun. I wanted to create a place where anyone and everyone could turn a look, regardless of if they were a "model" or "designer." It's about creativity, baby! Not what's on your résumé.

At the same time, I was selling all these fabulous clothes to people at my shop and realizing that they didn't have anywhere to wear them. Personally, I don't need an excuse to throw on a wig and a corset, but I could see that these customers needed something to dress for. All the pieces started to come together in my head: why not throw a party to promote the store, where everyone can turn up in their latest Susanne Bartsch finery? I'd already gotten people to dress up; now I needed to give them someplace to go.

Next door to my apartment at the Chelsea was a vacant space, I could see that someone was building a '70s-style disco even though it was the mid-'80s. I popped my head in one day and happened to meet the owner—this totally campy guy, done up like a dandy with slicked-back hair, who explained that he was opening a nightclub. It had mirrored paneling going downstairs, dense red carpeting, and a sunken dancefloor; he was going to call it Savage. The whole thing was so tacky that, in a way, it was fabulous. He agreed to let me throw a party there when it opened. This was the spring of 1986.

At the same time, things had started to sour at the shop. I'd moved into a larger space on West Broadway in SoHo, and it was incredible—Michael Costiff had designed a postmodern temple in terrazzo and tile. It went well for a while, but there'd been a change in my investors and the new money guys didn't get what I was doing. They wanted to just sell cheap T-shirts to make a quick buck. There was a lot of friction between me and them, and one day I just picked up my bottle of Shalimar and walked out, leaving it all behind.

TO THE DANCEFLOOR

In retrospect, the timing couldn't have been better. The night after I walked away from the shop, the owner of Savage called me to say he'd gotten his liquor license; I could have my party in two weeks. Having just left my business, throwing this party became even more important to me, because now I needed a different way to make a living. Everything was done on the fly: I made a flyer to get the word out, got Kenny Kenny to do the door, Ty Bassett—who I was dating at the time—did cashiering, Adam Glassman was helping out. I got a DJ from England named Big Sue.

I remember going down to Savage that first night and being so excited. The first person that showed up was Michael Musto, who was covering parties for the *Village Voice*, and I thought, "Oh, well this is a good sign." Then Roxanne Lowit, whom I'd met backstage at one of my first fashion shows, showed up, then Faye Dunaway, then Bette Midler. The whole thing just clicked: all the right people, almost a thousand of them, dressed head to toe in their best, showed up that first night. It was just me, a DJ, and a great space—that's how it all started.

The party was a hit, and I decided to make it a weekly affair. After a few weeks, I thought I needed to add something to the mix, so I brought in a few go-go boxes—which were not really a popular thing at the time—and hired a few working girls to strut their stuff. I always loved that industry, and it was perfect for the ambiance I was creating. After a year or so, I wanted to grow, so I added a new party at a club call Bentley's, which wasn't fashionable—it was the kind of place where secretaries would go for drinks after work. It was very drab, so for my night, I'd cover the place in streamers or paper cutouts of flames. That was when I started to get into doing décor for my parties. There were two dancefloors, so I got two DJs: Sister Dimension did disco downstairs, Johnny Dynell did house music upstairs. At that time, it was really exciting to be able to get two types of music under one roof.

Bentley's was the first place where I started hiring drag queens, and I also went deeper into the whole stripper world. I've always loved the art of striptease. One of my favorite performers of all time is Lady Hennessey Brown—she had the most incredible body and would do the craziest things, like spraying the audience with milk from her tits and pulling sixty-nine stockings out of her snatch. It was *wild*; truly incredible performance art.

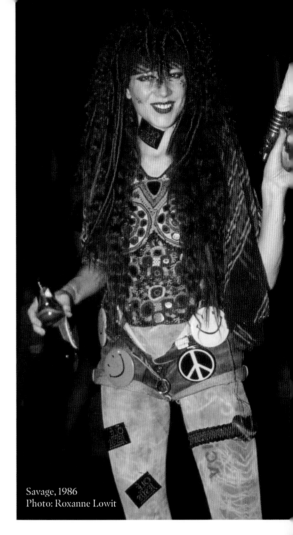

Savage, 1986
Photo: Roxanne Lowit

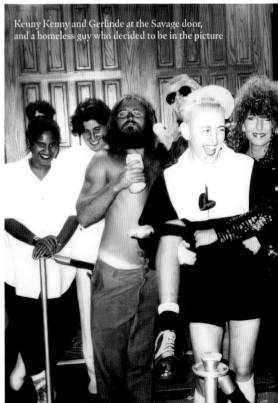

Kenny Kenny and Gerlinde at the Savage door, and a homeless guy who decided to be in the picture

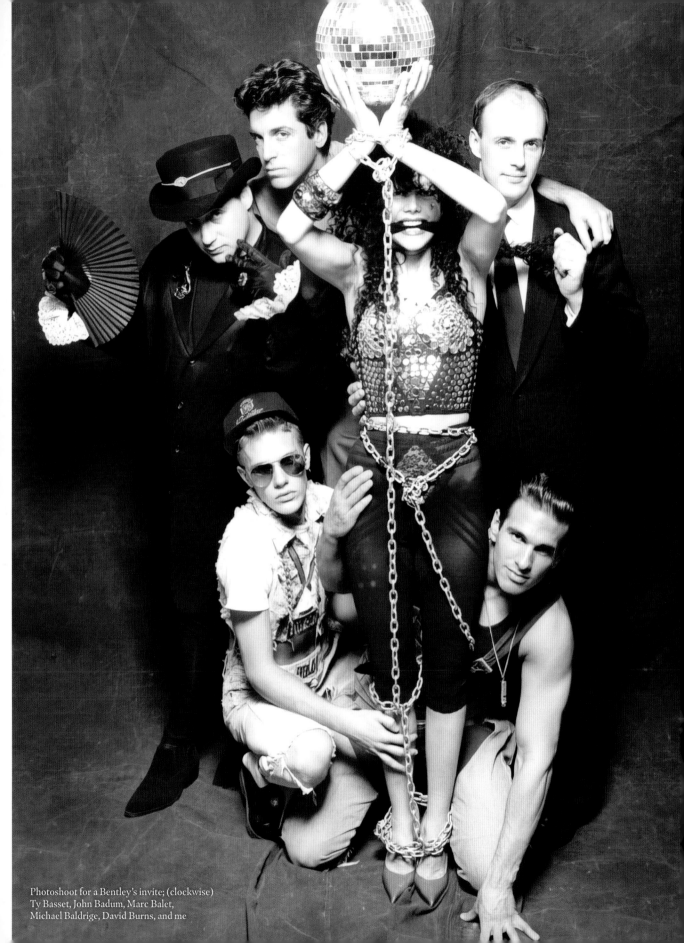

Photoshoot for a Bentley's invite; (clockwise)
Ty Basset, John Badum, Marc Balet,
Michael Baldrige, David Burns, and me

AT THE COPA

The family who owned Bentley's also owned the Copacabana—the iconic nightclub immortalized by Barry Manilow—which was popular with the mafia set. Bentley's had been going so well that, in 1987, they offered me the first Thursday of every month at the Copa. I'd been there once for a party Andy Warhol threw and loved it—it was huge and campy and glamorous all at the same time. Moving my party to the Copa took it to another level; this was the big time.

I started to add a lot of staff, lots of different kinds of people, because I wanted to evolve. My first night there, I hired the Village People to perform. They were passé—'70s disco was very much out, but I still loved it—and that's what made having them so amazing. I did that often over the years at the Copa, hiring performers that had fallen out of fashion but were still incredible: the Temptations, the Weather Girls, Sylvester. I also leaned into the Brazilian vibe by hiring a troupe of Carnival dancers, who'd come every month in their full feather-and-sequin regalia. I had Madame (who founded the Trockadero Gloxinia Ballet), Olympia, Baroness, and Gina—three drag queens and a trans girl—dress as look-alikes, all wearing the same thing, every time.

The Copa is where I first started having RuPaul emcee. I'd seen her out and about and could immediately tell she was going to be a star, and I told her. I've never been great alone on a mic—I like to have someone to play off—so I had Ru be the emcee at the Copa. Every month, we had a Miss Copa contest where the audience would award the best look, and Ru ran that show. To this day, I've never worked with anyone who can engage with a room as effortlessly as RuPaul.

It became such a happening. People knew it would be the last Thursday of every month, and they'd spend the whole month planning their looks. The club was in midtown, by the Plaza Hotel, and it really did attract a mix of uptown, downtown, and everyone in between, from Ivana Trump and Reinaldo Herrera to Lady Miss Kier and Divine. The party came to an end after a few years because the club's lease ran out and, unfortunately, now it's an office building. But it's amazing how many people still come up to me with memories of their nights at the Copa.

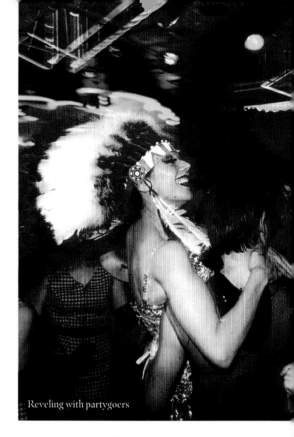

Reveling with partygoers

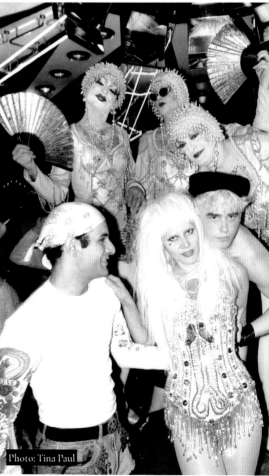

Photo: Tina Paul

34

SUSANNE AT THE COPACABANA

"EVERY LAST THURSDAY" OF THE MONTH!!

SUSANNE BARTSCH

invites you to the

COPA
OPENING

THURSDAY - JULY 28 at 10:30 p.m.

	NOV.	DEC.
28	20 24	29

Opening night invite—each invite came
with an oversized fluorescent tin badge

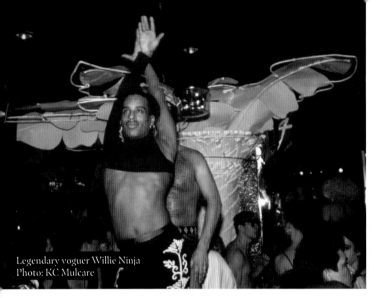

Legendary voguer Willie Ninja
Photo: KC Mulcare

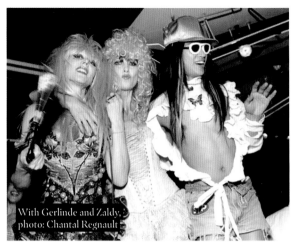

With Gerlinde and Zaldy,
photo: Chantal Regnault

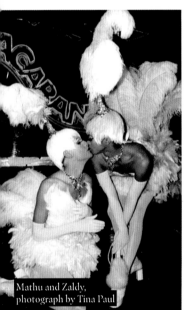

Mathu and Zaldy,
photograph by Tina Paul

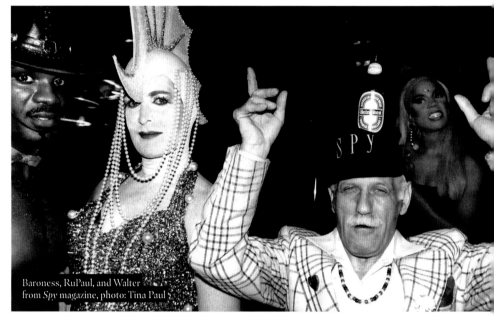

Baroness, RuPaul, and Walter
from *Spy* magazine, photo: Tina Paul

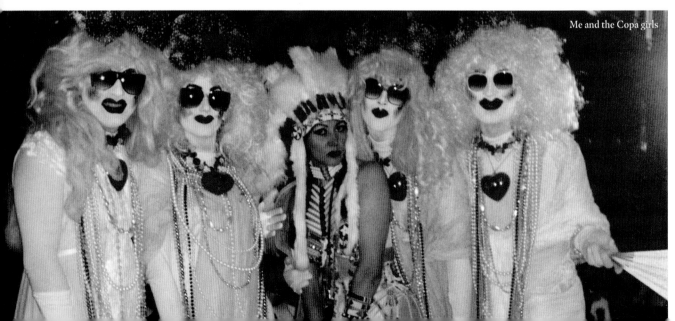

Me and the Copa girls

MARY MCFADDEN
HAMILTON SOUTH
BRUCE WEBER
NAN GOLDIN
LINDA WELLS
ORLANDO PITA
ABLE AND TIM
RU PAUL
DEB MAZAR
DANILO DIXON
ORIBE
MATHU & ZALDY
KATE PIERSON B-52
FRED SCHNEIDER B-52
KIR AND DIMITRI DEE LITE
INGRID SICHY
IVANA TRUMP
WORLD OF WONDER RANDY
ANN BASS
JUDY PEABODY
POLLY MELON
MARC BALET
FRAN LIEBOWITZ
ANNIE FLANDERS
STEVEN SABAN
GENE (FROM WESTWOOD)
CHI CHI AND JOHNNY
PAT FIELD
PAUL ALEXANDER
PERFIDIA
JO JO
JOEY ARIAS
KATIE K
THE BARONESS

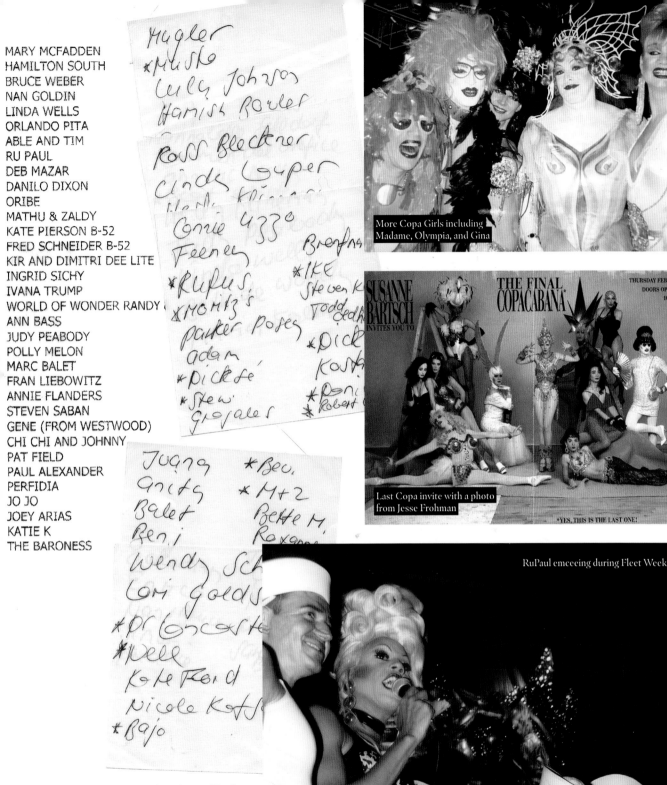

More Copa Girls including Madame, Olympia, and Gina

SUSANNE BARTSCH INVITES YOU TO
THE FINAL COPACABANA

THURSDAY FEB. 27, 19
DOORS OPEN 11
10 E 60

Last Copa invite with a photo from Jesse Frohman

*YES, THIS IS THE LAST ONE!

RuPaul emceeing during Fleet Week

Partial list of people I would call
personally to invite to the party

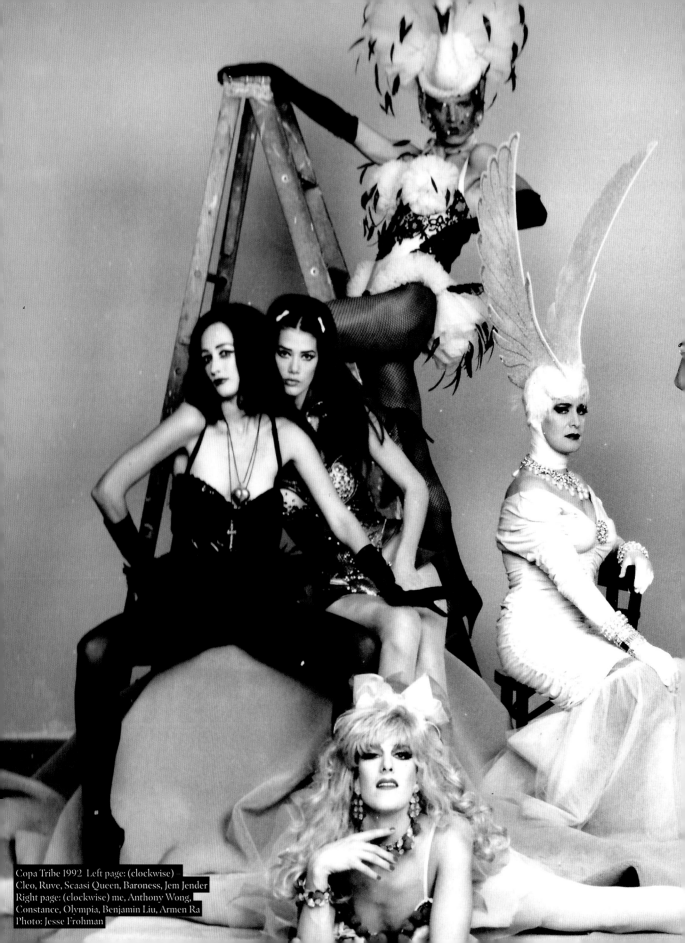

Copa Tribe 1992 Left page: (clockwise) –
Cleo, Ruve, Scaasi Queen, Baroness, Jem Jender
Right page: (clockwise) me, Anthony Wong,
Constance, Olympia, Benjamin Liu, Armen Ra
Photo: Jesse Frohman

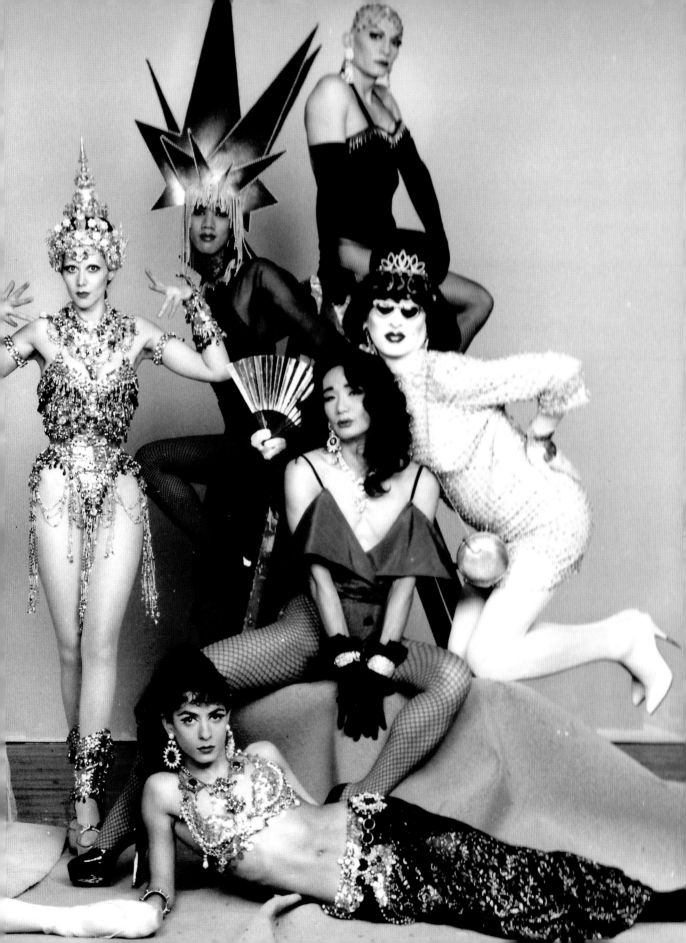

Haven't got a clue
Don't know what to be

Text and illustration : Mathū, Zaldy and Nicole

Why not cut this out
and you can come as me

A Halloween invite

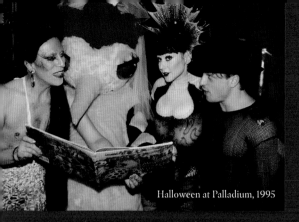
Halloween at Palladium, 1995

Halloween at Mondrian, 1995f

One of the hosts I'd hired—
Dita Von Teese

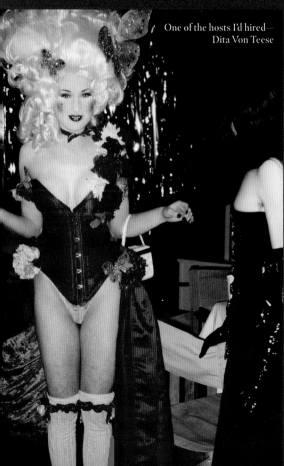

TRICK
OR TREAT

My first Halloween party was in 1988 at the Red Parrot. I did a kind of peep show setup, bringing a bit of 1970's Times Square into it with performers like Lady Hennessy and this girl Chi Chi, who'd smoke cigarettes with her pussy. It was kind of slow that night—I think I actually lost money—but it was so incredible. The people who came wore some of the best costumes I've ever seen. That kind of made me known as the queen of Halloween.

Halloween is still big today, but back then it was huge in New York. Everyone got into it. You'd be walking down the street and see a mummy driving a taxicab—I loved it. It's sort of the national holiday for drag; everyone who doesn't normally do a look the rest of the year has a reason to dress up. And dressing up is what my parties are all about, so it just made sense that Halloween became my thing.

There have been so many incredible ones over the years, and I used to always have a theme. One year at the Palladium, the theme was water, and I had all these fountain installations like in Vegas. I built these huge sets—it was crazy, 6,000 people came. One year it was nursery rhymes, and I remember Sade—this big Black drag queen—was the Itsy-Bitsy Spider. Witches, bordello, angels and demons, vampires, aliens, tropical madness, big-top circus . . . you name it, I've done it for Halloween.

From the get-go, people would come in incredible looks, and they just got bigger and more creative over the years. Every year, I'd do a costume competition, and people would win like five hundred dollars. Those are two things that have changed: the looks aren't as big as they once were, and I don't do costume competitions anymore. That's not to say that there isn't some amazing creativity out there, but it used to be that *everyone* came dressed up, and it wasn't just something you bought in a bag from the costume store. In a way, people don't need the excuse of Halloween to go wild with their look anymore. For so many of the people that come to my parties today, every day is Halloween, and that's fabulous.

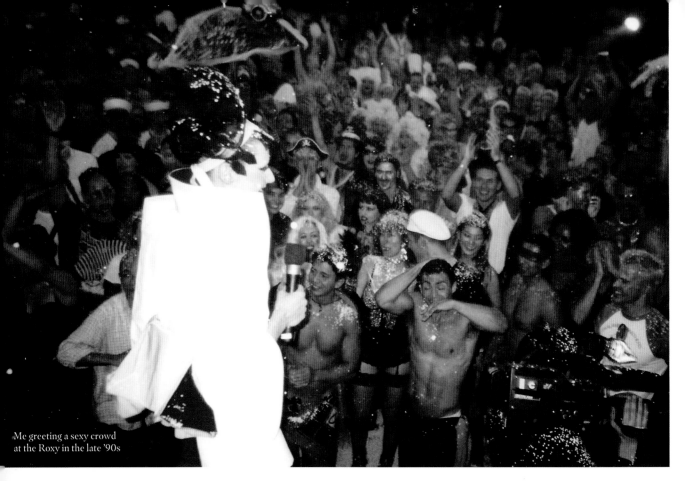

Me greeting a sexy crowd
at the Roxy in the late '90s

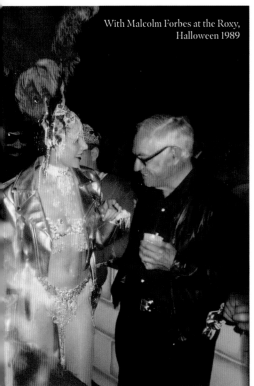

With Malcolm Forbes at the Roxy,
Halloween 1989

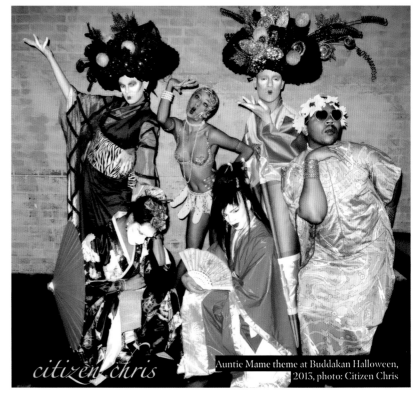

citizen chris

Auntie Mame theme at Buddakan Halloween,
2015, photo: Citizen Chris

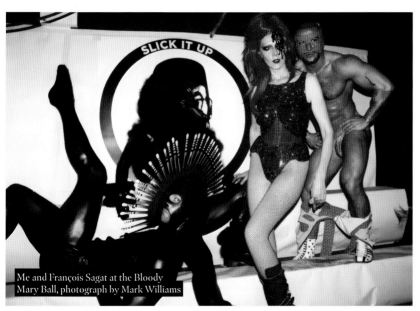

Me and François Sagat at the Bloody Mary Ball, photograph by Mark Williams

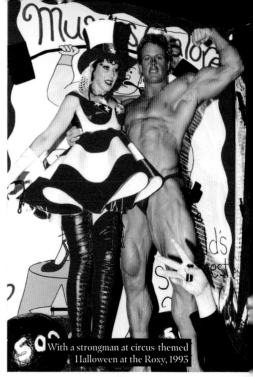

With a strongman at circus-themed Halloween at the Roxy, 1993

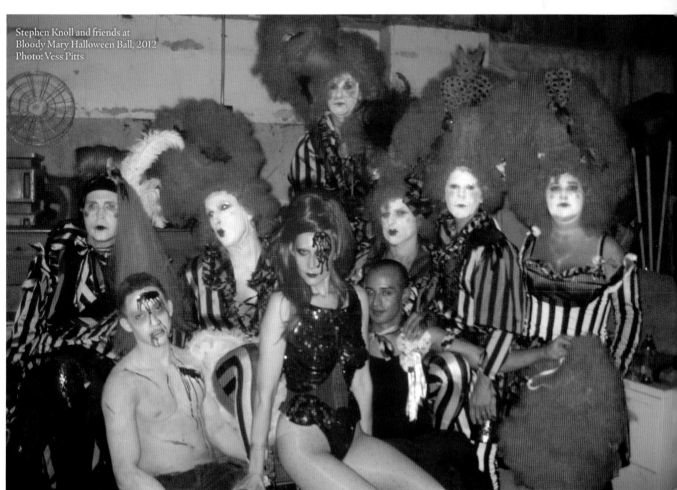

Stephen Knoll and friends at Bloody Mary Halloween Ball, 2012
Photo: Vess Pitts

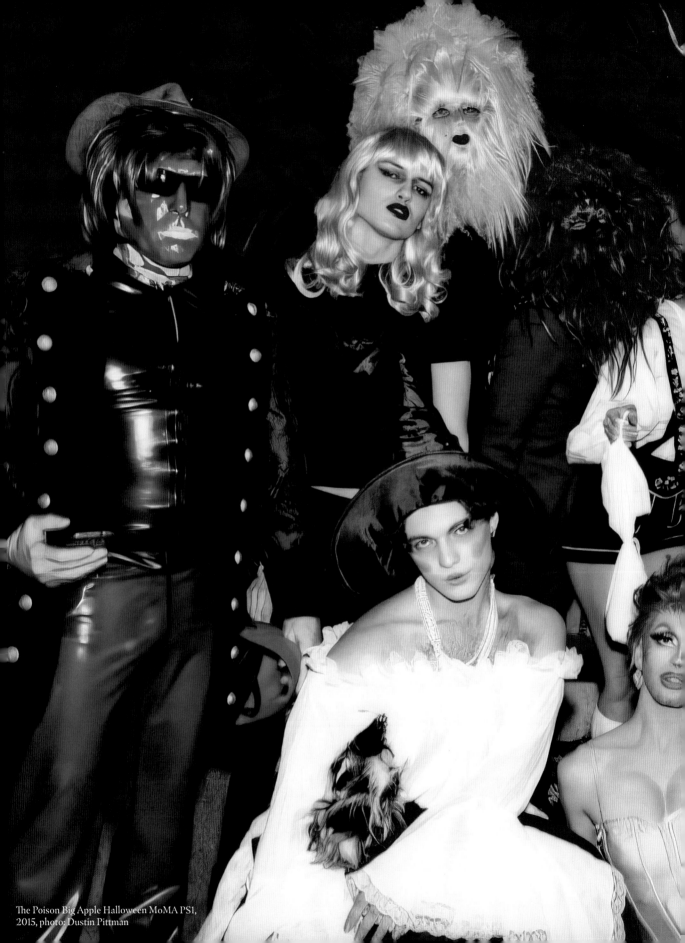

The Poison Big Apple Halloween MoMA PS1,
2015, photo: Dustin Pittman

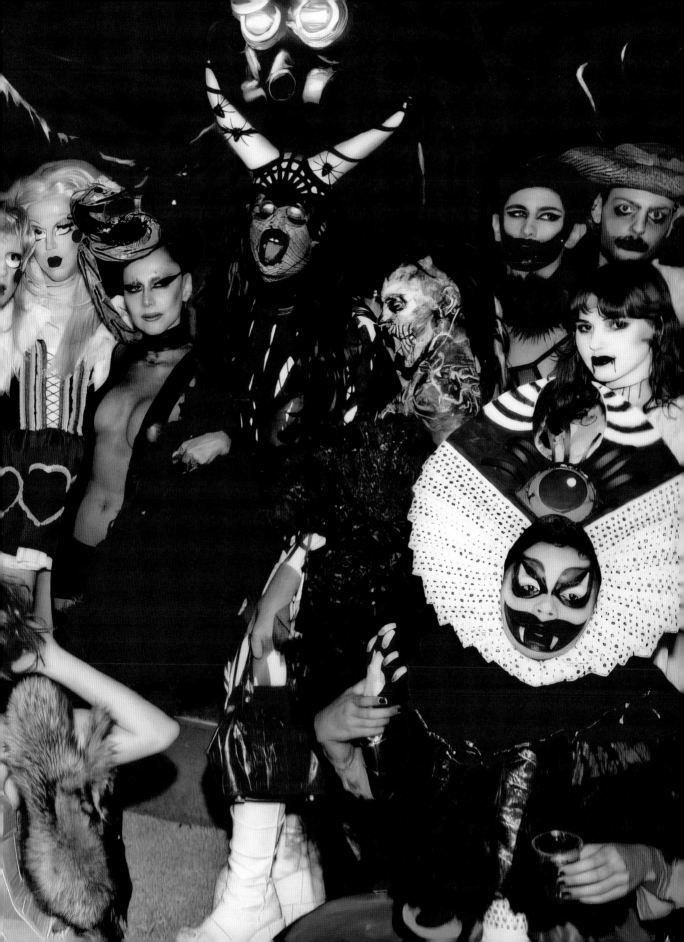

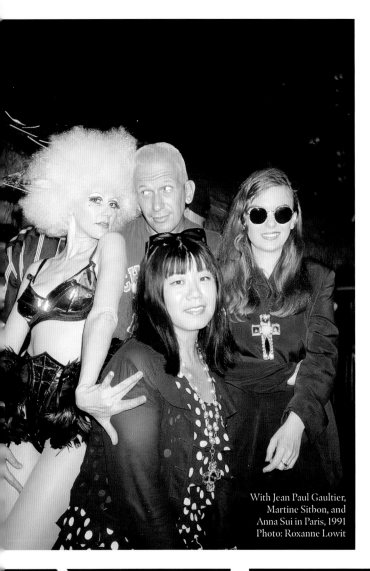

With Jean Paul Gaultier,
Martine Sitbon, and
Anna Sui in Paris, 1991
Photo: Roxanne Lowit

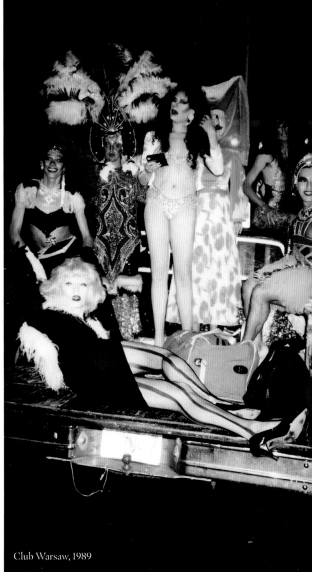

Club Warsaw, 1989

At the Gaultier show, Paris, early '90s

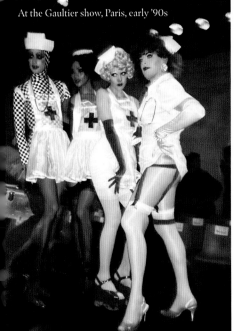

Me and Rossy de Palma with guests
at Armani party

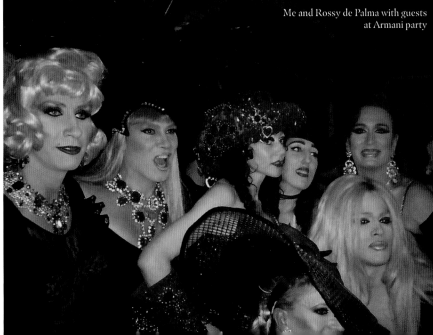

ON THE ROAD

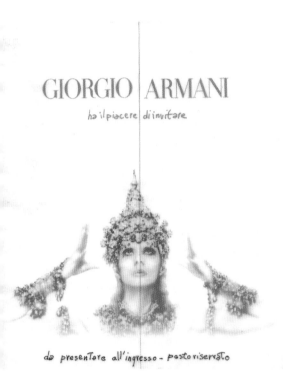

GIORGIO | ARMANI

ha il piacere di invitare

da presentare all'ingresso - posto riservato

The Copa is what really put my parties on the map. People would come from out of town; it became a kind of destination. So, I began to have fans all over the world. In the late '80s, a club in Paris called Queen asked me to come over with a few of my people, like Joey Arias and Baroness, and do my thing during Paris Fashion Week. That became a regular thing for a few years: I'd go do some kind of party every season at different places throughout Paris, like Les Bains Douches, Le Palace, and Le Boy. I also did a few one-offs in Spain, Italy, Germany, Japan—we even went to Thailand. It was always such a riot taking our motley crew on the road—you can imagine the hijinks at the hotel.

Around the same time, a club in Miami called Warsaw contacted me about doing a party. Back then, Miami was nowhere near what it is today. It wasn't a big party town; it was mostly just locals and a few fashion people, like Calvin Klein and Bruce Weber, who'd started to get places down there. It was just on the edge of having a renaissance, and I started doing parties at Warsaw monthly, which became like the Copa goes south. I began to build a following in Miami, and, to this day, it's probably the city I work in most frequently after New York.

When Ian Schrager opened the Delano Hotel, which started the boutique hotel scene on South Beach, he had me do the first New Year's Eve party there. This went on for many years at the Delano and several other Miami boutique hotels. I was down there recently, walking along the beach, and had this moment when I realized I'd done an event at every hotel I was passing by—the Raleigh, the Setai, the Shelbourne, and on and on.

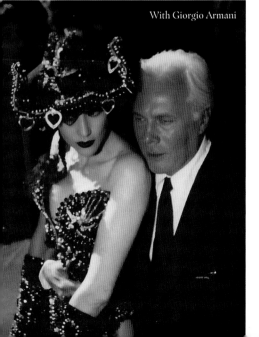

With Giorgio Armani

With Debi Mazar and Chanel Twins at the Mondrian LA, 1996

BARTSCH & I

BY MICHAEL MUSTO

The test of a great party producer is whether or not they care about more than just the party. And Susanne Bartsch really does care. In 1989, when a lot of people in fashion and the nightlife scene had their heads in the sand about the growing horror of AIDS, Susanne got those worlds together for the Love Ball, a splashy voguing competition that raised a whole lot of money for AIDS. As a result of that event—and a follow-up one—I got to prance around in drag (as part of the House of Nicole Miller) and tell gossipy tidbits onstage (as part of the House of Dish, which I organized) before a panel of celebrity judges and a crowd of panting glitterati. More importantly, we all got to feel like we were doing something substantial in the fight against AIDS. I was part of the activist group ACT UP at the time, marching in the streets to demand more attention be paid to the epidemic, but it was Bartsch who found a way to meld the activist spirit with the glitz and glamour. She made charity fabulous again.

It was also vital that Bartsch kept her parties going because we weren't going to let the epidemic destroy our will to live, and besides, her soirees had become great meeting places where all of us could bond and inspire one another. From the start, she's been the queen of the "mixed crowd"—bringing together all races, genders, sexualities, and ages. A lesbian CEO could find herself with a trans DJ, a straight Wall Streeter, and a bi club kid—and leading the parade was Bartsch herself, always dressed to the nines in extraordinary, surreal outfits that she never repeated but which live in the memory forever.

Her first party was at Savage, a Black club that wasn't on the radar for many of the stuck-up "fab crowd" (including myself). But there we were, getting a delicious taste of the place, as well as of the woman who always went against the grain of the conservatism that was encroaching from the outside world and threatening to destroy the party. The more they pushed down, the higher she lifted us, with music, entertainment, fashion, and spirits.

She helped elevate RuPaul to star status and always employed an eye-popping variety of underground figures to host her extremely *non*-debauched debauches. Bartsch's bashes have always been a safe place for LGBTQs and our allies to relax and party unselfconsciously. As a new wave of homophobia, drag-phobia, and transphobia has arisen—threatening to make punching bags and punchlines out of perfectly innocent people who simply want to express themselves—Bartsch's emphasis on celebrating the fabulous underdog is more important than ever. Long may she reign.

ouse of O

Extravaganza .

use of Dupree. H

use of La Beija. Hou

use of Afrika. House of

use is an extended family, a house

any, sewing through the night in

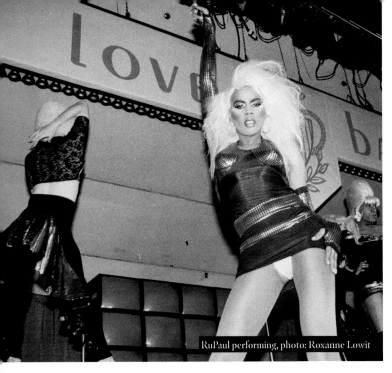

RuPaul performing, photo: Roxanne Lowit

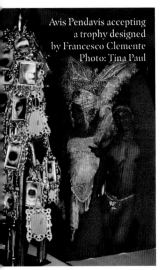

Avis Pendavis accepting a trophy designed by Francesco Clemente
Photo: Tina Paul

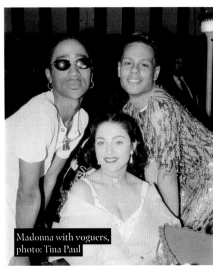

Madonna with voguers, photo: Tina Paul

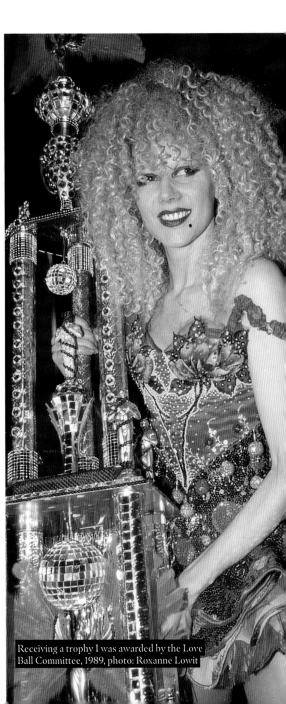

Receiving a trophy I was awarded by the Love Ball Committee, 1989, photo: Roxanne Lowit

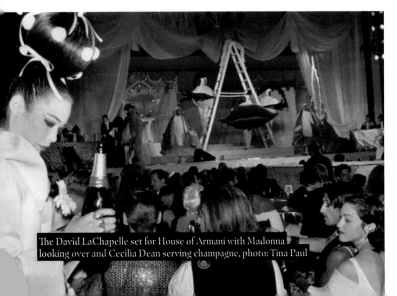

The David LaChapelle set for House of Armani with Madonna looking over and Cecilia Dean serving champagne, photo: Tina Paul

LOVE BALL

It's difficult to explain how surreal the onset of the AIDS epidemic was. You have to remember that, in the beginning, no one had a clue what this thing was—and very few people wanted to talk about it. All of a sudden, it felt like everyone was getting sick, and there was no information about why or how to make it better.

Even when there was little understanding about how the disease was transmitted, and HIV-positive people were treated like lepers, I went to the hospital to be with friends. The gay community was stigmatized; it was devastating and scary, but I didn't want fear to stop me from showing love.

I can vividly remember going through my Rolodex—it was like half of everyone I knew had died. There was so much sadness in those early days. I cried, I screamed, I cursed . . . but, eventually, I got fed up with all the sadness and anger. I wanted to *do* something about this crisis and, more importantly, I wanted to give people hope and create awareness. So, why not do what I do best? Throw a party. I'd gone to some house balls up in Harlem and thought they were incredible.

The idea of competing in looks, of creating your own identity—they were a different take on everything I'm about. So, I got the idea of throwing a house ball to raise money to fight AIDS.

I would get corporate sponsors to be "houses" for the night, pair them with people from my world and from the ball scene, and have them all compete against one another.

The first person I called was my friend Simon Doonan at Barneys. I explained what I was thinking, and he said Barneys would get on board, so we were off and running. I put together a planning committee that included an incredible group of powerhouses like Chi Chi Valenti, *Details* magazine founder Annie Flanders, Marc Balet, and so many others. I would never have been able to pull it all off without them. We'd meet every week to organize what would become the Love Ball.

The creative industries were some of the hardest hit by AIDS—given the number of gay men that were brilliant creatives—but no one in that world was doing anything about it. So, we got a slew of brands—Calvin Klein, Donna Karan, *Paper* magazine, Absolut, Swatch, etc.—to sign on as sponsors and helped them each put together a house. Everything, and I mean everything—the food, the booze, the venue, the time of everyone involved from the waitresses to me—was donated. I was very clear that every cent would be going toward the cause.

It all came together at Roseland Ballroom in May of 1989. The turnout was incredible. It was a mix of my usual partygoers, the corporate money crowd, and all kinds of celebs from Madonna and Keith Haring to David Byrne and Debbie Harry. One of my favorite quotes from that night is

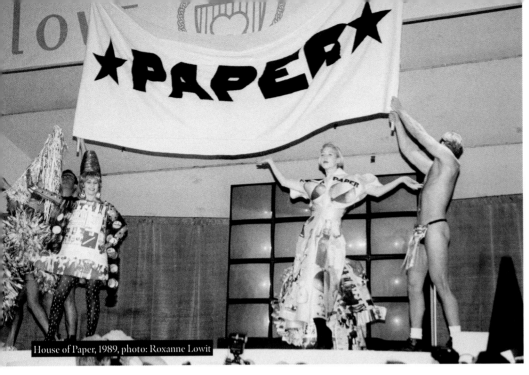

House of Paper, 1989, photo: Roxanne Lowit

With Donna Karan, Mathu, and Zaldy, photo: Roxanne Lowit

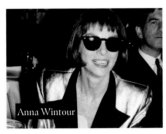

Anna Wintour

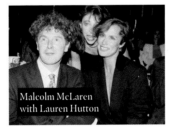

Malcolm McLaren with Lauren Hutton

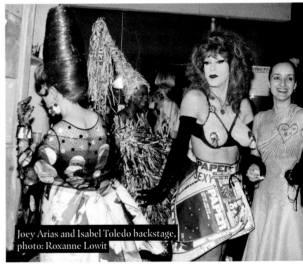

Joey Arias and Isabel Toledo backstage, photo: Roxanne Lowit

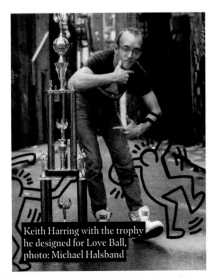

Keith Harring with the trophy he designed for Love Ball, photo: Michael Halsband

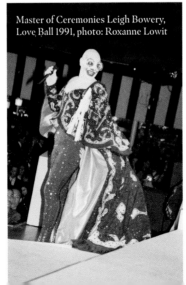

Master of Ceremonies Leigh Bowery, Love Ball 1991, photo: Roxanne Lowit

Posts for guest fax confirmations

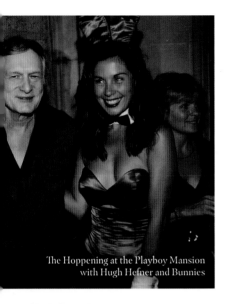

The Hoppening at the Playboy Mansion with Hugh Hefner and Bunnies

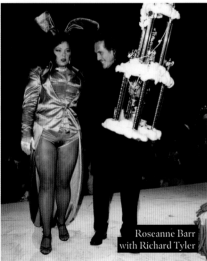

Roseanne Barr with Richard Tyler

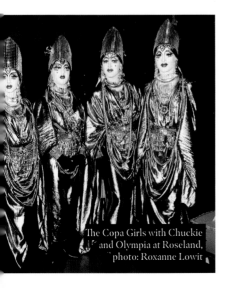

The Copa Girls with Chuckie and Olympia at Roseland, photo: Roxanne Lowit

from Ingrid Sischy, who was the editor of *Interview* magazine: "This is probably the greatest political act of our time." It was magical. I'll never forget standing on stage that night and feeling the love from the crowd being transmitted through me and projected back out to the audience—absolutely electric.

Given my connections in Paris, I did a follow-up a year later called Balade de L'Amour at the Folies Bergère with designers like Jean Paul Gaultier, Azzedine Alaia, Thierry Mugler, etc. Then we did the Love Ball II in New York, followed by another fundraiser called the Hoppening at the Playboy Mansion in LA. All in all, we raised more than $2.5 million to help those living with HIV/AIDS.

One very important aspect of the Love Ball for me was to make sure all the hard-earned proceeds went directly to the people and hands-on organizations, such as the meal-delivery nonprofit God's Love We Deliver. We actually bought them a delivery van instead of giving monies, and I even went as far as to create a committee to interview who we were donating to.

Mission accomplished! Not only were they all fabulous events, but, to this day, they are some of my proudest accomplishments.

Thank you letter from Hugh Hefner about the Hoppening

BALADE DE L'AMOUR FOLIES BERGÈRE PARIS

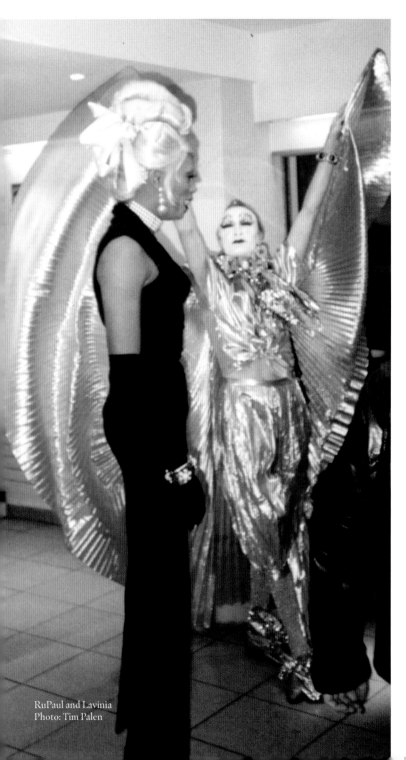

RuPaul and Lavinia
Photo: Tim Palen

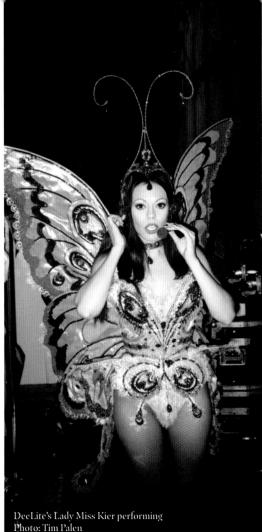

DeeLite's Lady Miss Kier performing
Photo: Tim Palen

A troupe of French firemen performing acrobatics
Photo: Tim Palen

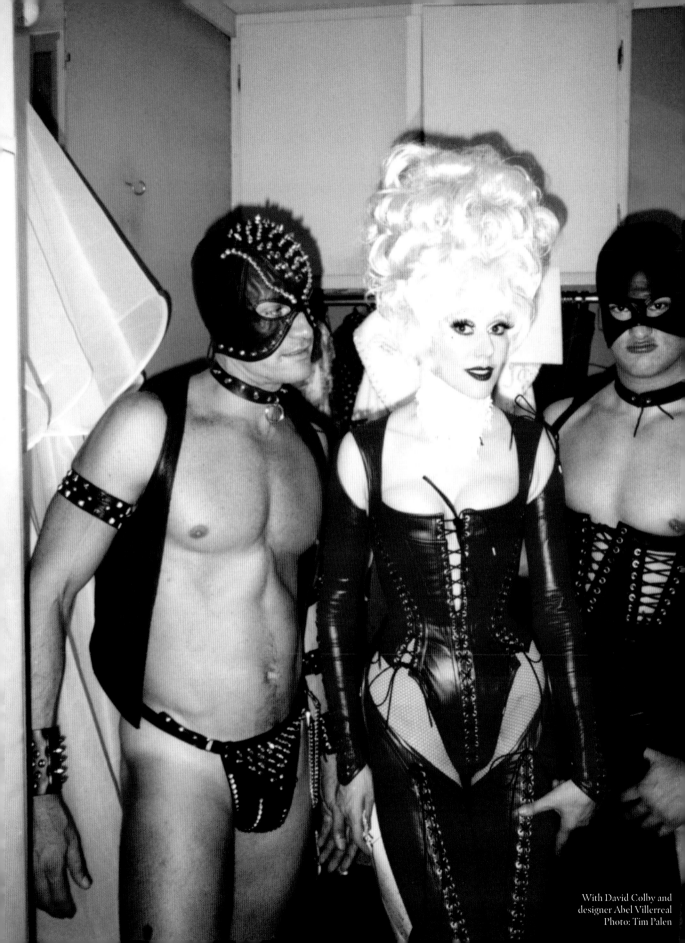

With David Colby and
designer Abel Villerreal
Photo: Tim Palen

HOUSE BALLS

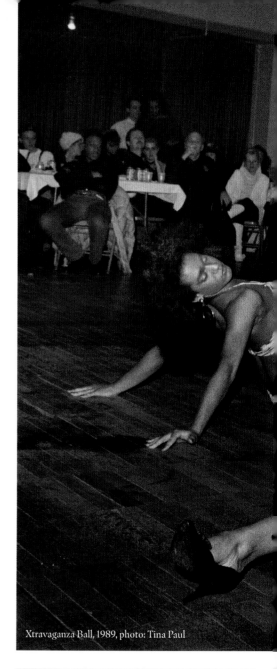

Julio, who worked with me at my shops, was the first person to bring me to a house ball. He was always out and about and was on the pulse of things, and he told me I had to go see these competitions up in Harlem. I was already familiar with the house scene because a lot of those queens would come to my shop—sometimes mopping, sometimes just scouting for inspiration. It was always fun when, lo and behold, I'd spot something from the store at a ball and see how a house queen made it their own. I remember it was just a big room, like a meeting hall—no décor or anything, just a magnificent line up of trophies and a table with judges. The people and the energy in the room was just amazing. I loved the fierce competition aspect and the ball lingo.

It was so inspiring seeing all this creativity, the way they could transform bits and pieces into something so surreal. Beyond the looks, I loved that this was a space where people—many of whom had a hard life—could come together and create their own reality. All the categories—face, swimwear, princess, executive, whatever—they could be that for the night.

The Love Ball was when I really hooked up with the whole house ball scene and made them the main event but, even after that, I kept working with the houses. It was important for me to try to give them work, to give the community exposure. I had voguing upstairs at the Copa every month. I actually used to hire Michelle Visage to manage that, organizing the ball upstairs. And I always had voguers as part of the troupe when we traveled. The ball scene has evolved a lot since then, but it's still fabulous, and I still work with houses like LaBeija, Aviance, Xtravaganza. They remain a source for incredible creativity and talent.

Xtravaganza Ball, 1989, photo: Tina Paul

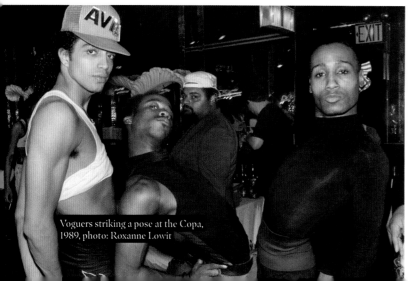

Voguers striking a pose at the Copa, 1989, photo: Roxanne Lowit

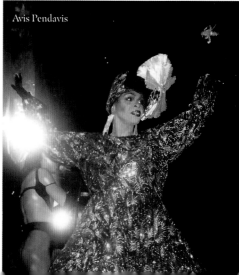

Avis Pendavis

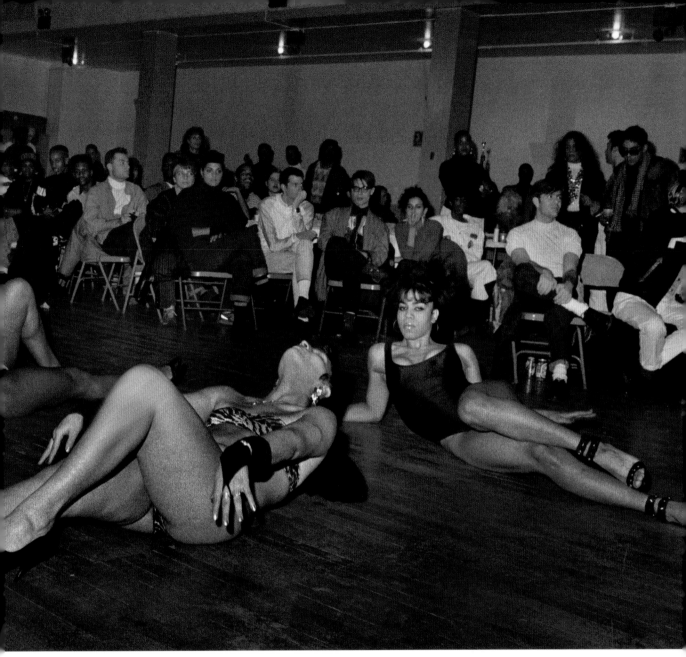

Mother Kevin Omni at home

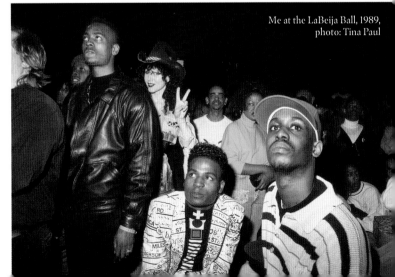

Me at the LaBeija Ball, 1989,
photo: Tina Paul

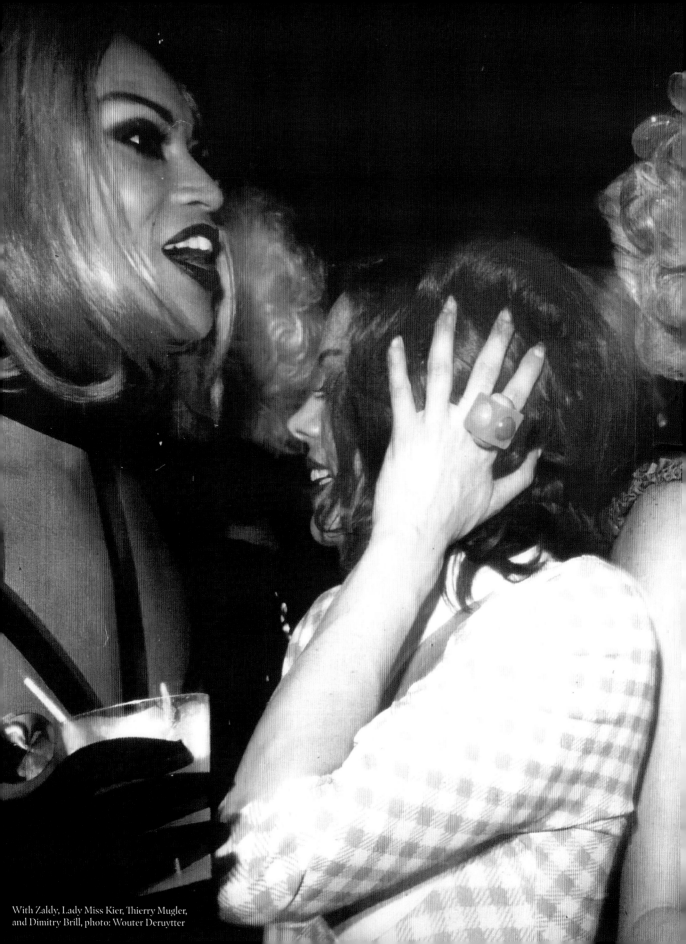

With Zaldy, Lady Miss Kier, Thierry Mugler, and Dimitry Brill, photo: Wouter Deruytter

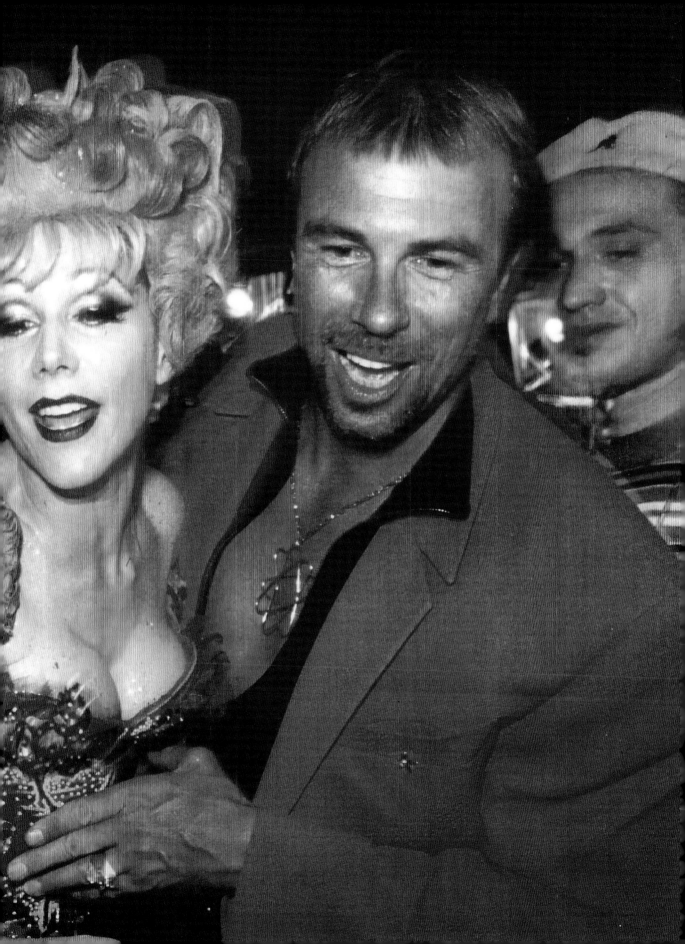

MUGLER

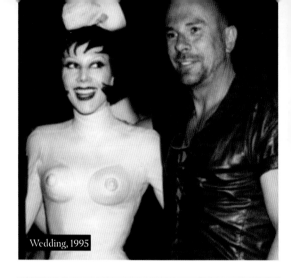

Wedding, 1995

I first met Manfred at my Copa party, and we just clicked right away. He'd come to the Copa and was inspired by what I was doing, and I was a huge fan of his work. Mugler's designs are the ultimate femme fatale—his clothes make you feel like a million bucks, like you could do anything. I loved his aesthetics and his sense of showmanship—his *defilés* were always a major highlight of Paris Fashion Week. But, more than that, he was a great friend—easy, nice, always had time to talk to you. He was a real mensch.

Our relationship was symbiotic. He actually designed one collection that was partly inspired by the looks I was doing in the '80s—a lot of shredded denim and big, curly hair. He had me walk in that show and it was disastrous; the heels he gave me were like ice skates, I could barely walk. I warned Thierry that I would end up on my ass, but he was just like, "Oh, c'mon, Bartschaunette [a nickname he had for me], you can do it." And voila, when I went out on the runway, I fell flat on my back. I just kicked my legs up and crawled down the catwalk; I had fun with it. That's one of the reasons I think we got on so well—we both took our work seriously, but the essence of it was always to have fun. I think he had some Swiss roots; he loved when I would say *chuchichäschtli*, Swiss for "kitchen cabinet," and he'd make me say it all the time as our inside joke.

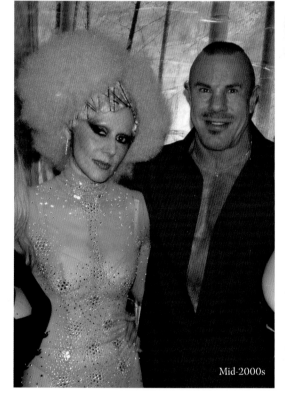

Mid-2000s

He gifted me so many incredible looks, many of which I still wear today. There are the showstoppers, like the gold sequin cowboy look, but I also love his relatively simple black suits. Even when Manfred did "simple," the clothes were still larger than life. I was also his tester when he was developing Angel, his pièce de résistance. I tried out several variations while we were working out at the gym. I remember when it came out and I started wearing it, I was at a deli and the butcher was the first one to ask me, "Is that Angel?" The fact that he could recognize it through the smell of all that raw meat was when I knew it was major. To this day, I never leave home without a few spritzes of it.

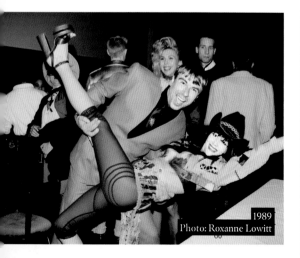

1989
Photo: Roxanne Lowitt
62

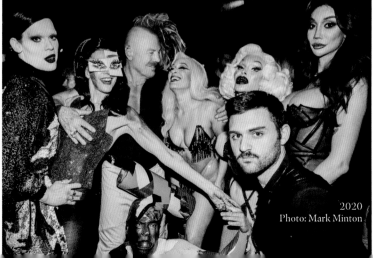

2020
Photo: Mark Minton

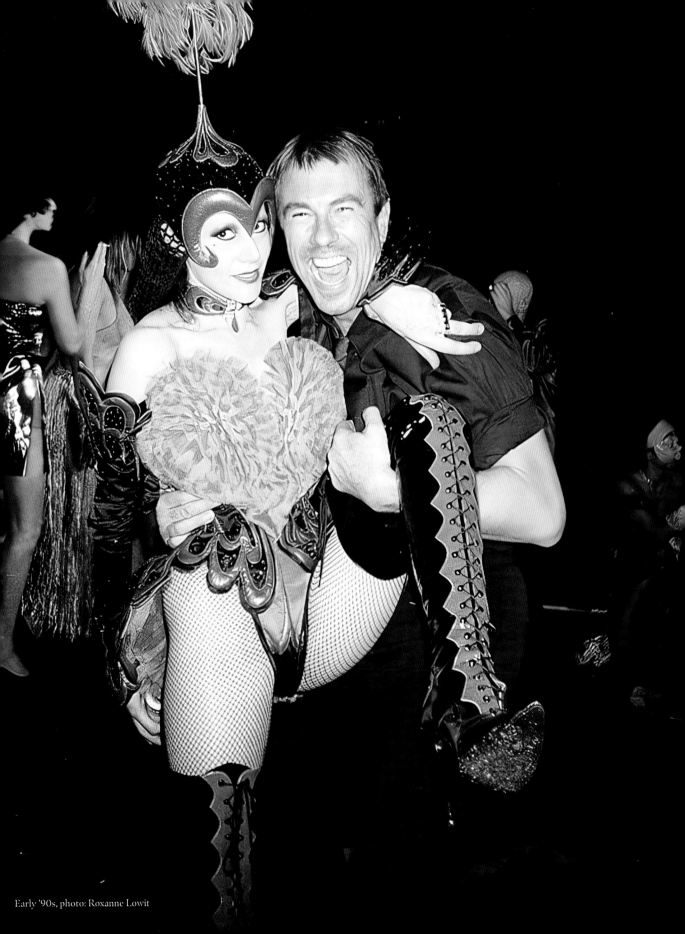

Early '90s, photo: Roxanne Lowit

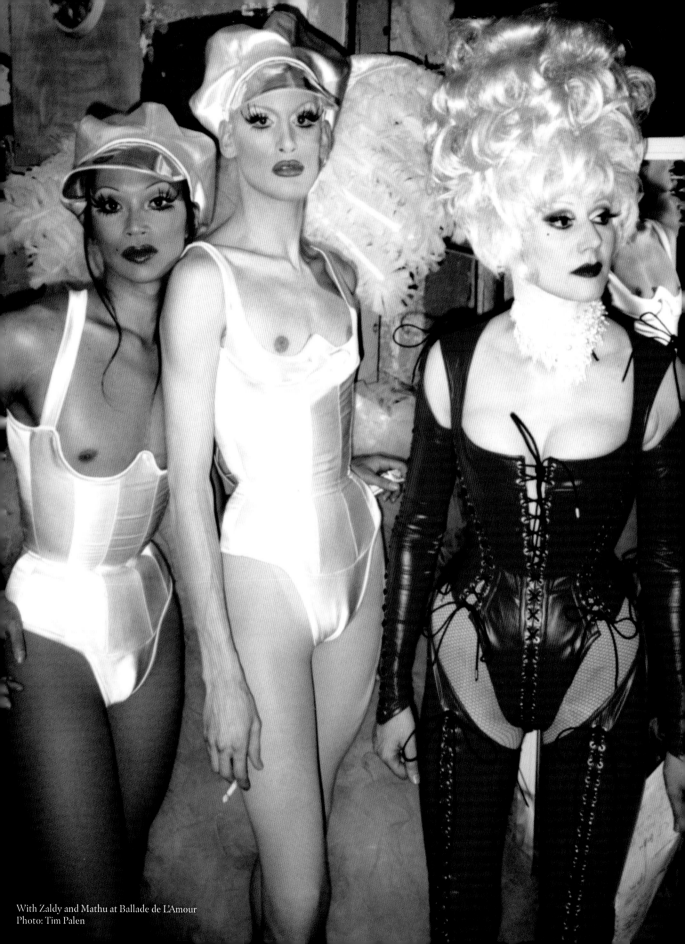

With Zaldy and Mathu at Ballade de L'Amour
Photo: Tim Palen

MATHU & ZALDY

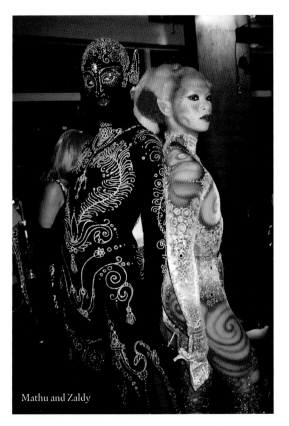

Zaldy and Mathu, 1991,
photo: Wouter Deruytter

Zaldy and I met at one of my parties in the '80s. I always liked his looks and found him magical—so sweet, stunning, and so talented. I became friends with him and his boyfriend, Mathu Andersen, and I remember saying that they should do look-alike, twin looks. They took my advice, and it became their thing.

They were looking for an apartment, and I suggested they move into the Chelsea, so we wound up being neighbors. It was the perfect setup— an upstairs-downstairs situation that led to a magical collaboration. Every time I needed a pin or a touchup, they were there. Mathu was a makeup artist and a fabulous photographer and art director—really, there's nothing he can't do. We began working together on all my invites: Mathu would do my hair and makeup and photograph it, and Zaldy, who was still in school at FIT, would design what I wore. It was an incredible collaboration—I trusted them completely, and they just got me. I would give them themes, like "hillbilly glam" or "alien babe," and they always turned it out. I didn't even have to do fittings with Zaldy. We became so close that he knew every inch, nook, and cranny of my body. It really is a special relationship. To this day, I don't even need to see a sketch or anything; I know that whatever Zaldy makes will be exactly what I want.

I also loved working with Mathu and Zaldy because they got me to push the envelope with my looks. They encouraged me to try things I'd never thought of or didn't think would work for me. And working with Mathu in particular, I began to realize how transformative hair and makeup could be. Mathu moved out to LA eventually and worked closely with RuPaul for a long time. Zaldy, thankfully, stayed here in New York, and even though his main business now is dressing superstars like Britney Spears and Katy Perry and Ru, he still is always there for me when I need a major look and as a great friend.

Mathu and Zaldy

Photo: Wouter Deruytter

With Mathu in LA

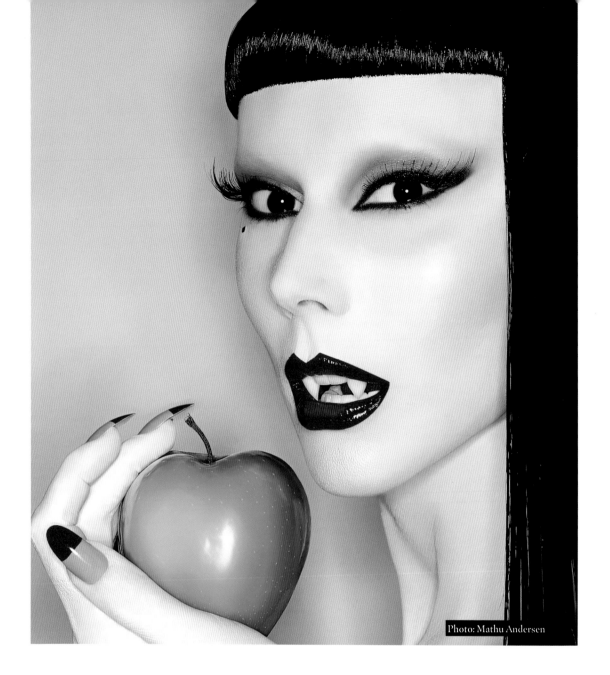

Photo: Mathu Andersen

Susanne is the first muse I met in NYC . . . she was free and unguarded, her style was bold and fun . . .
English Eccentric meets late-1980s NYC street style, meets Paris high fashion runway . . . she had model's
proportions (still does!), but with curves which wasn't exactly the look at the time outside of Mugler, Gaultier,
and Westwood. She had that aura of a superstar, but she was someone you could touch and feel she treated
everyone at her events as an integral part of the evening! She welcomed me into her fold, and eventually when
I met Mathu and she saw our creative connection, she encouraged us to dress as twins! Of course, Mathu and
my physical looks were polar opposites to each other, but somehow she saw it, and it is what put us out on the
global stage as Mathu and Zaldy. Eventually, it lead me to become an androgynous fashion model walking
for Mugler, Gaultier, and Westwood shows in Paris as both man and woman!

—ZALDY

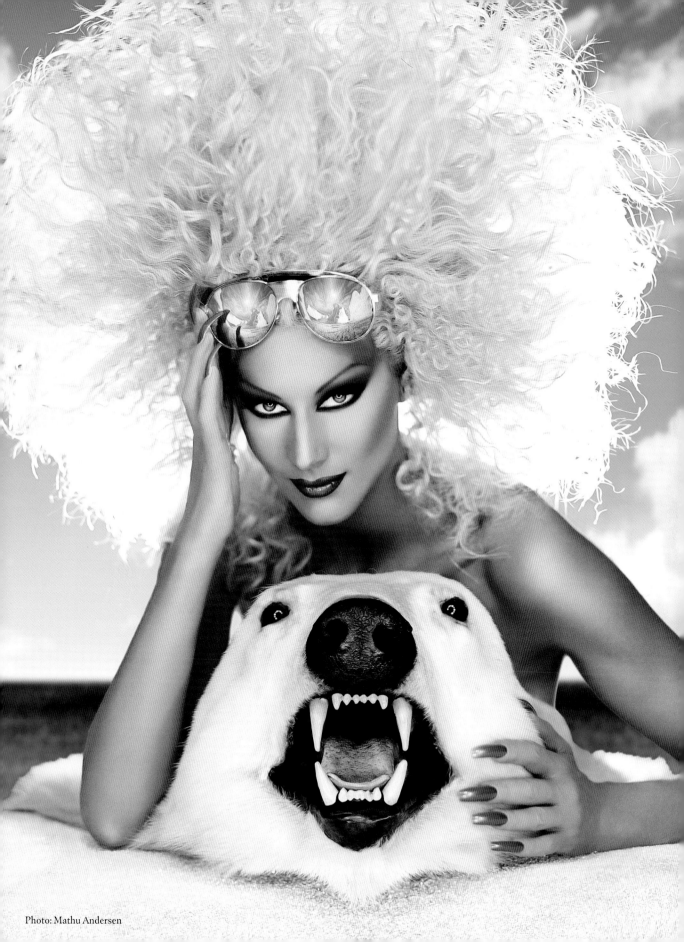

Photo: Mathu Andersen

HOUSE
OF BARTSCH
♥ BARTON

Bath time with Daddy

My assistant Baroness struggled with his weight, but then sometime around '92, he started to get in shape and was looking really good. I asked him what he was doing, and he told me about this new gym he'd been going to on Fifteenth Street. "It feels like home, going to that gym," he said. So, I decided to go with him to check it out. I remember walking in, going down this ramp, and seeing this guy coming up and turning to Baroness and saying, "He's hot." He didn't look like the average muscle head; there was something about him.

Baroness explained that that was the owner, David Barton. Little did I know, I had just set eyes on my future soulmate and the father of my child. I was inside trying out a machine, and, all of a sudden, David was standing there next to me. Apparently, he'd been leaving but the staff told him to come back because Susanne was there. He introduced himself and offered to train me. I had just broken up with Ty, and I wasn't looking to date, but it was like an avalanche had hit me and I couldn't stop it.

I invited him to come down to Miami for a New Year's Eve party I was doing at the Raleigh hotel. As I did the countdown to midnight, I saw David standing there, and as everyone rung in the new year, we had our first kiss. We wound up spending the whole night together, had sex on the beach, watched the sun rise, and that was pretty much it—we were hooked. That spring, I was in negotiations with HBO to do a TV show—it was stressful. David suggested a trip to Anguilla. While we were there, he proposed.

I never envisioned myself getting married—it just wasn't something I'd thought about. But, coincidentally, I'd just found out I was pregnant and I thought, "If I'm going to do this, David's the man." I could tell he'd be a great dad and he just got me—he wasn't threatened by my world and my drag looks. It was a match made in heaven.

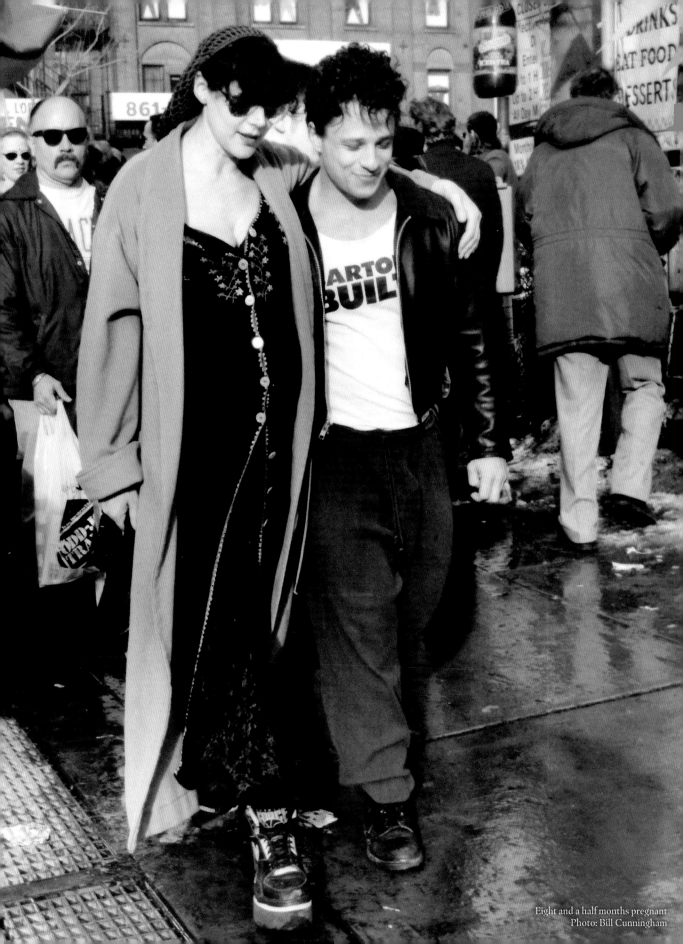

Eight and a half months pregnant
Photo: Bill Cunningham

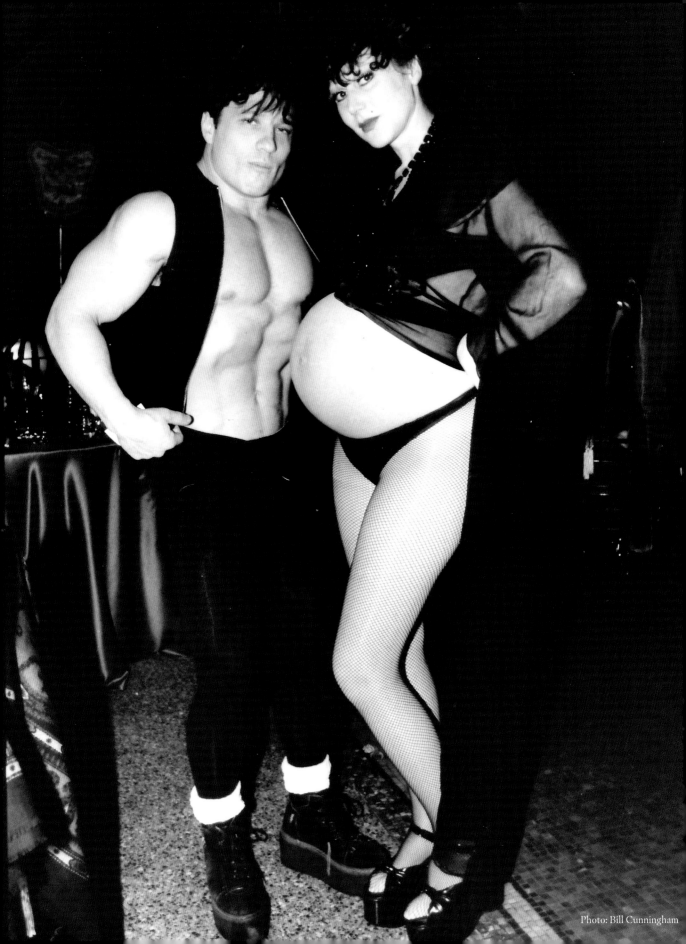

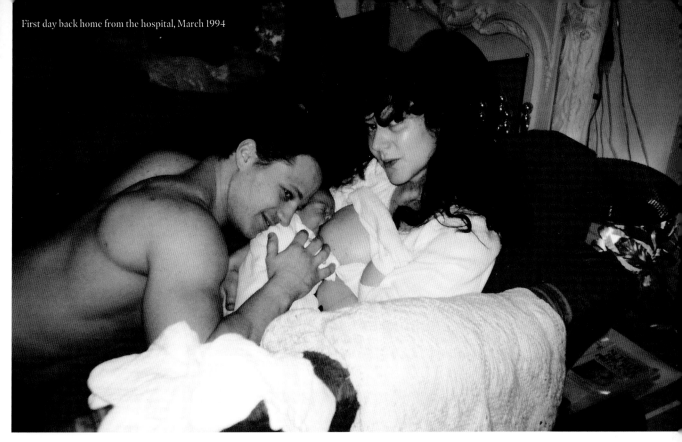

First day back home from the hospital, March 1994

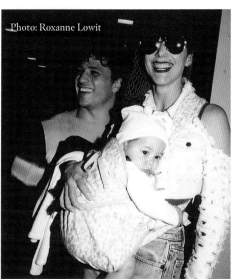

Photo: Roxanne Lowit

There was a moment during my pregnancy when I had a little identity crisis, thinking, "Who am I? What am I?" In retrospect, I think it was just the hormones doing their job. Other than that, I never really worried about how having a baby might change my life. I knew I'd need help and, thankfully, I had it. I was able to keep up my commitments—I even did Halloween while I was pregnant—and having my son, Bailey, was and is the most incredibly rewarding experience. Being his mother is the best thing I've ever done in my life.

Things got a bit trickier as he got older. Trying to keep up with the school schedule and my party life wasn't always easy. But I made it work and managed to bring Bailey to school every morning throughout his childhood. Sometimes I'd get home from the club, walk the dog, and make him breakfast, then crash after I'd dropped him off. Having Bailey taught me so much about myself, and I think I carry some of that into everything I do.

I wouldn't say I'm a mother in the traditional sense, but I do think a lot of people feel safe around me. I bring a sense of stability and reliability; they know I'll look out for them. A lot of motherhood is having empathy, patience, and understanding for others, and I'm grateful that comes naturally to me. Love is not just a word—it's really giving of yourself, and it can be hard. But there's nothing I would change about my experience as a parent, except maybe I wish I'd spent less time on the phone when Bailey was little. I always worked from home and was wandering around the apartment taking calls; now, perhaps not coincidentally, Bailey hates the phone.

69

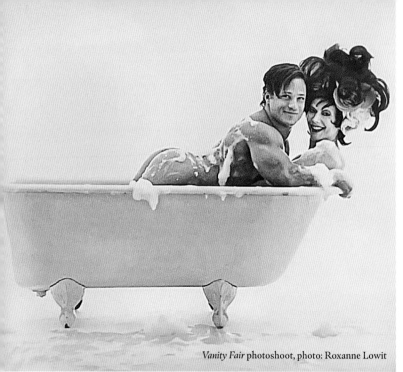

Vanity Fair photoshoot, photo: Roxanne Lowit

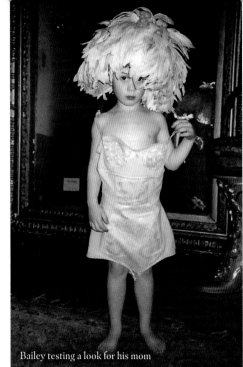

Bailey testing a look for his mom

With Bailey and my dad, Werner

Our dog Schnauzie with her newborn puppies

Three generations of Bartons (Howard, David, Bailey)

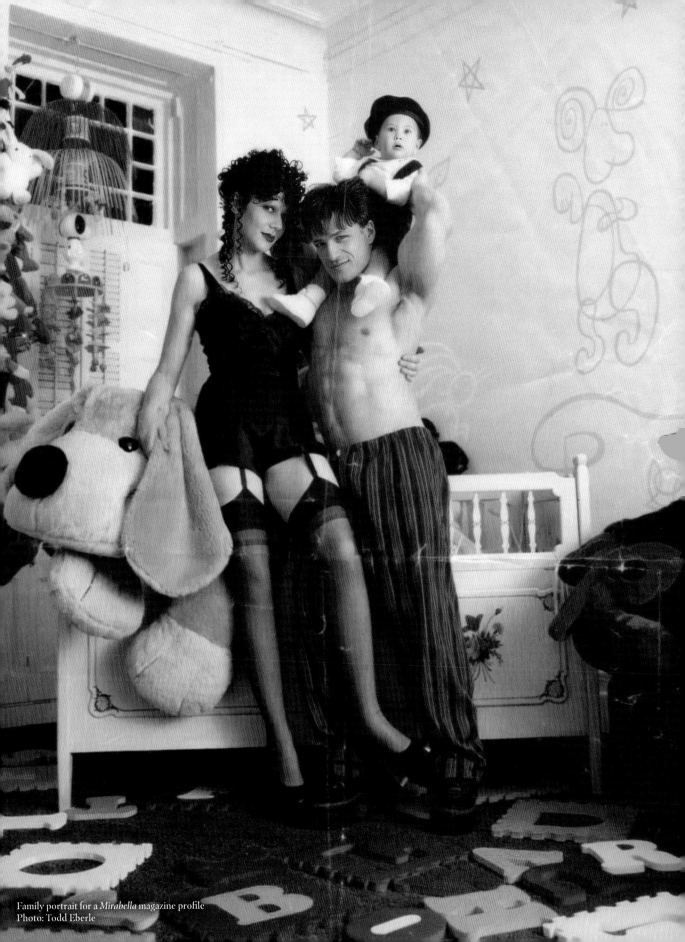

Family portrait for a *Mirabella* magazine profile
Photo: Todd Eberle

I DO!

Even back in my fashion days, I was always drawn more to the characters working behind the scenes and how it all comes together than to the supermodels on the catwalk. That interest is what led me to create an event called Inspiration in 1995. The concept was simple: a runway show where, rather than one designer showing their collection, a bunch of different people who are typically backstage got five minutes to do whatever they wanted on stage. Everyone from makeup artists to stylists to seamstresses to photographers to college students got their chance in the limelight. Even some major designers got in on it—Todd Oldham made a huge dress using a bunch of different pieces from his past collections patchworked together.

I never had any desire to do a traditional wedding thing—a big white dress and planning for years just isn't my thing. Bailey was about a year old at this point; it was no secret that David and I were together. But around the time that I was planning Inspiration, I started to think it would be nice for us to do something that brought all of our friends together to celebrate the little family we'd started. Since I was already planning Inspiration, and *Playboy* was sponsoring it, I thought, Why not turn it into our wedding? We're both very spontaneous people, and David loved the idea.

We decided and managed to keep the whole thing a secret. Only the people who were in the wedding party knew what was up. The 1,500 people in the audience didn't have a clue what they were in for. I loved the tradition of having a bride come out as the last look at a fashion show, so that's what we did—the bride was me and the wedding was the real thing! Of course, nothing about it was your standard matrimonial business.

I enlisted Thierry to make my look. We settled on a nude leather bodysuit, which was crafted by Abel Villareal (whom I'd introduced to Thierry), and a massive egg-like veil, and he had me wear the bridal bouquet on my head. David wore a nude leather thong—and nothing else. We got a nondenominational priest to officiate—no religious stuff—and got all of our friends involved. RuPaul and Thierry were the groomsmen; Richie Rich and Ken, a Robert Mapplethorpe muse, were the ring bearers on roller skates; Baroness walked little Bailey down the aisle; and I had a madcap lineup of forty-three bridesmaids: Joey Arias, Lypsinka, Betsey Johnson, Katie Ford, Ingrid Sischy, the legendary *Vogue* editor Polly Mellen, Kate Pierson from the B-52's, drag queens, trans girls, and on and on. I had dozens of light-up roses that I threw at the audience and confetti bombs went off. It was absolutely magical. We ended up in *People* magazine—how funny!

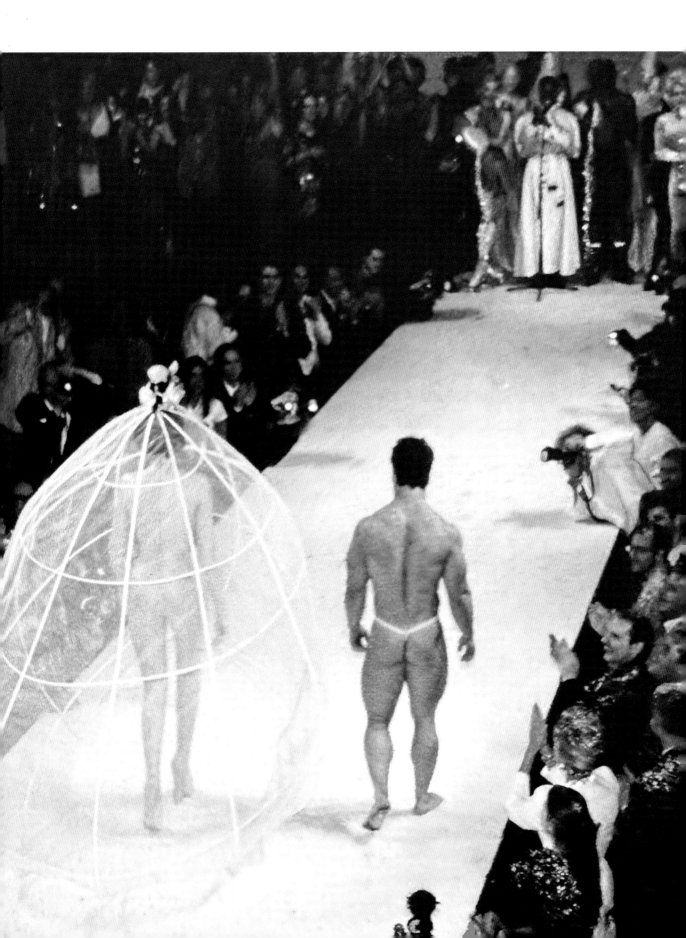

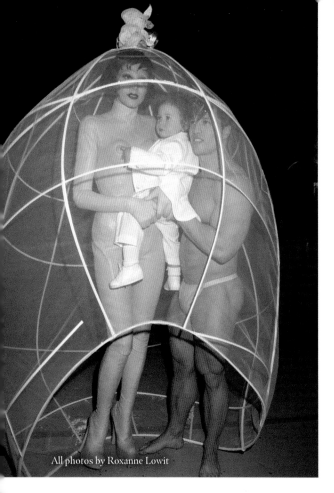

All photos by Roxanne Lowit

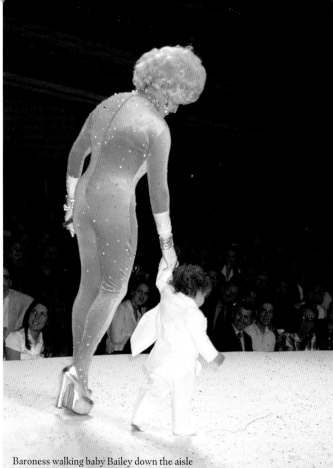

Baroness walking baby Bailey down the aisle

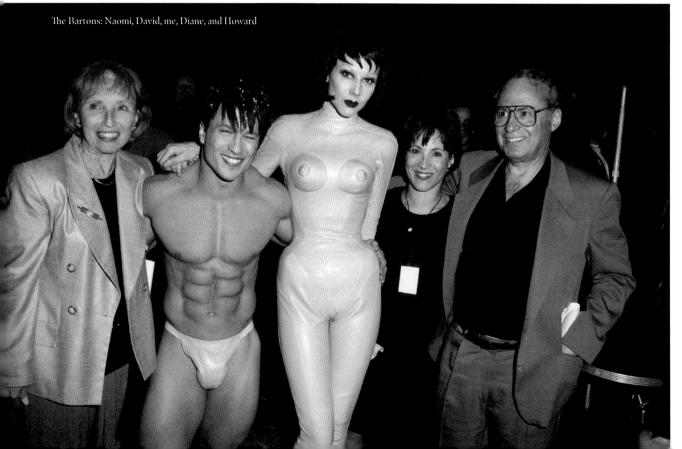

The Bartons: Naomi, David, me, Diane, and Howard

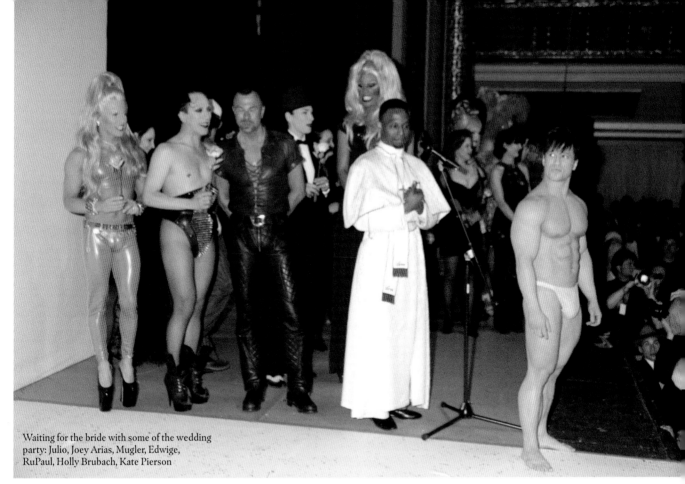

Waiting for the bride with some of the wedding party: Julio, Joey Arias, Mugler, Edwige, RuPaul, Holly Brubach, Kate Pierson

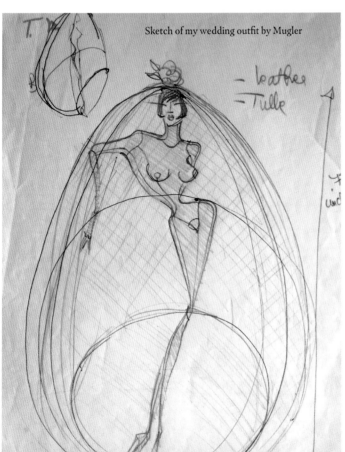

Sketch of my wedding outfit by Mugler

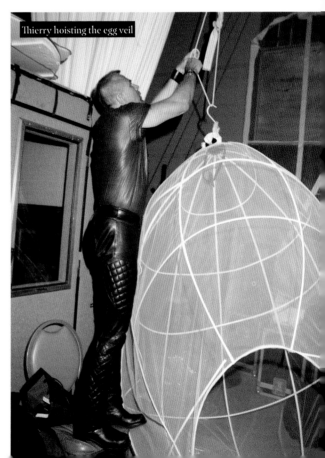

Thierry hoisting the egg veil

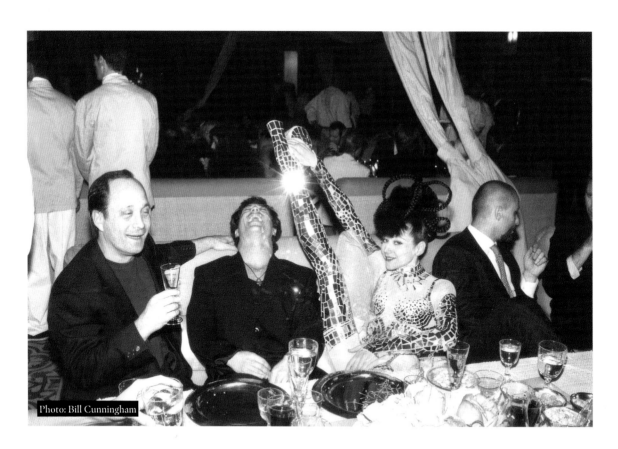

Photo: Bill Cunningham

New Yorker cartoon, March 1993
Drawing by Lee Lorenz

"That's Laura's Susanne Bartsch imitation. I guess it's time for us to go."

CORPORATE PARTIES

When Bailey was little, I decided to pull back from the club scene a bit so I could have more time at home with him. It was a natural progression really—the Copa had ended, and, as the culture began to evolve, more and more corporate sponsors approached me about doing one-off events for their brands. People liked what I was doing; it was progressive, out of the box in a way, but it felt safe and, to them, not too scandalous. People were getting comfortable doing more campy stuff.

One of the first corporate gigs I had was a party for Armani in Milan. Wilfredo Rosado, who had worked at *Interview* and whom I knew from New York, worked closely with Mr. Armani and hooked us up. After Milan, they had me do a big party when they opened their store on Fifth Avenue in New York. Another memorable event was the Grammy's party I threw for Sony/BMG at the Barneys store on Madison Avenue. The theme was music, and I had all of my people—Amanda Lepore, Mathu and Zaldy, Richie Rich, Anohni—installed as part of the decor. It was wild having a party on the shop floor. I created all these little vignettes: Amanda and Richie doing their thing on the perfume counter, Anohni and Johanna Constantine in the window, Sophia Lamar on top of the sweater display with a giant birdcage, playing a gramophone.

There was an amazing series of parties I did for Dewar's, the Scotch brand. One was a Scottish-themed Highland fling at Clinton Castle down by Battery Park; another was at Wollman Rink in Central Park. One of my favorites was at Chelsea Piers—a massive space—and the theme was hillbilly prom. I had mud wrestling, a pie-eating contest, hayrides—I even had a whole petting zoo with pigs and chickens and everything.

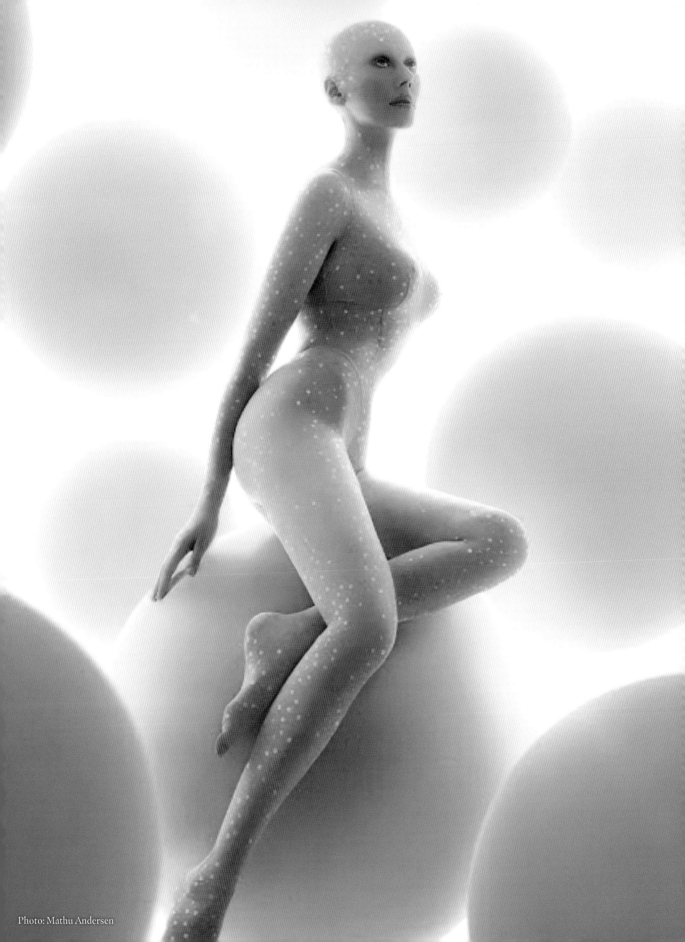

MY BODY IS MY CANVAS

At its core, everything I do is about self-expression. So much of the world, so much of what we're taught, is about fitting into conventions, putting yourself into one box or another. We've come a long way, but still, for most people, expressing themselves feels like a risk. No matter how much we've progressed, there's still a fear of what people will think.

Everything in my career, from my shop to my parties, has, in one way or another, been an effort to encourage people to be themselves—in looks and in life. When you find that confidence in yourself, it's an incredibly powerful, liberating thing. In my early days, I did it with fashion—wearing clothes and putting together looks that may not have been "in" by any popular definition, but that were true to me and my own personal style. Fashion, you could say, was my gateway drug to self-expression, and I think that's true for a lot of people.

As I gained confidence—in myself and my look—I started to push the boundaries even further. Where a look for me was once just the clothes I wore, it evolved to become more complex: hair, makeup, clothing, and accessories became my palette to create something more than just fashion. I have to credit Mathu and Zaldy and all of the amazing hair and makeup artists I've worked with over the years—Danilo, Charlie Brown, Bruce Lindstrom, Deney Adam, Rachel Martuscelli, Ryan Burke, Francis Rodriguez, to name a few—for bringing all my ideas to life.

I can't paint or sculpt, sing or do ballet, but, to me, the looks I create are my art. Back in the '80s and '90s, I'd often do a head-to-toe look—a showgirl or a dominatrix or an alien, for instance—that was more like a costume. These days, I rarely do anything so straightforward. For me, the fun is in the mix: taking a Victorian jacket, mixing it with a punk wig and '60s mod makeup, and topping it off with a mass of Maasai beads. Who says you need to wear a shirt on your back? Why not turn it into a turban? I love using things in a way that they weren't intended to be used, making them my own. My looks are an amalgamation of all the different references that live inside my head, coming together to become something else entirely.

I think people are finally starting to appreciate that our looks —it's not just me, it's also so many of the incredibly talented people I work with—are an art form. But unlike a painting or sculpture, what we create is deeply personal and ephemeral. Each look is a facet of who we are, there for a night and then it's gone. That's one of the things I love most about what I do: Each party is an opportunity to express something new, to try on another side of myself for the night.

Not everyone may need a wig and lashes to express themselves, but that's beside the point. I hope I give people an example of coloring outside the proverbial box and create spaces where people can explore all those other facets of themselves. And, most importantly, have fun.

WELCOME TO MIAMI

Ever since I started to host parties at Warsaw, Miami has become like a second home to me. When David opened his gym at our friend Ian Schrager's Delano Hotel, he had me do the opening event, which was such a hit that I started doing New Year's Eve events there regularly.

Every year, I would come up with a different idea of how to decorate the lobby, the swimming pool, and the orchard. We'd cover trees in miles of silver mylar streamers, turning them into moving silver sculptures, or fill them with big campy inflatable flowers. One year, Dick Walsh, whom I worked with around that time, got giant white inflatable dinosaurs for the pool. Sometimes we'd stage vignettes or have people like Muffinhead do a big look and float around in a gondola. One of my favorite moments each year was when the pool turned into the main stage at the end of the night, with everyone jumping in, some in head-to-toe looks—like Kabuki in his stunning fish look—some naked, and many in wigs and ballgowns.

The New Year's Eve parties became such a *thing*. They'd often sell out in advance. I always stayed in a bungalow by the pool, and I'd hang out there for a few days beforehand to deal with the set-up, prepare the décor, and get things ready. I remember sitting on the patio and people would come up, literally throwing money at me trying to get a ticket to the party—that was almost crazier than the party itself.

With Delano being such a hit, I got many offers to do other events in Miami, like the opening party at the Shelborne South Beach hotel during Art Basel, lots of events at the Raleigh, and a record release for Erika Jayne at the Setai during Winter Music Conference, which was a blast. More recently, I did the opening party of the Brickell City Centre, where I'd hired a punk marching band as part of the festivities. I also did a residency at the old-school cabaret club El Tucán, where, for two years, I staged a monthly variety show called Bareback Follies with legendary performers like Joey Arias and Amanda Lepore, along with some of the new rising stars, such as Aquaria, Violet Chachki, and Narcissister.

What I love about doing events in Miami is that it instantly feels like a celebration. It has all these ingredients that money can't buy—you have the ocean, the sunshine. Plus, it's a quick trip from New York, and it feels glamorous to pop down to Miami for a party.

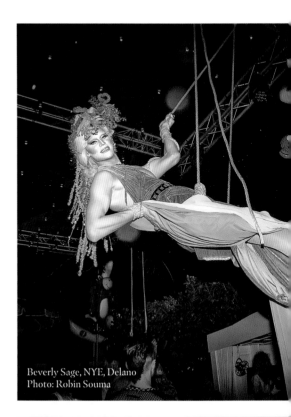

Beverly Sage, NYE, Delano
Photo: Robin Souma

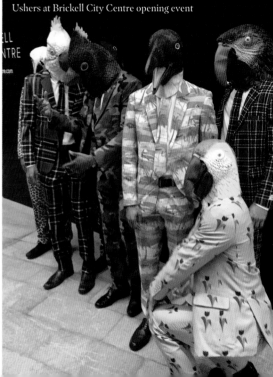

Ushers at Brickell City Centre opening event

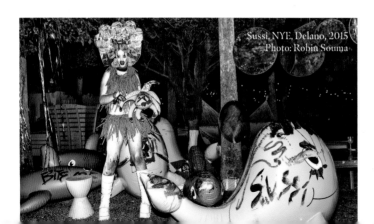

Sussi, NYE, Delano, 2015
Photo: Robin Souma

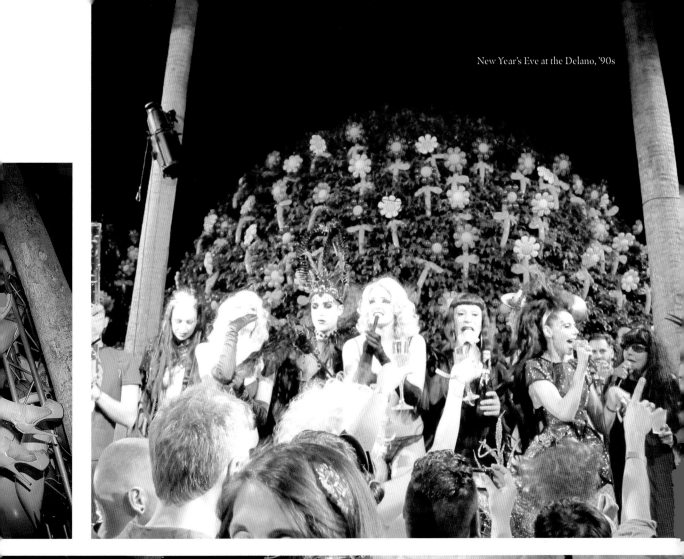

New Year's Eve at the Delano, '90s

Miami, NYE, 1999

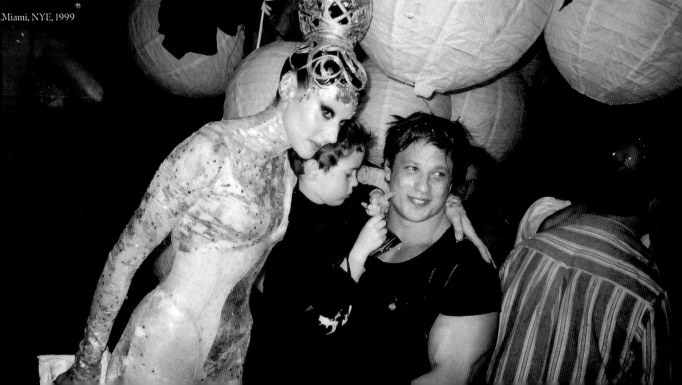

THE QUEENS & I

"Drag" is British slang for dressing up. And, to me, that's what it's always meant. It's not about being gay or straight, or even putting on a wig. It simply means getting, well, dragged up. I'd been aware of drag queens (that is, men impersonating women) when I was living in London, from people like Dame Edna. But it was when I moved to New York that I really fell in love with the whole drag scene.

One of the first clubs I remember going to in New York was a drag bar called Edelweiss. That and two other drag clubs, the Gilded Grape and GG's Barnum Room, were some of my favorite places to go out. I just found these queens totally inspiring. They managed to create these incredible looks out of nothing. That may be what I find most impressive about drag queens in general: their ingenuity and resourcefulness. Many of these guys lived very normal, unglamorous lives, but, at night, they turned themselves into the most fabulous creatures using a garbage bag and a glue gun.

When I first came to New York, drag was very nocturnal. Most of the clubs were in Times Square, where all the strip clubs and hookers were, and it was regarded as a kind of seedy, fetishy thing. Of course, I understood that for most of these queens, there was nothing sexual about it. They were just expressing their art, themselves, having fun, feeling their fantasy. It had nothing to do with getting laid, and I think more people understand that now. I can't take credit for changing that perception—there were a lot of factors, and people like Ian Schrager and Steve Rubell at Studio 54 who helped correct misperceptions—but I do think I did a lot to help get drag seen in a different light.

I started hiring queens for my parties pretty much from the beginning, taking them out of the dingy Times Square, Meatpacking District context and appreciating what they did as artistry. By the time I was doing the Copa, drag queens were a fixture. We did the Miss Copa competition every month, which was basically a drag ball. I think that really got people to see how fun and fabulous drag could be. The Copa crowd was so mixed, it gave a lot of the audience their first exposure to drag, their first chance to see what it really is, which dispelled misguided stereotypes they might have had.

The perception really started to change with the Love Ball, and, in the '90s, largely thanks to RuPaul. First, she got her talk show, and now she has *Drag Race*. I love to see how drag is now running the world!

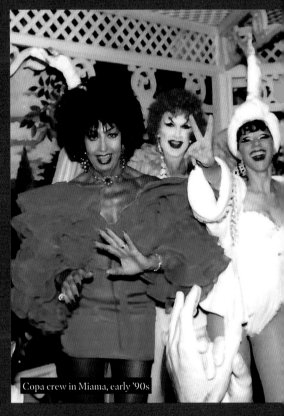

Copa crew in Miama, early '90s

John Badum channeling
Liz Taylor
Photo: Tina Paul

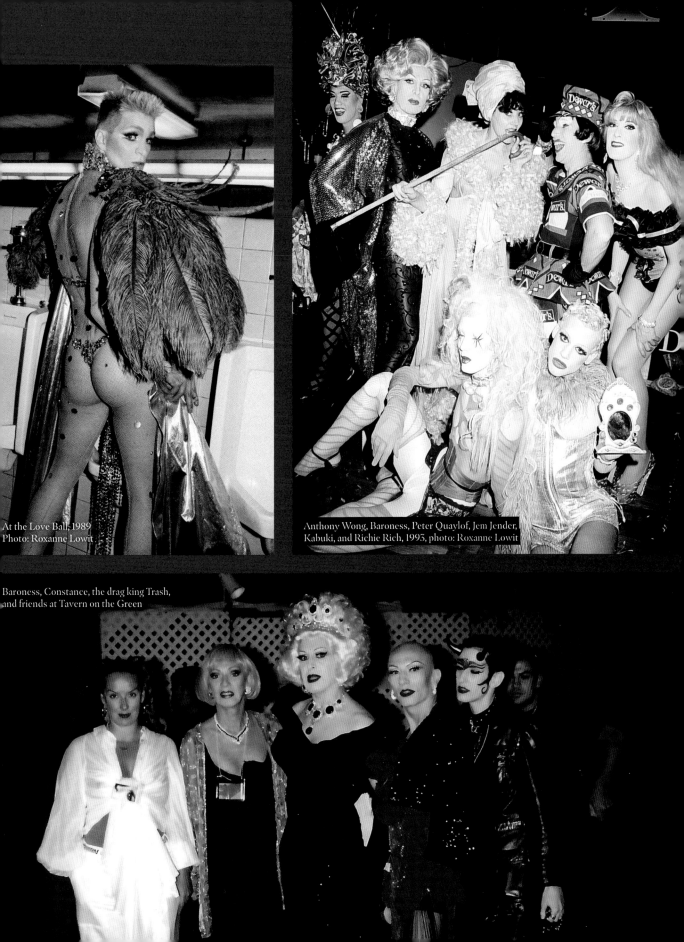

At the Love Ball, 1989
Photo: Roxanne Lowit

Anthony Wong, Baroness, Peter Quaylof, Jem Jender,
Kabuki, and Richie Rich, 1993, photo: Roxanne Lowit

Baroness, Constance, the drag king Trash,
and friends at Tavern on the Green

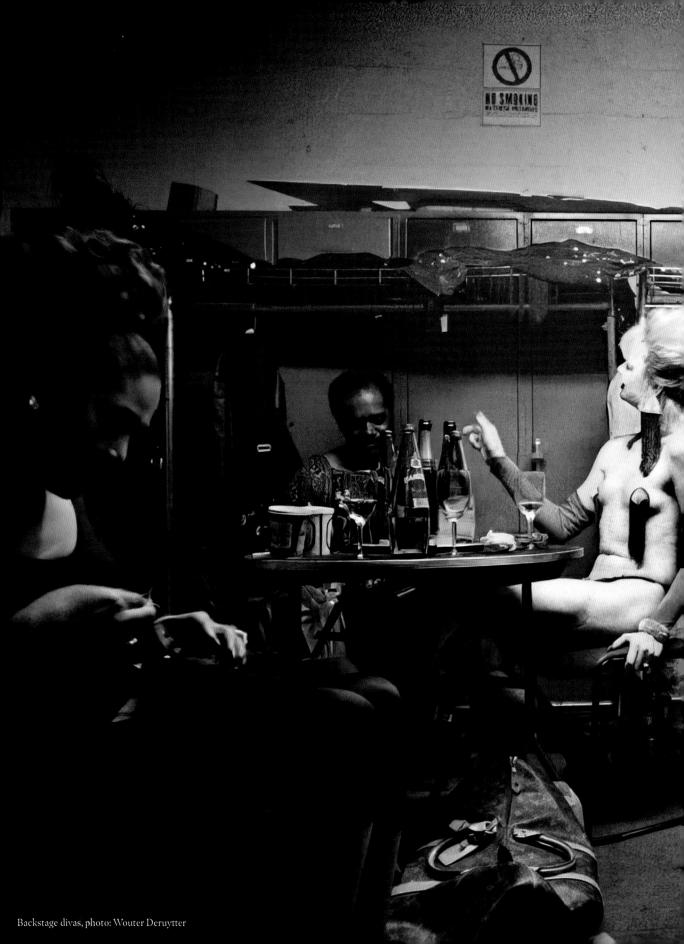

NO SMOKING

Backstage divas, photo: Wouter Deruytter

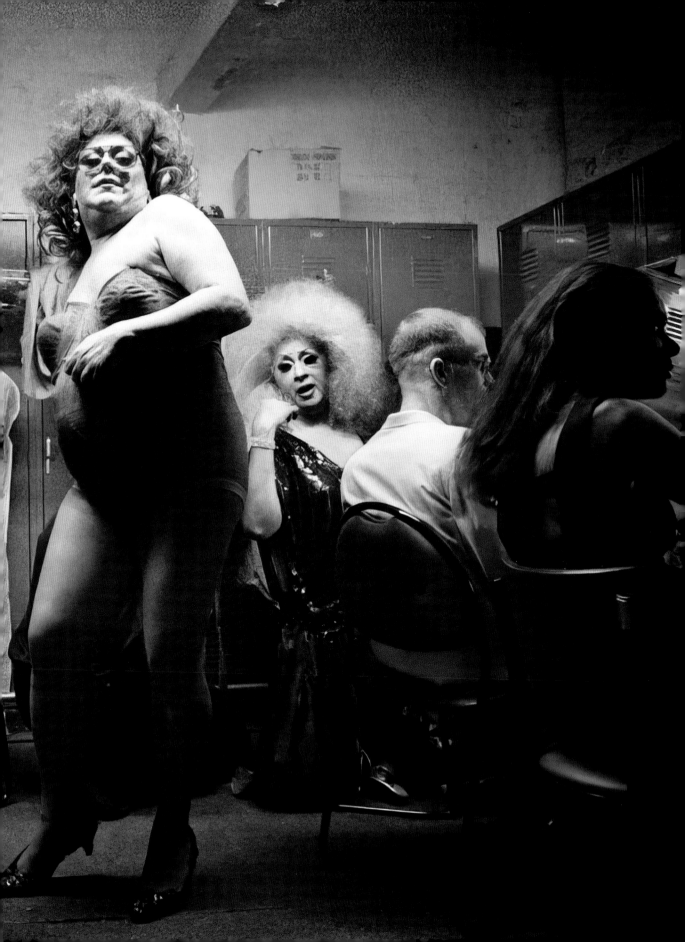

LOOK BETTER NAKED

Being married to a fitness guru changed my life. I'd never stepped inside a gym until I met David, but now I try to hit the gym at least four times a week. It's become a part of my DNA. Thank you, David!

David and I are a perfect creative match; we're aligned in many ways. We're a 24-7 entity: David gets people in shape during the day, and at night I provide a place for them to show off their bods.

We often seek each other's input on things, so as his business grew and expanded, we inevitably began collaborating.

David reinvented the gym business and made working out cool. We enlisted our friends to be part of the process. We worked with Mathu and Zaldy on the branding and ad campaigns, many of which I modeled in. His famous slogan, "Look Better Naked," is genius and timeless. We also did a lot of the shopping together for the furniture and décor at his gyms, which was perfect for me because one of my favorite hobbies is going to flea markets and finding unique treasures. I'd like to say I was the woman behind the man, but to be honest, the man's a genius all by himself.

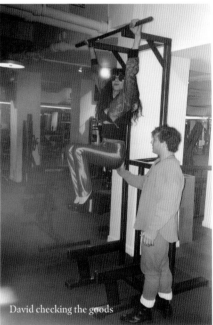

David checking the goods

Trendy workout babes at David Barton Gym,
photo: Ben Chabanon for *Vman* magazine

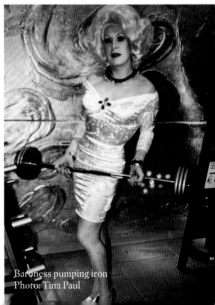

Baroness pumping iron
Photo: Tina Paul

SPRING 2004

DBG

DavidBartonGym
New location 23rd & Seventh

pening invite for
avid Barton Gym Chelsea

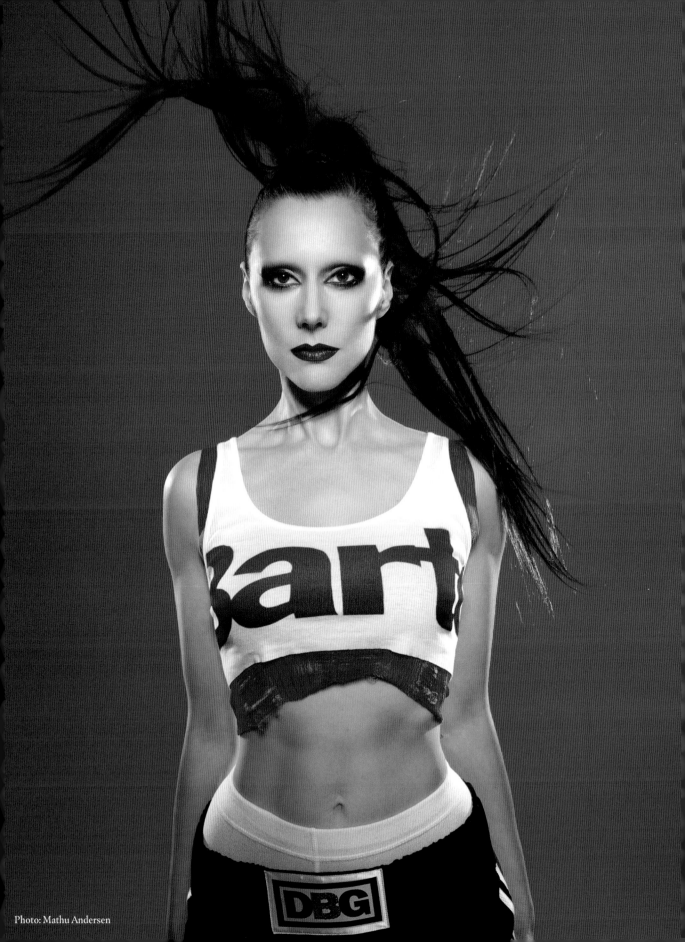

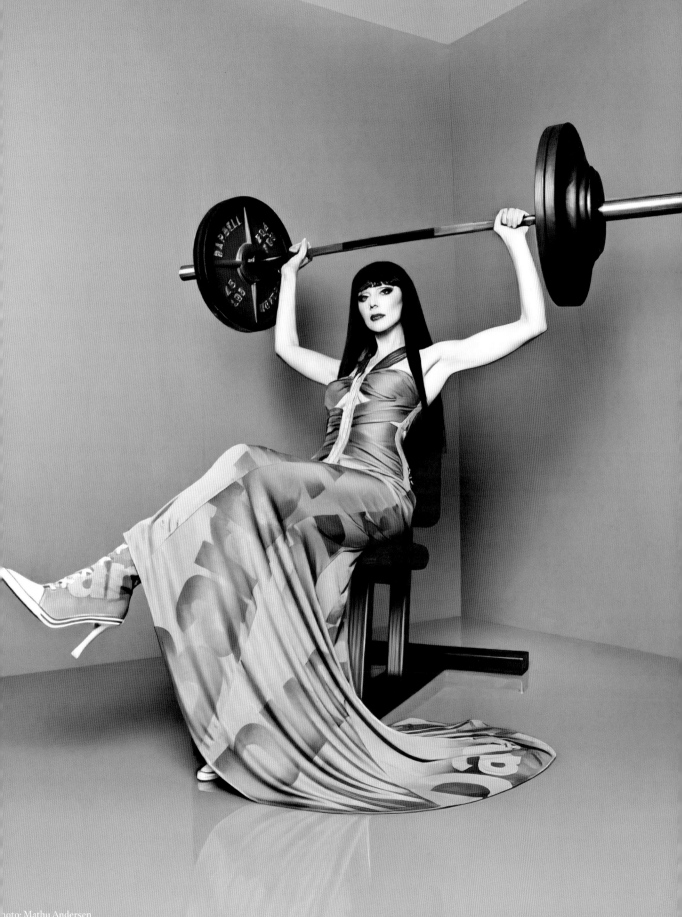

DavidBartonGym

PRESENTS

"We're 5000 toys short this year. So bring one and get your Yuletide groove on..."
— BAILEY BARTON

MIRACLE ON 15TH ST.

A TOY DRIVE FOR THE CHILDREN'S HOPE FOUNDATION

TOY DRIVE

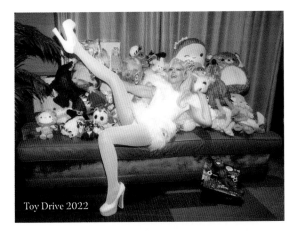

Toy Drive 2022

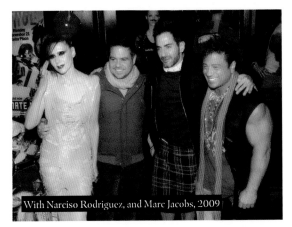

With Narciso Rodriguez, and Marc Jacobs, 2009

After having my own child, I started to become more conscious of children who weren't as fortunate as Bailey. Having done numerous AIDS benefits in the past, I began to think about ways to do something for kids. One holiday season, when David had this great gym on Fifteenth Street and we both had big followings, we decided to organize a toy drive.

The plan was to host a party where admission would be in the form of a toy donation for underprivileged children. We called friends and supporters to cohost, and people arrived with bags full of toys. It turned out to be an amazing and magical night. There was so much joy, everyone was smiling, and we collected thousands of toys. So there it was––our annual toy drive was born.

Every year we're joined by big-name friends like Marc Jacobs, Calvin Klein, Debbie Harry, Bette Midler, and Steven Klein as cohosts and thousands of people attend. Over the years, together with Jonathan Bee's efforts, we distributed countless toys to hospitals and charity organizations throughout the tristate area. Seeing people embrace the spirit of giving back is truly fabulous.

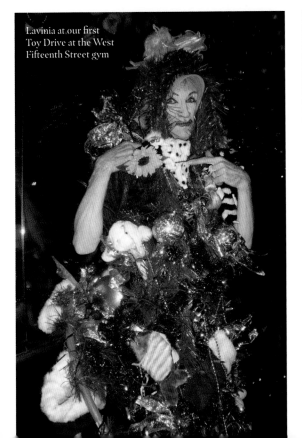

Lavinia at our first Toy Drive at the West Fifteenth Street gym

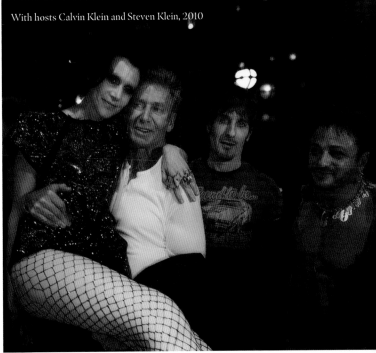

With hosts Calvin Klein and Steven Klein, 2010

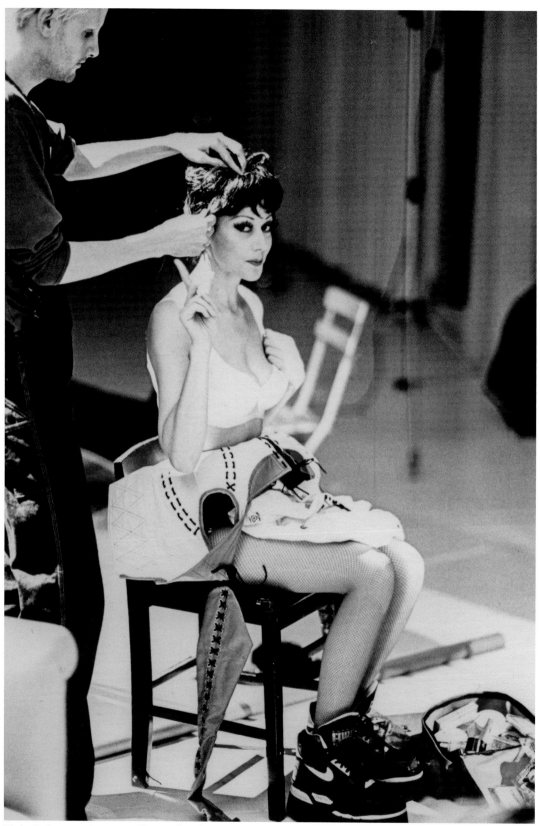

Mathu Andersen turning me out. Photo: Arthur Elgort

THE
NINETIES

When I was focused on raising Bailey and didn't have regular club nights, the party scene in New York underwent a significant shift. Of course, that's one of the beautiful things about this city—it's always changing, evolving. It's also one of the many things that makes New York such an adventure.

Back in the mid-'80s when I started doing parties, the decadent disco days were over, and nightlife was very segregated. There was a club for every scene, be it rockers or muscle queens or whatever, but there wasn't much that brought everything together—different kinds of music, different kinds of people—all under one roof. That's what I'm all about, and as I continued to do more and more events that began to change.

By the time the '90s rolled around, the popularity of my parties and the performers I hired started getting really big. People were embracing campier clubs, bigger looks, drag—a bunch of us even went on some major daytime TV shows, like *Geraldo*. The term "club kids" entered popular lingo; we were part of the culture. Although I don't really see myself as a club kid, or part of that particular scene, we were all part of an exciting new energy in nightlife.

Around this same time, the then-mayor, Rudolph Giuliani, launched a major campaign to "clean up" the city. After-hours parties used to be huge—you could go to places like AM/PM and dance from five in the morning until noon. Then suddenly there were all these new laws and regulations, and clubs had to close at 4:00 AM. Parties were being shut down. It all started to feel very policed. As a result, a lot of the more colorful, eccentric nightlife started to disappear. Times Square was turning into Disney World, and it became more about these very minimal, bougie kinds of clubs.

On another level, the looks began to become more androgynous. I've always been attracted to androgyny, and drag was well on its way to becoming mainstream. I am all about underground, so the emergence of this new generation of people was very exciting to me. I started to work with people like Johanna Constantine, Iggy, and Desi Monster, whose looks were totally otherworldly. It was a bit like the first time Vivienne Westwood hiked up a skirt and made it seem totally new—it was a new way of looking at looks.

The most significant shift was the rise of the bottle service hustle. While I can't speak for every club in New York, at my events, everyone was equal on the dancefloor, regardless of their wealth (and this remains true to this day). But in the late '90s, clubs began to realize they could make big money by essentially selling VIP treatment to whoever could afford to spend hundreds of dollars on bottles of booze. This shift began to change the dynamic in clubs and created a sense of segregation where only those with money mattered. Don't get me wrong, I love a big spender, but that shouldn't run the party. It was clear that the city needed a place where everyone and anyone could come just to dance and have a good time, a place that would bring back some color. It felt like the perfect moment for me to get back into the clubs.

HAPPY DAYS ARE HERE AGAIN

EIGHTIES PARTY ICON SUSANNE BARTSCH RETURNS TO SAVE NIGHTLIFE FROM BOTTLE SERVICE AND PARIS HILTON. BY DAVID AMSDEN

T

HE MAKEUP GUY is a total absolute *geeenius*. Just look at the way he swoops and orbits around her pale, narrow face—a surgeon with the glittery periwinkle eyeliner, his hands seemingly laser-sighted as he carefully crimps a pair of very long, very fake eyelashes. Over the years, legions of theatrical boy-men have hovered over her face with their tiny wands and top-secret compacts, but she digs Bruce like no other. The man is a guru. A magician. With Bruce around, you would never guess that Susanne Bartsch is 55 years old and has, minus a brief hiatus to give birth to a child, been going out nightly for the past four decades.

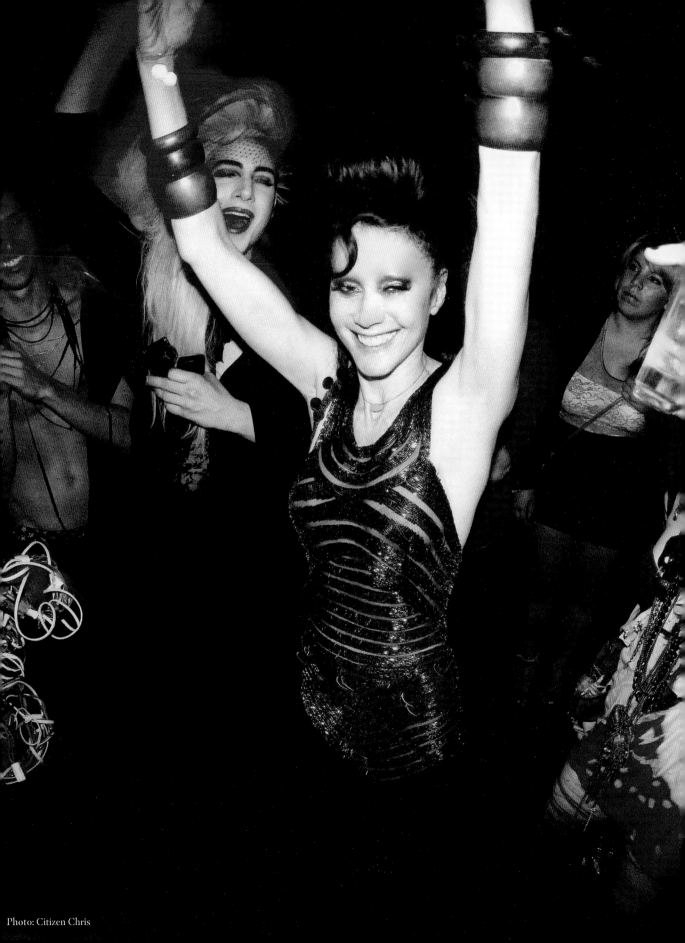

HAPPY VALLEY

In 2006, Kenny Kenny, who I'd hired to do the door for my Savage, Bentley's, and Copa parties, called me about a Tuesday party he was doing that wasn't going according to plan. He thought having me involved could make it work. At the time I had no intention of returning to the club scene, but Kenny thought I was the perfect match and hoped I would get involved.

The club was called Happy Valley in the Flatiron District, and once I saw the space, I was sold. Jeremy Scott had designed the interiors, and it was so fabulously camp: the stage was tiered like a wedding cake, the bathroom had a light-up dancefloor (think *Saturday Night Fever*), and there were enormous mechanical burlesque legs that moved. But the pièce de résistance was the massive disco ball DJ booth hanging from the ceiling. It was just the perfect environment for a party--for my kind of party--so it was a no-brainer.

The party drew a very diverse crowd. People still dressed up but, unlike in the '90s, there was a more casual attitude to it, more of a street element—the whole hipster scene was happening. We were hiring more artsy androgynous performers and drag queens who did more interesting looks. We had performers like Julie Atlas Muz, Anohni, and Dita Von Teese before they became huge superstars. It was dressed up and dressed down all at once. I remember the basement was kind of dead, so one night we said, "Let's put Amanda down there," and the basement was the most packed room in no time. That's one surefire trick I can always count on: If there's a spot in the party that needs livening up, put Amanda Lepore there and the problem is solved.

It was so special. The space, the people, the owners--they were all amazing. It felt like a homecoming. Kenny had helped change my mind, and I was back in the club world.

And I ended up owning the incredible disco ball DJ booth.

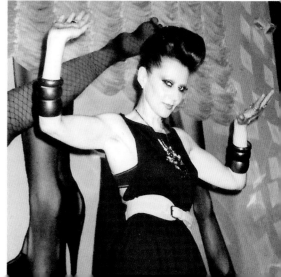

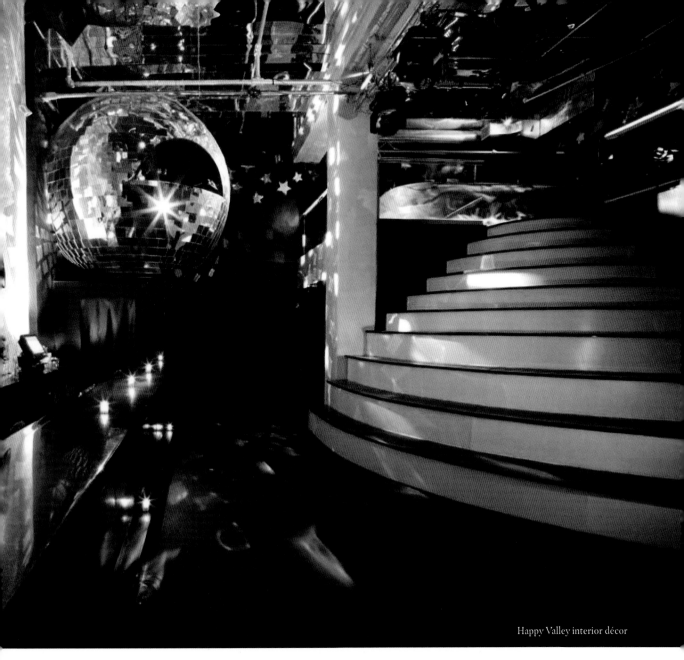

Happy Valley interior décor

With Kenny Kenny, photo: Lisa Fiel

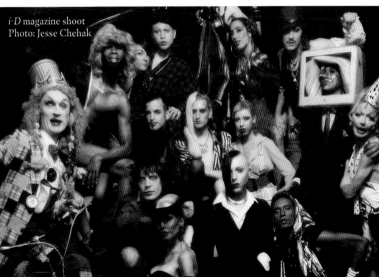

i-D magazine shoot
Photo: Jesse Chehak

VANDAM

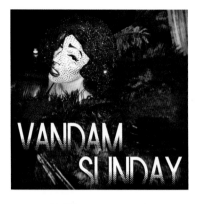

After the Happy Valley club fell prey to real-estate panthers and was turned into condos, Kenny and I started looking for a new space where we could do something together again. We'd done a few parties—Kino 41, Room Service, Juliette—that were all great but didn't end up lasting for one reason or another. (Hey, that's showbiz!)

We knew Vandam, which used to be a really trendy restaurant that I loved to go to in the '80s, was being turned in to a nightclub. While I liked that I had a nostalgic connection to the place, there was one problem: they only offered us Sunday nights. Initially, I wasn't keen on having a Sunday party and was concerned about the turnout. But given that I had already hosted parties on pretty much every other night of the week, including Happy Valley Tuesdays, Copa Thursdays, and so on, I thought, Why not? And so we decided to go for it.

Vandam had two floors: Johnny Dynell was on the first floor playing pop and disco, and Will Automagic and Michael Magnan were downstairs playing house and Italo disco. It was one of the first regular parties I did where there was no entry fee, which I loved. Everyone was welcome, and we didn't have to worry about making money from the door.

We hired lots of peeps: Amanda Lepore, Kayvon Zand, Dylan Monroe, and Jessica Love reigned upstairs, while Desi Santiago ruled the basement, which we called the Disco Dungeon. It was a really wide spectrum of people, from younger kids to more established social butterflies to colorful characters like Calli and Jeanise (aka Bunny and Piggy Huggums), Dirty Martini, and DeeDee Luxe on roller skates

Every week we'd have at least one show—we were finding new performers to showcase, everything from punk acts like Christeene and Rose Wood to dancers like Jonté to burlesque babes like Dirty Martini. I think because it was a Sunday night, there was something wonderfully relaxed about it—like coming and hanging out with your family, which is what it felt like to me, and it wound up being a huge success.

Resident DJ Michael Magnan

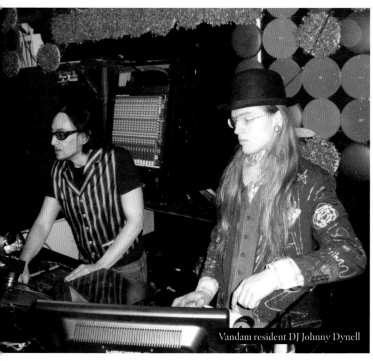

Vandam resident DJ Johnny Dynell

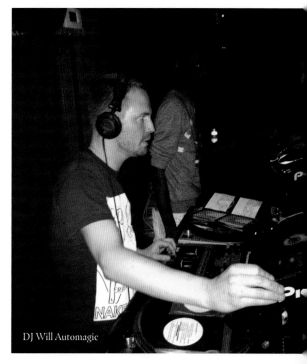

DJ Will Automagic

VANDAM SUNDAY AT LE BARON

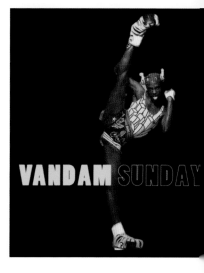

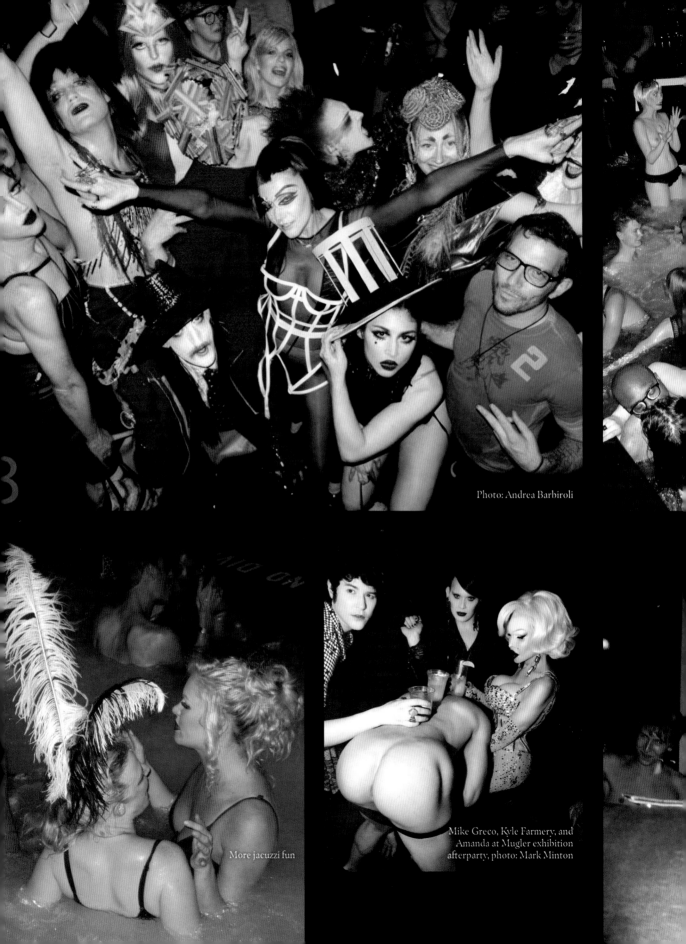

Photo: Andrea Barbiroli

More jacuzzi fun

Mike Greco, Kyle Farmery, and
Amanda at Mugler exhibition
afterparty, photo: Mark Minton

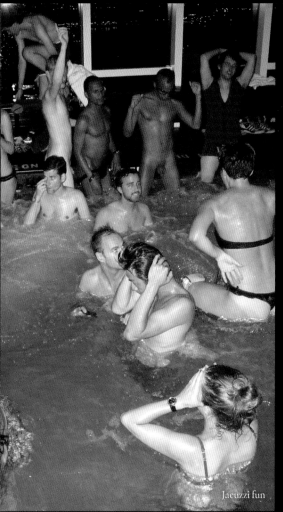

Jacuzzi fun

Working the swing

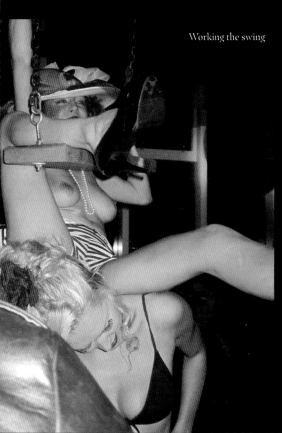

ON TOP

Robert Isabell was genius and a friend who has done events everywhere, from Studio 54 to the White House. In 2009, he told me that some incredible spaces that would be perfect for me were about to open—Le Bain and the Boom Boom Room, both at the Standard Hotel on the High Line in New York.

As it happened, Stephane Vacher, the then director, offered me a Tuesday night at Le Bain, which is on the very top floor. Everything about it is pure glamour—it probably has the most glamorous view in the city. It overlooks the Hudson River, and the main club has a jacuzzi in the middle of it and views of all downtown. The rooftop upstairs has panoramic views of the entire skyline, and there's an outdoor shower and a small creperie. The whole place oozes decadence, which I love.

As soon as I laid eyes on the space, the name On Top immediately came to me. The name not only refers to the club's literal location on top of the Standard, but it also evokes its sex appeal and top-of-the-line status. I decided to play up the decadence of it all: I booked people to host and do art inside the jacuzzi. For the first few years, I hung a swing above the dancefloor and had hosts dancing on the bar. I also hired Joseph—a gorgeous guy with a fantastic body and a huge you-know-what—to hang out in the shower upstairs. I booked androgynous and goth hosts, avant-garde drag queens and artists.

The space is magical, and the party just keeps getting better year after year. I started it in 2011, so it's been going for over a decade now—which is the longest-running party I've ever had. What's truly fabulous about it is that new people are discovering it every year. It's constantly evolving; it's never stale. Every season, it reflects the current pule of the scene happening out there, which is what makes the party so truly special.

BOOM

A few years ago, I started the party called BOOM! by taking over the whole eighteenth floor of the Standard, opening up and combining TOTS (aka Boom Boom Room), Le Bain, and both the rooftops.

I do this big party a few times a year—it's such a treat and fun for everyone to be able to bounce from one club to another, all on one floor. The hotel never has one person run both spaces. I am the only one who can do this, thanks to Stephane.

Photo: Wade Muir

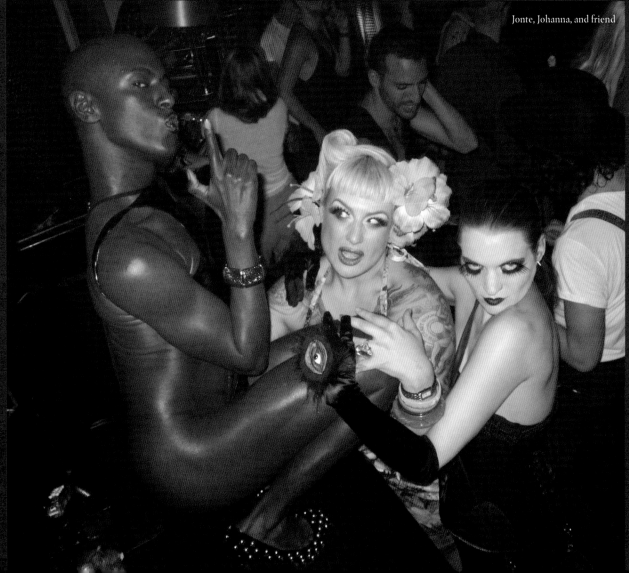

Jonte, Johanna, and friend

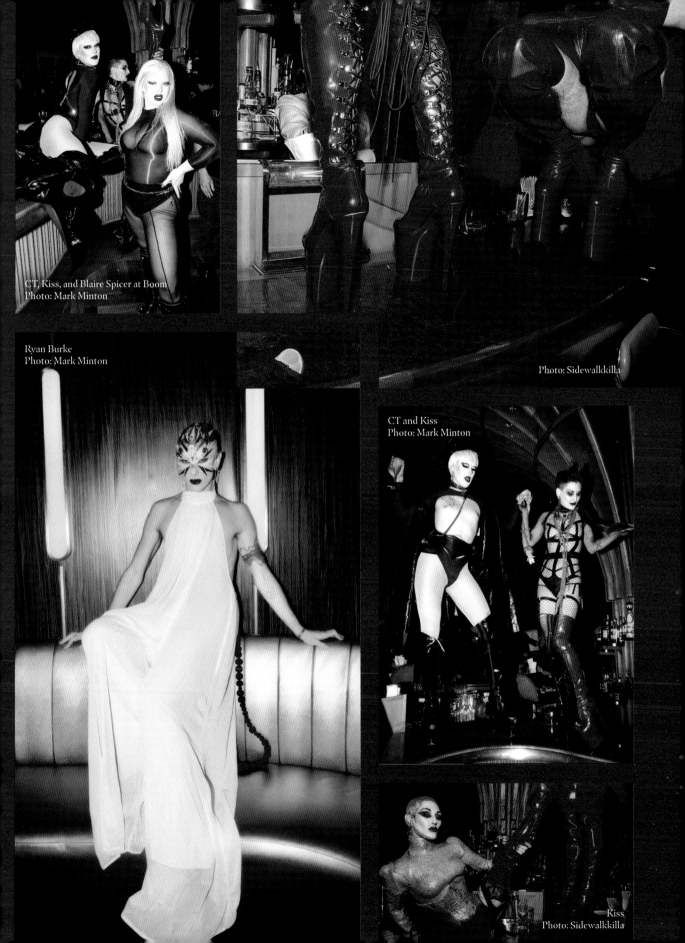

CT, Kiss, and Blaire Spicer at Boom
Photo: Mark Minton

Photo: Sidewalkkilla

Ryan Burke
Photo: Mark Minton

CT and Kiss
Photo: Mark Minton

Kiss
Photo: Sidewalkkilla

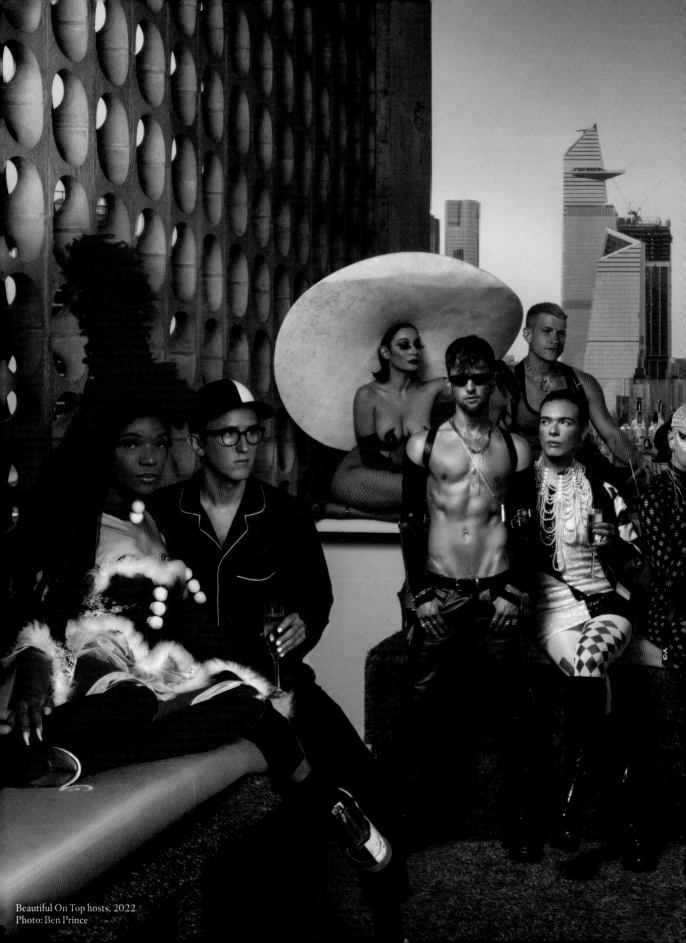

Beautiful On Top hosts, 2022
Photo: Ben Prince

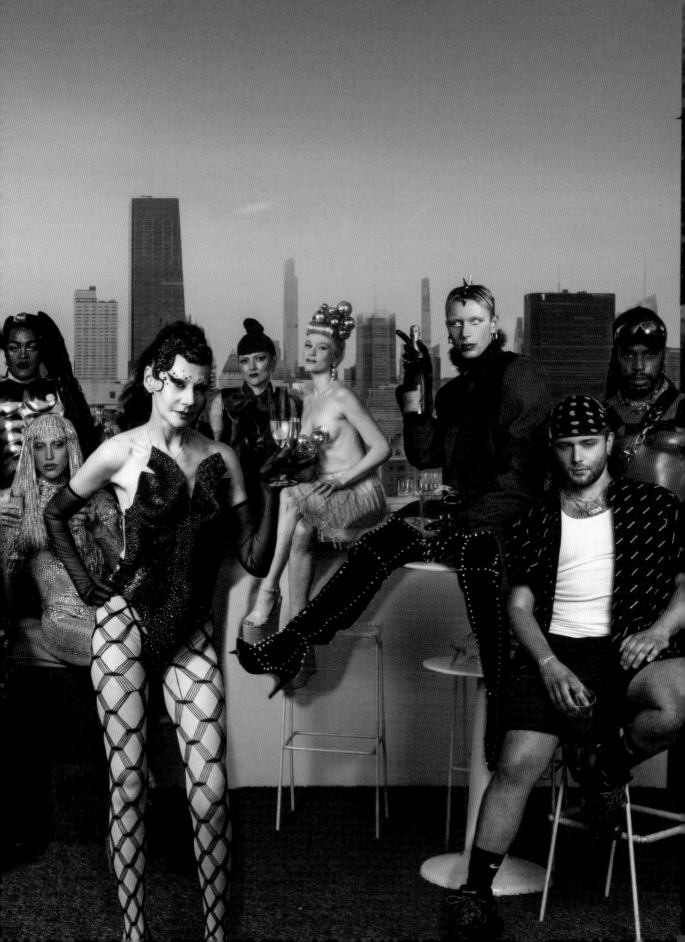

SALON

The Soho Grand Hotel contacted me a couple of years after I'd started On Top to do an event at their Club Room on Tuesday nights, the same night as On Top, but the two places had a completely different atmosphere. The Soho Grand felt like coming into my living room; it's kind of bougie but relaxed at the same time. It's a place to sit, hang out, have a cocktail. It's not a dance club. So I decided to do both: Soho Grand early, like 8:00–11:00 PM, then—always with entourage in tow––head over to On Top to dance the night away. For a few years, I was hosting both parties on Tuesdays, another party on Thursday nights, and Sundays at Vandam.

I named the Soho Grand party Salon, because it had a luxurious, lounge-y vibe to it—very nonchalant and chill, it was the perfect setting for shows. I had Joey Arias performing his Billie Holiday sets every week, which was perfect for the intimacy of the space. I had guest performers, including Bridget Everett. I loved how she added an irreverent twist to traditional torch songs, throwing her tits around. There was no stage, which just added to the intimacy of the night: just the performer and the mic in the middle of the floor, with everyone crowded around. It always felt like the show was just for you.

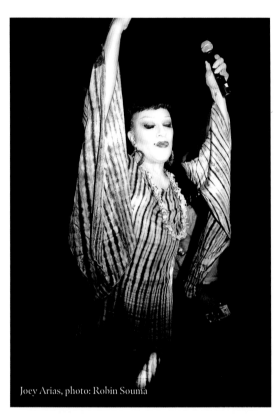

Joey Arias, photo: Robin Souma

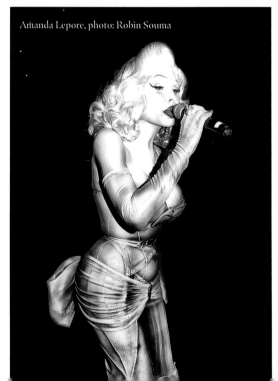

Amanda Lepore, photo: Robin Souma

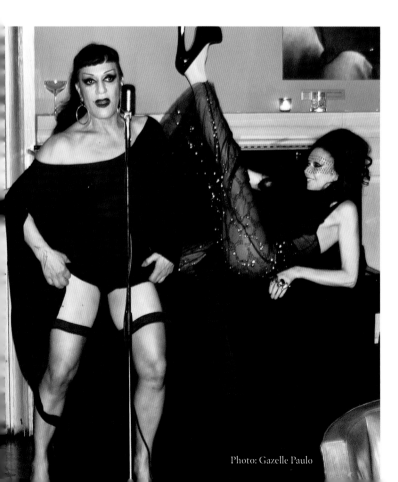

Photo: Gazelle Paulo

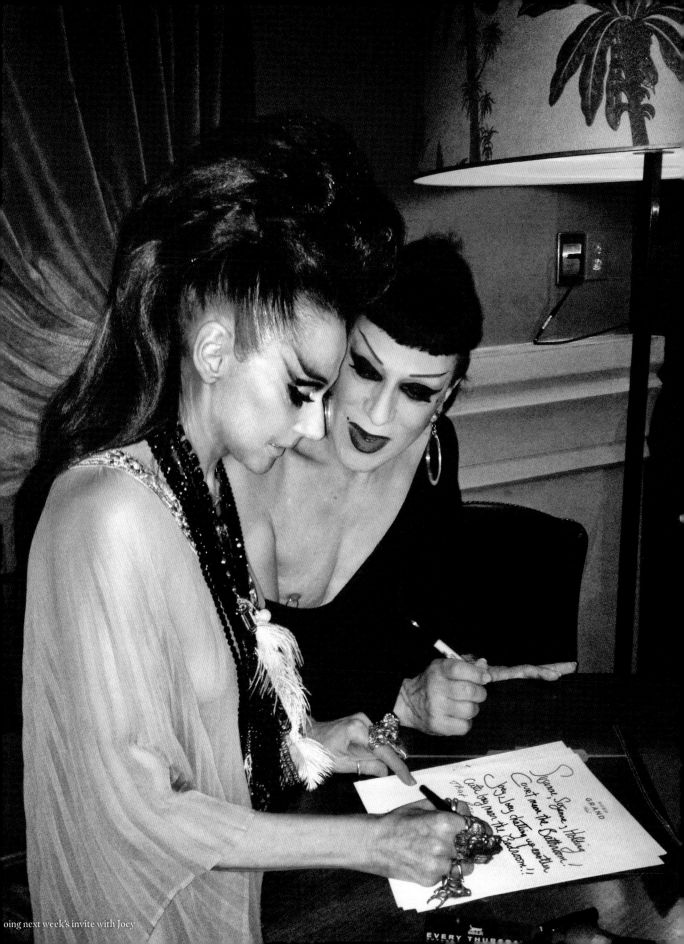

oing next week's invite with Joey

CATWALK

I knew one of the owners of Marquee, a big proper dance club in Chelsea, really geared toward music and DJs—totally different from what I was doing at Salon and On Top. They offered me Thursday nights, and I decided to give it a go. I loved that there was an exposed catwalk hanging around the perimeter of the dancefloor—it was more technical rigging for lighting than a stage, but I thought it would be incredible to do installations up there. So that's where I got the name: Catwalk.

Each week, I had different performance artists like Kembra Pfahler take over the catwalk and do their thing. It was fabulous, until the fire department came one week and said we had to stop because it wasn't a public space. I decided to move the living art installations to the dancefloor.

It was a new way of looking at the kinds of performers I'd always been working with—a more modern take on drag and the elements I'd had at the Copa and Bentley's.

It was fun being in a big club like that; it lent itself to major productions. I did Heidi Klum's Halloween party there one year, turning the whole space into a haunted dollhouse, à la me. I hung hundreds of demented dolls and doll parts from the catwalk. I had multilevel scaffolding in the middle of the dancefloor that was filled with asylumesque characters—living dolls, nurses and gurneys, and sexy doctors. Another time, I did an album release party for Cher with dozens of Cher impersonators—it was mad.

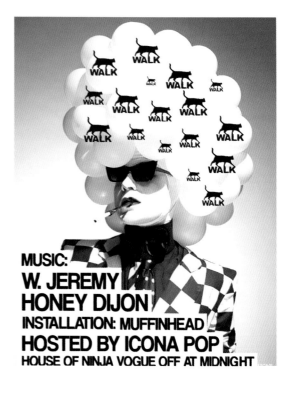

MUSIC:
W. JEREMY
HONEY DIJON
INSTALLATION: MUFFINHEAD
HOSTED BY ICONA POP
HOUSE OF NINJA VOGUE OFF AT MIDNIGHT

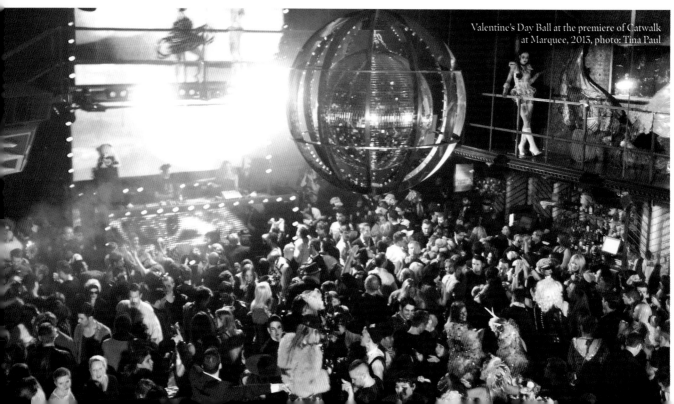

Valentine's Day Ball at the premiere of Catwalk at Marquee, 2015, photo: Tina Paul

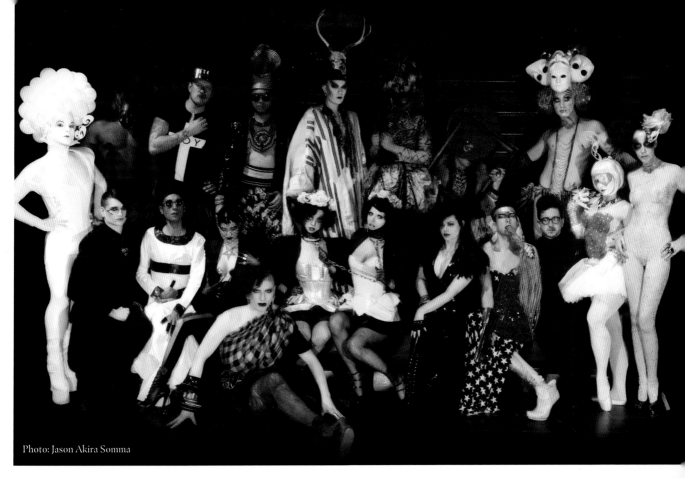

Photo: Jason Akira Somma

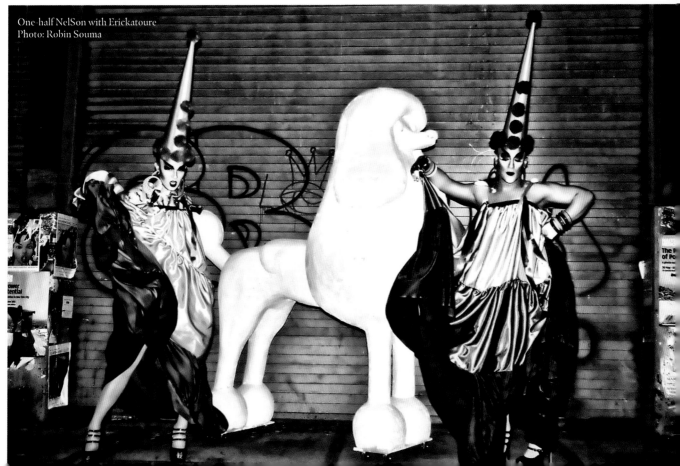

One-half NelSon with Erickatoure
Photo: Robin Souma

JULIET, BONBON, KINO, ROOM SERVICE

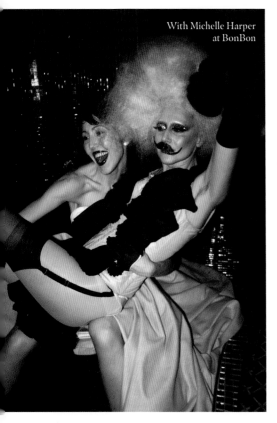

With Michelle Harper at BonBon

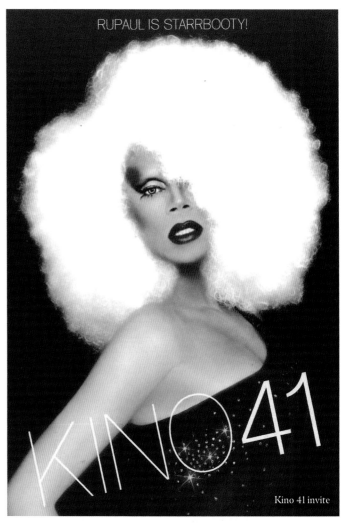

RUPAUL IS STARRBOOTY!

KINO 41

Kino 41 invite

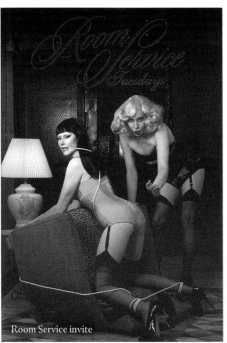

Room Service invite

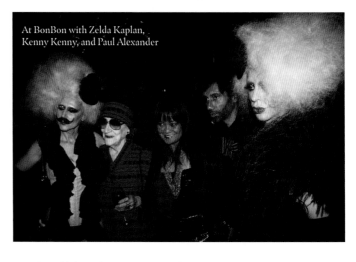

At BonBon with Zelda Kaplan, Kenny Kenny, and Paul Alexander

> *"Susanne's parties are always about bringing together an upper echelon of high vibration and taste. Being much more than a visual stimulant, there's also a total willingness to promote renegade fashion and performance, pushing hard and far in orchestrating the stylish disco superheaven that she's famous for."*
>
> —MUFFINHEAD

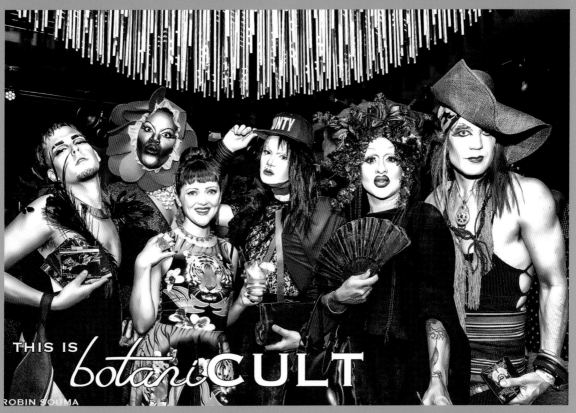

Photo: Robin Souma

COPA 1988

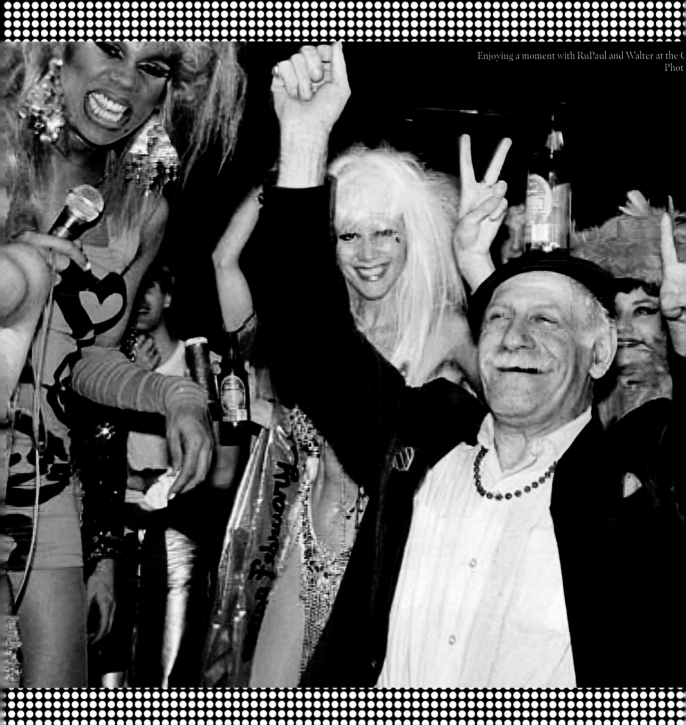

Enjoying a moment with RuPaul and Walter at the C
Phot

ON TOP 2018

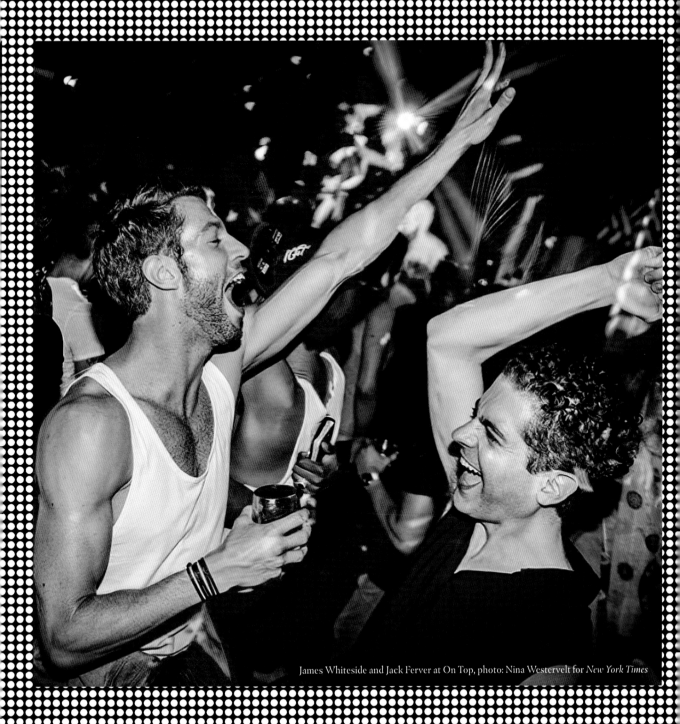

James Whiteside and Jack Ferver at On Top, photo: Nina Westervelt for *New York Times*

ONE-NIGHT STANDS

Even when I was doing three club nights each week, I would always produce one-off special events. One of my favorites was a collaboration with François Nars and Steven Klein, two geniuses whom I've worked with in many different capacities over the years. It was a party for NARS Cosmetics, bringing to life a shoot that Steven had done. The location was Alder Manor—this fabulously derelict estate just outside of the city. I arrived with buses of my favorite talent, and the music was played by Honey Dijon. The event was incredible. I had installations and vignettes created that were all inspired by Steven's photographs—it was incredible!

I also did events for musicians, like an album release for Diesel with Nicola Formichetti for Brooke Candy, and one for Mark Ronson. Back when Simon Doonan was at Barneys, I did a massive Grammy party for BMG, taking over half of Barneys and filling the space with music-themed performance installations on top of display counters. Like on the perfume counter, I had bikini-clad dancers, including Amanda Lepore and Richie Rich and his roller skates.

Another project I really loved working on was a holiday window for Bloomingdale's. They gave me carte blanche to create a Christmas window, and I had a custom neon chandelier made, inspired by the face of Leigh Bowery when he did the light bulb head look. The chandelier was the center of a solar system where each planet was a head that was decorated by various artists circling the chandelier.

Another favorite was the event I did for Kenny Scharf. I took over the Sony Plaza, and one of the focal points was a DJ in the glass elevator going up and down.

One of many Dewar's event invitations

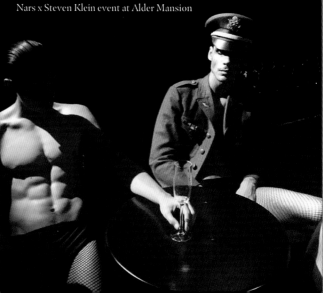

Nars x Steven Klein event at Alder Mansion

Christmas window I did for Bloomingdale's

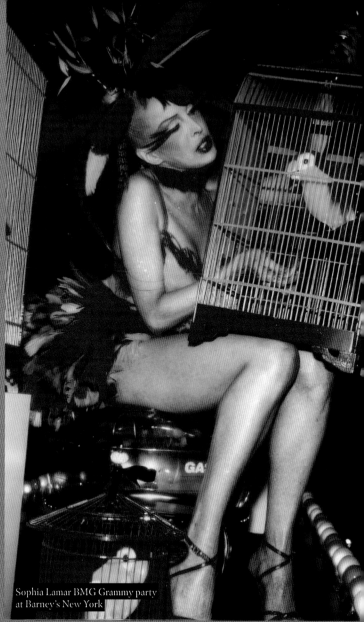

Sophia Lamar BMG Grammy party at Barney's New York

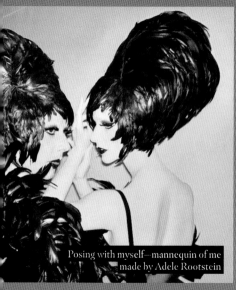

Posing with myself—mannequin of me made by Adele Rootstein

UGG × Bartchland

UGG collaboration, artwork: Bob Bottle
COMING NEW SEPTEMBER 2021

Mark Ronson's Club Heartbreak event

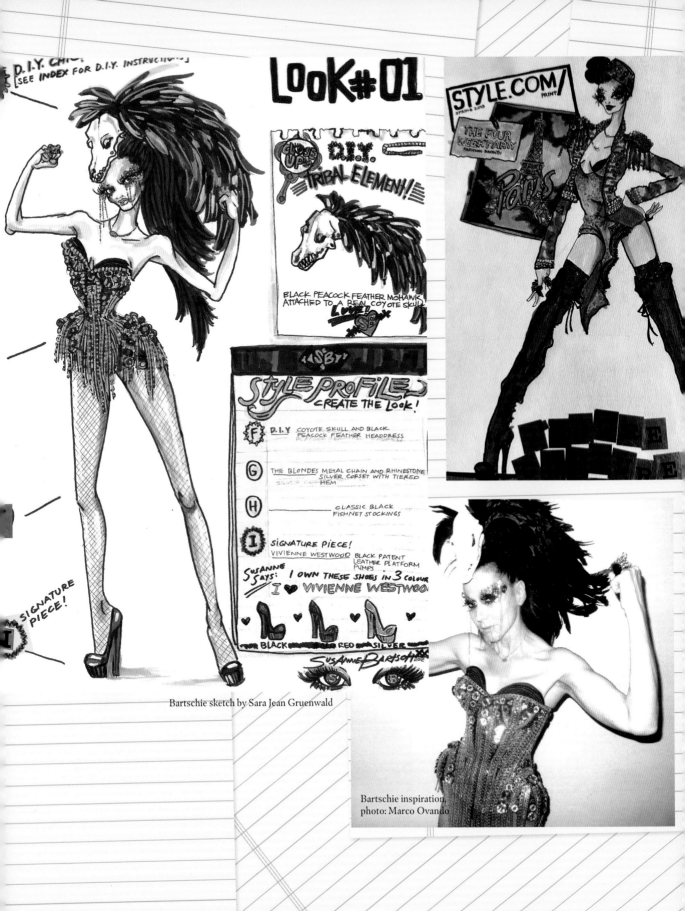

LOOK #01

THE FOUR WEEK PARTY
FASHION MONTH

Paris

D.I.Y. CHIC!
[SEE INDEX FOR D.I.Y. INSTRUCTIONS]

CLOSE UP! D.I.Y. TRIBAL ELEMENT!

BLACK PEACOCK FEATHER MOHAWK ATTACHED TO A REAL COYOTE SKULL.
Love! xx SB

STYLE PROFILE
CREATE THE LOOK!

F D.I.Y. COYOTE SKULL AND BLACK PEACOCK FEATHER HEADDRESS

G THE BLONDS METAL CHAIN AND RHINESTONE SILVER CORSET WITH TIERED SILVER HEM

H CLASSIC BLACK FISHNET STOCKINGS

I SIGNATURE PIECE!
VIVIENNE WESTWOOD BLACK PATENT LEATHER PLATFORM PUMPS
Susanne Says: I OWN THESE SHOES IN 3 COLOUR
I ♥ VIVIENNE WESTWOOD

♥ BLACK ♥ RED ♥ SILVER

SUSANNE BARTSCH 2012

SIGNATURE PIECE!
I

Bartschie sketch by Sara Jean Gruenwald

Bartschie inspiration,
photo: Marco Ovando

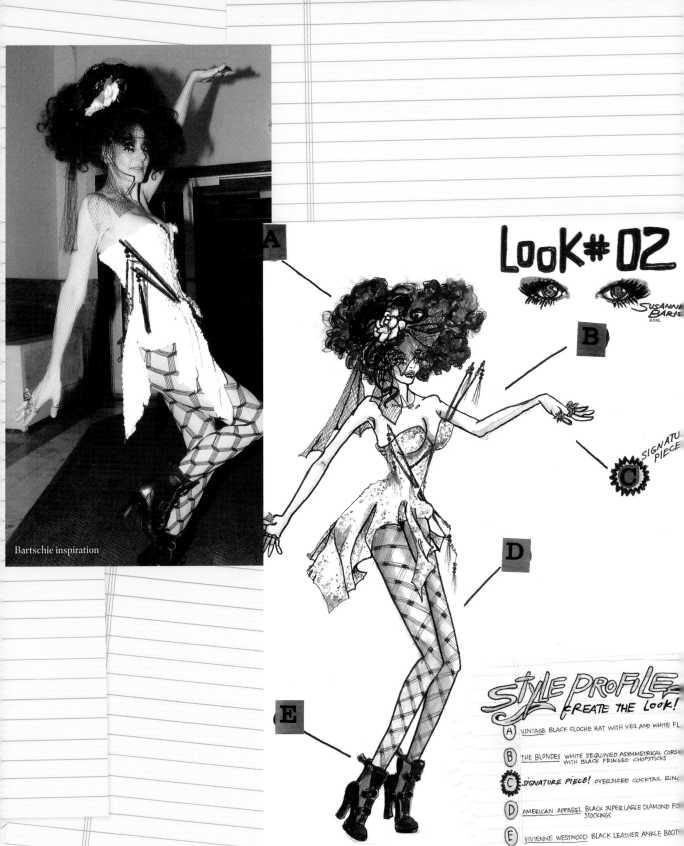

Bartschie inspiration

A

LooK#02

SUSANN
BARTS
2012

B

C SIGNATURE PIECE

D

E

Bartschie sketch by Sara Jean Gruenwald

ART-A-PORTER

My friend Anita Durst runs a fantastic organization called Chashama that provides vacant real estate to artists to use as studios or to exhibit their work. Thanks to her, I was able to take over several spaces in Times Square for one week during New York Fashion Week. I curated more than sixty artists to create their own fashion and art happenings, as a departure from the typical runway shows.

Over the course of a week, they created performance art installations which ran hours long; some even ran all day long. There was a group done up in looks having an opulent picnic in the abandoned lobby of a former bank. You could watch Muffinhead building a "dress" on a live model. Kindra created a human petting zoo, Asher Levine staged a public fashion show, the artist Alice Farley did an installation with a group of her other-worldly creatures. Steven Klein showed some of his films in a public passage called Anita's Way. All in all, over a hundred performers participated in the weeklong event.

The finale of this art happening was a surrealist dinner party that took place in the massive glass-encased lobby of an office building in Times Square. Given the location, we got tons and tons of tourists and random passersby stopping in their tracks on the sidewalk to watch. This was in 2014 and the fashion world was still quite stuck in its old ways, so a lot of people didn't get what I was doing at the time, but it would be a different story today.

Onlookers at Art-A-Porter

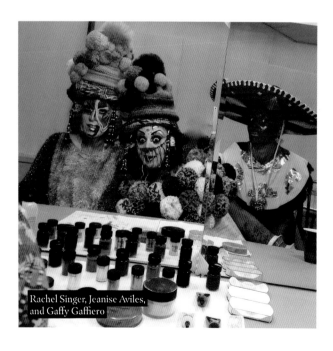

Rachel Singer, Jeanise Aviles, and Gaffy Gaffiero

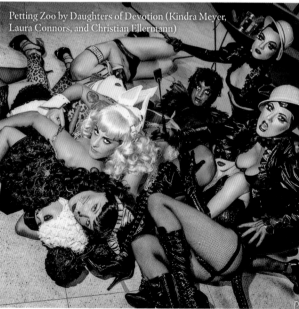

Petting Zoo by Daughters of Devotion (Kindra Meyer, Laura Connors, and Christian Ellermann)

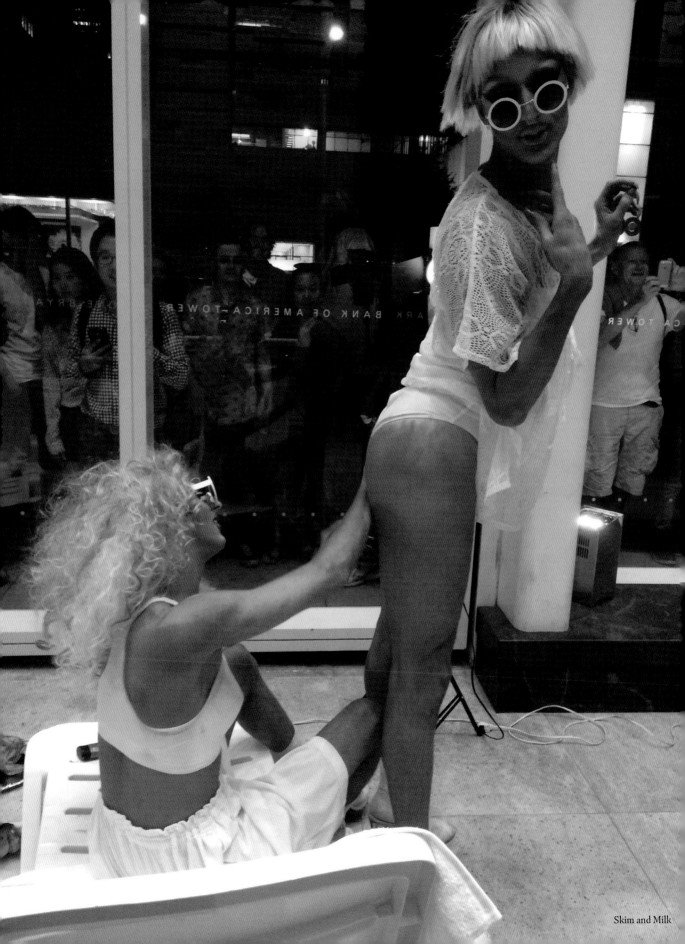

Skim and Milk

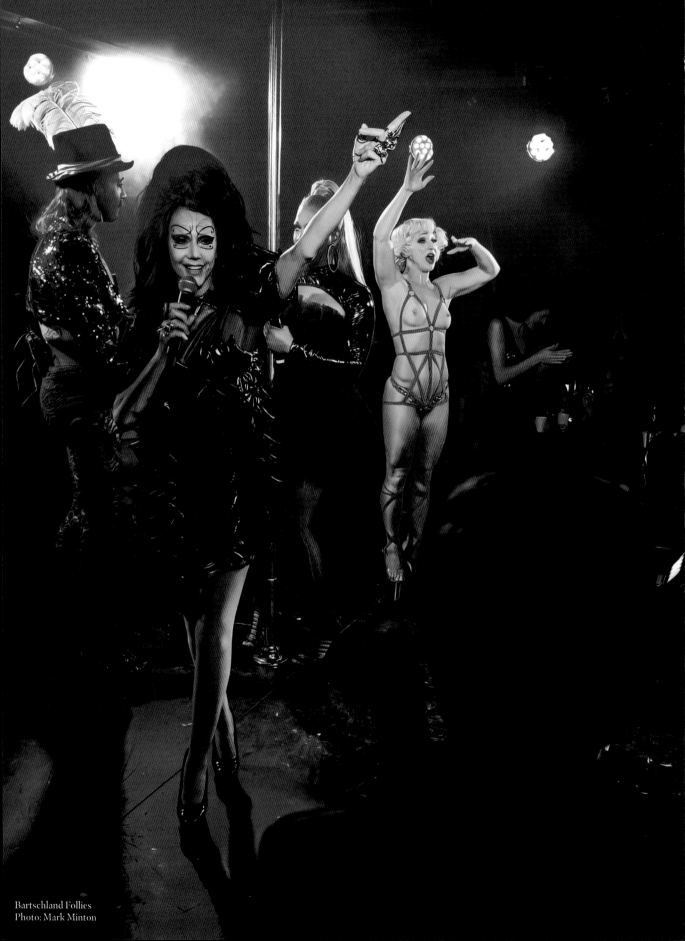

Bartschland Follies
Photo: Mark Minton

SHOWTIME

I've always included some type of a live performance at my parties, like a pop-up show moment that could be anything from a burlesque act to ballet, to oddity acts, acrobatic feats, drag shows, dance numbers, or singers' performances. Eventually I wanted to take that element a step further, and I came up with an idea to create an entire show that felt like a party, instead of a show at one of my parties. And with that, Bartschland Follies was born.

The show was an eclectic and eccentric cabaret extravaganza––a night at the opera collides with a burlesque circus meets a concert for a high-fashion, madcap, and unforgettable entertainment experience.

The Follies evolved into my show called New York New York. I believe one success of these shows is the element of surprise. You never know what comes next. I intentionally don't do too much planning or too many rehearsals, so the audience is treated to sparkling, structured chaos that's unique every time.

And that goes for all aspects of the show! I'll never forget tasting pussy for the first time in my life, by applying lipstick that Amanda Lepore pulled out of her vagina. Or the time I was undressing a guy for Joey Arias's act, and he liked my taking-off-his-shirt skills and ended up asking me out and taking me on a wild trip to Paris.

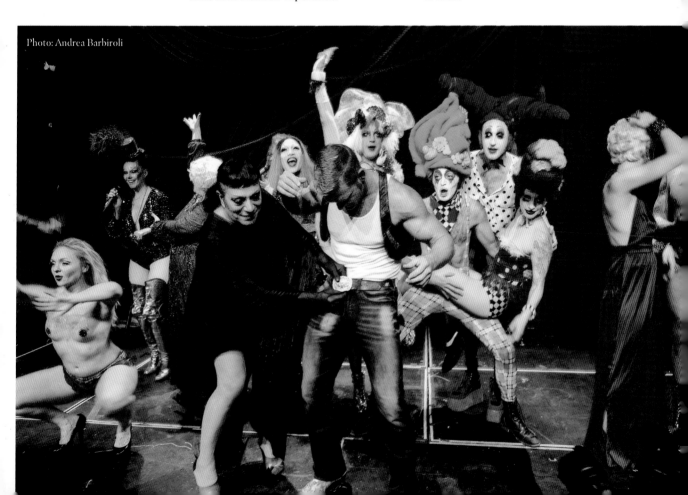

Photo: Andrea Barbiroli

WORKING GIRLS

I've always admired the art of striptease, from the fetish looks, to the dance form, to the stylized acrobatics. Working Girls is a celebration of sex workers, giving them a platform that showcases their art form, rather than the selling sex aspect. Of course, this party is also a space for performers from all walks of life—all trades welcome.

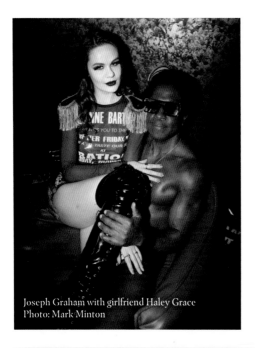

Joseph Graham with girlfriend Haley Grace
Photo: Mark Minton

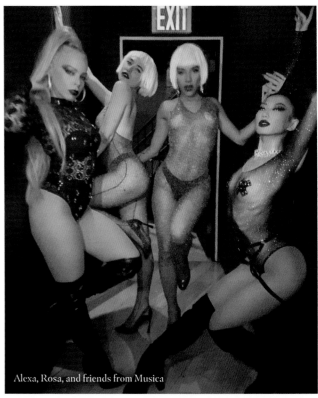

Alexa, Rosa, and friends from Musica

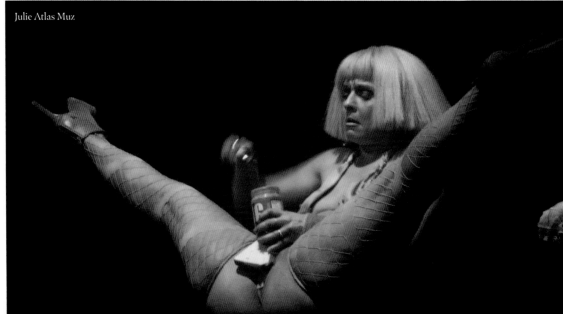

Julie Atlas Muz

Steven Rodriguez
Photo: Mark Minton

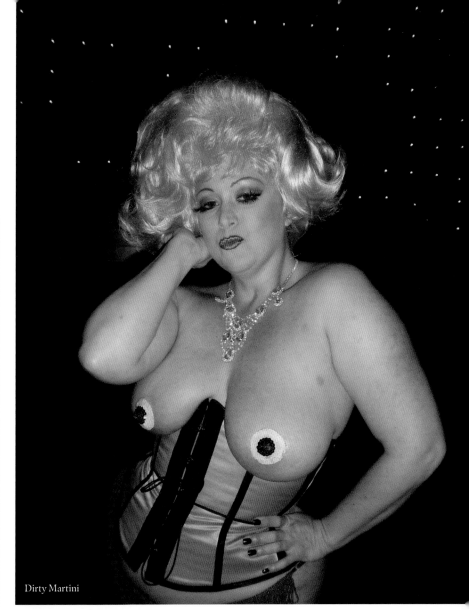
Dirty Martini

Gallexi

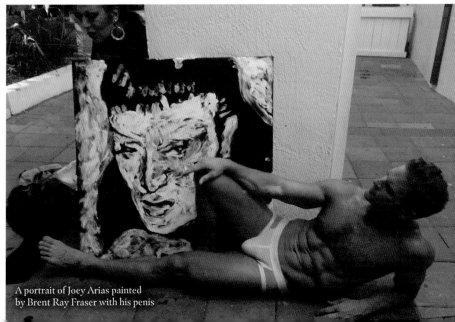
A portrait of Joey Arias painted
by Brent Ray Fraser with his penis

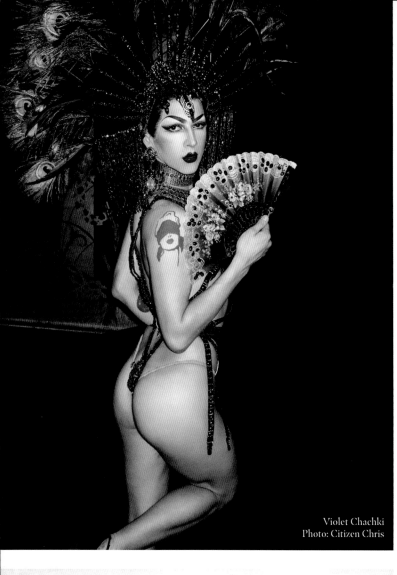

Violet Chachki
Photo: Citizen Chris

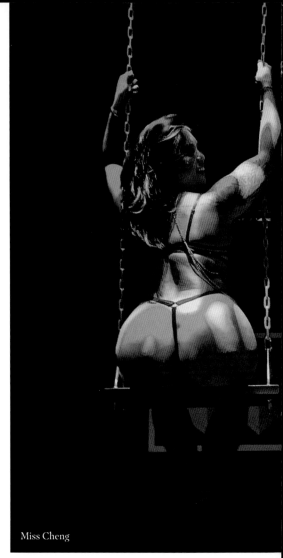

Miss Cheng

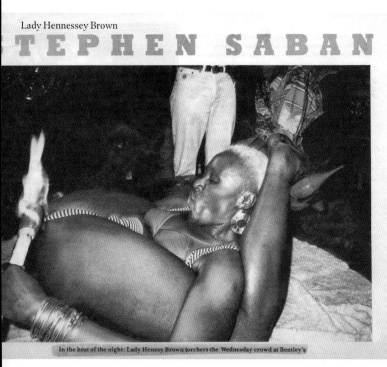

Lady Hennessey Brown

STEPHEN SABAN

In the heat of the night: Lady Henesy Brown torchers the Wednesday crowd at Bentley's

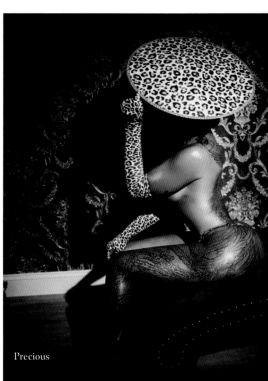

Precious

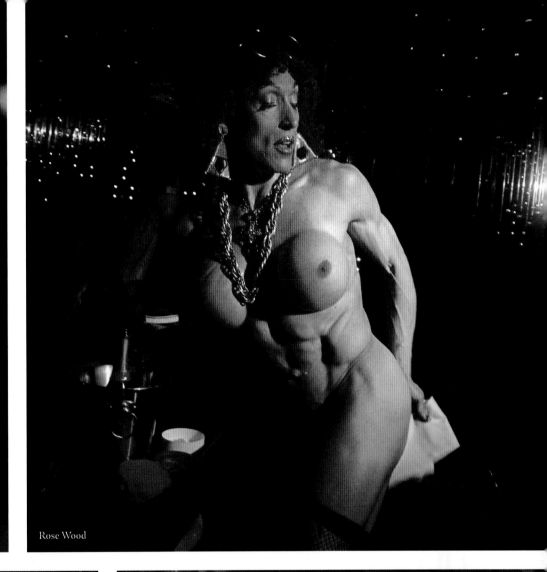

Rose Wood

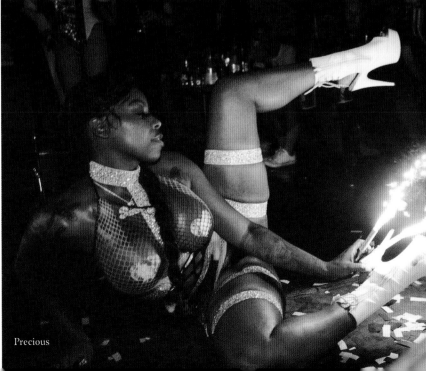

Precious

MEET YOUR HOSTS

On a nightly basis for most of her lifetime, Susanne has used her events as a vehicle for the marriage of self-discovery and self-liberation. While doing so, she's managed to challenge societal norms with her rebellious spirit; something that has empowered countless people over the years. In Bartschland, whether it's downtown in the '80s, through the screens of our phones, or sometime in the future: the value of humanity rings strong.
—LINUX

For those whom I was not able to include in the book, please know it was only due to the limited space. —SUSANNE

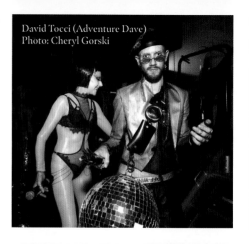
David Tocci (Adventure Dave)
Photo: Cheryl Gorski

Devintasy

Emmxtt

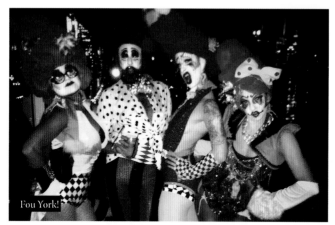
Fou York!

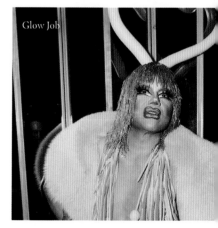
Glow Job

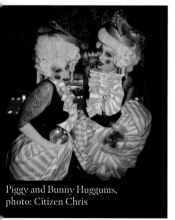
Piggy and Bunny Huggums,
photo: Citizen Chris

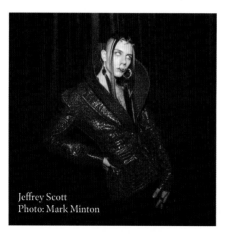
Jeffrey Scott
Photo: Mark Minton

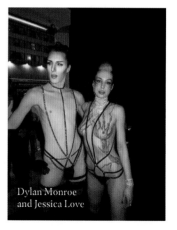
Dylan Monroe
and Jessica Love

Jeremy Kost and
Darian Darling

Aquaria and
Rify Royalty

Jeanise, Calli, and Rachel, photo: Gerry Visco

Carnation

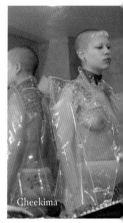
Cheekima

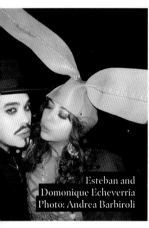
Esteban and
Domonique Echeverria
Photo: Andrea Barbiroli

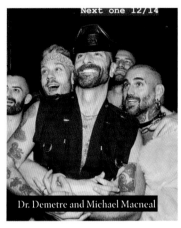
Dr. Demetre and Michael Macneal

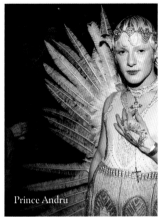
Prince Andru

Darrell Thorne
Photo: Andrea Barbiroli

Hana Quist

Nicky Doll

Theodora Sopko
and Kareem Rashed

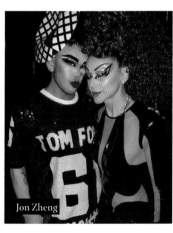
Jon Zheng

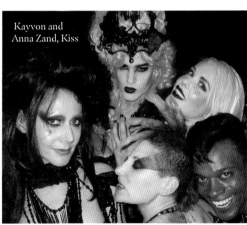
Kayvon and
Anna Zand, Kiss

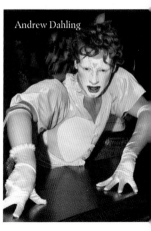
Andrew Dahling

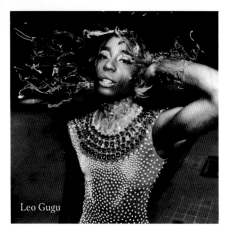
Leo Gugu

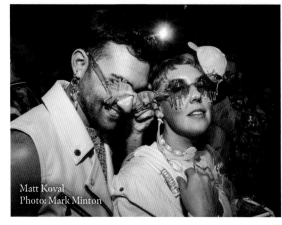
Matt Koval
Photo: Mark Minton

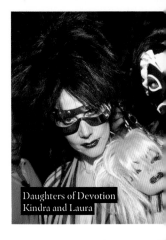
Daughters of Devotion
Kindra and Laura

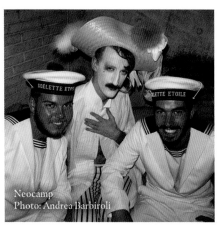
Neocamp
Photo: Andrea Barbiroli

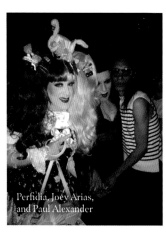
Perfidia, Joey Arias,
and Paul Alexander

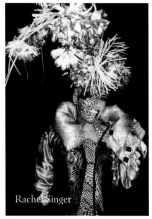
Rachel Singer

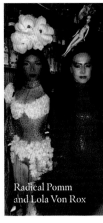
Radical Pomm
and Lola Von Rox

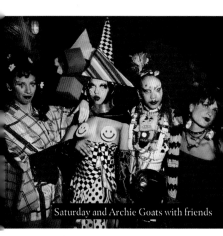
Saturday and Archie Goats with friends

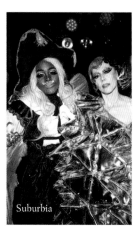
Suburbia

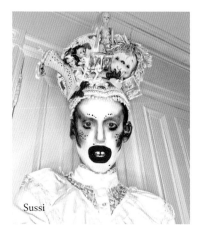
Sussi

Harry Charlesworthy
and Sussi

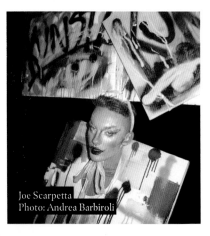
Joe Scarpetta
Photo: Andrea Barbiroli

Blair Spicer
Photo: SMLTD

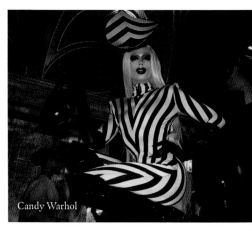
Candy Warhol

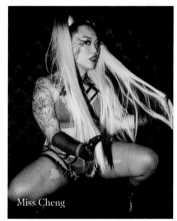

Miss Cheng

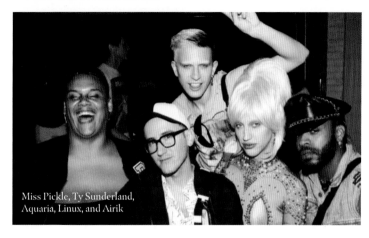

Miss Pickle, Ty Sunderland, Aquaria, Linux, and Airik

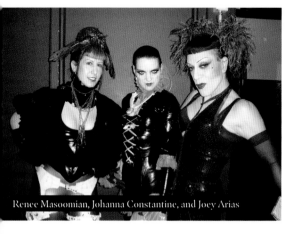

Renee Masoomian, Johanna Constantine, and Joey Arias

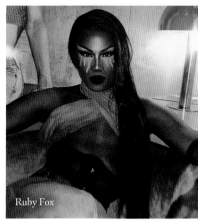

Ruby Fox

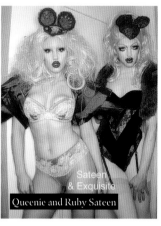

Sateen & Exquisite

Queenie and Ruby Sateen

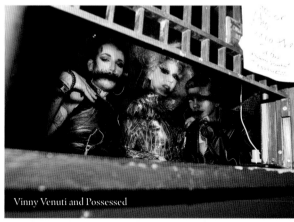

Vinny Venuti and Possessed

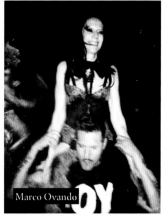

Marco Ovando

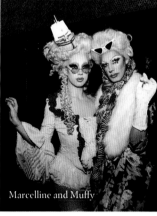

Marcelline and Muffy

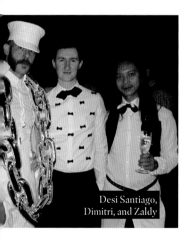

Desi Santiago, Dimitri, and Zaldy

Austin James Smith

Gazelle Paulo

BOROUGH HOPPING

I remember back in the '90s the best night to go out was Thursdays. We all avoided Fridays and Saturdays like the plague because the weekend was delegated to the "bridge and tunnel" crowd. Now, funny enough, some of the best club nights happen by crossing the bridge in the other direction.

I was especially into the Bushwick scene. Underground artists had been flocking to this neighborhood over the last decade and making their own universes there. This renaissance is what inspired me to throw a monthly party in the neighborhood with Linux called "Play Now!" a celebration of all things current and underground. Play Now! was our love letter to Bushwick and the kids who thrive there by way of techno.

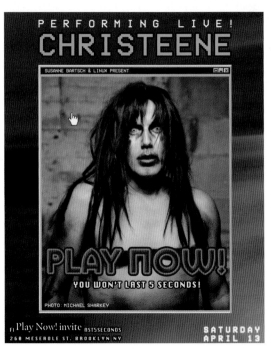

PERFORMING LIVE!
CHRISTEENE

SUSANNE BARTSCH & LINUX PRESENT

PLAY NOW!
YOU WON'T LAST 5 SECONDS!

PHOTO: MICHAEL SHARKEY

Play Now! invite
268 MESEROLE ST. BROOKLYN NY

SATURDAY
APRIL 13

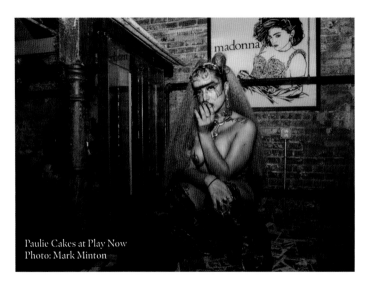

Paulie Cakes at Play Now
Photo: Mark Minton

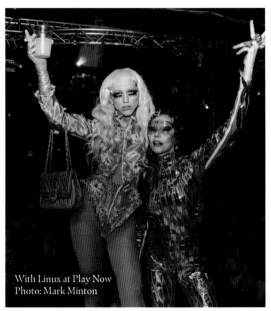

With Linux at Play Now
Photo: Mark Minton

SUSANNE BARTSCH & LINUX PRESENT

CENSORED

PLAY NOW!

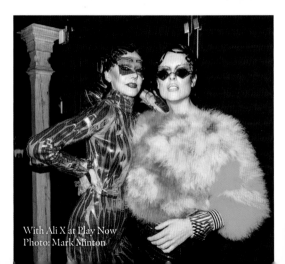

With Ali X at Play Now
Photo: Mark Minton

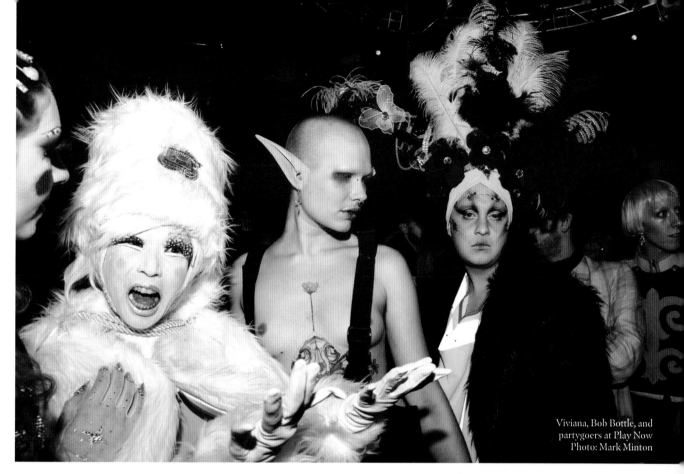

Viviana, Bob Bottle, and partygoers at Play Now
Photo: Mark Minton

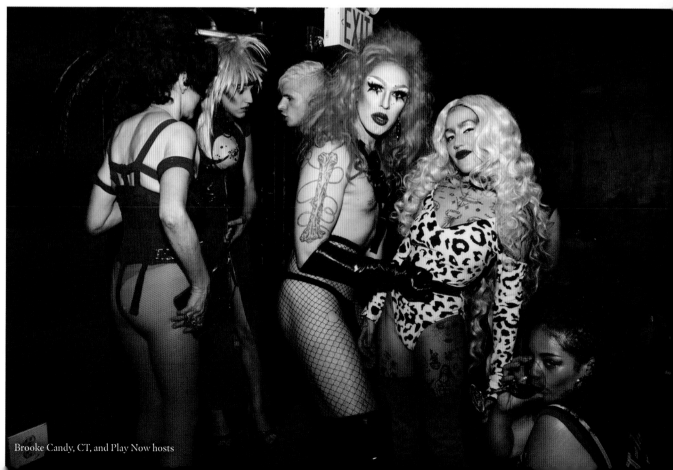

Brooke Candy, CT, and Play Now hosts

KUNST

Kunst had such a buzz around it. Susanne had never thrown one of her extravaganzas in Brooklyn before, which I found shocking at the time. Susanne teamed up with Gage, and something about the partnership of Susanne Bartsch and Gage of the Boone was exactly what was needed to merge these two worlds on Brooklyn soil. They seamlessly flowed. Susanne brought the glamour, and together they provided the raw art and experimentation to create something our community so desperately needed at the time.

The party is always a sea of over-the-top glamour and boundary-crushing looks sprinkled with local and global celebrities. A mixture of club kids, drag queens, artist, and personalities from both sides of the river mingling in an alternate dimension. Throughout the night, Susanne would coast by, floating over the crowd on the shoulders of a twenty-something hunk followed by a wave of cheers and gags.

Kunst was an honest, creative playground for many of us. My best memories are the looks we were all wearing: A never-ending fashion show. A reminder of the power in lived experience as queer art. Kunst is nightlife as work of art.

—ONE-HALF NELSON

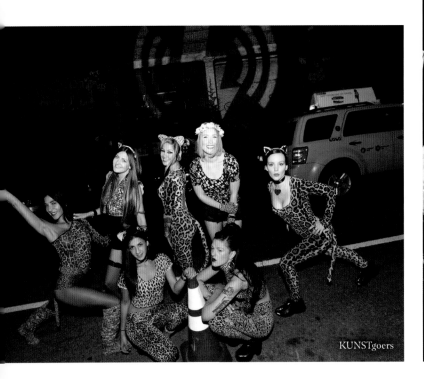

KUNSTgoers

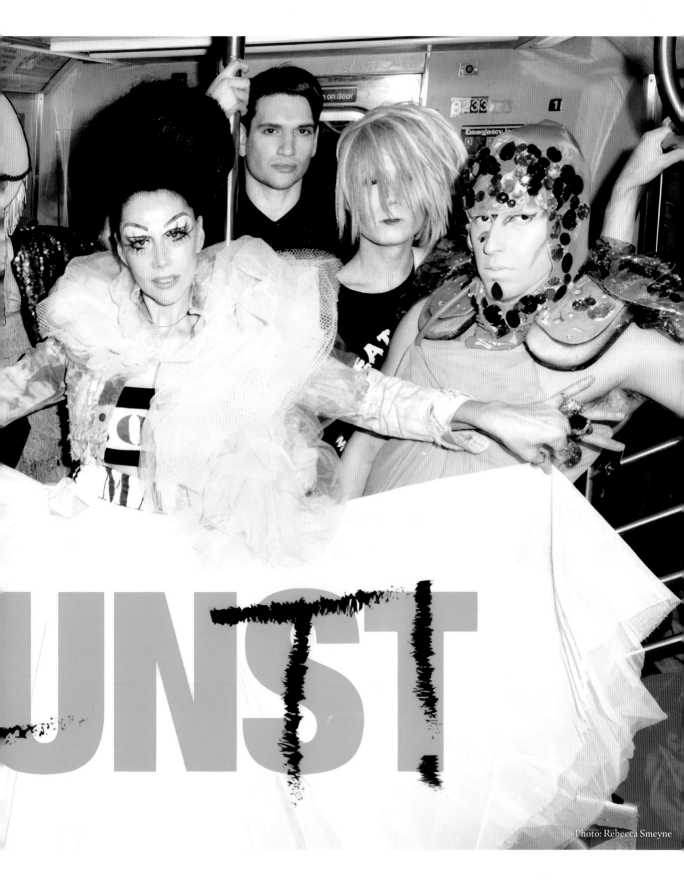

UNST

133

HALLOWEEN AT PS1

Susanne's 2016 Halloween ball at MoMA PS1 was the first of her parties I had ever attended. The theme that year was "The White House of Horror." In hindsight, a startlingly prescient theme choice, with the 2016 presidential election just over a week away. The true horrors that lay ahead were unbeknownst to us all, as it was a fabulous evening of over-the-top costumes and seemingly endless cocktails served in juice pouches with glow-in-the dark straws. As I made my way through the massive crowd, I encountered Susanne dressed as a clownish Uncle Sam. Despite her outlandish appearance, she was very much in "work mode," making sure everything was running smoothly, from performances to drink bracelets. She patrolled the grounds with a curly red wig and oversize top hat. I was blown away by the sheer scale of this party, which took over the entirety of the museum's grounds. It was an overwhelming visual spectacle, with larger-than-life hosts atop massive platforms and performers swinging through the air inside the museum's geodesic-dome theater. This annual party was one of my personal favorites for the next few years, with themes like "Cirque de Musée" and "Valley of the Dolls." Parties like these, and many more over the years, are why Susanne is practically synonymous with Halloween.

—Bob Bottle

With Adrien Brody, Klaus Biesenbach, and Duoraw
Photo: Andrea Barbiroli

With Casey and Rify Royalty
Photo: Andrea Barbiroli

Kiss on swing

Marzia Aloisi
Photo: Dustin Pittman

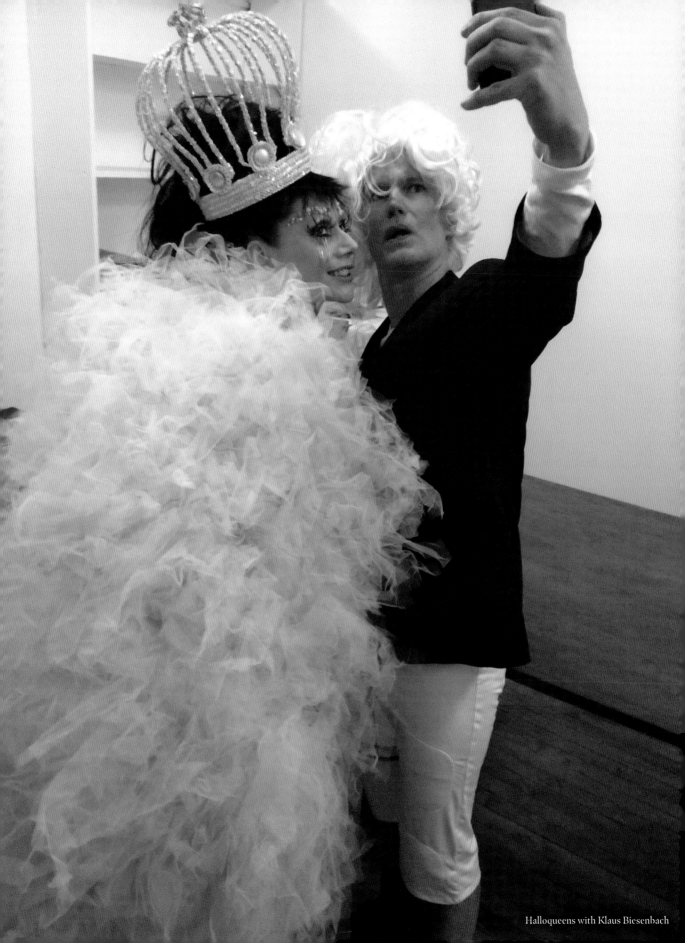

Halloqueens with Klaus Biesenbach

FASHION UNDERGROUND

My museum exhibition sprung to life when I happened to be seated next to the fabulous Valerie Steele at a MAC dinner, and suggested we should do an exhibition at the Museum at FIT. And in Valerie's own words, here's what ensued...

"Susanne asked if I would be interested in seeing her fashion collection and, perhaps, consider organizing an exhibition at the Museum at FIT. I quickly made an appointment to visit Susanne in the Chelsea Hotel. When I arrived at her apartment, she began pulling boxes out of closets and from under the bed. As we held up one garment after another, I became more and more excited. It was clear that she had the material for an extraordinary exhibition."

Our exhibition, *Fashion Underground: The World of Susanne Bartsch*, featured more than 130 of my looks.

Visit: http://fit.synthescape.com/ for a virtual tour of the exhibition.

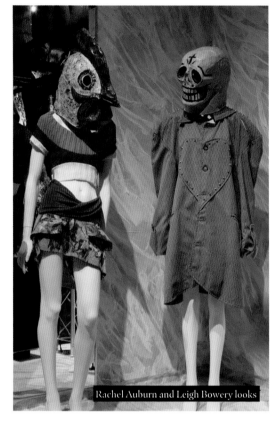
Rachel Auburn and Leigh Bowery looks

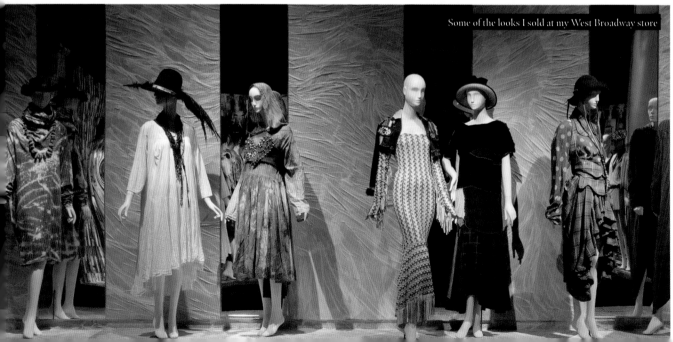
Some of the looks I sold at my West Broadway store

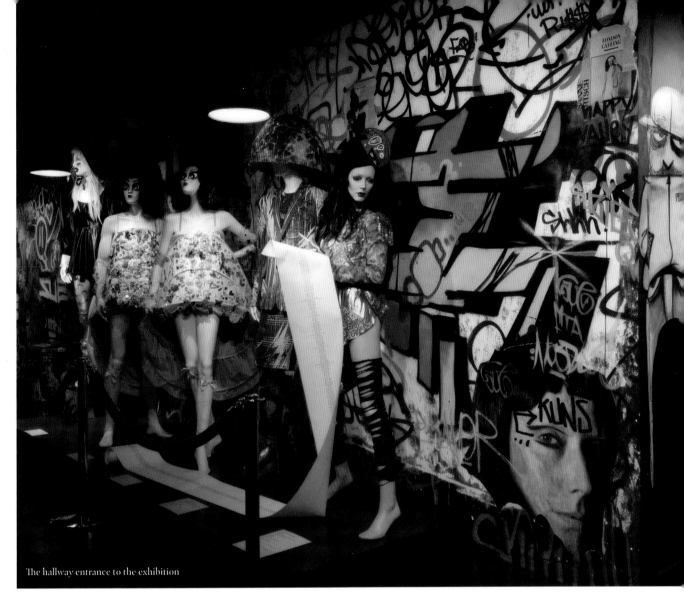

The hallway entrance to the exhibition

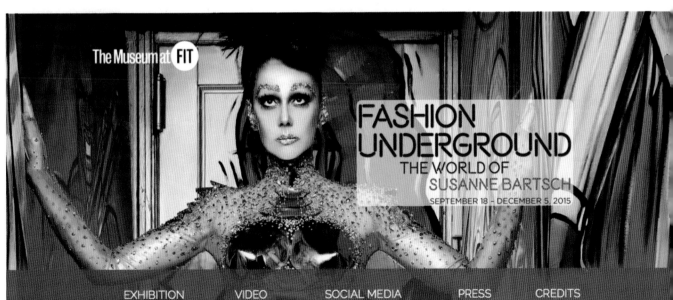

The Museum at FIT

FASHION
UNDERGROUND
THE WORLD OF
SUSANNE BARTSCH
SEPTEMBER 18 – DECEMBER 5, 2015

EXHIBITION VIDEO SOCIAL MEDIA PRESS CREDITS

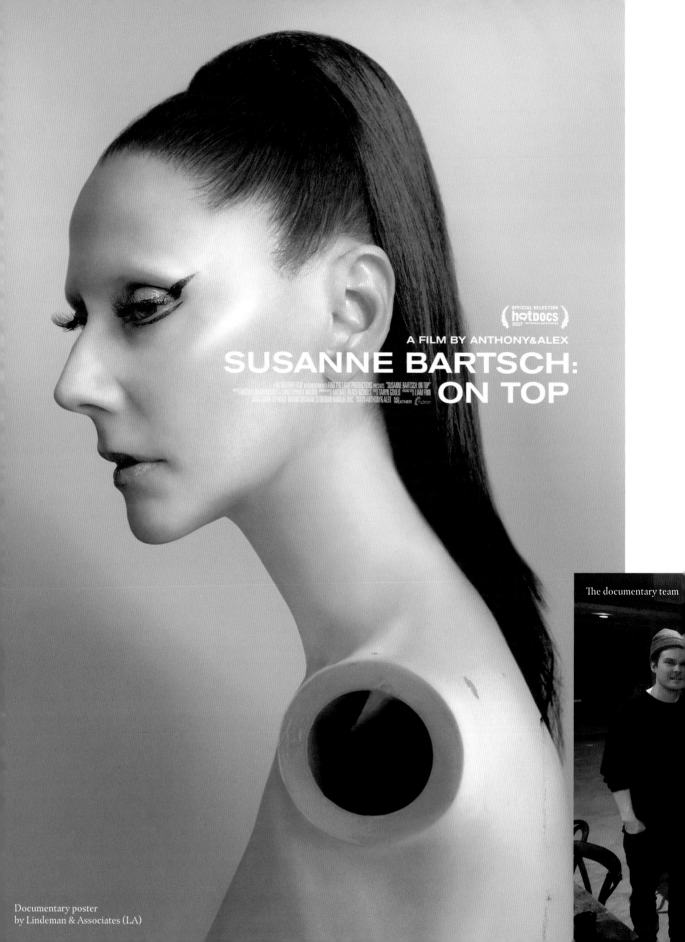

OFFICIAL SELECTION
hotdocs
2017

A FILM BY ANTHONY&ALEX

SUSANNE BARTSCH:
ON TOP

The documentary team

Documentary poster
by Lindeman & Associates (LA)

ON THE SILVER SCREEN
SUSANNE BARTSCH: ON TOP

I started by writing an extremely flowery paragraph about Susanne, her world, and how we met. Which was great and true and felt nice, but then I decided to sit down and actually write about what the experience of documenting and working with Susanne was like. Susanne is tough. She's aggressive and smart and one of the most tenacious people I have ever met. She's a woman who has spent her life challenging norms, building safe spaces where they didn't exist, and carving out a career that is quite honestly like nobody else's on the planet. The tenacity it takes to build a life like she's had and to do it with such a sense of fashion and glamour speaks to her character in ways I hope the documentary succeeds at showing. It wasn't always easy or fun. Making a documentary is extremely difficult for both the director and the subject. Things got deeply personal, emotional, and in the end cathartic for both Susanne and me. We built a relationship that quite honestly is unlike any other in my life. The relationship between director and subject is strange and wonderful. I've acted as her confidant, and at times she has certainly acted as mine.

My hope is that the documentary is built similarly to what it was like to meet and get to know Susanne. At first sight, she is extreme glamour. She is fashion and beauty and looks almost untouchable. You hear these larger-than-life things about her—stories about her parties, about her personality, about the people she knows and the things she's done, but then slowly over time, you get to see her on a much deeper level. The woman who loves her family; who loves her son, Bailey; the person who thinks about legacy and aging and has insecurities like all of us. The woman who fought her way through so much to get to where she is now. This was the part of Susanne I found and still find the most compelling and the most relatable. While I was completely blown away by the clothes and glamour, I was much more blown away by the person Susanne is underneath it all. There's a magic in looking at someone who is larger than life or feels out of reach, and then peeling back the layers to find how much you have in common and how much you share. It takes a deep openness, a sense of exploration, and a lack of fear to let people in and allow them to see those sides you've never shown before. Susanne allowed me in, and I will forever feel deeply privileged and beyond grateful to have spent any amount of time in service of documenting what she has achieved and the world she has built.

—ANTHONY CARONNA, director

STREAMING ON ALL PLATFORMS

139

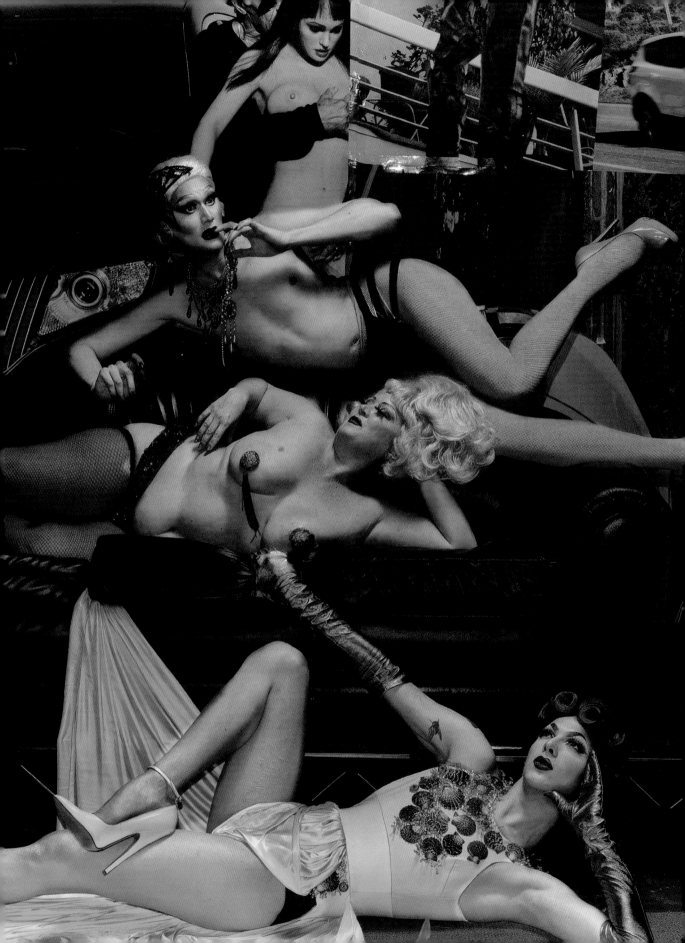

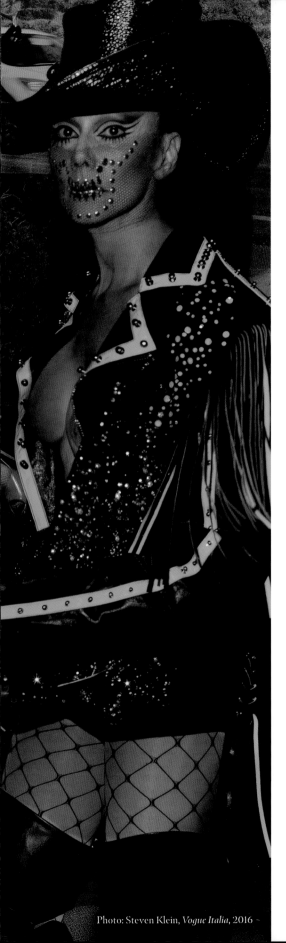

ME...
BY STEVEN
KLEIN

Susanne is an artistic stimulator, activating a dynamic sequence of actions correlating into events that can be considered performance art or social interactions of trends and cultures, formulating the new, building on the old. She is a creator of atmospheric intrigue where the revolt against the norm is celebrated. An articulator of wild beauty.

—STEVEN KLEIN

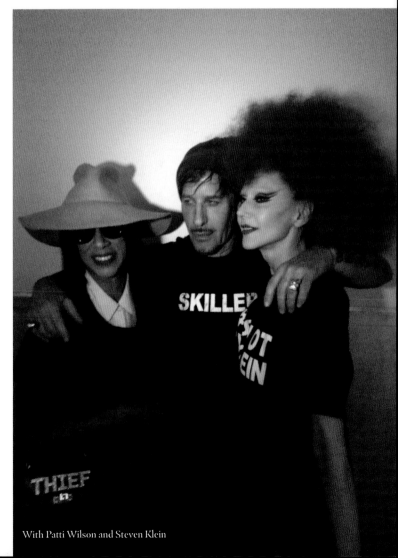

Photo: Steven Klein, *Vogue Italia*, 2016

With Patti Wilson and Steven Klein

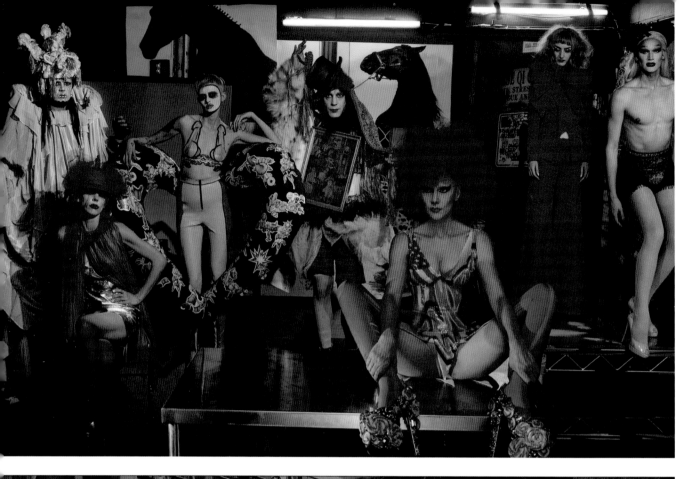
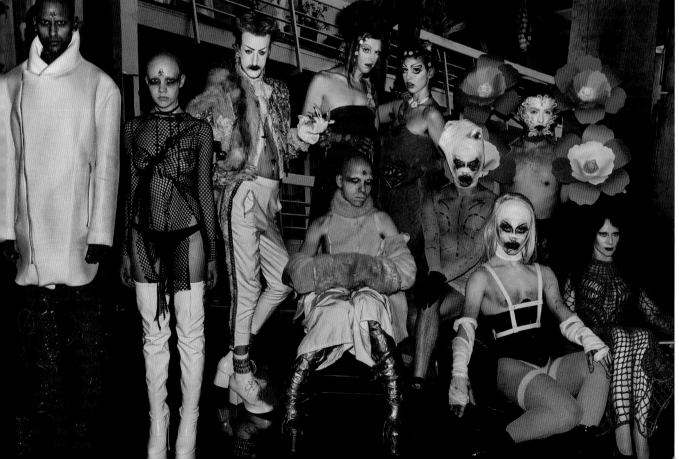

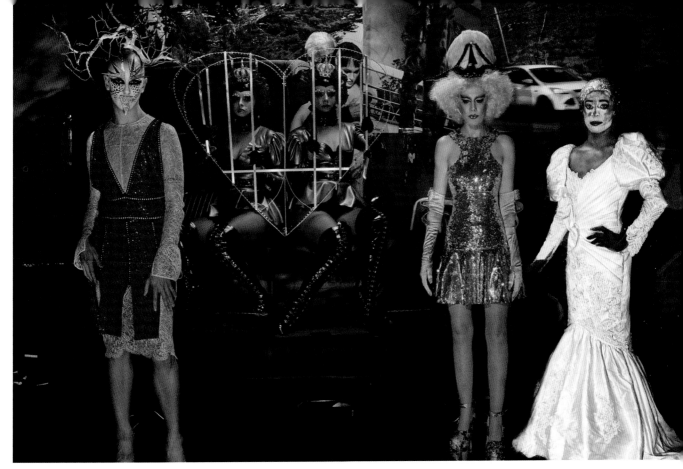

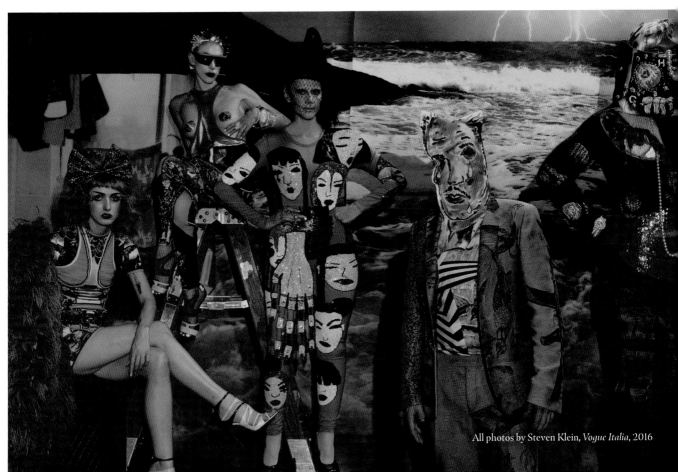

All photos by Steven Klein, *Vogue Italia*, 2016

NEW YORK, NEW YORK: THE SHOW

When I step into a Susanne Bartsch show, it feels like a world where I belong. Coming from a strict dance background and career, I found the ultimate freedom of expression as a performer with Susanne. And I'm sure the audience feels the same way; it's a connection I can't explain. There's a certain magic Susanne creates with her family of performers and audience. . . . We're all there for the spectacle, the party, the love. It's a world of its own and I love living in it.

—LOLA VON ROX

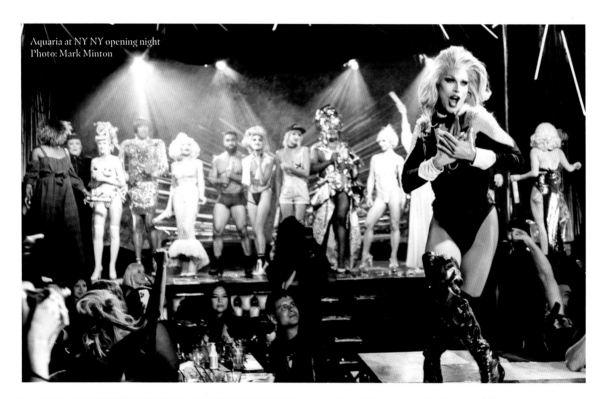

Aquaria at NY NY opening night
Photo: Mark Minton

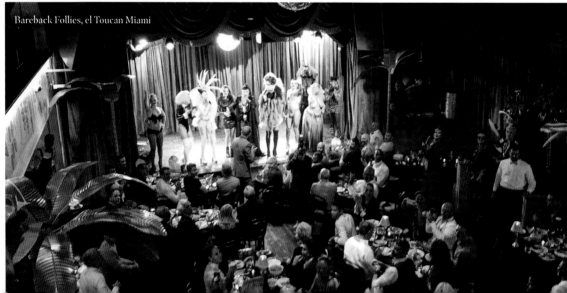

Bareback Follies, el Toucan Miami

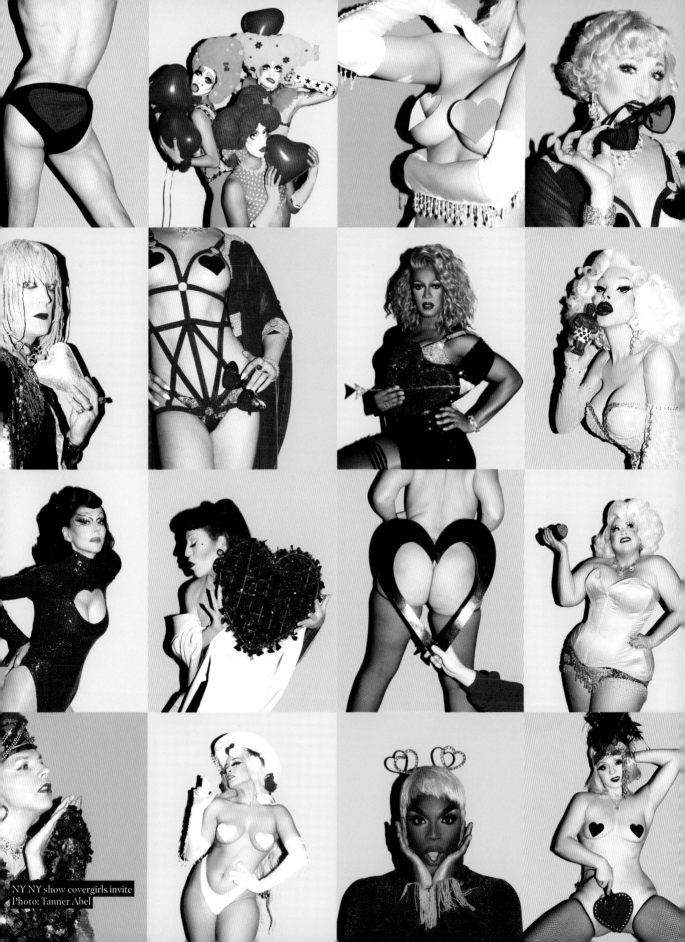

NY NY show covergirls invite
Photo: Tanner Abel

Vanity Fair photoshoot
Photo: Roxanne Lowit

GETTING READY

I always felt that we were in a playground with Susanne, and she was the most wonderful contemporary beauty to build and imagine with.
—DANILO

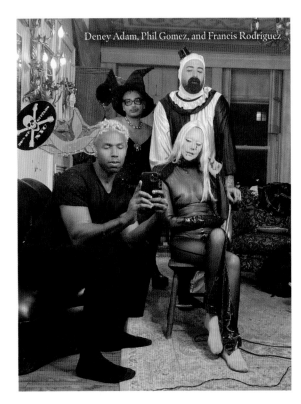
Deney Adam, Phil Gomez, and Francis Rodríguez

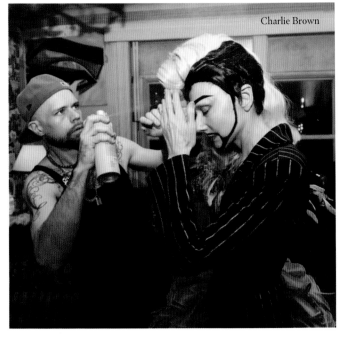
Charlie Brown

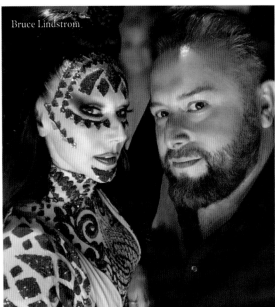
Bruce Lindstrom

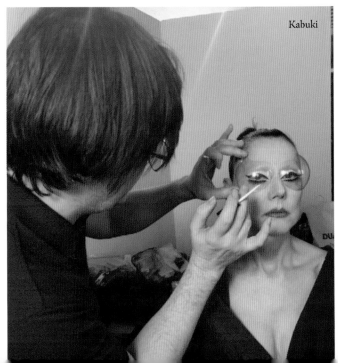
Kabuki

INTERVIEW: How do you get ready for a night out?
Susanne Bartsch: The glue should be a little tacky...

WHY BE DRAB? My day-time look is very visual. But when I get dressed for a night at the Copacabana . . .

FIRST, I slip into something comfortable, like a slinky robe or a kimono.

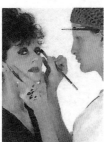

AS OFTEN AS POSSIBLE I have someone do my eyes. Mathu is a genius. Plus, he lives in my building.

LIPS ARE MY TRADEMARK so I do them myself. If you ever see me without lipstick, it means trouble.

BLACK EYELASH GLUE is best. Clear looks messy. The glue should be a little tacky before applying the lashes.

STRETCHING HELPS me to get in the mood for the evening's revelry.

WEAR FISHNETS over tights. Normally I prefer stockings, but they would look wrong with this outfit.

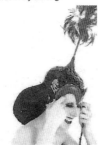

I LIKE HATS AND WIGS. And how many people do you know nowadays who wear a snood?

SHOW OFF! I have a good figure, so the corset is one of my favorite looks.

OPTIONS ARE NICE. These sleeves can be worn on or off. This corset is boned and laces up the back.

MY SECRET: a strategically placed zipper means I don't have to get undressed for the ladies' room . . .

THE BOOTS present a major lacing job. That's why it helps to have someone like the Baroness around.

MAKE SURE the glue begins to dry before applying each nail.

THEY LOOK GOOD NOW, but I lose nails like crazy. Sometimes at the end of a night I have only two or three left.

AND I'M ON THE PHONE doing business the whole time—mostly planning events like the Love Ball.

BUY THE BIGGEST TUBE of glitter you can find. I don't just wear it—I throw it on people.

GLITTER LIBERALLY! When you find it all over the house the next day, you know you've had a good time.

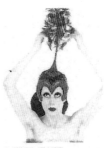

A FINAL FLUFF. The whole process takes around an hour.

YOU KNOW, DARLING, getting dressed is easy. Planning what to wear is what takes time.

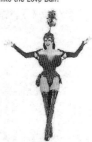

THAT'S ALL there is to it!

STEPHEN GRECO

Interview magazine: Getting Ready, photo: Todd Eberle

Photos: TODD EBERLE. Hair and makeup: Mathu Andersen/Marek & Assoc. Dresser: Baroness. Outfit: Pearl. Film: Kodak Ektachrome 64

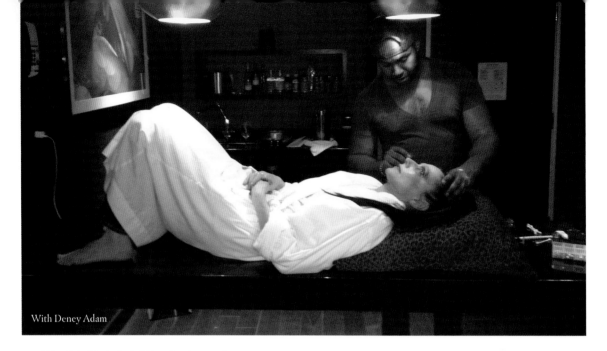
With Deney Adam

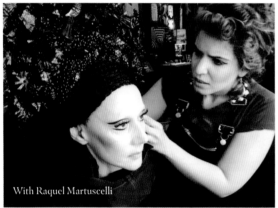
With Raquel Martuscelli

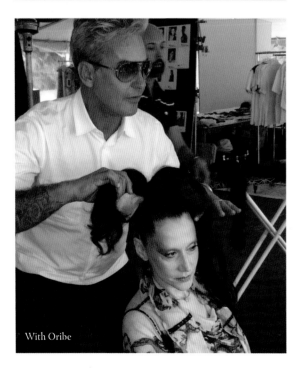
With Oribe

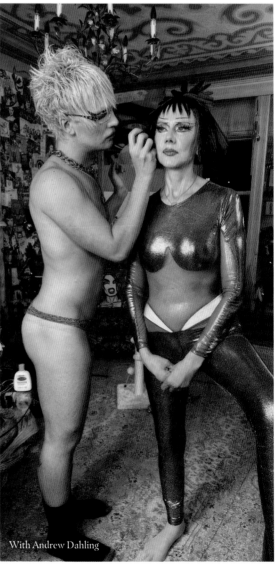
With Andrew Dahling

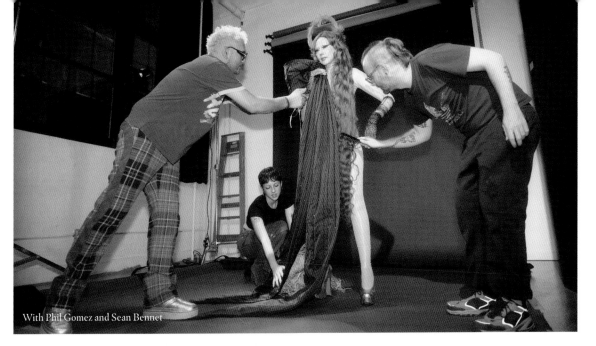
With Phil Gomez and Sean Bennet

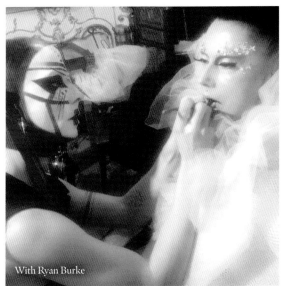
With Ryan Burke

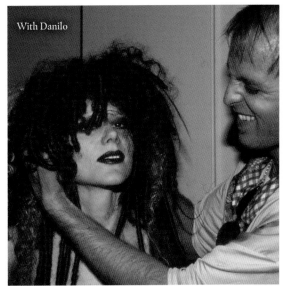
With Danilo

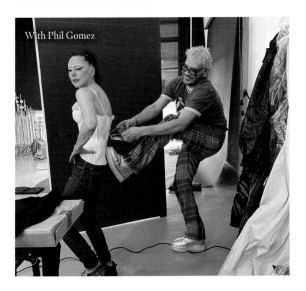
With Phil Gomez

With Francis Rodriguez

JET-SETTING

As the saying goes, if you really want to get to know someone, take a trip with them. I have so many travel stories with my Bartschettes that I could write a whole book just on that.

We've seen and done it all around the world and back . . . and missed flights along the way, like one in Tokyo because we were kabuki makeup shopping! At the end of a late night in Paris, we couldn't find taxis back to the hotel, so I stopped a gendarmes prisoner van and a dozen of us piled in. It was a tight squeeze, but we got a free ride and the gendarmes were really hot!

On our way to Miami, NYE 2015

On our way to Boston with Amanda

Didn't make it to first class on this trip to Paris

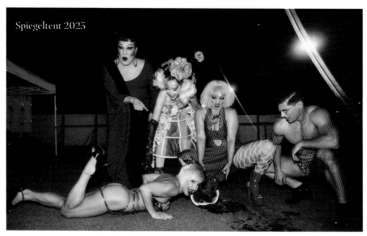

Spiegeltent 2025

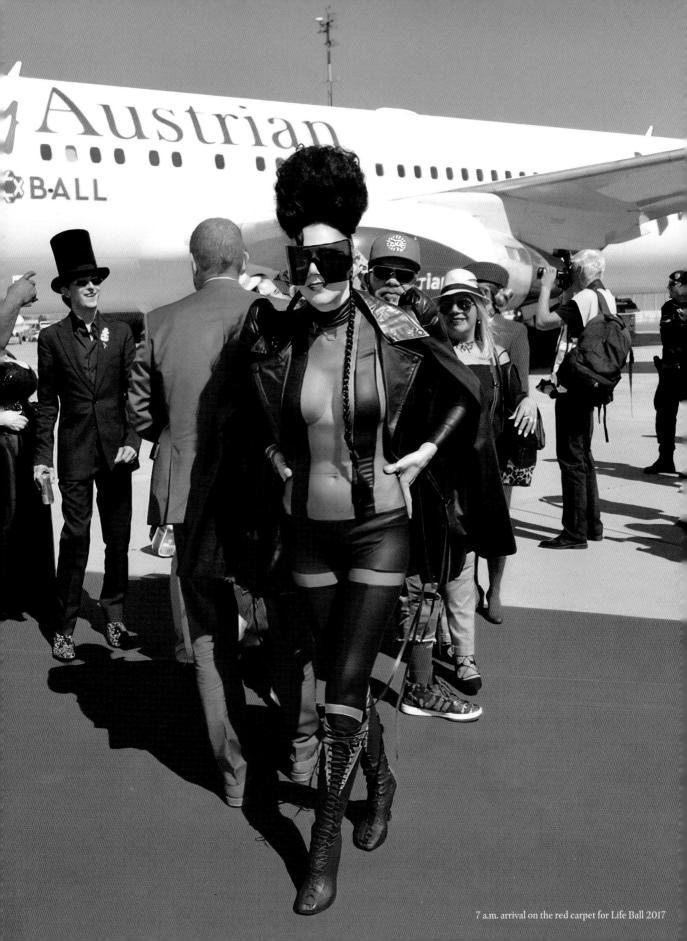

7 a.m. arrival on the red carpet for Life Ball 2017

WHO ARE YOU WEARING? ME!

Every day I walk in and out of my apartment through a hallway that's covered with paintings and party invites … and one day it hit me: Why not take all this fabulous art off the wall and wear it out on the street? I got to work and created a genderless and timeless collection that is a 24-7 look you can wear from dawn to dusk and back to dawn. And in keeping with the times, I am bringing the Bartschland collection to your home via an online shop you can visit at www.susannebartschcollection.com.

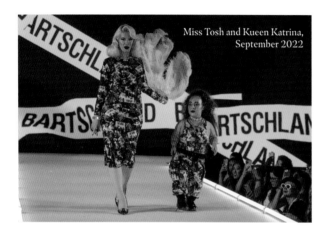

Miss Tosh and Kueen Katrina,
September 2022

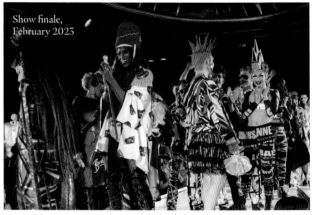

Show finale,
February 2023

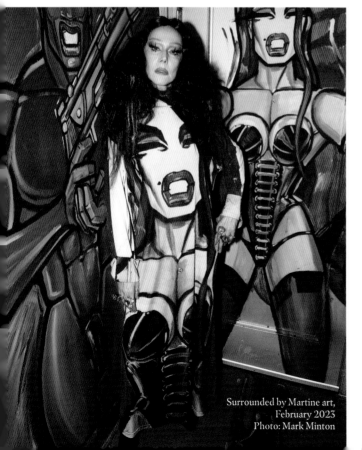

Surrounded by Martine art,
February 2023
Photo: Mark Minton

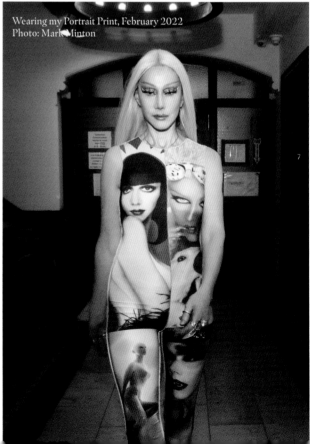

Wearing my Portrait Print, February 2022
Photo: Mark Minton

7

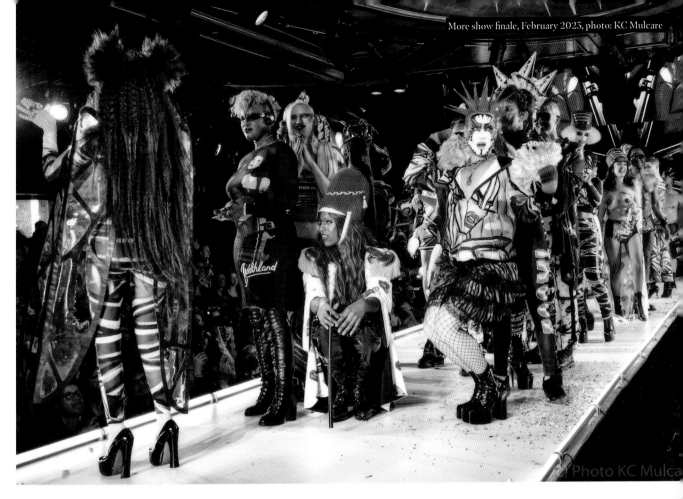

More show finale, February 2025, photo: KC Mulcare

Photo KC Mulca

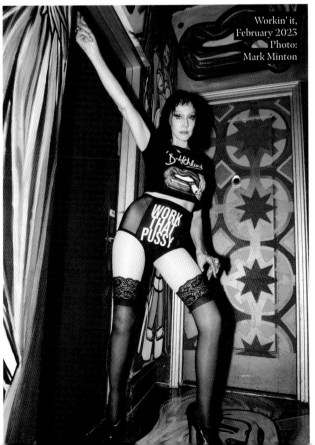

Workin' it,
February 2023
Photo:
Mark Minton

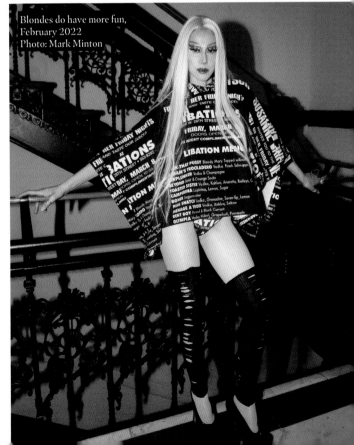

Blondes do have more fun,
February 2022
Photo: Mark Minton

CT VISIT.COM

SUSANN

VEC TOR

Magic was made with CTVISIT. Pride 2023
Photo: PETER LueDERS

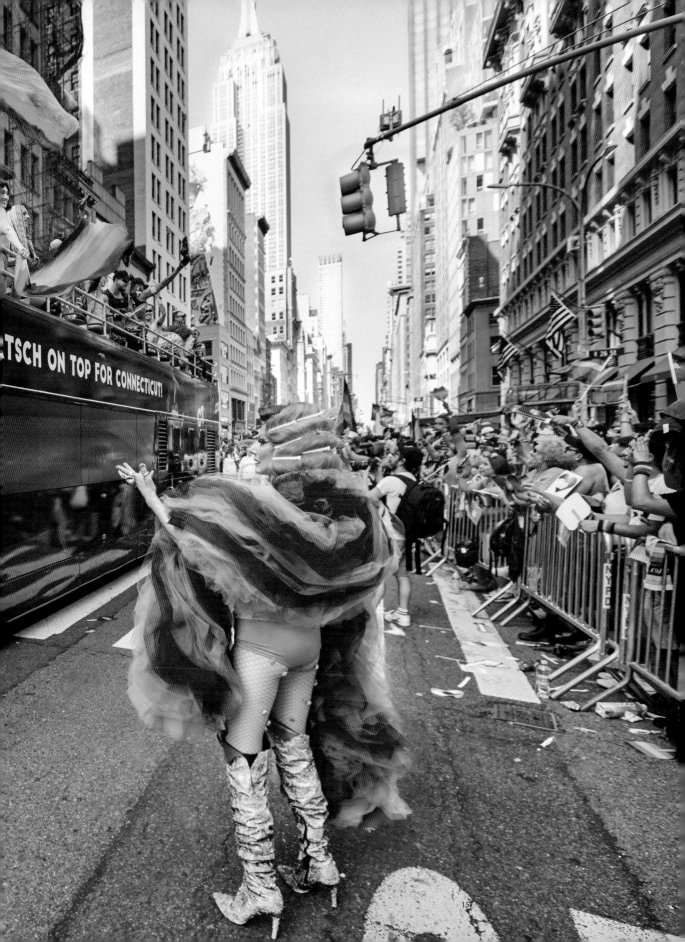

ETSCH ON TOP FOR CONNECTICUT!

157

EYE ♥ MAC

MAC and Susanne have had a long-lasting love affair. From Love Ball to our Bartschland Powder Kiss Cabaret . . . from Master Classes to creating a MAC & Bartsch lash collection, she has been an incredible partner with a strong vision that never disappoints.

—CHRISTIAN MITCHELL, MAC Cosmetics

Me on my lashbox cover

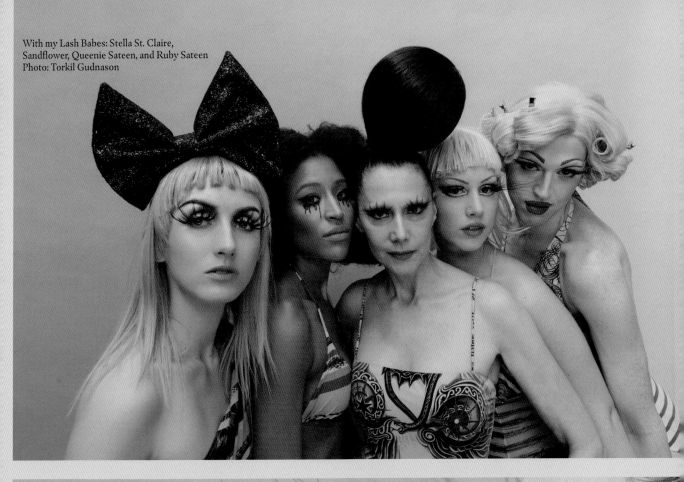

With my Lash Babes: Stella St. Claire,
Sandflower, Queenie Sateen, and Ruby Sateen
Photo: Torkil Gudnason

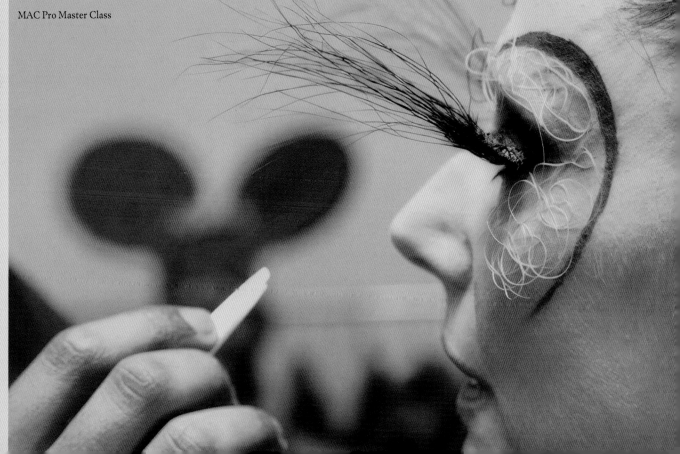

MAC Pro Master Class

NARS FANTASIES

What I love about Susanne is her uncompromising attitude, her fearless and fabulously creative vision of life, beauty, and style. It's always a delight and a privilege to be around her. I adore her!

—FRANÇOIS NARS

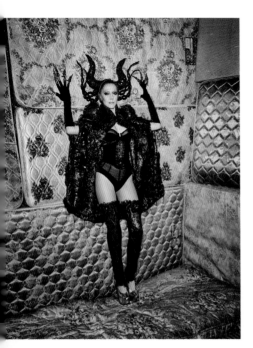

All photos by François Nars

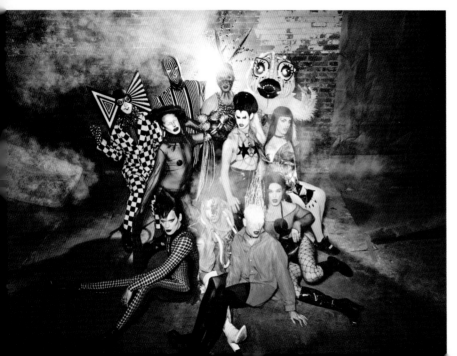

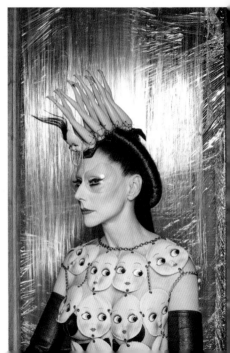

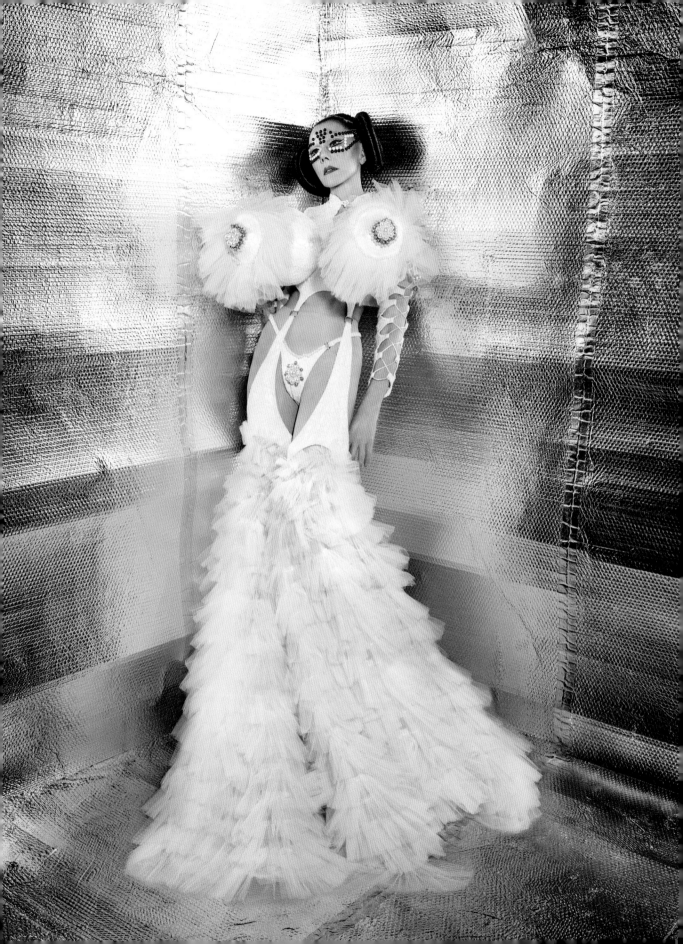

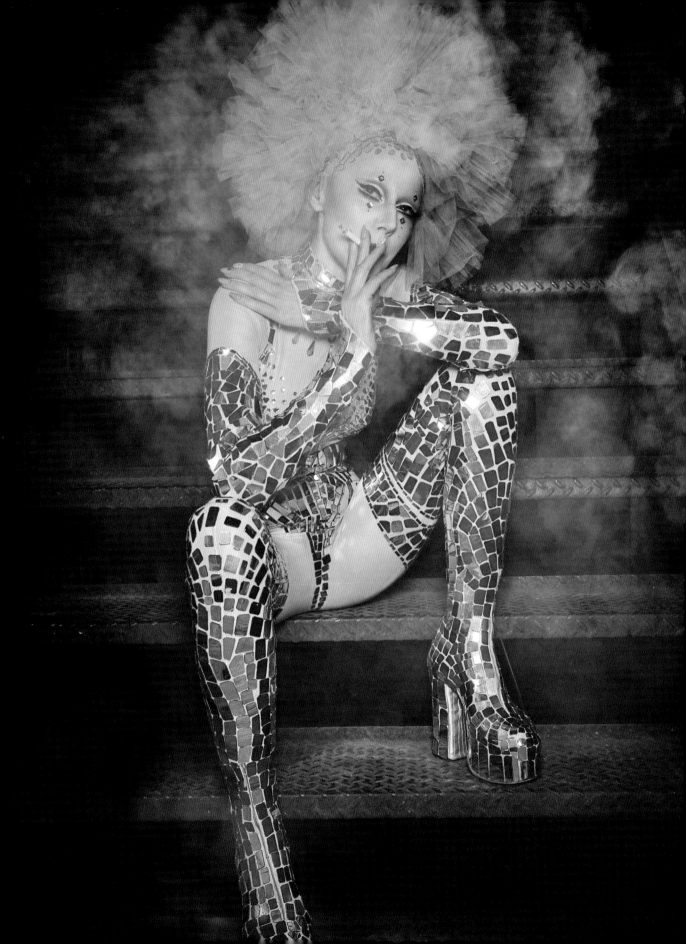

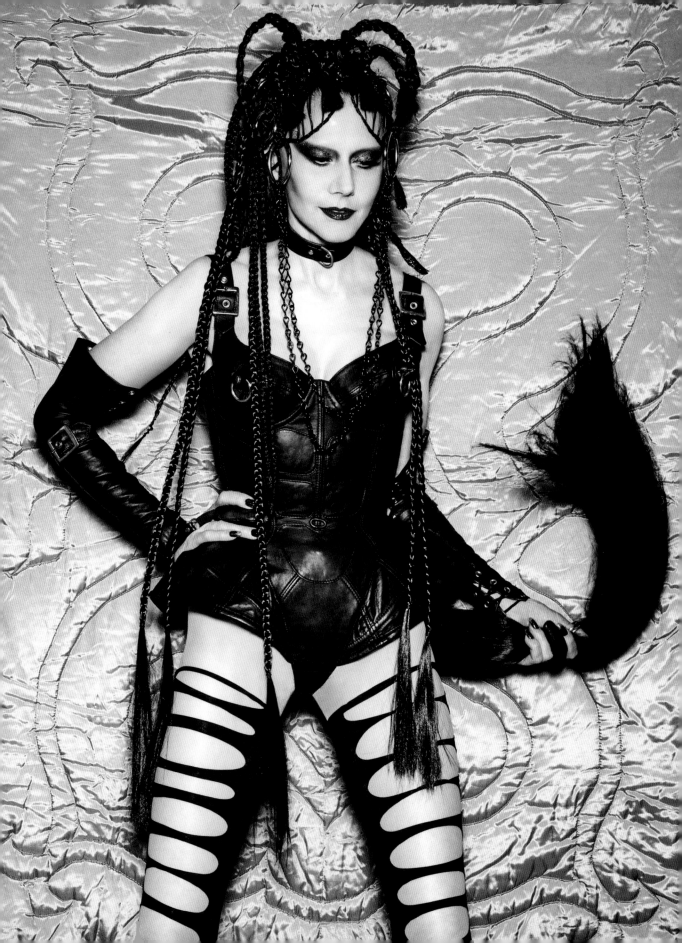

BIG NIGHT IN: ZOOM PARTIES

As the COVID lockdown was really starting to sink in and you could hear a pin drop on the empty streets of Manhattan, I was missing my community more than ever. So when Adventure Dave came up with the idea to do a Zoom party, I knew that was the answer and a great way to do looks and stay connected.

Enter the digital world of Bartschland and a full transition from club to couch! Not only were the On Top Zoom parties a great reason to dress up and be creative, they were also a fantastic way to keep sane. The best part of it all was that I was able to raise money to provide my creative tribe with at least enough funds to keep their pantry full each week.

I'll never forget the moment when I told the Zoomers to shake their booties, and I saw like a thousand people shaking their butt all at the same time on my computer screen. It was fantastic.

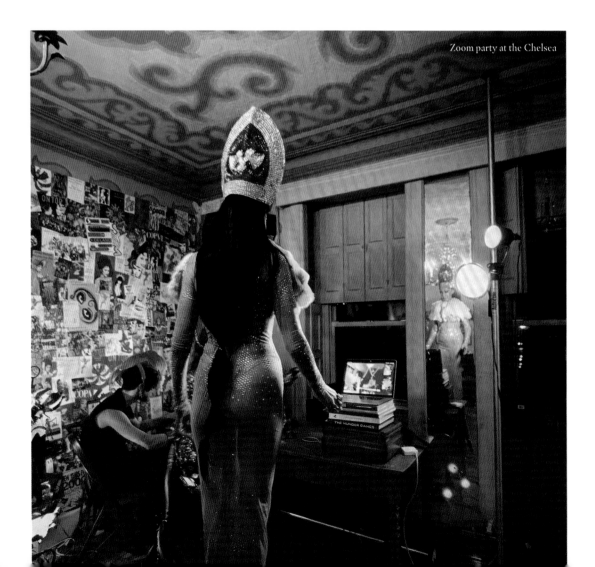

Zoom party at the Chelsea

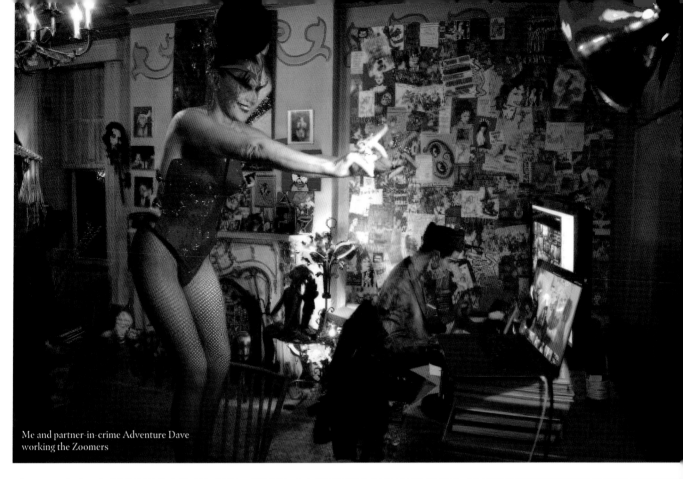

Me and partner-in-crime Adventure Dave working the Zoomers

My surprise birthday party at my neighbor Tony's place, photo: Vito Fun

DRESSING THE ROOM

Transforming a space is crucial to my events and one of my favorite parts in the planning process. From the big installs down to the smallest details, the décor of an event transforms a place and experience, and has become a Bartschland signature.

If given an endless budget for décor, I'd have a museum of my own by now. I love quantity, especially if it's many of the same things, like hundreds of inflatable monkeys instead of a dozen. I'm drawn to the wacky and chic, the eccentric and eclectic, tasteful art and the rawness of artists with my execution for décor. It's like creating a painting that you can enjoy for one night only, and then it's gone.

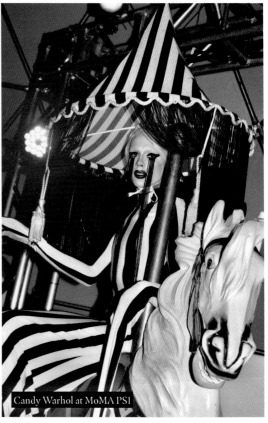

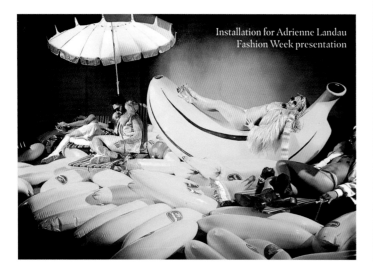

Installation for Adrienne Landau
Fashion Week presentation

Candy Warhol at MoMA PS1

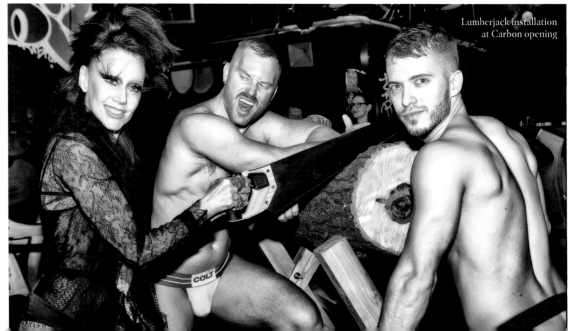

Lumberjack installation
at Carbon opening

My décor bitch Anette

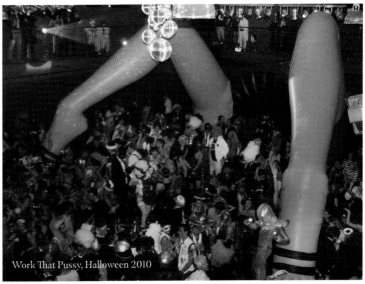
Work That Pussy, Halloween 2010

At Nemacolin Pride 2021

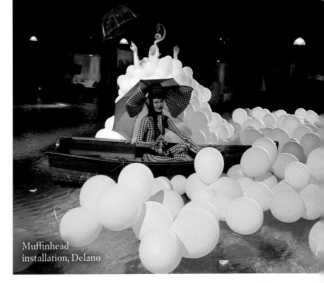
Muffinhead installation, Delano

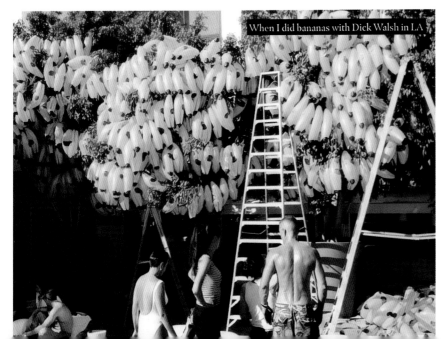
When I did bananas with Dick Walsh in LA

Delano, NYE

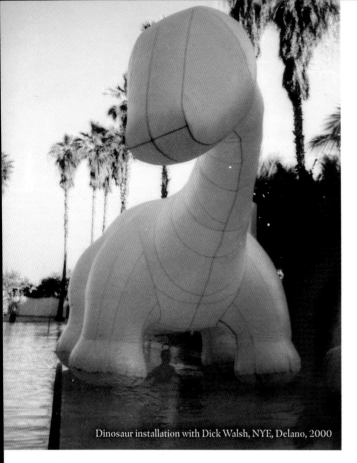

Dinosaur installation with Dick Walsh, NYE, Delano, 2000

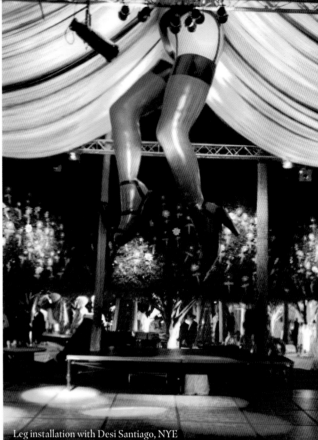

Leg installation with Desi Santiago, NYE

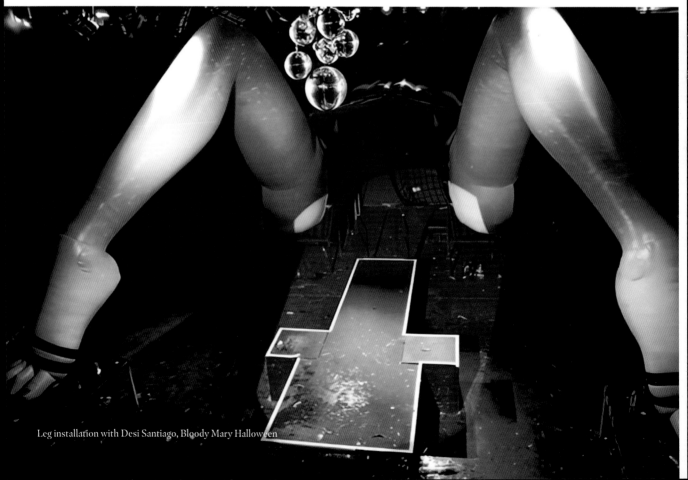

Leg installation with Desi Santiago, Bloody Mary Halloween

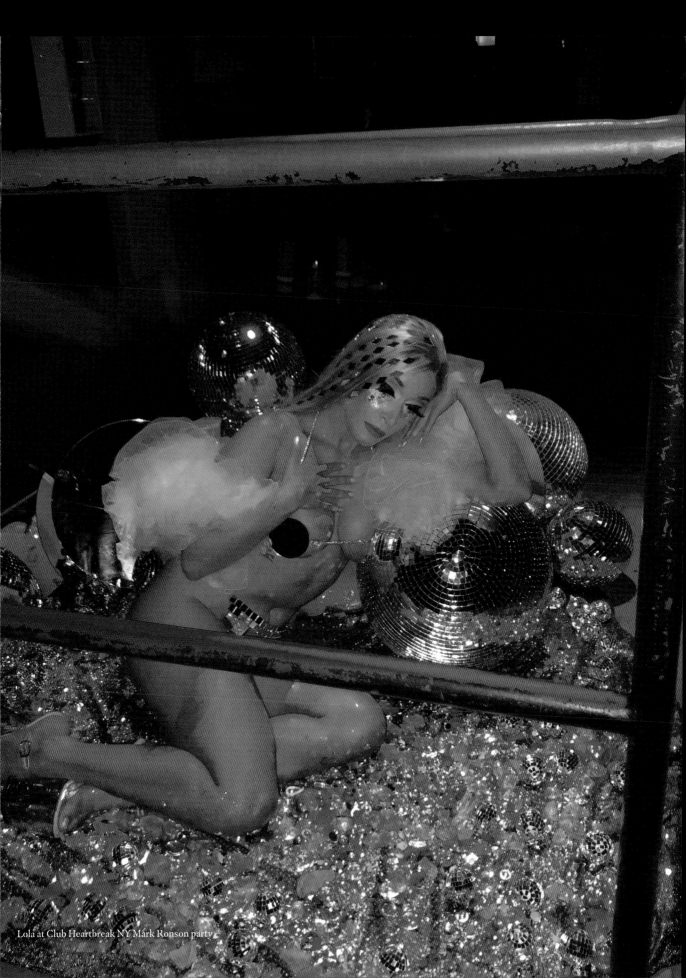

Lola at Club Heartbreak NY Mark Ronson party

BARTSCHLAND

COMMUNITY

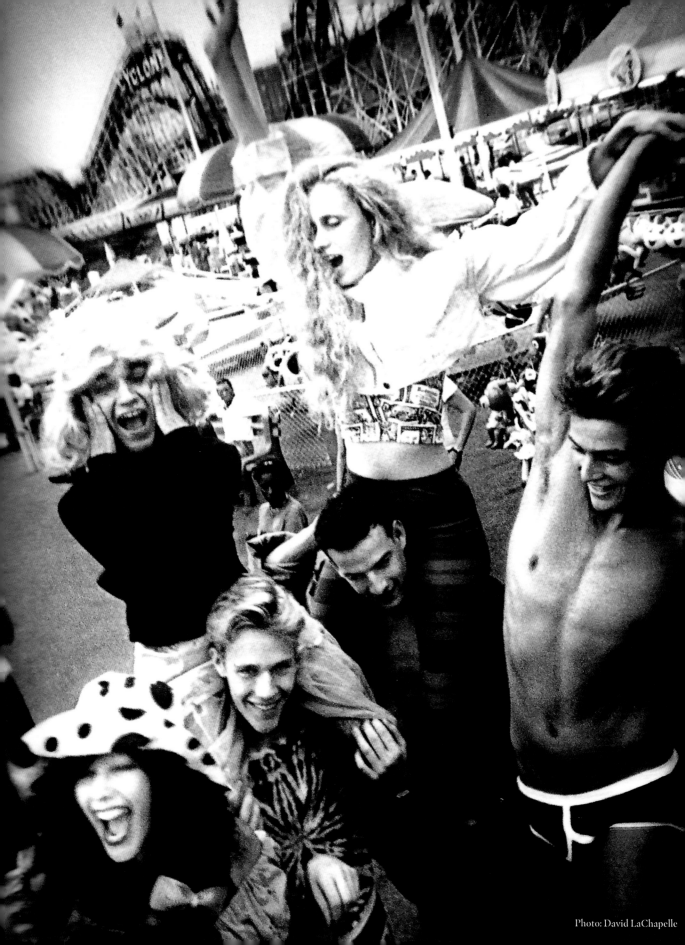

Photo: David LaChapelle

BARTSCHLAND COMMUNITY

As a young artist in New York in the early '90s, I was quite extreme. I was doing underground shows for the underground. I was very glamorous (in my way), half starved, and assumed people outside of our insular world would cross the street to avoid me. I accepted this was the price to pay for my freedom of expression. Then one day I got a call from Susanne Bartsch.

My first mission was to fly to Europe with my then roommate Kabuki, Amanda Lepore, and a few others to appear at an "event" of an unspecified type for more money than we'd normally make in a month. The directive was to create anything you want that "is fabulous." I wore a Giger-esque exoskeleton wrapped with red roses and copious amounts of red grease paint (to match my two-inch-long spiked nails, which I never removed). I figured she must know what she's paying for . . . I had no idea.

Kabuki and I had our own luxury honeymoon suite with a glass shower in the middle of the room. Then there was a limo to the event, of course. When we arrived, everyone was in evening attire. We crossed the room to the stage, where Susanne was waiting. We asked her what type of performance was expected. She said, "Just relax, darlings. Sit down, you've done enough. Do you need some champagne?"

That was an amazing moment. Half the time our appearance was something that put us in physical danger, but she had created an environment where it was a precious thing to see. Not just downtown, but *all* the way uptown.

Susanne would find all kinds of strange jobs for us. She would just say, "I got you another job," and direct us to an area. It was often a surprise. Once Kabuki and I ended our evening chasing a Volkswagen through the Meatpacking District

for a car ad. We both had very serious aspirations; she helped us pay the bills. It was more than fun memories—it was real artist support.

Mainstream corporate culture was constantly taking cues from the street, but they just took the ideas, not the people. Susanne always took the people. That is part of her magic. She sees beauty, passion, and talent. It doesn't matter where you came from or who's heard of you—if she sees a star, she will treat you like a star.

I know so many artists, performers, and designers who have had this experience with Susanne. Too many to list. A great example of her process is Leigh Bowery. Most people tried to copy a look, so Susanne asked him to design some pieces for her uptown couture boutique! And of course, he did.

She helped launch the work of many of NYC's design talents on her own body before they even had their first line out. She could have worn anyone, but she's wearing Zaldy. She made the choice the use her platform this way—to help legitimize these artists while allowing them to showcase their most extreme work. She does this to this day.

Often the culture emerging out of clubs is devalued as a frivolity. Culture happens where it happens. It takes a special kind of person to go in and pull people up instead of using them and throwing them away. She would advocate for someone before they knew they could advocate for themselves. I think of Susanne Bartsch as a cultural force. It becomes more apparent the more people talk about her. That's where she's done her greatest work, not with the looks, but with the people.

Though the looks are *really* good. Love you, Susanne!

— JOHANNA CONSTANTINE

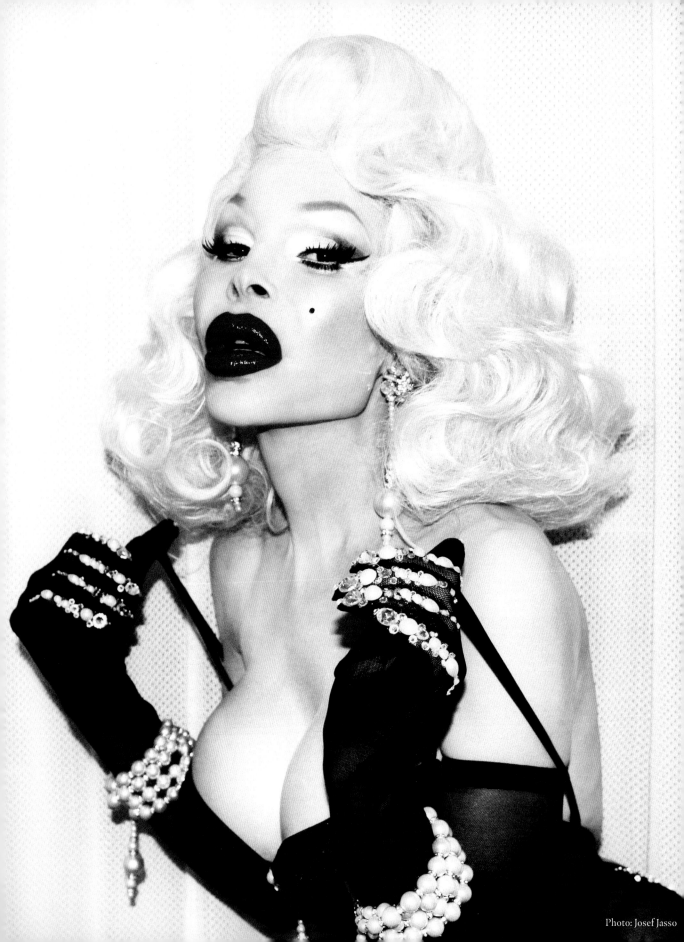

AMANDA LEPORE

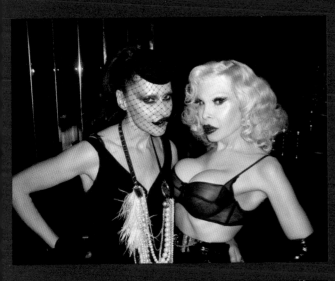

❖ AMANDA LEPORE ON SUSANNE ❖

I love that Susanne loves the freaks and loves what she does. There's always a new crop of young people working for her. It's really cool, the way she mixes club culture and fashion and brings everything together; it's what keeps her relevant. Her parties are always crazy and fun. We definitely have the same interests and taste for parties, and we both love Mugler.

❖ SUSANNE ON AMANDA LEPORE ❖

The Statue of Liberty has competition and that's Amanda Lepore. Not only is she a New York icon, but she is also one of the most zen people I've known. I've worked with Amanda for decades and only saw her mad once, for a good reason. I got carried away and bit into a lipstick from her pussy act and ruined it.

She never fails; if you have a dead spot in your event, just put Amanda Lepore there, and magic happens. She's a living, sparkling diamond.

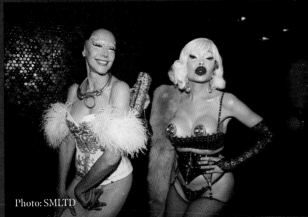

Photo: SMLTD

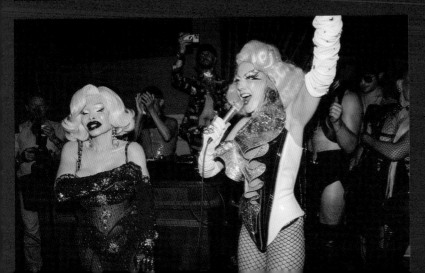

AIRIK AND DOMBEEEF

Airik has amazing style; I love that he makes
fetish look fresh. He is also an incredible hair
stylist and photographer.

After about a year of hosting my parties,
he started bringing a new boy toy, Dombeeef,
along and doing looks together, and I fell in
love. I've always loved twins and look-alikes.
Together they are double the pleasure.

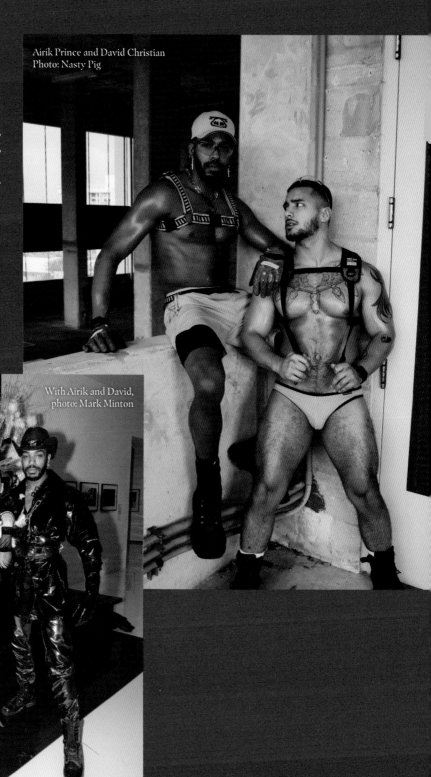

Airik Prince and David Christian
Photo: Nasty Pig

With Airik and David,
photo: Mark Minton

ANN ARTIST

Now a regular working all my shows and parties, I met Ann at my Nemacolin Pride event. We had a competition, and I awarded him the five-thousand-dollar prize for best performance and look. Need I say more?

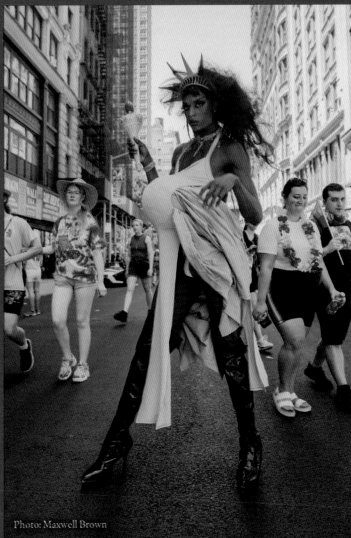

Photo: Maxwell Brown

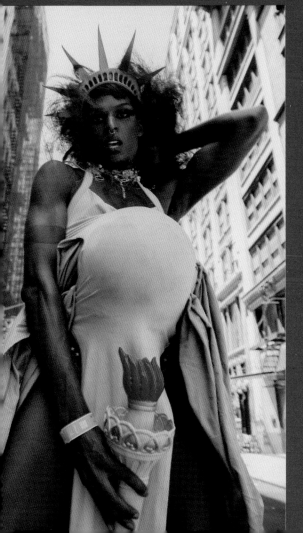

◆ ANN ARTIST ◆

I decided to be a pregnant Statue of Liberty for Pride two days after the overturning of Roe vs. Wade. I begrudgingly told everyone that I was being forced to carry my uncle Sam's baby as I chain-smoked cigarettes and drank alcohol throughout the day.

I wanted my outfit to beg the question: Is this what liberty and justice for all looks like?

AQUARIA

◆ SUSANNE ON AQUARIA ◆

When I think of someone who captures fabulosity personified, my mind immediately goes to Aquaria. For my FIT exhibition, Aquaria was part of a new batch of personalities I'd hired to turn looks. She turned it out so well that all I could say was, "Wow, this queen is talented. I need her at all my parties." Aquaria is just so good at everything—hosting, performing, serving looks. I seem to have an eye for winners, because years later she went on to compete in (and win) Season 10 of *RuPaul's Drag Race*.

◆ AQUARIA ON SUSANNE ◆

My friendship with Susanne is one of the most special relationships I can think of, and working with her has opened the door to so many unimaginable opportunities, particularly for a drag artist. Her Rolodex of visual references and styles informs my creative process and constantly challenges me to imagine new and otherworldly glamour. This is a look I created for DragCon LA in 2022 wearing pieces by Windowsen and styled by Marta Del Rio. I wanted to develop a youthful take on a mecha anime–inspired look, so I paired these dramatic accessories with equally dramatic hair and makeup that felt both referential and fresh. I have so much appreciation for my job and feel so lucky that every new day is a new opportunity to inspire others with new creative looks.

Photo: Marco Ovando

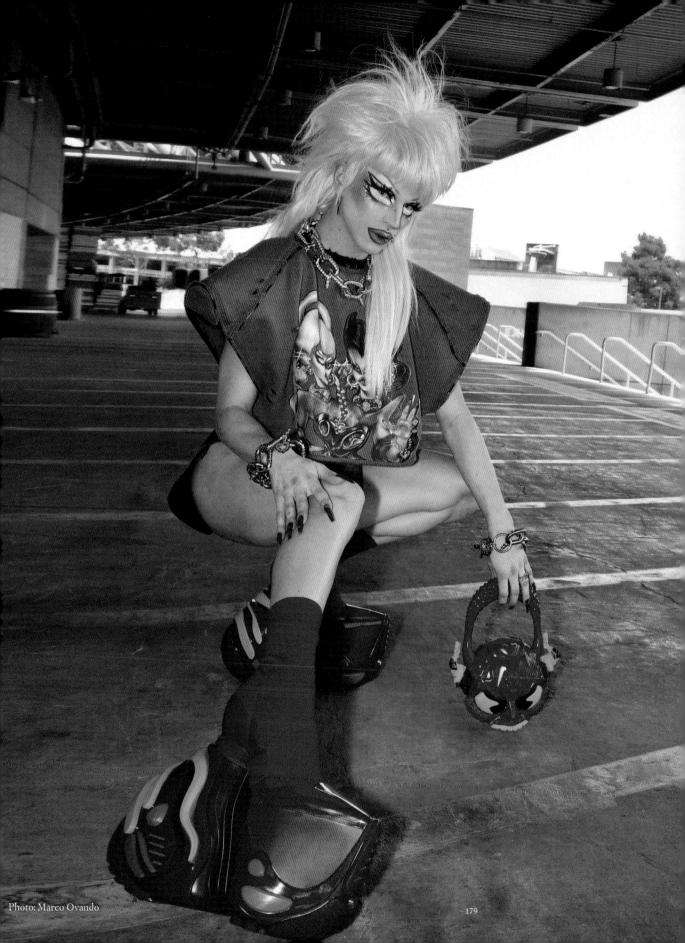

179

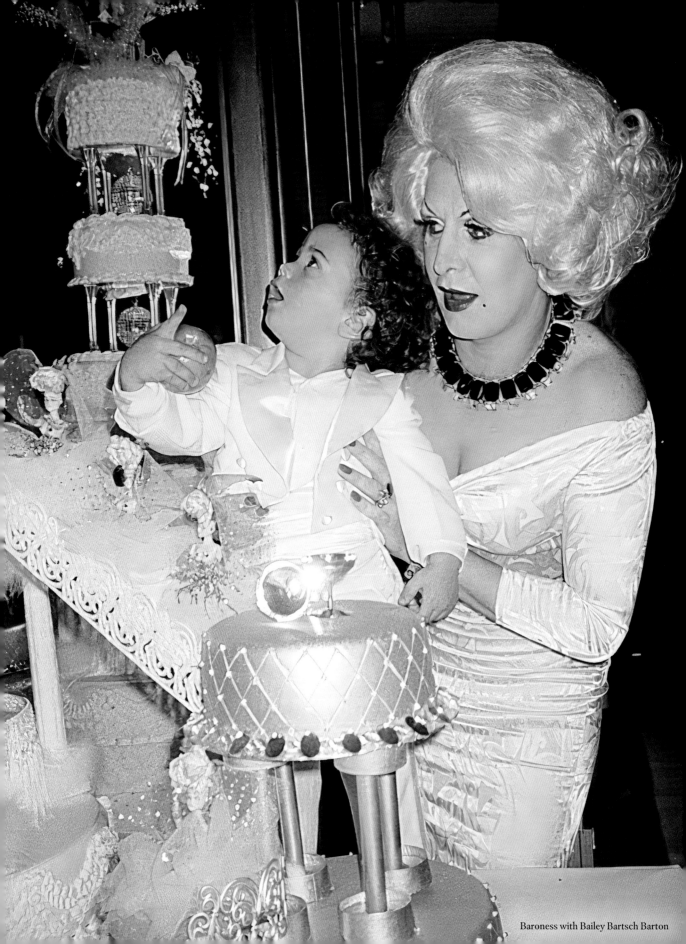

Baroness with Bailey Bartsch Barton

BARONESS

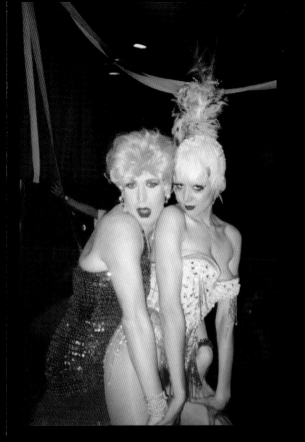

❖ SUSANNE ON BARONESS ❖

Baroness was a very special presence in not only my life, but also my son's life. He was my son's godmother. He took to Bailey like it was his own child and he was really there for him; Bailey knew he could go to Baroness for advice. They were very close, and even now Bailey says, "I smell Bayo," (a nickname he had for her) when he says he smells her perfume

She was my assistant, and thanks to Baroness I met David Barton. In fact, thanks to Baroness, Bailey is here at all. He introduced me to David and it was love at first sight, so I owe this queen a lot. His final request was that I throw his ashes in Place de la Concorde. Bailey and I did just that hiding so not to get caught by the gendarmes. We also sprinkled some in the Tuileries, so we could visit her.

At the Copa, 1991

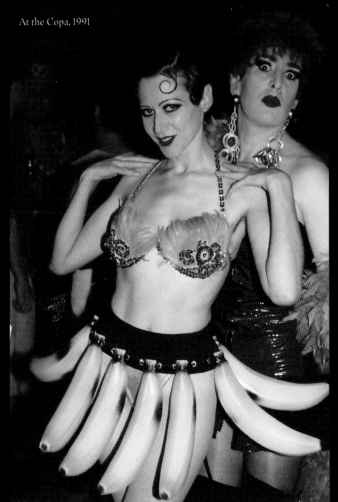

BRANDON OLSON

Brandon was my assistant for a few years, and he was very
inspiring to work with. When it came to his looks, one
never knew what he was going to bring, and his styling
choices would always inspire me. Brandon is one of those
talented people who can turn garbage into anything and
make it look chic.

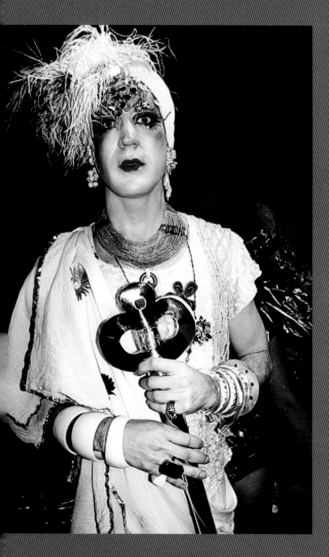

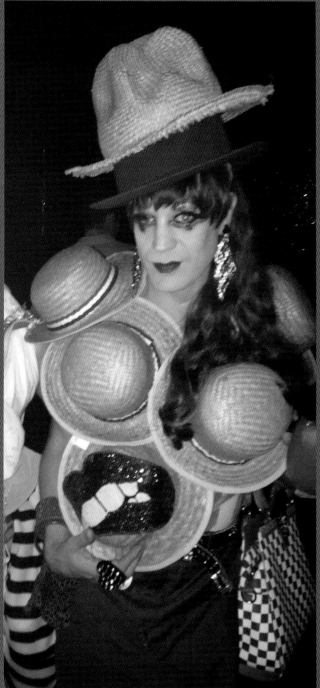

JONTE MOANING

Jonte is a true dancing queen. I met him at Vandam where he sometimes performed stark naked. His dance style is so energetic and engaging, one can't help but be drawn in—he never fails to amaze. His incredible talent has gotten him to choreograph for Beyoncé and other pop stars.

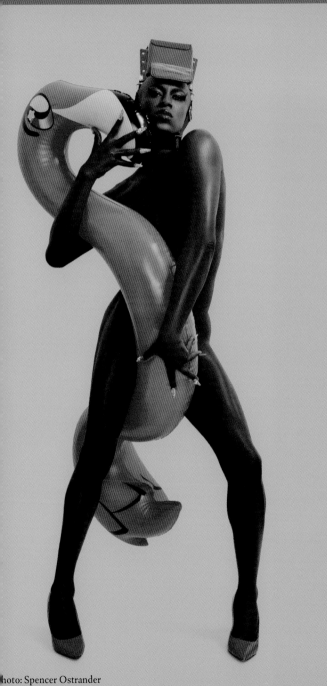

Photo: Spencer Ostrander

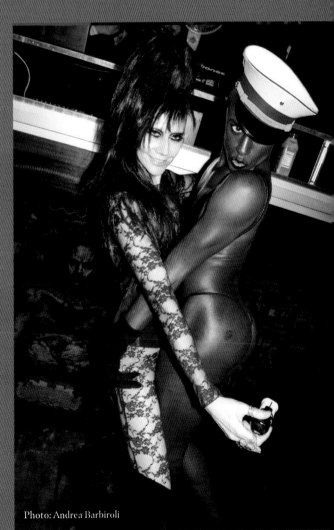

Photo: Andrea Barbiroli

BOB BOTTLE

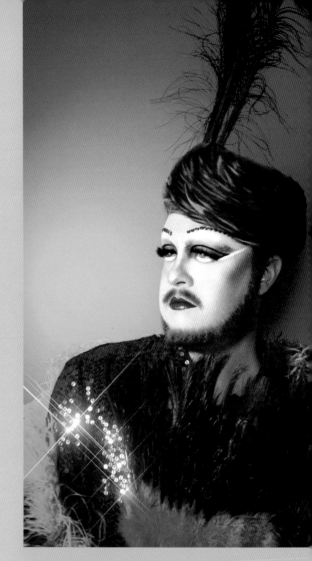

❖ SUSANNE ON BOB BOTTLE ❖

Bob is my man—a genius and an incredible friend and confidant. Any flyer or promo material I post these days, odds are Bob is behind it. I met him when I was doing Kunst parties through Gage. He offered to make GIFs of the hosts, and I was so blown away by his creativity and style that I started hiring him for everything. Bob completely understands my sensibility and the campiness I am looking for.

We are so tuned in; all I have to say is a few words and he gets it. That's a real gift to have between two people. He's an old soul in a young body, always fun and bubbly, and I love his Shakespearean-punk-sultan looks.

❖ BOB BOTTLE ON SUSANNE ❖

Seven years ago, I received my first phone call from Susanne. Pacing around a gym parking lot in suburban Long Island, nothing could have excited me more at the time. I was a twenty-year-old graphic design student at Pratt Institute in Brooklyn, home on my summer break. She had initially called about producing an animated video backdrop for a holiday window she was designing at Bloomingdale's. Due to technical limitations, the video never materialized. Nevertheless, this call would be the first of many. Susanne has said to me before, "You *always* pick up the phone—no one ever picks up the phone!" The truth is, I don't always pick up the phone either, but when Susanne calls, you pick up the phone.

Since then, Susanne has become the cornerstone of my career as designer. It is because of what she taught me (and continues to teach me), that I am able to work for myself and create fulfilling work. A favorite memory I have of working with Susanne is being up at 2:00 AM, laughing our heads off, exchanging dirty jokes about Brazilian wax specialists and dungeon masters, which became the invitation design for her party Working Girls.

I always chuckle whenever Susanne says, "You're a genius, Bob," after we complete an invitation design. The truth is that the confidence Susanne has given me has empowered me to create a career and life for myself that I never could have imagined without her.

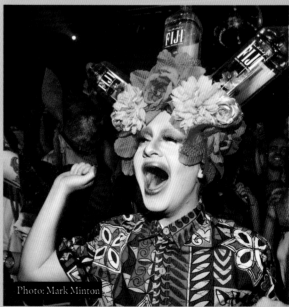

Photo: Mark Minton

DENEY ADAM

Deney is like my other son. We know all of each other's ins and outs; he understands how I tick and knows all my tricks. We are each other's life-lines. Having my makeup done with Deney is an eighteen-year-old story and counting. He is my calm before the storm. I sit in my kimono while he beats my face and turns me out with his magical hands in between all the dings and rings of the phone. My not sitting still is met with a serene calm, even though I know it makes him crazy. I loved seeing him discover his love for singing, and watching his musical career blossom is such a joy. I *love* my singing makeup artist *so much*!

❖ DENEY ADAM ON SUSANNE ❖

To put it in simple words, Susanne made me the artist I am today—better yet, the person I am today—and continues to inspire me.

Our relationship is beyond makeup; it's eighteen years of growth, friendship, being confidants, mothering, love, part-nership, evolution, and guidance . . . this list could go on, but that would take a chapter away from her book. The chap-ter in my book will take a lifetime of gratitude for touching my life so deeply. Words cannot express the love I have for this woman: my forever muse.

THE DENTISTS

With Steven and Michael

Meet the two sexy dentists who make everyone's smile gorgeous: Drs. Steven Cordoves and Michael Gulizio, the Core Smiles duo whom I love so much, support me in all my affairs, from the dancefloor to the dentist's chair.

They are the ones who cured me of my fear, and going to the dentist is no longer scary. And with my love for dogs, a big perk is having their hairy assistant, Enzo, always there to greet me.

Photo: Fernando Milan

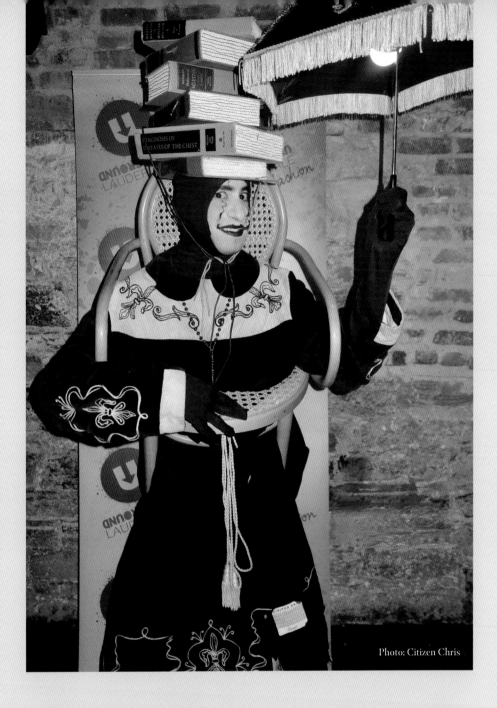

Photo: Citizen Chris

DOLLY DHARMA

I remember seeing Dolly Dharma at my Vandam parties and was like wow, he's definitely one of a kind. I love his ability to incorporate objects in creating his looks, like putting himself in an ice cream cart. His looks are couture craft, performance art, and living sculpture all in one.

DESI SANTIAGO

❖ SUSANNE ON DESI SANTIAGO ❖

Working with Desi is effortless. I admire everything about him, from his amazing looks, his creative direction, and his production skills to his friendship. We became close when he hosted the basement of the Vandam Sunday parties, and he introduced me to many things, including DJs like Horse Meat Disco, Severino, and Will Automagic, who went on to be half of the Carry Nation duo. He was an incredible addition to anything we did together, especially Bloody Mary, which got so big that the fire department shut us down. I love his art as much as I love him, and I want more!

Photo: Miguel Villalobos

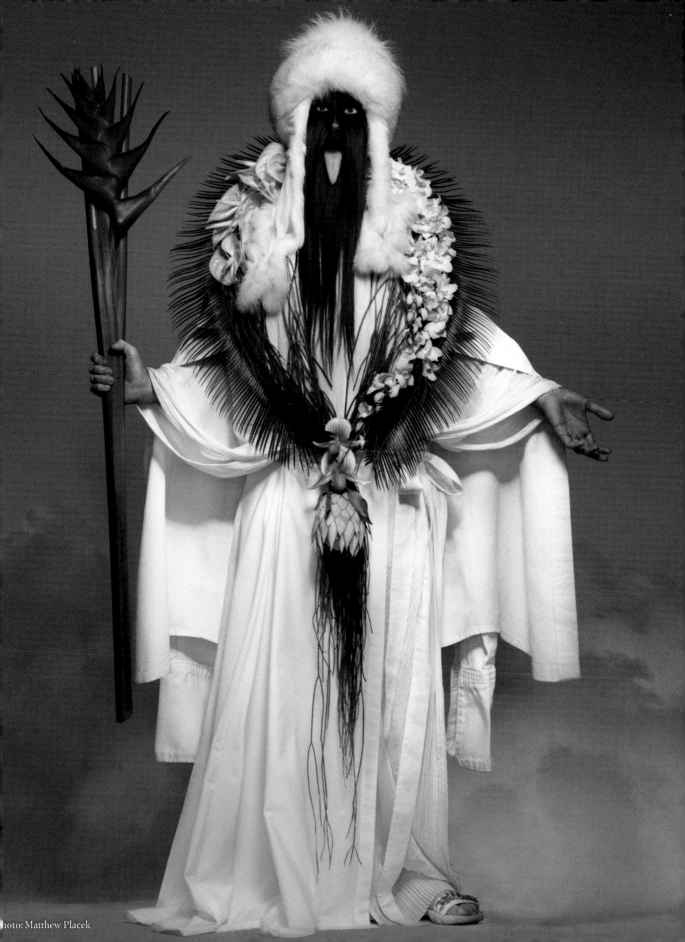

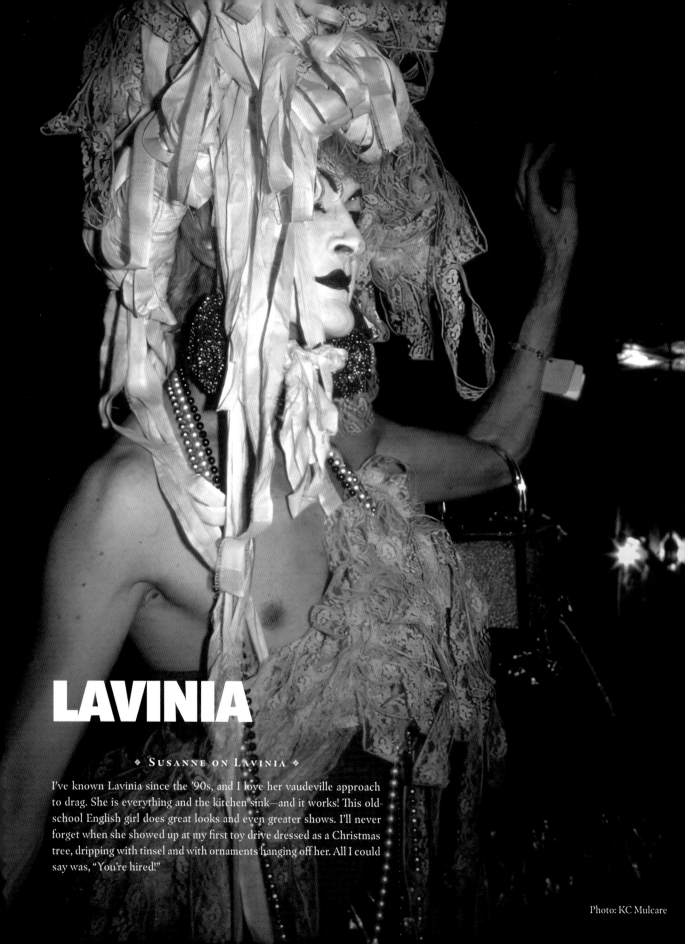

LAVINIA

◈ SUSANNE ON LAVINIA ◈

I've known Lavinia since the '90s, and I love her vaudeville approach to drag. She is everything and the kitchen sink—and it works! This old-school English girl does great looks and even greater shows. I'll never forget when she showed up at my first toy drive dressed as a Christmas tree, dripping with tinsel and with ornaments hanging off her. All I could say was, "You're hired!"

Photo: KC Mulcare

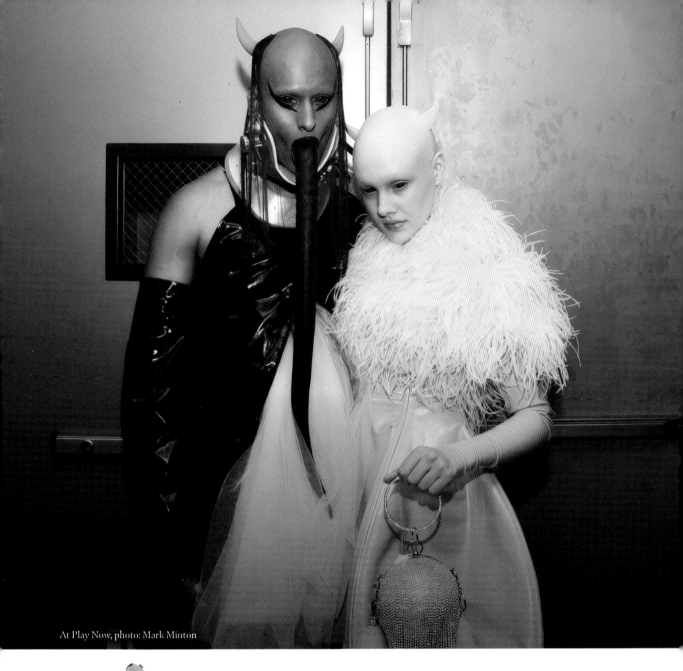

At Play Now, photo: Mark Minton

FECAL MATTER

❖ SUSANNE ON FECAL MATTER ❖

During a twenty-five-page Italian *Vogue* shoot that I was doing with Steven Klein, someone brought two friends to say hi. I was really impressed with their incredible aesthetics. I just grabbed them and said, "Are you ready for your closeup?" They answered: "We are!" Years later, I hired them to DJ at my Play Now parties that I did with Linux, and the rest is history: *Fecal Matter*.

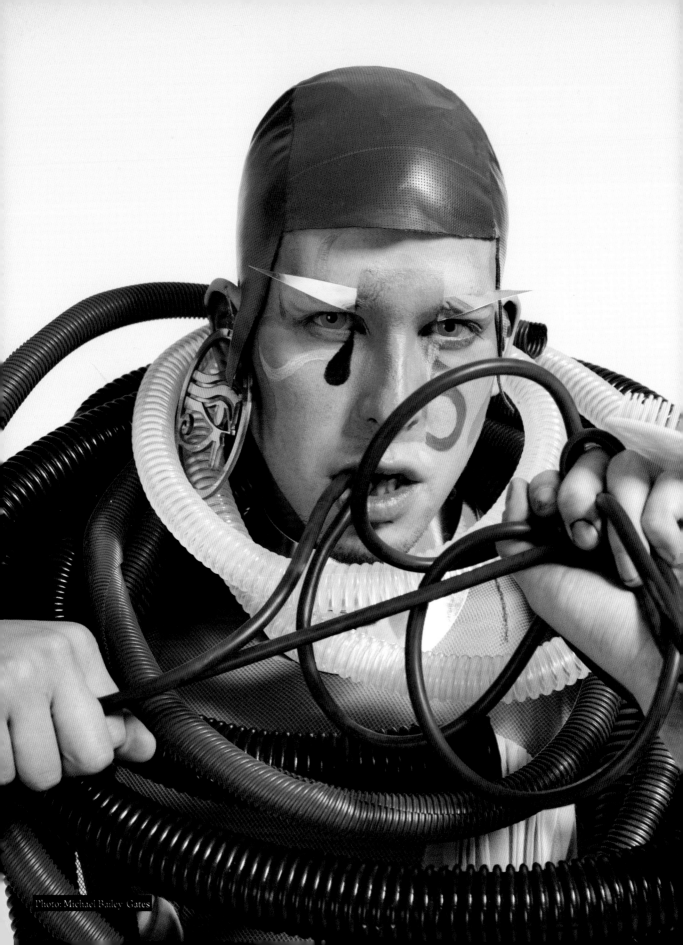

GAGE SPEX

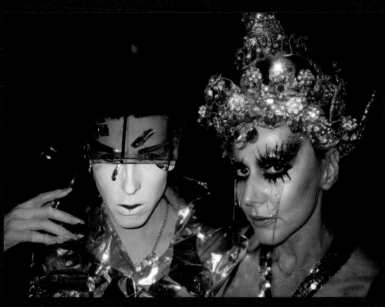

Kunst invite

◆ GAGE SPEX ON SUSANNE ◆

Working with Susanne since age twenty-five as a host and dancer, and doing installations and then coproducing Kunst (as Dreamhouse Productions) has been a dream come true. To collaborate on numerous lineups and flyers was really fun. It was a great meeting of minds, inspirational in many ways. At the time, it helped me push myself to think big and dream bigger. With my venue the Spectrum, I had a limit to the size of events, so with Susanne, the events could really go to the next level of opulence. Our collabs were sort of beauties and the beasts, trash and glamour. Underground meets megaclub. My favorite memories of Bartschland are of traveling, because while we are used to our wild lives and friends in NYC, when you go abroad, you see how truly groundbreaking and diverse her curation is. That was when I really realized Susanne's impact. It was beautiful to experience.

◆ SUSANNE ON GAGE SPEX ◆

When I first saw Gage, I knew right away that I wanted to work with them. Gage is not afraid to push boundaries, and I always love their non-referential, unique looks.

Gage turned out to be a fabulous artist and host, and a great partner. For years we've been collaborating on a party we throw together called Kunst, which merges art, performance, music, and style—a true celebration of the New York underground. Over the years, they have become a cherished friend. I value and love everything about Gage.

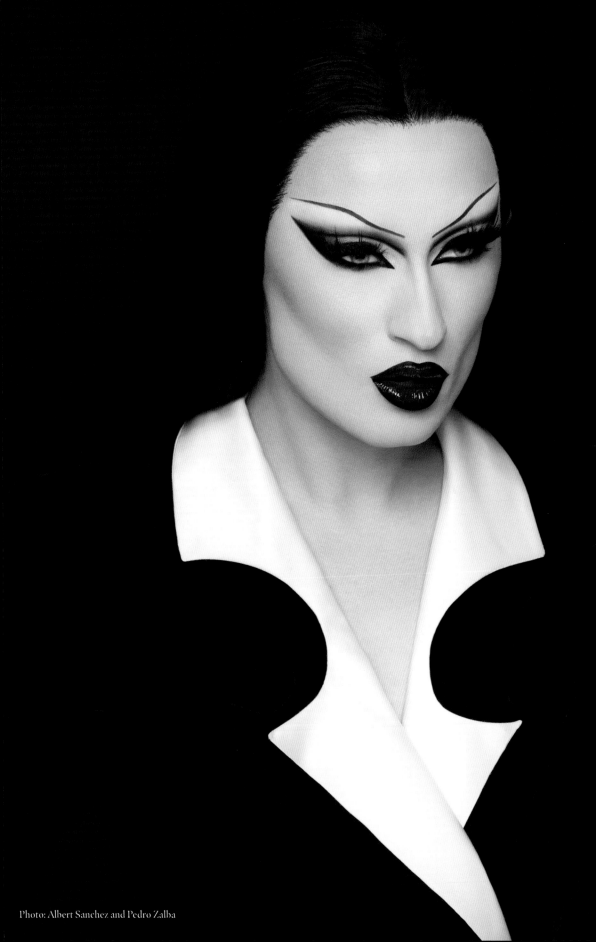

Photo: Albert Sanchez and Pedro Zalba

GOTTMIK

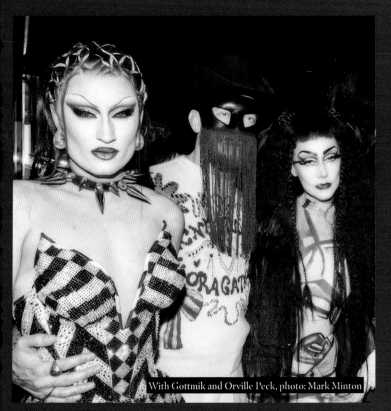

With Gottmik and Orville Peck, photo: Mark Minton

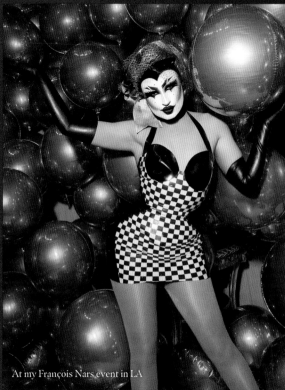

At my François Nars event in LA

◆ SUSANNE ON GOTTMIK ◆

Gottmik's talent as a makeup artist is unparalleled. Even before transitioning, they did my makeup whenever I was in LA. Danilo did my hair for the premier of my documentary and brought them to do my makeup and we really clicked. I love their work and them, and we became good friends. When I learned that Gottmik would be on *Drag Race*, I was thrilled, because I knew that Gottmik's modern take on goth would be a hit. Their talent is undeniable, and I considered Gottmik a winner from the day I met them.

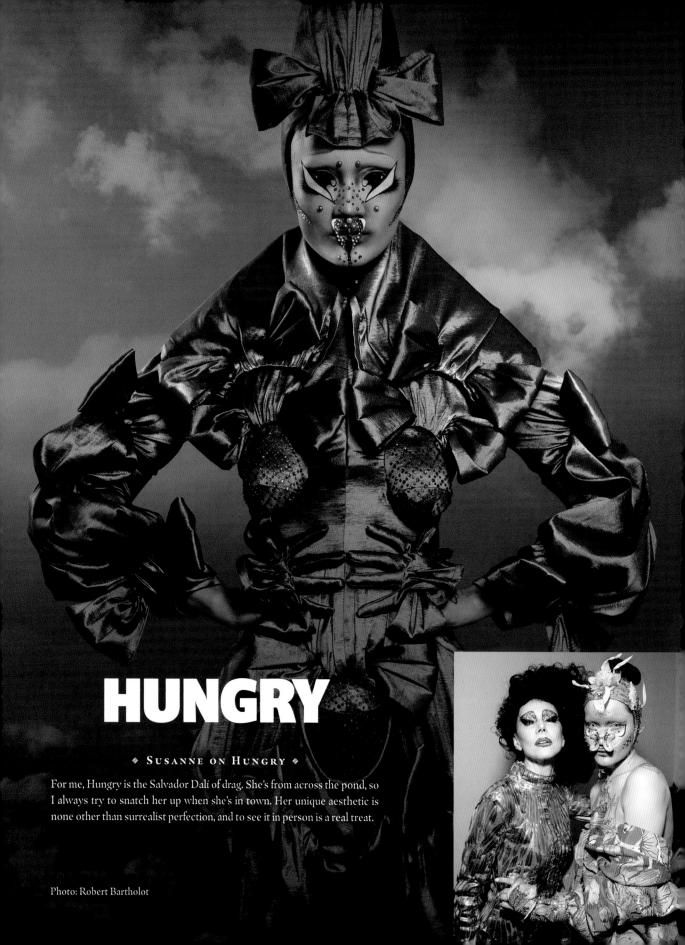

HUNGRY

◆ SUSANNE ON HUNGRY ◆

For me, Hungry is the Salvador Dalí of drag. She's from across the pond, so I always try to snatch her up when she's in town. Her unique aesthetic is none other than surrealist perfection, and to see it in person is a real treat.

Photo: Robert Bartholot

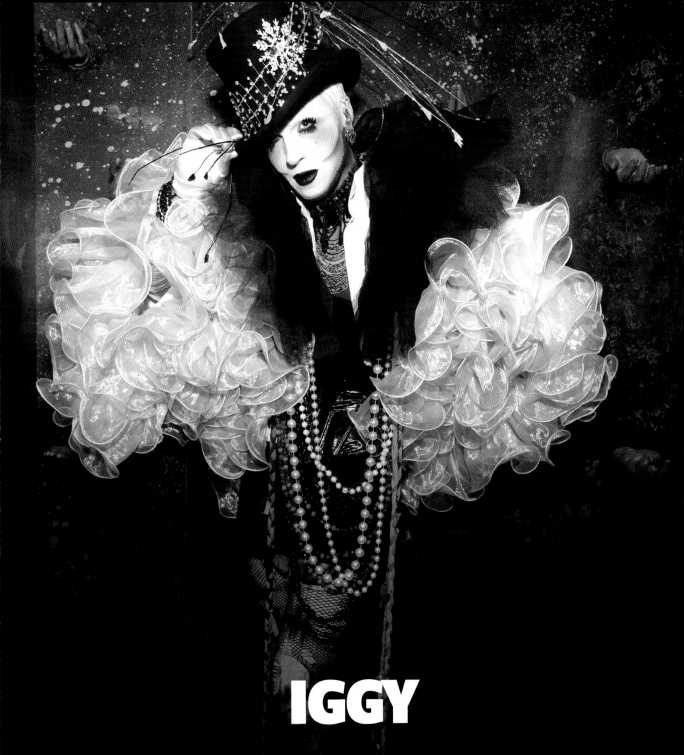

IGGY

❖ SUSANNE ON IGGY ❖

Madame brought Iggy to dance in one of her tutus at my Amazon party in the Summer of 1991, and a week later he started working for me. He is a former ballet dancer who worked with Madame at La Mama. I loved the idea of a man in drag and a tutu doing ballet, so I was in heaven when I met him. Iggy is a great performer. I had him and Madame do *The Dying Swan* so many times; they were incredible. I'll never forget the time he did a show as a big gorilla, and when the gorilla suit came off, he was Marlene Dietrich underneath. I took him on the road to work many events with me, and I consider Iggy a sweet and special friend. He was and still is a showstopper.

JOEY ARIAS

◆ SUSANNE ON JOEY ARIAS ◆

Where do I begin with this queen? If all the good times I've had with Joey
Arias could bring peace to the world, we would have peace.

Joey is just one of those people. From the first day we met, we con-
nected on every level; we inspire each other. He can sing anything from
Billie Holiday to Led Zeppelin, and when we do shows his skill at reading
the room and knowing exactly what to do is incredible. He's somebody
I know will always be there for me. Our friendship is forever. It's a great
love—we're stuck with each other!

With Joey 1992-93, photo: Roxanne Lowit

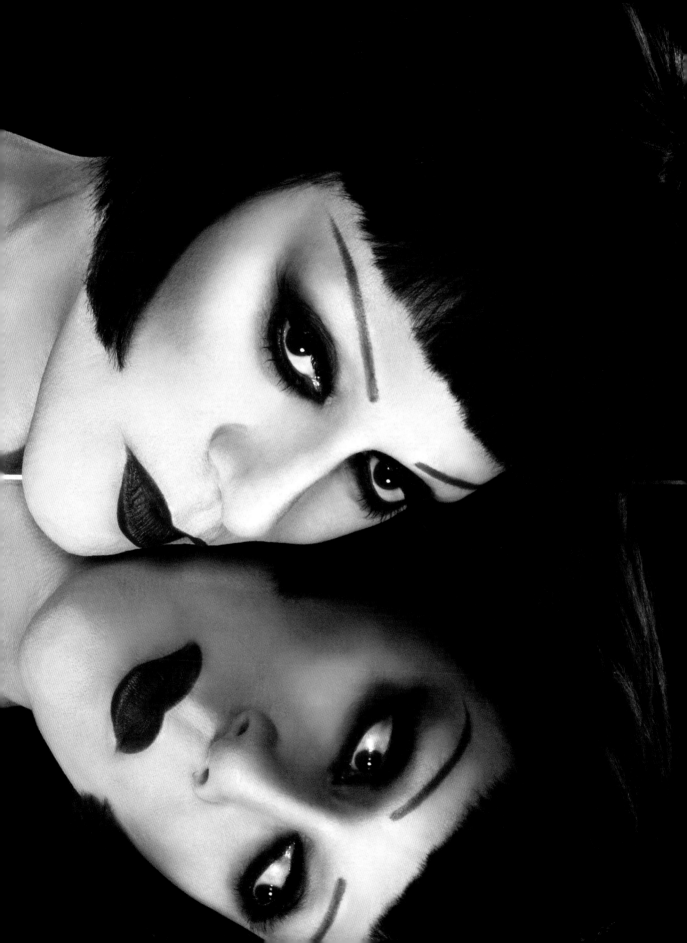

KRISTINA KISS

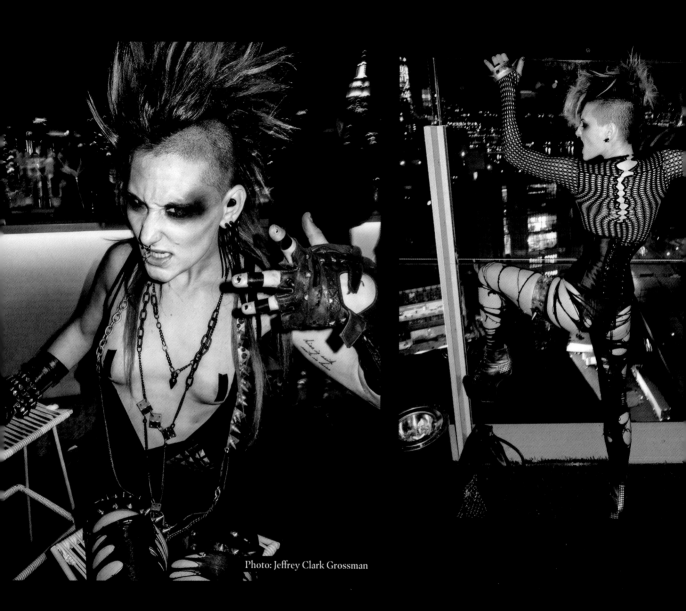

Photo: Jeffrey Clark Grossman

◈ SUSANNE ON KISS ◈

There are no other punk-rock kids quite like Kiss. She has been hosting my parties for many years, and I love the gothy-rock-star vibe she brings to everything she does. Also a fashion designer, Kiss takes the classic punk style and gives it a modern twist that you just can't take your eyes off of. Between that and the feminine pussy power she brings into the mix, I find myself calling her the punk rocker of the menagerie!

DANILO

Danilo with Billy Beyond

◆ SUSANNE ON DANILO ◆

Danilo is major; a giant in the business. He's the one who turned me on to the magic of wigs—at this point I have more wigs than one can count. We met at my West Broadway store. I was hooked immediately. The first wig he put me in is coined "The Babe," and ever since, I go nowhere without one on! Danilo taught me so many how-to hair tricks, which I still practice to this date. A beautiful friend and confidant, an inspiration and supporter. We have not only bonded over wigs, we have many stories and adventures together. Once Danilo became an LA jet-setter, Charlie Brown, who was Danilo's protégé, was prepped, primed, and ready to take over and create bigger hairdos than ever on me.

◆ DANILO ON SUSANNE ◆

Susanne and I met early on in my career, so she is a link to many of my experiences and memories. There are so many stories to tell that the list is endless . . . the times we had at the Copa, the posse that we were. We would cry, we would laugh, we would bitch—just do it all. There was never any judgment, and that was an incredible world for me to grow up in.

I admire how much Susanne is still doing—time seems to have no effect on her. Her momentum just increases, the more she does. I'm so happy it's being captured and acknowledged.

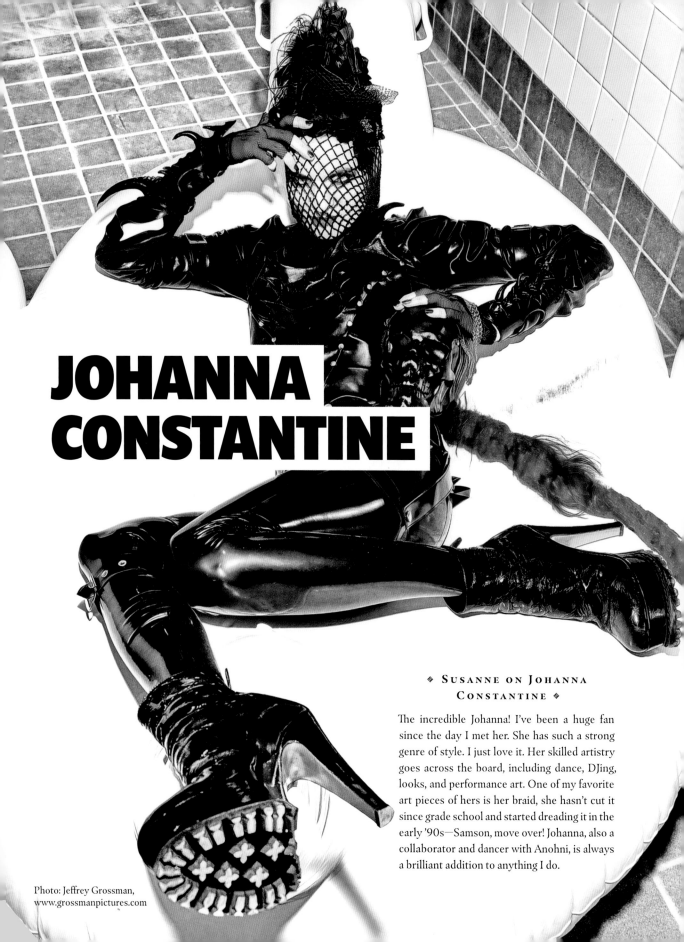

JOHANNA CONSTANTINE

❖ SUSANNE ON JOHANNA
CONSTANTINE ❖

The incredible Johanna! I've been a huge fan
since the day I met her. She has such a strong
genre of style. I just love it. Her skilled artistry
goes across the board, including dance, DJing,
looks, and performance art. One of my favorite
art pieces of hers is her braid, she hasn't cut it
since grade school and started dreading it in the
early '90s—Samson, move over! Johanna, also a
collaborator and dancer with Anohni, is always
a brilliant addition to anything I do.

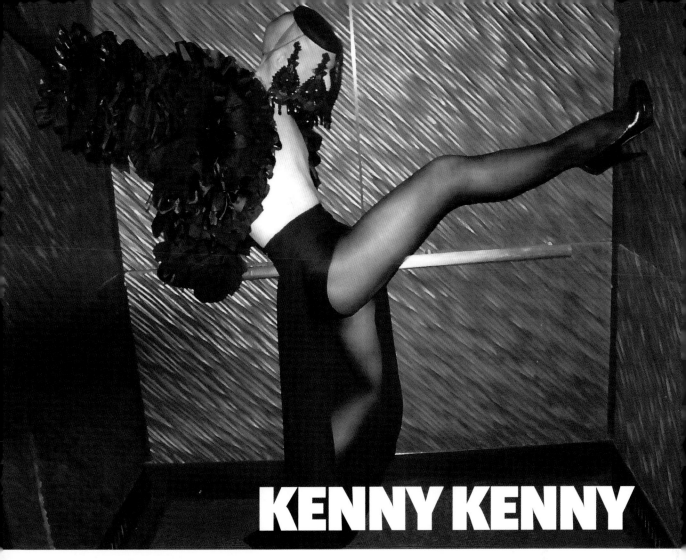

KENNY KENNY

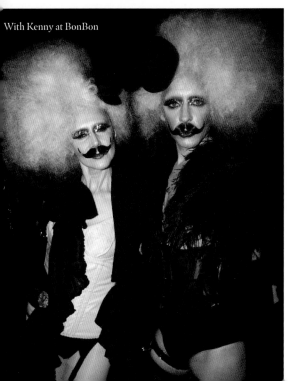

With Kenny at BonBon

With Johanna Constantine and Kenny Kenny

❖ SUSANNE ON KENNY KENNY ❖

I started out hiring Kenny—who is a great artist—to do the door for my club nights. Kenny got me back into nightlife and clubs after I had my baby, and we ended up partners, doing some legendary parties. We had a great, long ride together. Collaborating with Kenny was a great experience I'll always cherish.

Photo: Stephen Blais

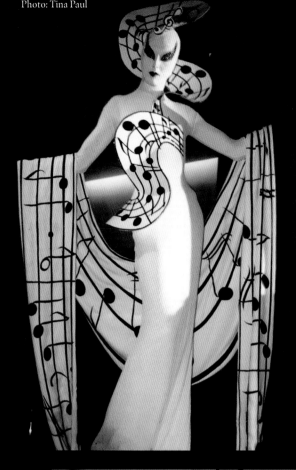

KABUKI

❖ SUSANNE ON KABUKI ❖

I just went through a box and found all these Christmas cards that Kabuki sends me every year. Each one is truly a work of art, so magical and fairy-tale like, and they take me back to our early days together. When I met Kabuki, he was his own canvas. I wanted to be in his sphere, and I hired him immediately. He would create stunning, surrealistic art on himself, from a fish with fins where each scale was meticulously hand painted, to a golden goddess the likes of which you'd never forget.

All that talent has made him a big star in the industry, and he's now a hugely successful makeup artist and *innovator*. I've done shoots with him where he'll invent something I haven't seen before, which amazes me. He's a favorite of Steven Klein's and so many other photographers because he has that innate ability to know exactly what the moment *calls for*. To this day I love working him because I know it's going to be 110 percent.

❖ KABUKI ON SUSANNE ❖

I first laid eyes on Susanne in person at the Limelight. It wasn't one of her events but part of something called the Style Summit that had been hyped up for a long time as a star-studded event. Navigating my way up the back stairs, packed with club kids, she was coming the other way, a vision engulfed in a hurricane of tiny white feathers. I heard that distinctly camp voice for the first time, talking to no one in particular. Her reputation as *the* New York nightlife diva was confirmed in a fleeting moment. Fast forward to a year later, I was one of her "girls" and getting flown all over the world, walking in Thierry Mugler fashion shows. I was getting paid to enjoy myself and do what most likely would have gotten me a black eye if I'd stayed in my hometown.

Looking back, I see not only did she open doors for me but provided inspiration and motivation to do the work it took to get through those doors. There's a magnetic forcefield of creative energy that she generates without even realizing it. It encircles her like that kinetic cloud of tiny feathers at three in the morning on a stairwell in the Limelight in a time gone by.

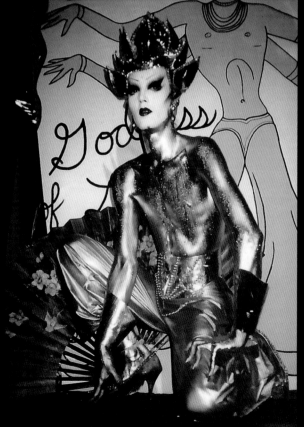

205

KYLE FARMERY

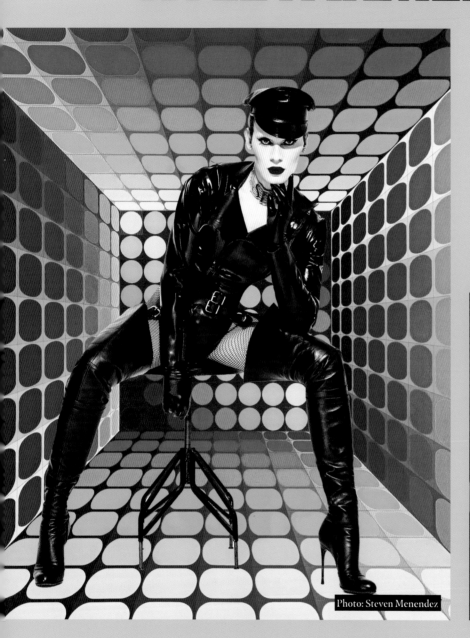

Photo: Steven Menendez

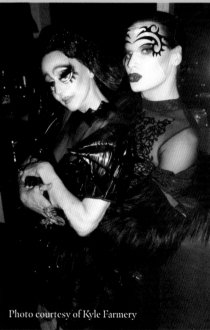

Photo courtesy of Kyle Farmery

◈ SUSANNE ON KYLE FARMERY ◈

I met Kyle at Vandam when he was only a kid, going out nightly with Amanda Lepore. What a way to grow up! He has always been so glamorous and so chic, only becoming more so as he's grown up before my very eyes. Somewhat recently, Kyle began working on his own fashions, in which he creates stunning Swarovski corsets. In fact, there's not a thing Kyle isn't able to cover in Swarovski crystals! He's stoned the most fabulous things for all kinds of downtown icons and celebrities, and I love wearing his stuff.

MICHAEL MUSTO

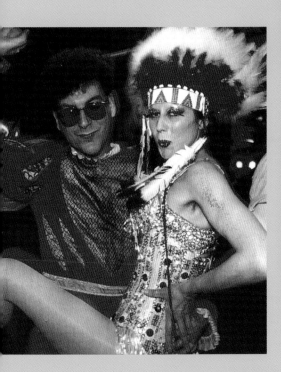

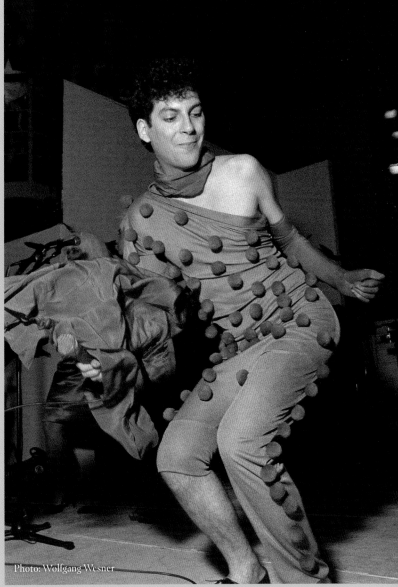

Photo: Wolfgang Wesner

◈ SUSANNE ON MICHAEL MUSTO ◈

At my first party at Savage, Michael Musto walked through the door in a head-to-toe look. I was a fan, and I knew he wrote for the *Village Voice*. I thought to myself, "I've made it." I was thrilled that he was interested in what I was doing. Over the years, Michael became a great friend, and we've enjoyed so many parties together that I've lost count. He's one of those people who's seen it all and understands the history of New York nightlife better than anyone. And I love that he still comes and supports what I do.

LEIGH BOWERY

Leigh Bowery and I connected through Michael and Gerlinda Costiff by being in the same circles in London. He was a larger-than-life, sharp-witted, very charismatic performance artist and fashion designer. Leigh shared a fabulous, eclectically decorated apartment with the artist Trojan, and together they did incredible looks. I was so taken by them both that when I decided to stage a fashion show/happening in NYC called New London in New York, I knew they had to be a part of it. And that is how I introduced Leigh Bowery to the US and the Big Apple.

New London in New York was a huge success, and Leigh's designs took the city by storm. Not only did I carry his clothes at my store, but I also wholesaled them to Barneys, Saks, Bloomingdale's, and many other major stores.

Savage, the first weekly party that I started in NYC, was inspired by Leigh's night at a club that I loved called Taboo. We ended up working together a lot and became good friends. Sometimes he'd stay at the Chelsea when he was in town. Leigh was an incredible performance artist, and every time he went out it was a performance.

His looks were incredible, very intricate and restrictive. One time I asked him, "What do you do when nature's calling?" He responded, "I just pee through everything; it's only vodka." To this day, I'm still in awe of his artistry and the influence he's had on popular culture.

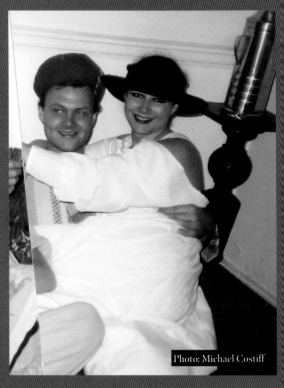

Photo: Michael Costiff

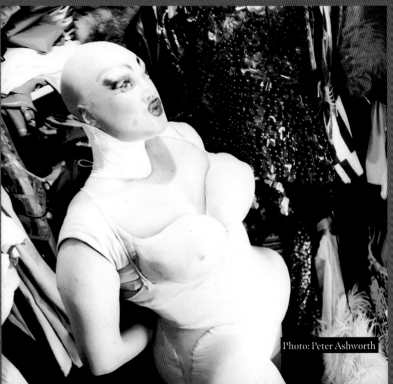

Photo: Peter Ashworth

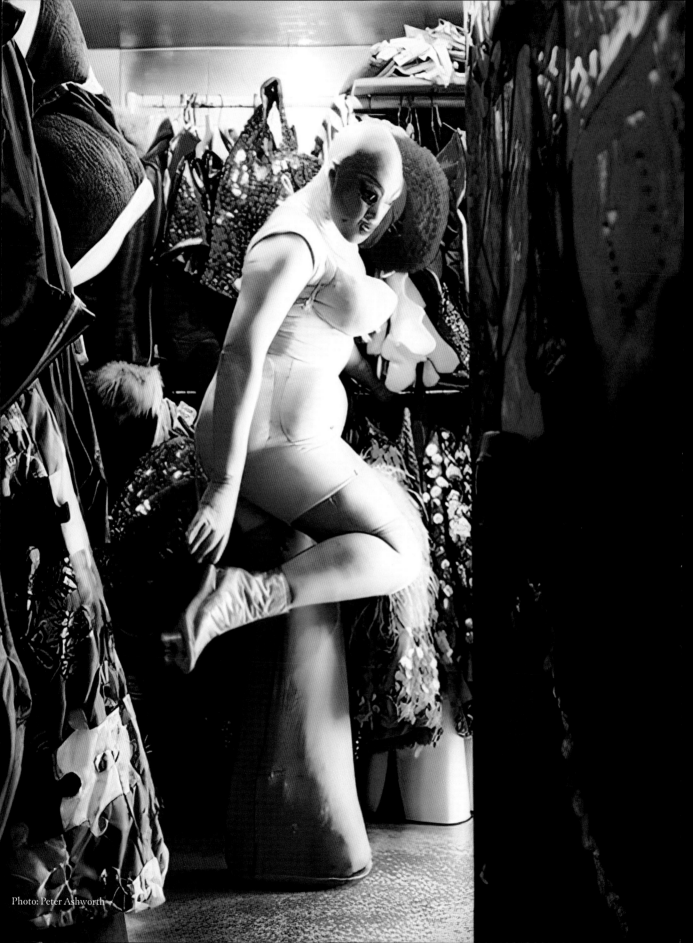

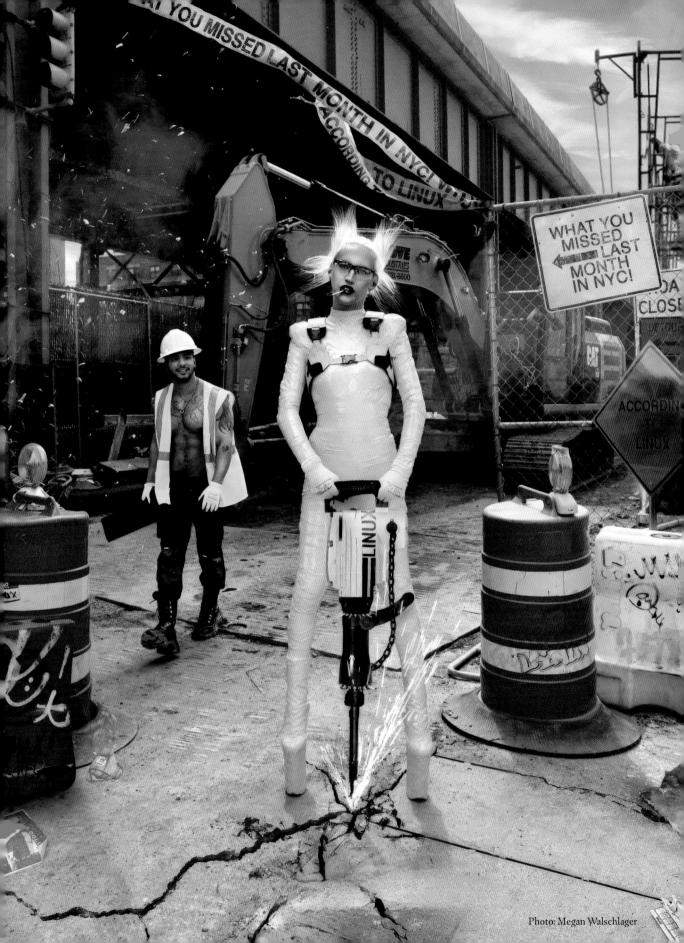

WHAT YOU MISSED LAST MONTH IN NYC! ACCORDING TO LINUX

WHAT YOU MISSED ←LAST MONTH IN NYC!

ACCORDING TO LINUX

LINUX

Photo: Megan Walschlager

LINUX

Photo: Mark Minton

❖ SUSANNE ON LINUX ❖

The first time I saw Linux, I remember liking her artsy look. It was inspiring. In fact, I remember telling her her look was very Leigh Bowery-esque, which made her night since she is a huge fan of his. One of her great talents—believe me, she has many—is making looks and these massive costumes out of god knows what. These days she's done a 180 and now brings edgy trendy looks, which she does just as well. Soon after our first encounter, I started hiring Linux to host and bring her looks to my events. I also had her travel with me to work my out-of-town parties. I loved working with her, and eventually we became besties. I partnered up with her for a party series called Play Now in Bushwick. For my On Top party, Linux has my back. And if ever I am away, I trust her with it in all aspects. She really cares and is a great partner in crime. Linux is a real go-getter, well on her way to wherever she wants to go. I don't have a single doubt in my mind about that babe reaching whatever heights she aspires to. You go, girl!

❖ LINUX ON SUSANNE ❖

The first time I laid eyes on Susanne Bartsch, she was strutting into the Copacabana, sporting a sequin-emblazoned leotard. It was neither the year 1988, nor was I witnessing her in the flesh. Instead, I was being introduced to her on the screen of my laptop over two decades later through archive footage found online. Then and there, from my childhood bedroom, I was instantly drawn to the ultra-glamorous allure of Bartschland. A place on earth that could be described as nothing other than as a salute to art, creativity, and individualism. Whether she knew it or not, Susanne Bartsch and her bubble in New York City were calling my name.

After moving to New York the following year, it was only a matter of time before I indoctrinated myself into the world of Bartsch. Within mere seconds of interacting and working with Susanne, it became clear to me that her universe contained much more depth than the rhinestones and champagne presented on the surface. Beneath the oh-so-fabulous parties, looks, and entourage, an impassioned mission statement rang true in Susanne Bartsch's soul, focusing solely on bringing people together and celebrating diversity.

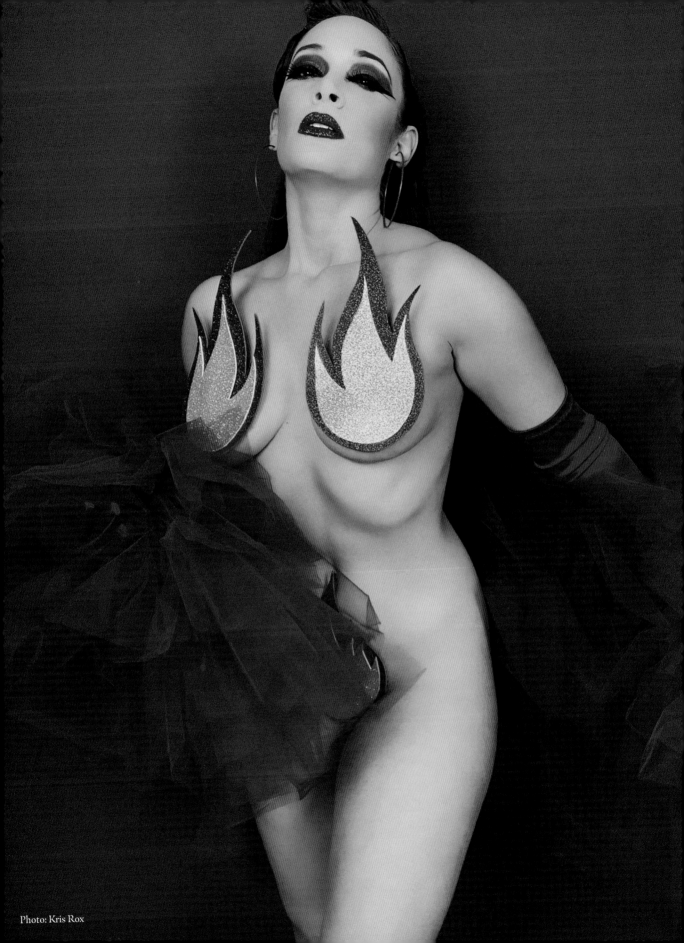

Photo: Kris Rox

LOLA VON ROX

Photo: Mark Minton

Photo: Cheryl Gorski

◆ SUSANNE ON LOLA VON ROX ◆

Lola has become an amazing contributor to many of my creative projects, especially my shows.

She is a brilliant performer and artist, an incredible host, and one of my best "besties." She always goes the extra mile with everything I do. And as if giving her giving 150 percent, her handmade pasties, and her forever-oozing glamour weren't enough, her fabulous life partner, Kris Rox, is always right there ready to step in if anything is needed.

Lola, always one bat of the eyelash away, is a rare gem. She's a gift to the world, and I am grateful that she is part of mine.

◆ LOLA VON ROX ON SUSANNE ◆

When I step into a Susanne Bartsch show, it feels like a world where I belong. Coming from a strict dance background and career, I found the ultimate freedom of expression as a performer with Susanne. And I'm sure the audience feels the same way—it's a connection I can't explain. There's a certain magic Susanne creates with her family of performers and the audience. We're all there for the spectacle, the party, the love. It's a world of its own, and I love living in it.

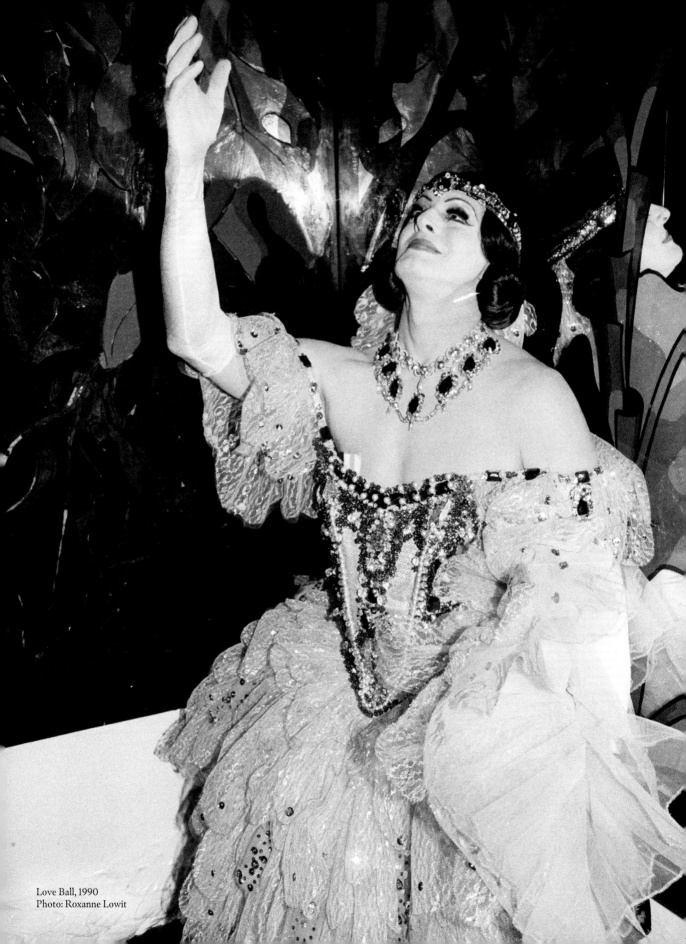

Love Ball, 1990
Photo: Roxanne Lowit

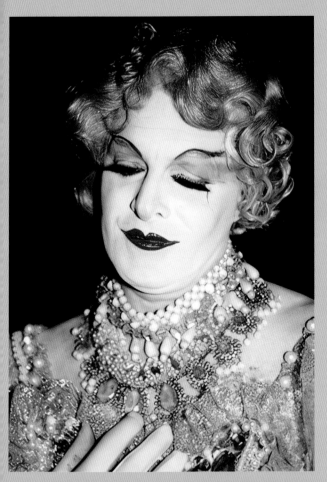

MADAME

◆ Susanne on Madame Ekathrina Sobechenskaya ◆

I first laid eyes on Madame at the corsetier Mr. Pearl's East Village basement studio, helping him bead corsets and stitching the night away. In those days we lovingly referred to Pearl's helpers as Stitch Bitches, and Madame was one of them.

I became a huge admirer of Madame's, who was an incredibly talented ballet dancer. He was a founder of the Trockadero Gloxinia Ballet, an all-male drag ballet troupe that parodied romantic and classical ballet, which was the inspiration for Les Ballets Trockadero de Monte Carlo, which still exists to this day. Madame worked my events around the world, so I got to witness his genius firsthand.

Unfortunately, he never really got the recognition he deserved. In a way, he was his own worst enemy, a dramatic character, very *Sunset Boulevard* "Mr. DeMille, I'm ready for my close-up!" He was a perfectionist, and that was evident in all he did, including creating the most stunning larger-than-life tutus, embellished with beads and sequins. Sadly, they don't make them like him anymore.

Copacabana, 1989, photo: Chantal Regnault

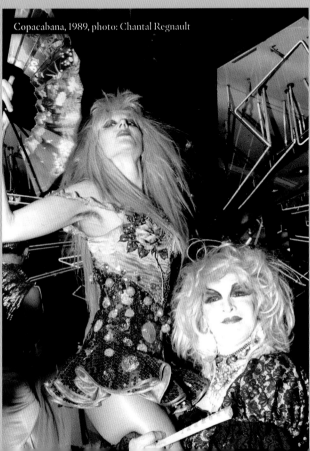

MILK

◆ SUSANNE ON MILK ◆

I met Milk many years ago at one of my On Top parties. I spotted him on the rooftop in the middle of a group of artsy queens. I remember his look was singular and more evolved than what I'd seen around, and it really excited me. It was art. I've been lucky to work with him ever since that night. Milk went on to become one of Ru Paul's *Drag Race* stars, but to this day he always makes time for me and my events. I still have his number saved in my phone as "Milk queens."

◆ MILK ON SUSANNE ◆

When I first met Susanne, I made eye contact with her gorgeous nipples and have never looked back!

Photo: Angel Añazco

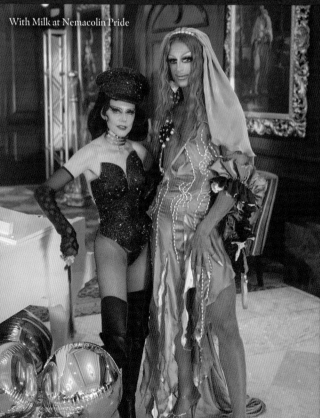

With Milk at Nemacolin Pride

SLOBODAN

❖ SUSANNE ON SLOBODAN ❖

Slobodan is an incredible friend and supporter who makes many things that I do possible.

I'm so grateful that he understands what I and my world are about. It was his generosity that helped the documentary about me come to life.... I always love seeing him on the dancefloor in his fab, unique looks! Love is the answer is our connection.

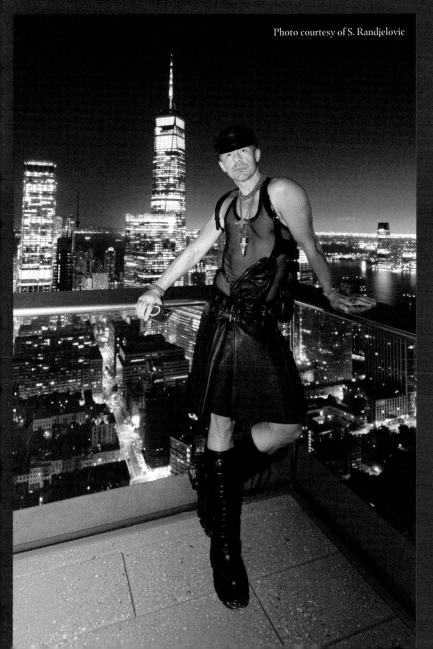

Photo courtesy of S. Randjelovic

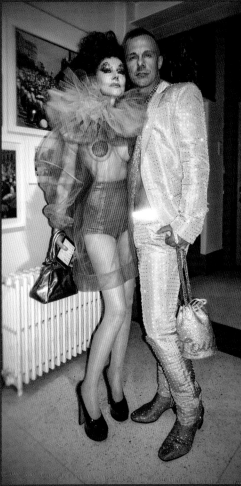

MUFFINHEAD

❖ SUSANNE ON MUFFIN ❖

Muffin is a visionary. What he does is far more than just drag. With remnants of Leigh Bowery, but in a totally different style, he is a man who uses his body as a canvas for his art. Muffin creates these brilliant installations for many of my events, and such incredible head-to-toe pieces that even I sometimes wear. Many of the people I work with, including myself, admire the mind that conjures up these creations. He also just had a baby, so congratulations, Muffin!

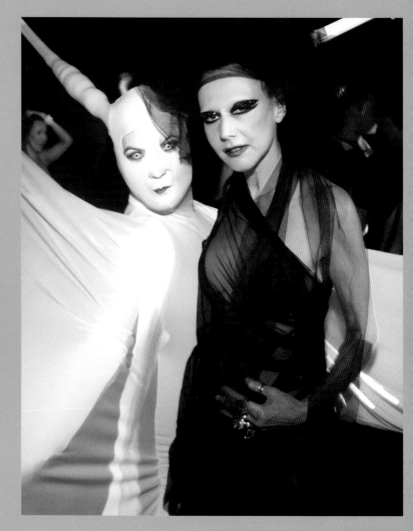

Photo: Roxanne Lowit

ONE-HALF NELSON

◆ Susanne on one-half Nelson ◆

With Nelson, it was love at first sight.

She came.

I saw.

She stayed.

We conquered.

Nelson is one of those people who can fit into any stiletto and work it any which way. What I mean is that there's no aspect of a project she can't handle and execute to perfection, and she's always so much fun to work with. We've been around the block and are still going. One of my wackiest memories is when Nelson disassembled an old laptop of mine to help me build a disco robot planet as part of my Bloomingdale's window installation, which reminds me, I have to find the name of that planet.

◆ one-half Nelson on Susanne ◆

Susanne and I first met when Desi Santiago introduced me and my group EnSubtitles to her, and she hired us to perform at her Bloody Mary event. Susanne had always seemed like a mythological creature floating throughout the night; a living masterpiece of fabric, feathers, and gems. There was instant synergy between us, and within a few months, I was working on countless projects and events with her both on stage and behind the scenes. During my fifteen years in NYC, Susanne became a mentor and a close friend. A part of my chosen family. I traveled the world with the Bartschland family producing events and performing. She pushed all of us creatively; nothing is ever crazy enough! It was reassurance that our existence was art and important. I like to think of Susanne as a composer of chaos, somehow taking the most motley crew of artists and personalities and weaving them into a circus of art and self-identity, all under the glow of the stars. Her events and parties create spaces where LGBTQ+ people can feel free to be themselves and celebrate their identities—a playground for self-expression and identity. Viva la Bartschland!

Photo: Ves Pitts

RICHIE RICH

I met Richie years ago when he was a club kid. I had him as my assistant for a while too. In addition to making him my office girl, he was my go-to, just like family is. He also traveled the world with me, helping to create many memorable moments. He even babysat Bailey—that's how much I trusted him. He's the reason Bailey hates black nail polish, but that's a story for a different time! Richie is as whimsical as he is talented. I'd often have him work my events in roller skates, including the time he skated down my wedding aisle as our ring bearer.

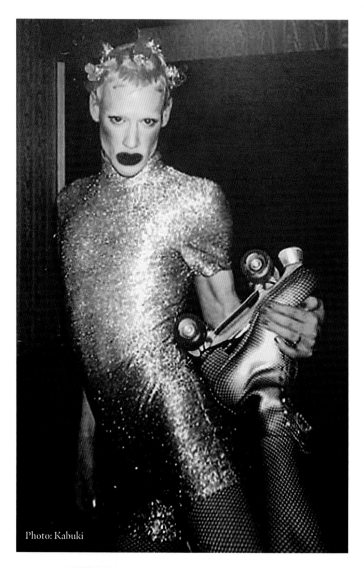

Photo: Kabuki

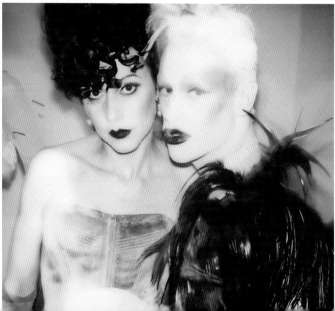

222

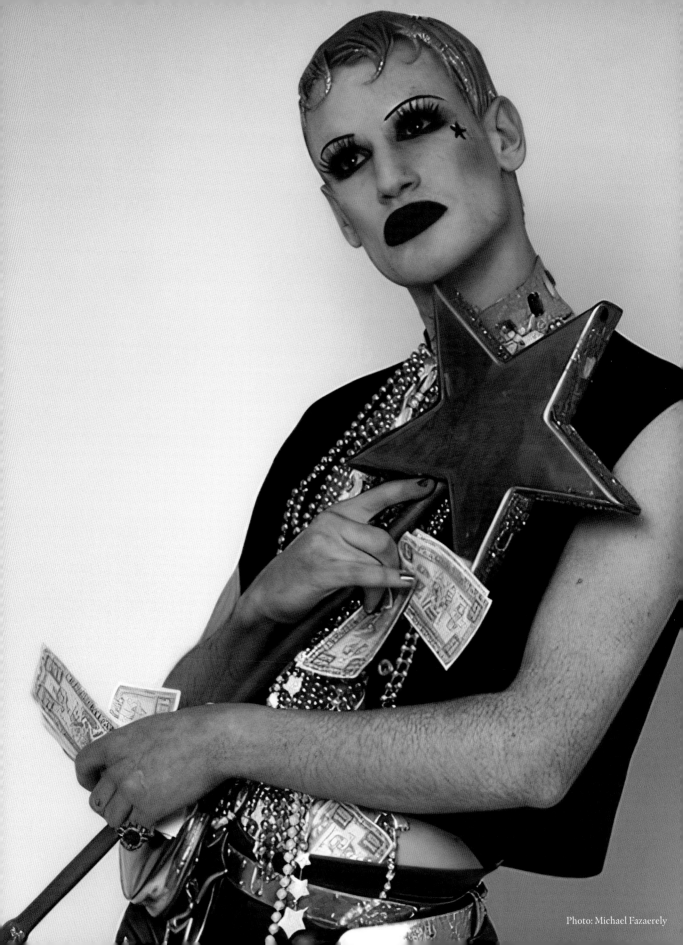

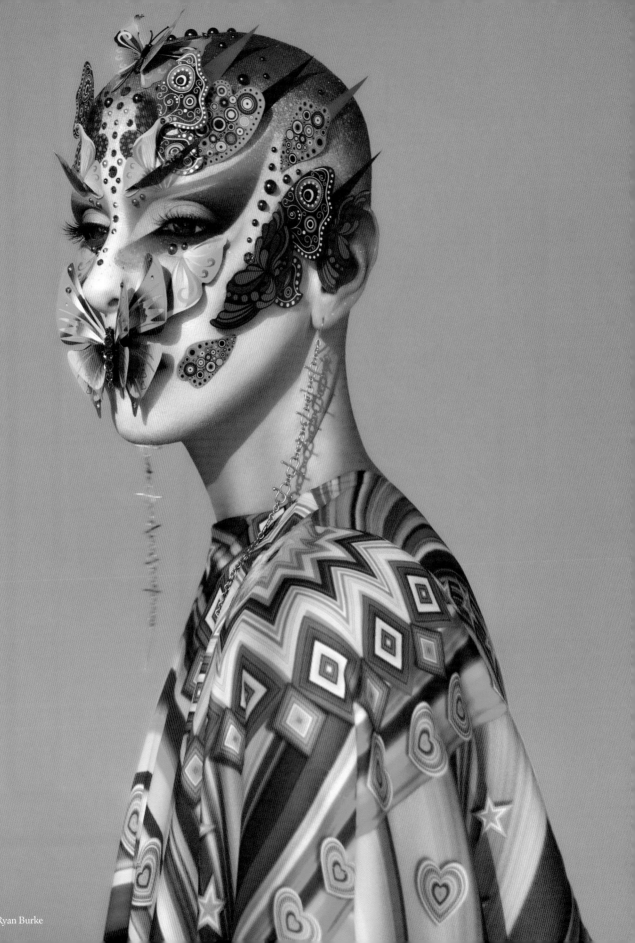

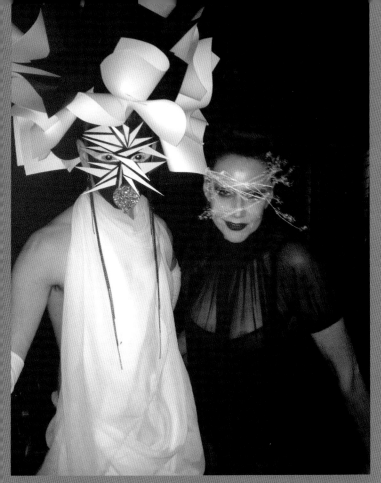

RYAN
BURKE

◆ SUSANNE ON RYAN BURKE ◆

What can I say? Look at this page; it says it all. Ryan is a walking piece of art. Ryan is a very special friend to me. He is one of those people, whether it's his own looks, or if he's doing my makeup, I know he will always deliver exactly what I hope for. It's always a treat when we get ready together, with him doing my makeup to go out on the town. I love and I'm always honored when Ryan is available to showcase his art and is part of my events.

◆ RYAN BURKE ON SUSANNE ◆

Susanne's impact on me is immeasurable. Despite having already realized that I was an artist, when I arrived in New York I was a bit directionless and unable to see my own potential. After meeting her, Susanne helped me establish a direction as an expressive person and inspired me to let my creativity flow freely amongst the dynamic nightlife community. She is a visionary, with both her character and style, who always encourages others with her boldness and creativity to express themselves authentically to the fullest degree. After years of working for her at her events, I came to help her create her own looks in makeup. I learned a lot through how she puts a look together. We also talked and bonded over relationships and career situations. She's become an invaluable family member and mentor to me over the years, and I consider her one of the keys to my becoming a respected artist both in New York and to myself. Bartsch constantly innovates and expands her sphere by embracing new talents, DJs, venues, and communities to keep things fresh and exciting. She has a passion for discovering and nurturing the new and extraordinary. New York and queer nightlife are so lucky to have her as she has been a huge supporter of the community and has helped create safe spaces for us to celebrate and thrive.

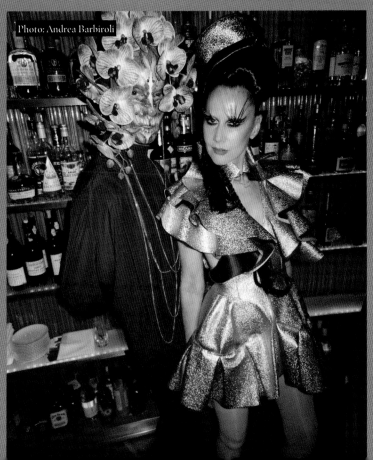

Photo: Andrea Barbiroli

SISTER DIMENSION

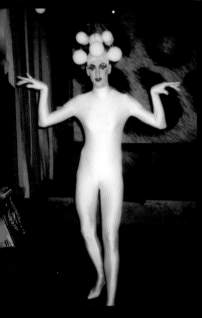

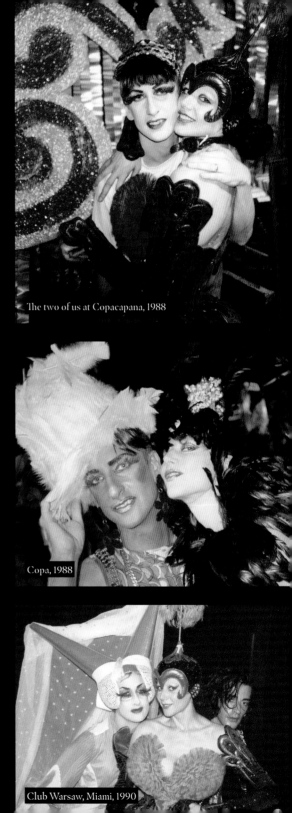

The two of us at Copacapana, 1988

Copa, 1988

Club Warsaw, Miami, 1990

❖ SUSANNE ON SISTER DIMENSION ❖

Sister Dimension is one of the founders of the infamous Pyramid Club where many of my early New York nightlife memories were formed. We became friends in the mid-'80s, and when I started my parties, I had Sister D DJ. I remember when my son, Bailey, came early before the nursery was ready. Sister D and Beverly, his then-wife, saved the day. They fixed the nursery up for us—they were pros since they already had a baby girl. Together we became parenting buddies and nightclub buddies alike. We went around the world together, places like Japan and all over Europe, where I'd have Sister DJ in these insane looks. Nowadays, Sister Dimension spends his days in the banking business. He'll call me from the office and say, "Don't worry, I'm wearing pantyhose under my suit." To this day Sister and Bev are like family to me, and our kids are still friends.

❖ SISTER DIMENSION ON SUSANNE ❖

Susanne, what was the name of the club in Paris for your party? Just before you and I traveled together to Berlin to meet Romy Haag and research East Berlin drag queens right after the fall of the Berlin Wall? I recall being ash gray from the full-body black greasepaint look I did to DJ your party the night before, and we had that *New York Times* reporter in tow.

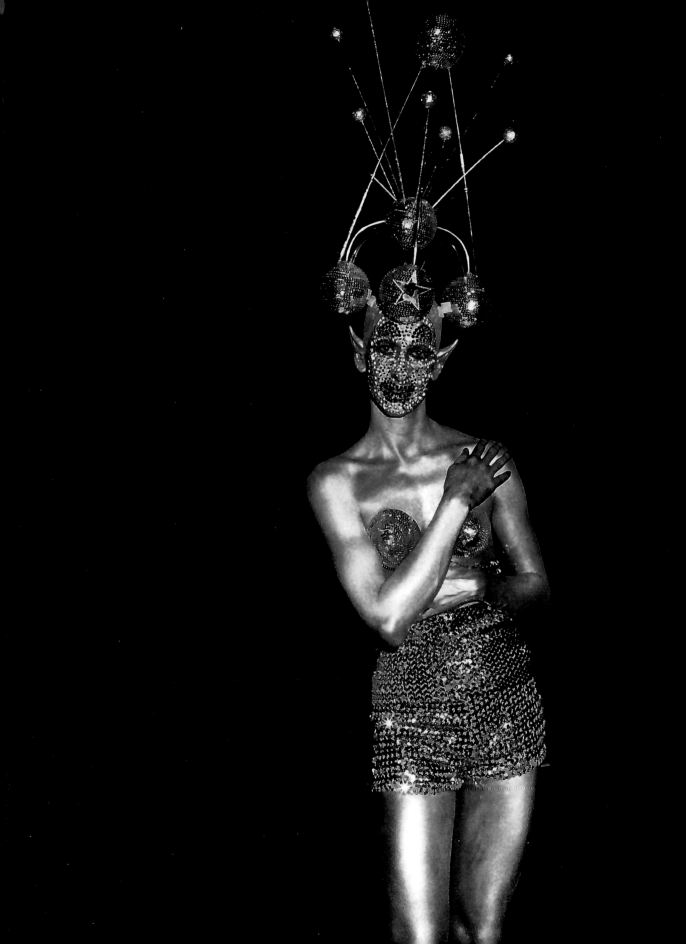

STEPHEN JONES

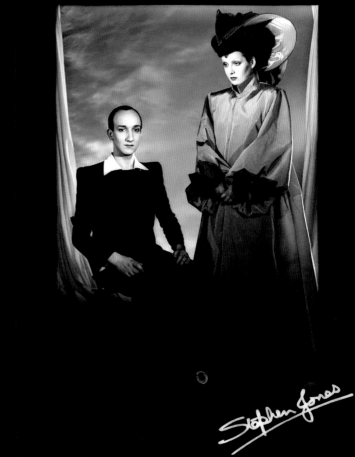

Photo: Peter Ashworth

Stephen Jones [signature]

◈ SUSANNE ON STEPHEN JONES ◈

Stephen Jones and I go back to my time in London, during the Blitz kid and new romantic era. An amazing, incredibly talented milliner and friend, he's who I blame for my hat obsession! Ever since I met him, I felt absolutely naked if I didn't have a Stephen Jones on my head. When I opened my store, it was a must to carry his hats, and I was proud to be able to include him in all my fashion shows and events. Stephen was and forever will be my hat bitch.

◈ STEPHEN JONES ON SUSANNE ◈

I first met Susanne in her tiny, tiny stall the size of a postage stamp in the Chelsea Antique Market in probably 1980. We became firm friends, and then she invited me to have hats in her seminal boutique on Thompson Street in SoHo. Susanne really made it happen for me in New York, and I will never forget the summer of 1982, which I spent with her. She even got me a money-making deal of designing sable coats for Feldman Furs to pay for the whole trip.

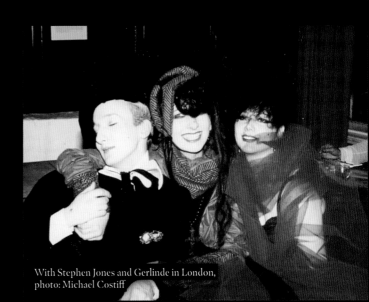

With Stephen Jones and Gerlinde in London, photo: Michael Costiff

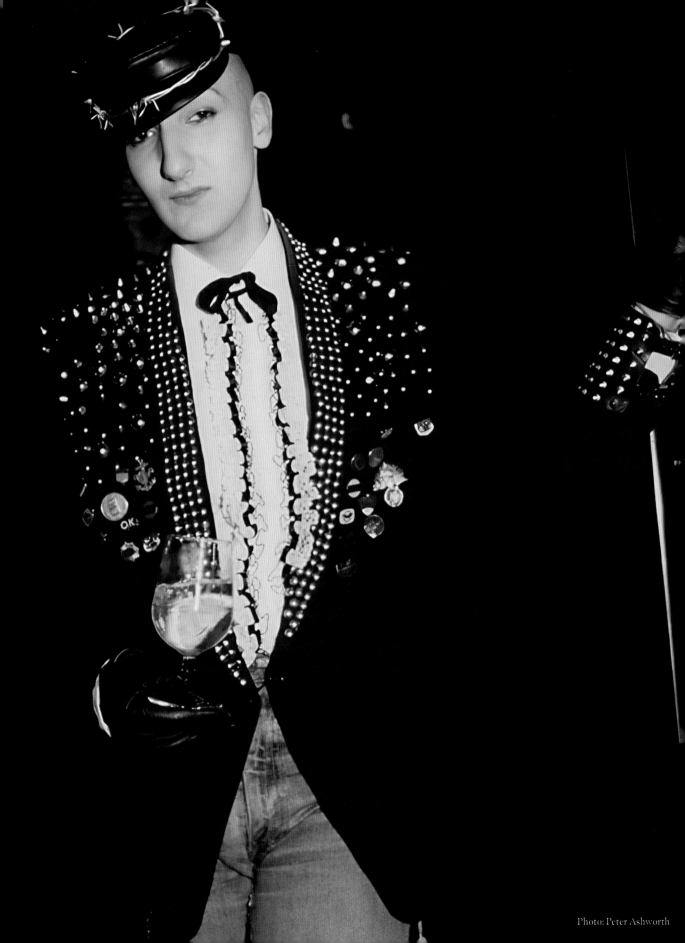

TY BASSETT

'y was such a great partner that I ended up marrying him, and for a time
ne was the man behind the woman. I was single and ready for something,
nd Gerlinda Costiff told me about this hot boy, I went to check him out,
t voilà. Clearly, Gerlinda knew me better than anyone. This was around
vhen I was starting my party life, so it was perfect timing. He enjoyed
loing all the behind-the-scenes stuff, which is everything I didn't want
o do. Ty and I got married in '88. He was a great love and a big part of
ny life—we had the best time. Ty was multitalented; he could build any-
hing from corsets to houses—both of which he did for me. His support no
loubt helped propel me to where I am today.

He recently passed away, and I miss him. He was truly loved by every-
one. He will forever be part of my life even if it's not on this planet.

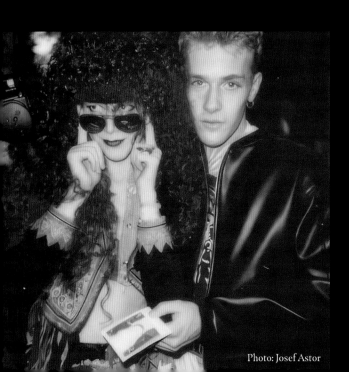

Photo: Josef Astor

Photo: Tina Paul

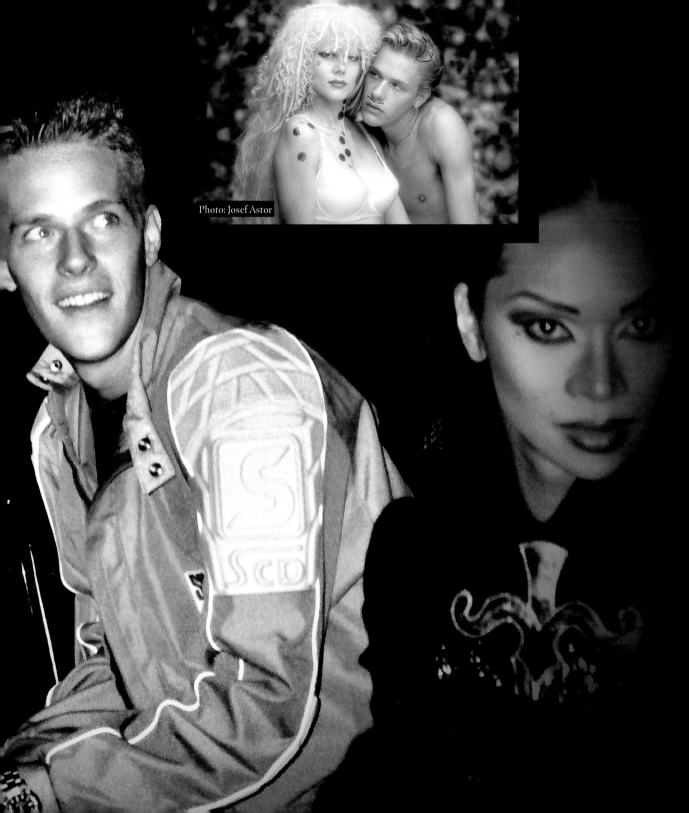

Photo: Josef Astor

ZALDY

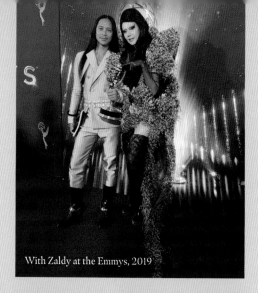

With Zaldy at the Emmys, 2019

◆ Susanne on Zaldy ◆

Zaldy is family to me. He has seen it all: the birth of my son, Bailey, my hook-ups, my break-ups. We've laughed and cried together and still do. He knows every inch of my body and mind, no fittings needed—ever.

He is single-handedly responsible for fostering the next steps with my looks and helped nurture what was my art all along. We lived in the Chelsea Hotel, four floors apart, and it was an incredible adventure and creative time for both of us. We collaborated on many levels, including Zaldy hosting all my events with me around the globe.

Zaldy's incredible talent earned him three Emmys, and Hollywood has definitely caught on to him. However, when the moment is called for, he always makes time for me. We have an incredible unspoken love.

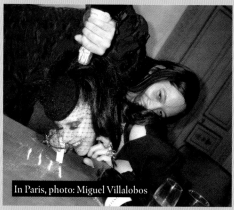

In Paris, photo: Miguel Villalobos

◆ Zaldy on Susanne ◆

Susanne opened the world of fashion to me. I traveled with my family a lot as a kid, but I had never experienced the world as a personality hosting parties in Paris, Italy, and Japan to name a few. And we did this together, with my extended family curated by Susanne—she has a way of putting people together. RuPaul, Amanda Lepore, and Joey Arias would all be on these international tours creating bonds that have only grown and endured since then. It was at one of our club dates in Japan, I think in Nagoya, backstage where RuPaul asked Mathu and I if we would work with her to create her look for an album deal she had, which would become the phenomenon of *Supermodel*. And I have been designing RupPauls looks ever since. Almost thirty years and three Emmys later, and *RuPaul's Drag Race* is still growing!

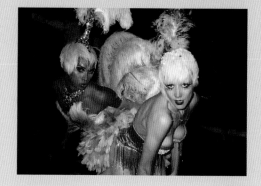

Custom-making clothes for Susanne is always an inspiration! I remember the first time I made her a bodysuit. I was still going to school at FIT and never learned swimwear or lingerie. I made the crotch really narrow, like under an inch wide to fit the dress form, and in our fitting she said in her distinctive Bartsch accent, "The pussy is wider. You have to make room for that pussy." As glamorous as Susanne is, she has a kind of punk attitude that is so special! She is the embodiment of a true Virgo—details, details, details! Her fingers never stop playing, or tidying, which taught me to look closely at the fine details and how to consider refining them.

Us in the '90s

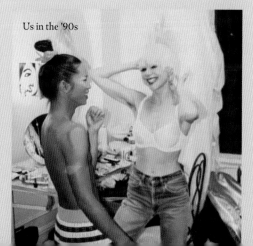

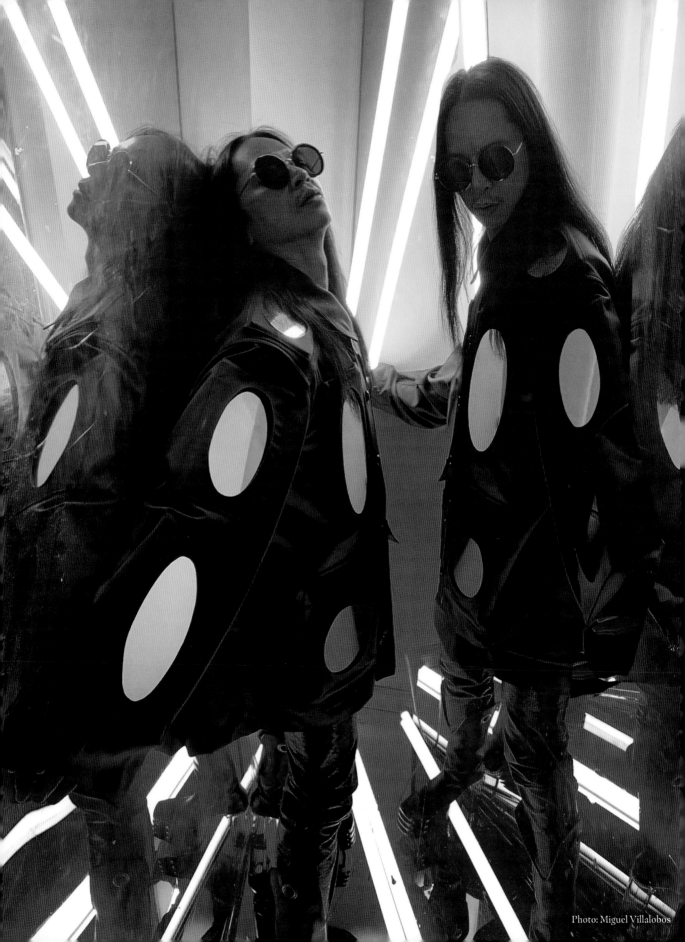

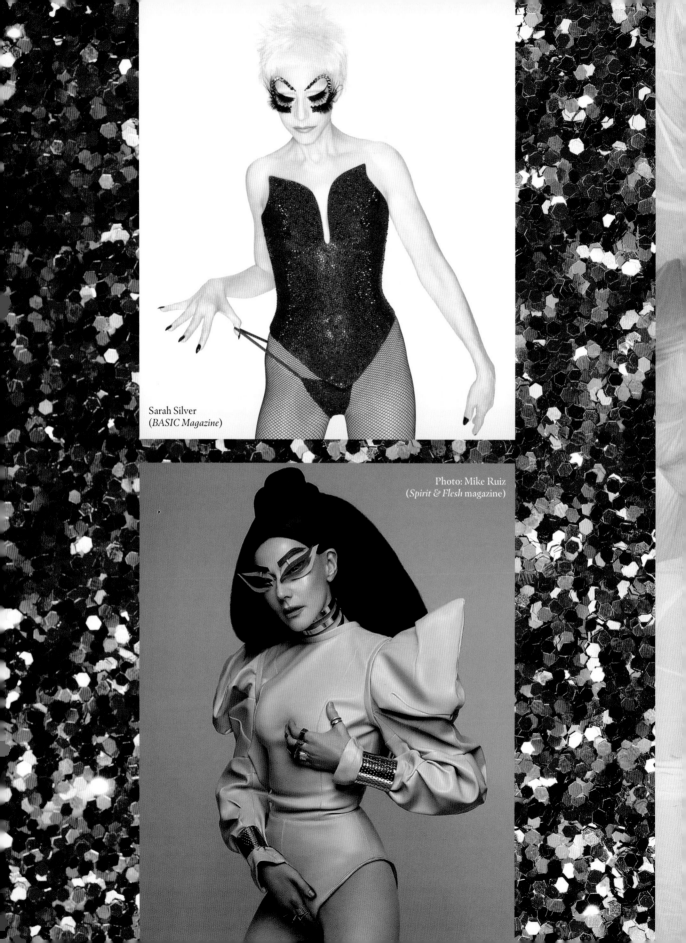

Sarah Silver
(*BASIC Magazine*)

Photo: Mike Ruiz
(*Spirit & Flesh* magazine)

STRIKE A POSE WITH FASHION FRIENDS

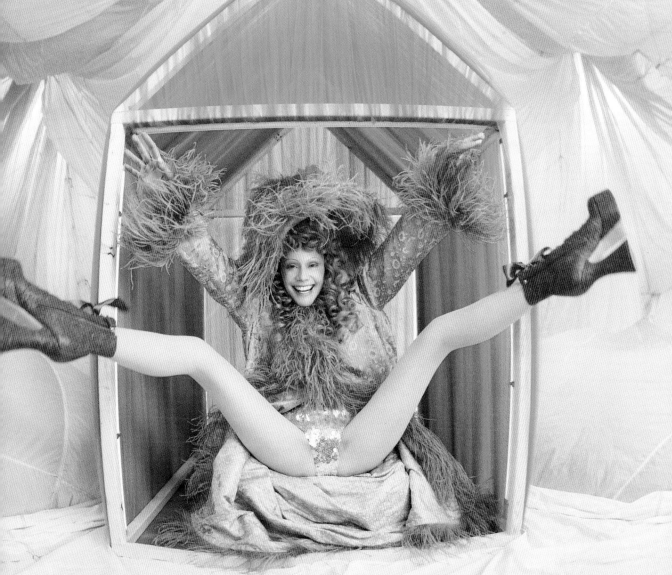

For me, looks have always been about self-expression.
It's like creating living art, which I find incredibly inspiring.

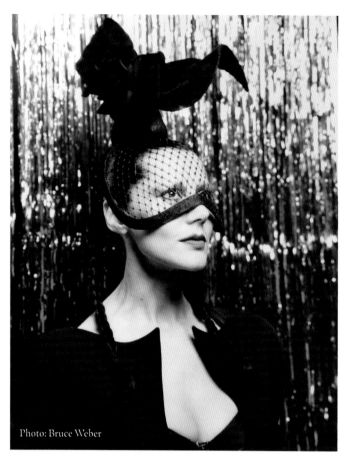

Photo: Bruce Weber

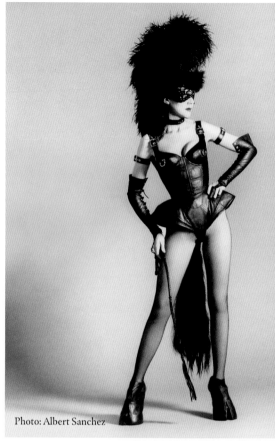

Photo: Albert Sanchez

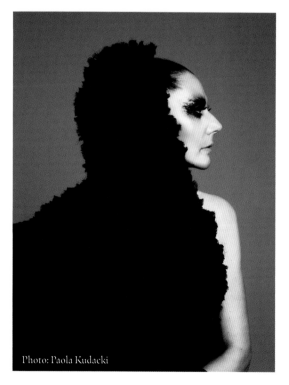

Photo: Paola Kudacki

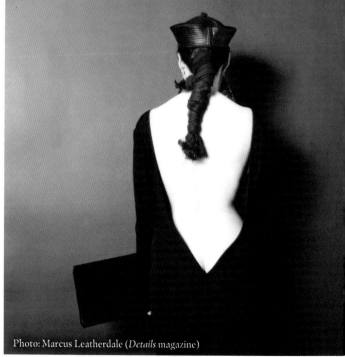

Photo: Marcus Leatherdale (*Details* magazine)

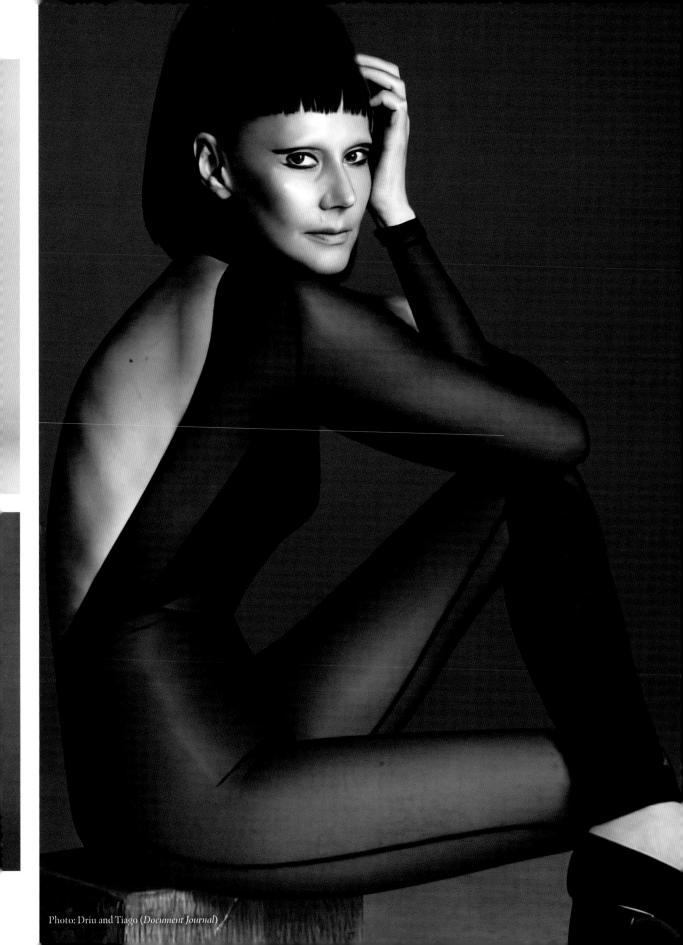

Photo: Driu and Tiago (*Document Journal*)

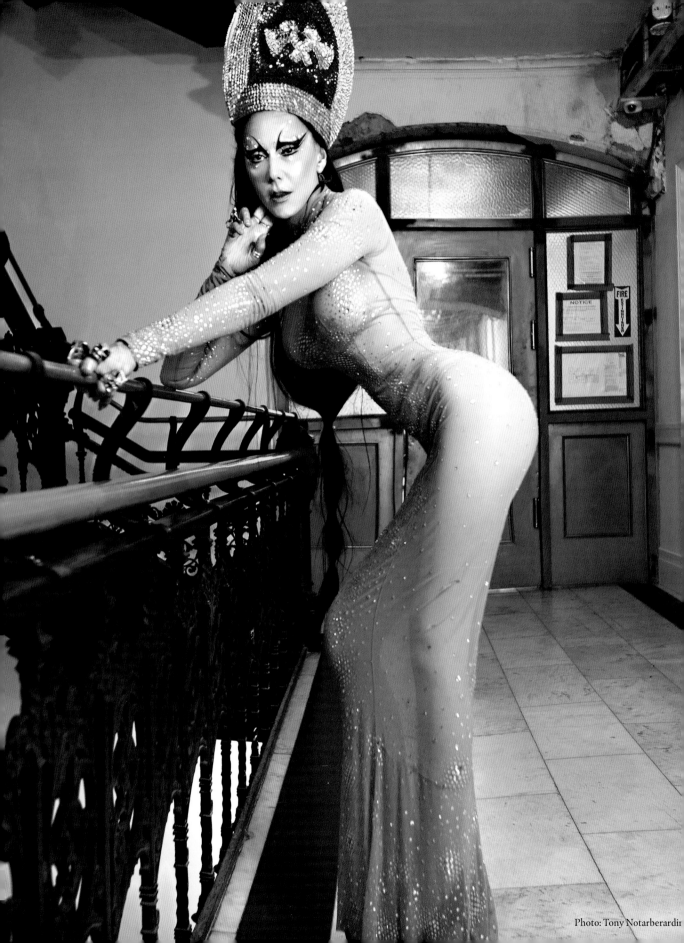

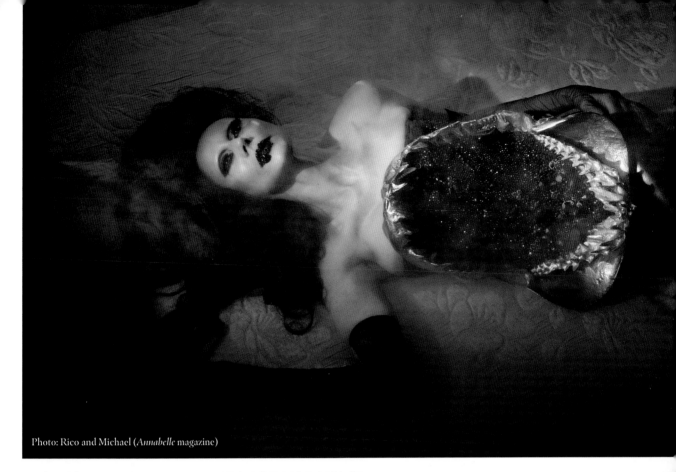

Photo: Rico and Michael (*Annabelle* magazine)

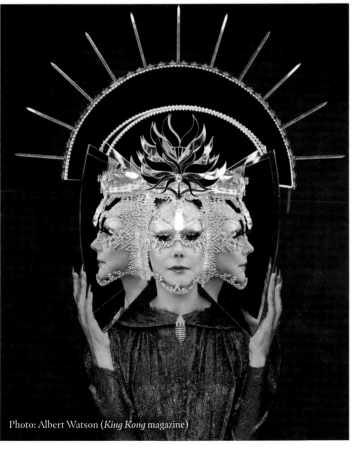

Photo: Albert Watson (*King Kong* magazine)

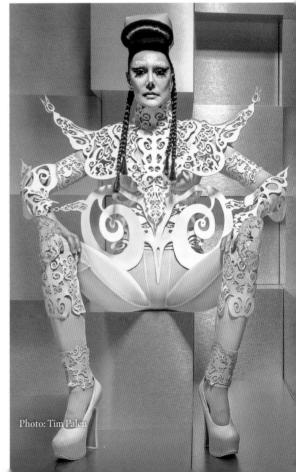

Photo: Tim Palen

Christy Turlington, Cindy Crawford

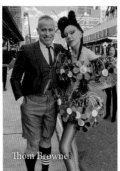

Thom Browne

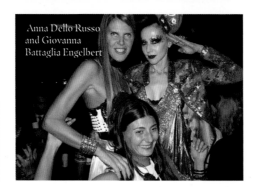

Anna Dello Russo and Giovanna Battaglia Engelbert

Bcalla
Photo: Michael Burk

Casey Cadwallader of Mugler

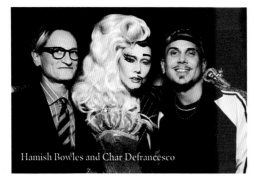

Hamish Bowles and Char Defrancesco

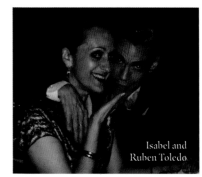

Isabel and Ruben Toledo

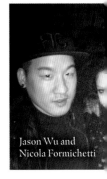

Jason Wu and Nicola Formichetti

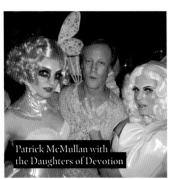

Patrick McMullan with the Daughters of Devotion

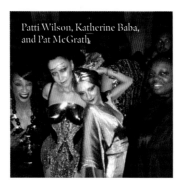

Patti Wilson, Katherine Baba, and Pat McGrath

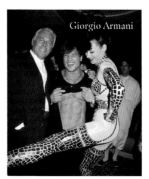

Giorgio Armani

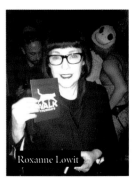

Roxanne Lowit

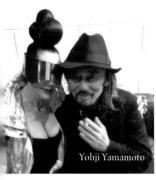

Yohji Yamamoto

François Nars

Betsey Johnson

Michele Lamy and Rick Owens
Photo: Andrea Barbiroli

Valerie Steele and Bill Cunningham

Viktor and Rolf

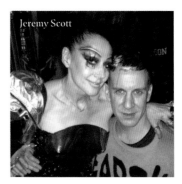

Jeremy Scott

Sushi and Patricia Field

Brooke Candy, Calvin Klein, and Donna Karan

Willie Chavarria
Photo: Jeiroh

Shayne Oliver/HBA

In the amazing company of Genius

Demna and Loïk Gomez/BFRND

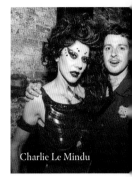
Charlie Le Mindu

Kim Hastreiter and Isabel Toledo

David LaChapelle
Photo: Jeff Eason

Marco Ovando

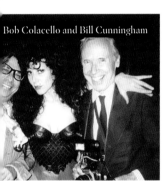
Bob Colacello and Bill Cunningham

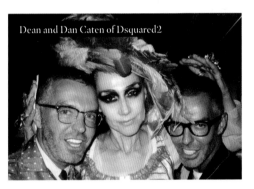
Dean and Dan Caten of Dsquared2

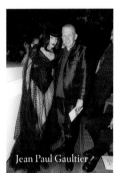
Jean Paul Gaultier

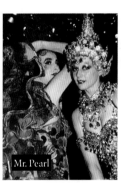
Mr. Pearl

Riccardo Tisci
Photo: Andrea Barbiroli

Ellen von Unwerth

Steven Klein

Steven Meisel and Billy Norwich

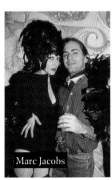
Marc Jacobs

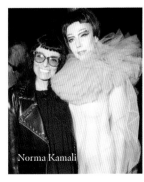
Norma Kamali

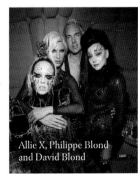
Allie X, Philippe Blond and David Blond

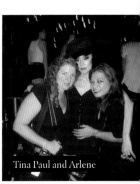
Tina Paul and Arlene

PARTY MIX

One of my greatest passions is creating events where people from all walks of life, who wouldn't necessarily cross paths otherwise, come together. I love mixing uptown and downtown, gay and straight, chic and street in a space that has energy, imagination, and most of all, love. Seeing people being free, flirting, and enjoying themselves is just as much a high for me as it is for everyone there.

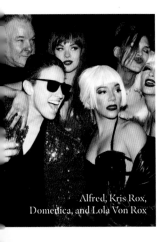

Alfred, Kris Rox, Domenica, and Lola Von Rox

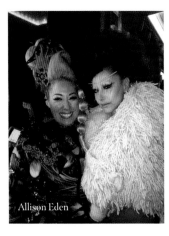

Allison Eden

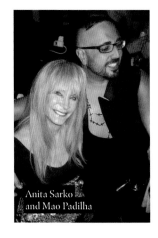

Anita Sarko and Mao Padilha

Ansoni

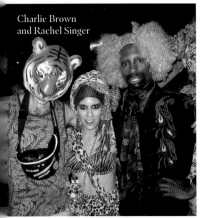

Charlie Brown and Rachel Singer

Derek Essegian, Kareem Rashed, and Markus Kelle

Dick Walsh and Cleo

Gigi Gorgeous

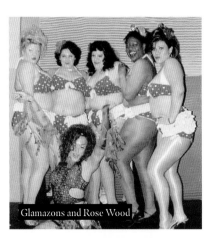

Glamazons and Rose Wood

Giuseppe Delpiano and Ansoni

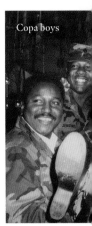

Copa boys

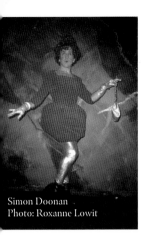

Simon Doonan
Photo: Roxanne Lowit

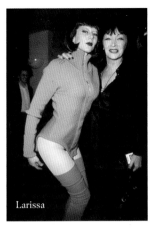

Larissa

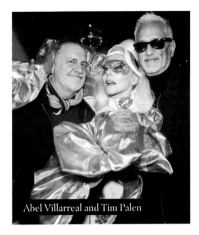

Abel Villarreal and Tim Palen

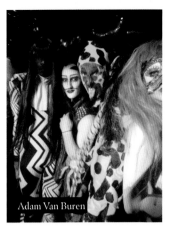

Adam Van Buren

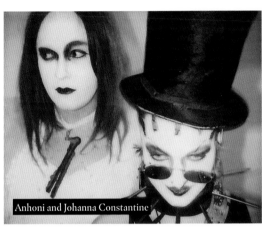

Anhoni and Johanna Constantine

Botanicult partygoers

Cesar Hawas

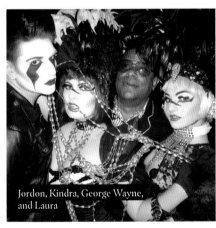

Jordon, Kindra, George Wayne, and Laura

Gogo boy and Gerlinde Costiff

Dupont twins

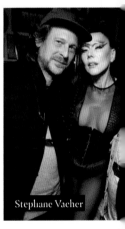

Stephane Vacher

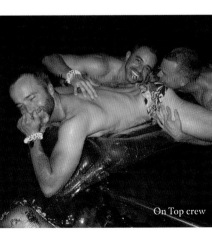

On Top crew

Adam Lambert and DJ Griffin Maxwell Brooks

Frankie Grande and Hale Leon

Hana Quist, Viviana Evans, Daniella DeLuna

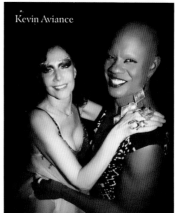
Kevin Aviance

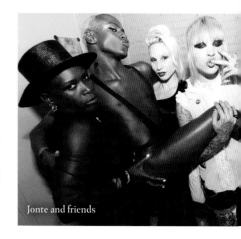
Jonte and friends

Marzia and friend

Michou, Freddie Lieba

Mickey Boardman

Nicky Doll and friend

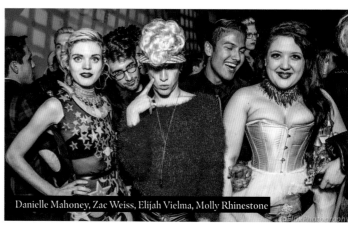
Danielle Mahoney, Zac Weiss, Elijah Vielma, Molly Rhinestone

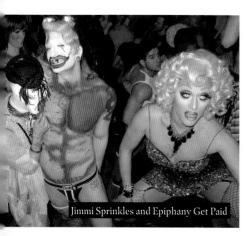
Jimmi Sprinkles and Epiphany Get Paid

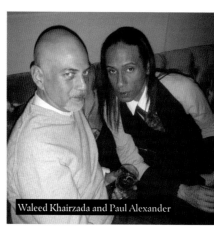
Waleed Khairzada and Paul Alexander

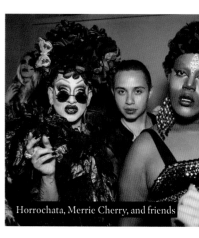
Horrochata, Merrie Cherry, and friends

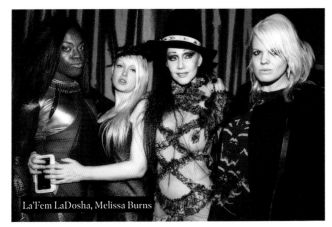

La'Fem LaDosha, Melissa Burns

Roger Padilha

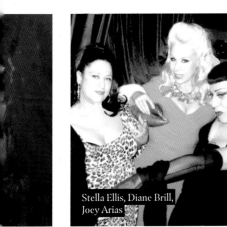

Stella Ellis, Diane Brill, Joey Arias

Gerard Garvey

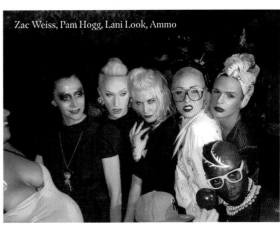

Zac Weiss, Pam Hogg, Lani Look, Ammo

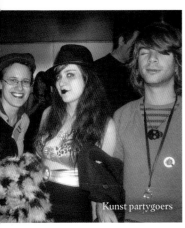

Kunst partygoers

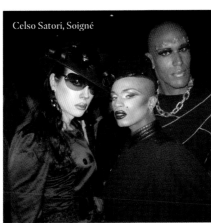

Celso Satori, Soigné

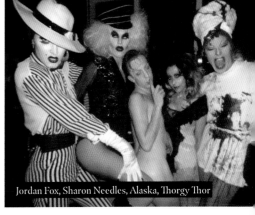

Jordan Fox, Sharon Needles, Alaska, Thorgy Thor

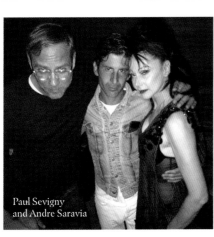

Paul Sevigny and Andre Saravia

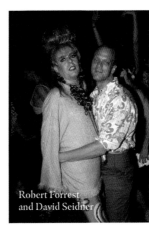

Robert Forrest and David Seidner

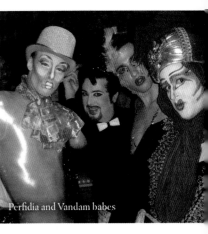

Perfidia and Vandam babes

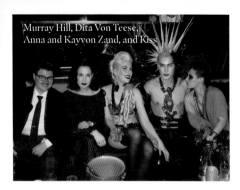
Murray Hill, Dita Von Teese, Anna and Kayvon Zand, and Kiss

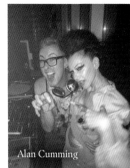
Alan Cumming

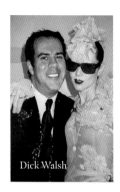
Dick Walsh

André Balazs

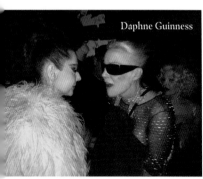
Daphne Guinness

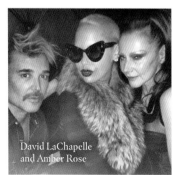
David LaChapelle and Amber Rose

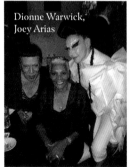
Dionne Warwick, Joey Arias

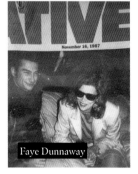
ATIVE
November 16, 1987
Faye Dunnaway

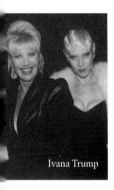
Ivana Trump

Cindy Crawford

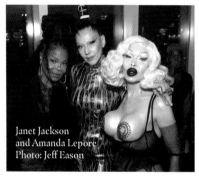
Janet Jackson and Amanda Lepore
Photo: Jeff Eason

Johnny Dynell, Michael Musto, Flotilla DeBarge, and Mickey Boardman

Kim Petras

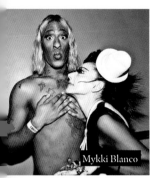
Mykki Blanco

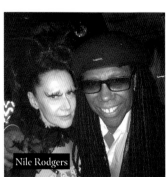
Nile Rodgers

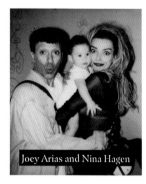
Joey Arias and Nina Hagen

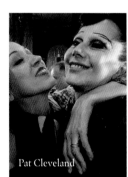
Pat Cleveland

Paris Hilto

Alexandria Ocasio-Cortez

Cher and Erickatoure

Sandra Bernhard

Ian Schrager

Anna Piaggi and Vern Lambert

August Getty

Bette Midler, Char Defrancesco, Marc Jacobs, Sophie Von Haselberg

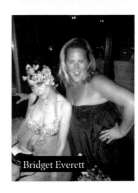
Bridget Everett

Cindy Sherman

Clermont twins

Christy Turlington

Jack Nicholson

Ingrid Sischy and Sandy Brandt

Rob Moritz

Lady Bunny

Maripol and Edwige Belmore

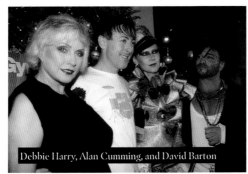
Debbie Harry, Alan Cumming, and David Barton

Nicky Doll and TS Madison

Paul Sevigny

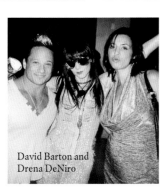
David Barton and Drena DeNiro

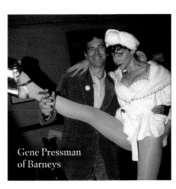
Gene Pressman of Barneys

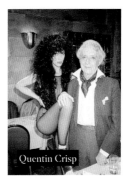
Quentin Crisp

Rufus Wainwright

Ivan Bart and George Wayne

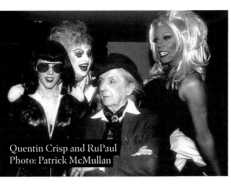
Quentin Crisp and RuPaul
Photo: Patrick McMullan

Georgia May Jagger and James Goldstein

Michael Costiff

Amber Valentine

Mark Ronson

Severino of Horse Meat Disco

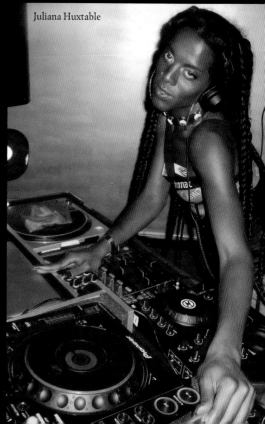

Juliana Huxtable

DJS • DJS • DJS • DJS • DJS • DJS • DJS • D

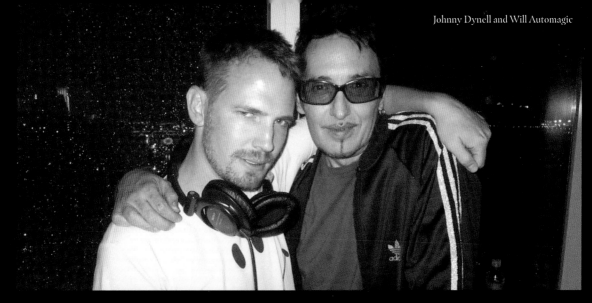
Johnny Dynell and Will Automagic

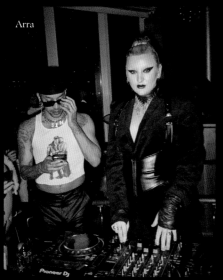
Arra

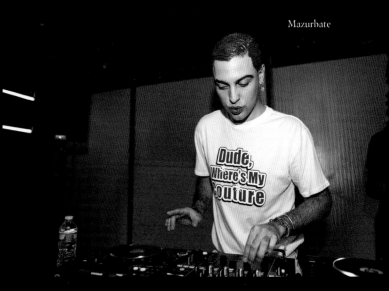
Mazurbate

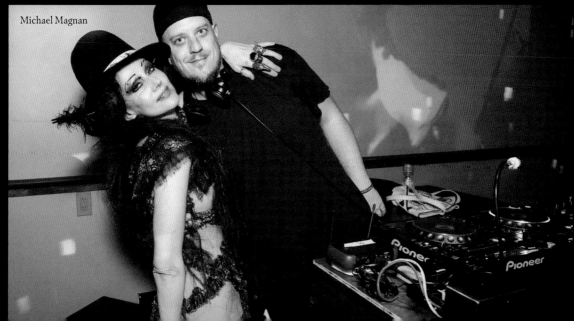
Michael Magnan

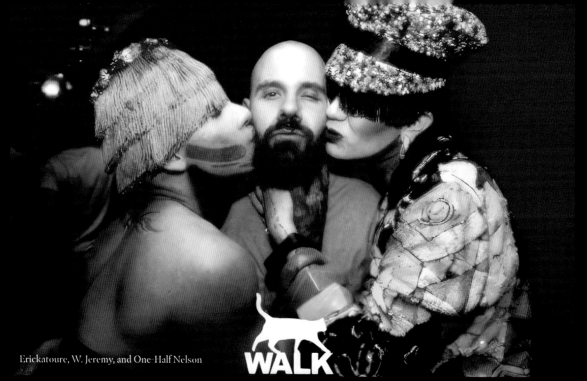

Erickatoure, W. Jeremy, and One-Half Nelson

WALK

Tom Peters,
Photo: Andrea Barbiroli

MONSIEURBOY

DJ O-H

Tommie Sunshine

David Guetta

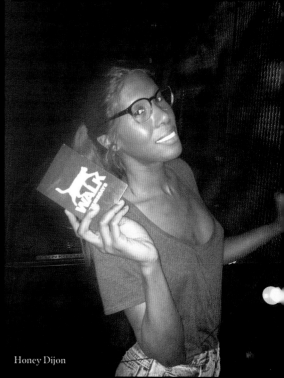

Honey Dijon

Fecal Matter

DJ Boyyyish and PAT

Blue Rose, Griffin Maxwell Brooke, DJ Boyyyish

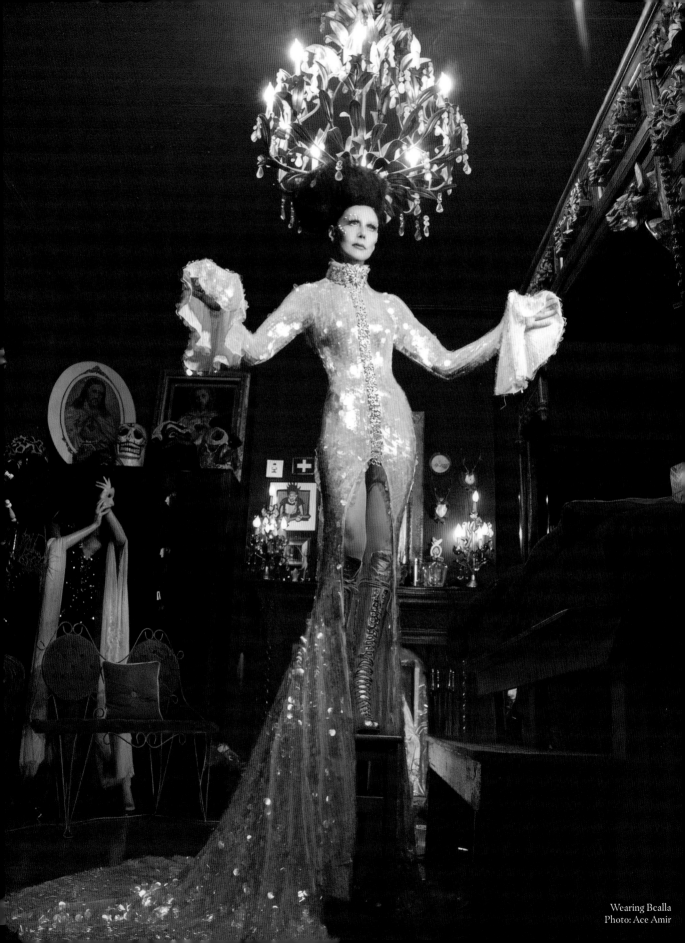

INTERVIEW

Photo: Driu and Tiago

Kareem Rashed: What you do encompasses so many different things—it's events, it's products, it's entertainment, it's your own looks. When a new project comes along, what makes you think, "Okay, this is something that's right for me"?

Susanne Bartsch: I get an instinct. Basically, if it's something that I feel is creative. Creativity is very important to me. Creativity, to me, it's like God. You have an idea, you have something inside you, and you make it happen. And then as it happens, people come to see it, or people get inspired by it. They get joy out of it. They see something that you created, and it sparks a response. Whether that response is good or bad doesn't really matter—it's just important to create. When a project is brought to me, I'm attracted when I feel like I'll be able to create something new, something that I can put my twist on.

KR: What is that thought process like? For instance, how do you go from seeing a raw space to saying, "I'm going to do a cabaret show here," or "I'm going to do an art installation here"?

SB: I think about the energy—how it feels—a lot, like "Oh, you can flirt here," or "This feels cold." Most things I do are to bring people together, which is one of my callings. I unite people. So how the space works with people inside of it is very important, because, at the end of the day, you can create until the cows come home, but it's about the people coming and being able to experience whatever I've created. I like when there is a way to be interactive, which has always been my thing: bringing different cultures together, such as the house ball scene, the drag scene, the trans scene, art, fashion, uptown, downtown.

KR: And you manage to do that in new ways with every event you produce. How do those ideas take shape?

SB: I went to see a space yesterday, and before you enter the dancefloor, there's this cool little lounge. When I walked into that lounge, I saw six blonde look-alike girls, naked with big cigarette holders—like 1920s meets now meets 2050. I don't know where it came from. They didn't even have any furniture in there yet. It had these high ceilings, and the walls were lacquered this dusty oxblood color, and I just thought: "This is what I would do here."

I don't really plan. Somebody said to me recently, which I never really realized, "I didn't understand how you worked, but I suddenly realize you

see the whole thing before it happens." And it's true. I'm not a visionary; I don't know what's going to happen in your life. But I see how a room, a look, an event will come together. Sometimes it can be a little bit hard because people don't know what I have in my head and might not understand when I explain it, but that's fine. Now, I wouldn't have thought of these six girls in that room if I didn't see the room. If someone said, "There's a lounge," it wouldn't have come to me. It's almost like I meet the walls and the walls tell me something.

KR: Your events, and your fashion, take on a lot of different appearances. What would you say are some constants in your style?

SB: I like quantity of one thing. One of my favorite inspirations is Carnival in Rio, because there are thousands and thousands of turquoise feathers. Each school has feathers, as far you can see, in the same color. Turquoise and yellow might be the colors of one school, so they're all in the same color scheme. And when you're in the bleachers, you see them approach from miles away, all these feathers of the same colors. That's very me. Like at the Delano [Hotel in Miami, New Year's Eve, 1999] they have twelve trees, like an orchard, and I decorated them all with those thick silver Mylar streamers—the whole tree, it looked surreal. It was a simple thing, just Mylar streamers, but the quantity of it just blew you away.

KR: I feel like that's kind of a Susanne Bartsch signature: turning up the volume to a hundred on something—taking it to an extreme or contrasting it with another extreme.

SB: Absolutely, and also, you know, to give it that chicness. Cheesy in my eyes is not cheesy in someone else's eyes, but even the people that like cheesy, when they see a version of the same thing but à la me—you know, well done—they will react to it. They will know the difference, even if they won't necessarily go, "This is a better version of that cheesy thing." I'm very much not into the norm; I'm into things that we all know but done in a way that we haven't seen before. Like, if I have a burlesque performer, it's never about sex. I don't want a performer that just strips and has a fabulous body. I want a performer that does something you don't expect, like painting with his penis or making peanut butter sandwiches while spread eagle. It's about making people see things with new eyes. It's like with Joey Arias—he had his show and I told him to put on a dress and become Billie Holiday, and his performance went to a totally new level. There's a million burlesque shows. Why is mine popu-

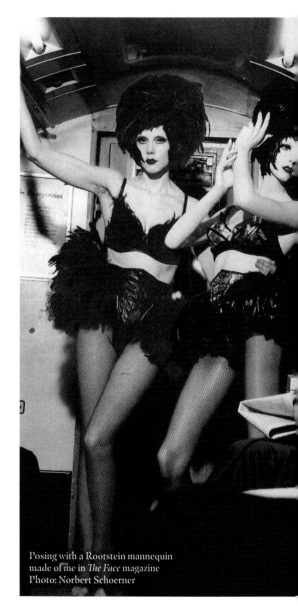

Posing with a Rootstein mannequin made of me in *The Face* magazine
Photo: Norbert Schoerner

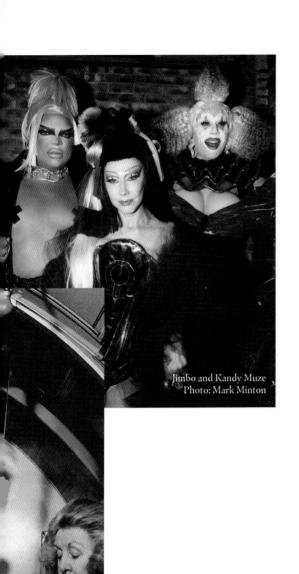

Jimbo and Kandy Muze
Photo: Mark Minton

lar? Because you have burlesque performers doing more than what the audience expects them to do.

KR: So much of what you do is about aesthetics. Do you think there is such a thing as good taste or bad taste?

SB: There is and there isn't. When I do a look, it won't be tacky. If it was, I wouldn't feel good in it. But sometimes you see someone in an overdone, tacky look, and it's so bad that it's good. It's a lot about pulling it off. Energy is the most powerful thing each one of us has in our lives. Thinking can fuck it all up or make it all good—the thinking is the key. Just generally in life, if you have good energy, you feel good. I definitely have energy. I can give energy and make people feel really good; I know that. Somebody said that to me when I was like sixteen: I have charisma; I can walk into a room and make everybody feel really special and important. But I can also walk into a room and not do anything. They won't feel bad, but I won't get any positivity back. I don't think I'm an exception in that; I'm definitely very aware of it, though. It's a superpower.

I want to give people that energy, and the look is what helps me amplify that. If I walk into a party dressed like I am now, I would *not* be feeling it. The looks and creating environments for my events, really everything that I do, wakes up that energy and enables me to give more of it. Dressing up and expressing myself with looks is actually a tool for me to go and do what I enjoy most: make people feel good. When I see people feel good, I feel good myself. So, it actually, selfishly, serves me. I mean, I'll never forget when I did my first show at the Roxy, New London in New York [1983]. It was the first fashion show I ever did, the first event I ever did, period. I arrived and there was a line of people waiting to get in that went around the block twice. Feeling that excitement of people showing up to experience something I'd created was just so amazing. It's such a high. You have an idea, you're excited about that idea, then it grows within, and you make the idea come to life, and *then* other people are excited about it. That is such a gift.

KR: A lot of what you do is out of your control, in a way. You're not the one playing the music, you're not the one performing in the show—you put all of these pieces together. How do you leave room for the unexpected in that?

SB: The unexpected is part of the charm. I like the unexpected. That's why I don't like to do rehearsals, because I don't want it to be perfect. If some-

one comes out at the wrong time, it's okay. Speaking of New London in New York, everything went wrong: We had the music blasting and there was just a curtain dividing the audience and backstage, so there was no sound barrier, and, in the back, nobody could hear anything. I'd be screaming "Leigh Bowery! Leigh Bowery!" and BodyMap went on stage. It was a mess. But, the success of that show and the big hype was the chaos. Nobody knew the chaos was not planned. They thought it was *it*, like a totally modern kind of fashion show, because they were used to the very proper, Calvin Klein type of shows.

When things go wrong, I like to work with that. Like, I fell down in the Mugler show because he gave me shoes like ice skates. I was wobbling around and, of course, the minute I went out, I fell flat on the runway, wig flying. What do I do? I crawled down the runway, and I lifted up my legs, and had fun with it. It was the only thing to do.

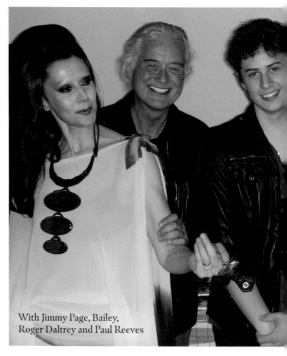

With Jimmy Page, Bailey,
Roger Daltrey and Paul Reeves

KR: On the topic of New London in New York [1983], doing that fashion show and the London Goes to Tokyo show [1984], you were giving a platform to these young designers . . . that's not such a common thing for a small boutique to do.

SB: Well, I'll be honest. This is what happened: Like usual, I decided to open the store without really planning. . . . I'd moved to New York and there was no one doing looks like we'd been doing in London, so I decided to import what I missed. That was in June, I think. I found a space in SoHo, and then, in August or early September, John Duka from the *New York Times* came before I'd even opened, and I showed him some samples. And I'm like, "It's all young English designers. Some of them haven't got a business. They're still working behind the scenes in design houses, or this one is in college. BodyMap's still in school." And he said, "This is amazing. This is street fashion." That term came from John Duka. Then the night before I opened, I had a whole page in the *New York Times*, and the *Times* style section never did a page on one person.

So, it became a big success. Donna Karan and Norma Kamali, they all came shopping there, and English fashion really became a thing. Everybody from Saks to Charivari, Bergdorf, Barneys, Bloomingdale's, Ultimo in Chicago, Maxfield in LA—they were all going crazy for it and were all going to London. I was worried I couldn't compete with these big stores, so I decided to sign [the designers] all up. I didn't know how to do it, technically or financially, but I went to London and saw eighteen designers, including Leigh, Galliano, Stephen Jones, Judy Blame. And I said, "I'm going to do a show in New York. I'm going to represent you. I'm

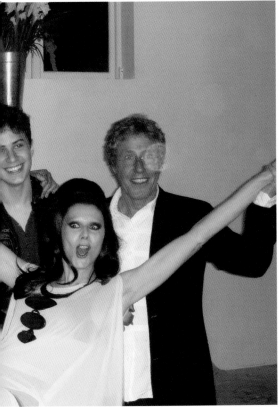

going to have a showroom. You're coming over; you can show whatever you want. You have three minutes on stage." And they all came. It wasn't so much that I wanted to showcase my designers. It was "How do I survive this huge buzz I've created without even planning?" And then I got involved with everybody's business.

Women's Wear Daily in Japan heard about it and said, "We want to work with you," and we ended up in Tokyo doing a three-day show. The English ambassador and the Japanese prime minister came, then Leigh Bowery came out pant-less with Trojan and Rachel [Auburn], all in aprons: butts hanging out, bending over, balls dangling. Oh my God—*scandalous*. So, the reason I did those shows was to protect my brand. But, I didn't plan any of it. Like with everything I do, it was all very organic.

KR: Even if it wasn't your initial intention, you wound up giving a platform to so many talents that, otherwise, didn't have much representation. I see that as a kind of theme throughout your career.

SB: I think it's the same with everything I do: the people are what motivates me. And that's why I like to give platforms to all these different people and embrace what is going on, culturally. I'm definitely a pioneer. I finally admit that. I mean, I'm a forerunner for so many things. *RuPaul's Drag Race*, even. When I started out, drag was not well regarded. I put it into a different context and, through events like the Love Ball, I helped it become part of the mainstream. I set the stage for it, and Ru took it and made it happen. Like with the Love Ball, the house scene was kind of isolated and had been devastated by AIDS. I'd been up to Harlem to see them, and they were incredible, and with Love Ball, I put them on the map while also getting people to do something about the AIDS crisis. In those early days, it was just pain and loss, no one was doing anything to give people hope. I'm not saying I discovered voguing or was the first person to raise money for AIDS, but you know what I mean? There are so many cultural things that I set in motion. Trans people . . . even at my store in the '80s, I hired a Black trans salesgirl.

KR: So many young people today are doing amazing looks, but it's something that they do for Instagram or TikTok; it doesn't leave their house. There's nothing wrong with it—

SB: No, there's not.

KR: But I was wondering how the physical experience of being out and interacting with people, how is that important to your looks and what you create?

SB: Well, this is a really interesting question, because not so long ago, I think my answer would be different. The Internet, Instagram, and TikTok are really important. I never thought I would say that. There's good and a lot of bad. But the good is that it gives a lot of people exposure. Before, if a company wanted talent like they'd seen at one of my events, they would have to call me and say, "Where would I find a so-and-so?" Or they would have to go to an agent; they would have to work for it. Now, all they have to do is go on my Instagram and see what's up. They call people I work with and say, "Hey, would you like to do . . ." And I'm very happy for them. One girl was just telling me that she's gotten so many jobs because of me, because I'm tagging her, for example. There are opportunities for people now, which is fantastic.

In the '80s and '90s, designers would come to my events to see what's going on. You would see Gaultier and Mugler and Galliano and Margiela. You'd see these designers looking and getting inspired. Today, you don't have to do that. You've got Instagram. But these kids who are doing these looks on Instagram . . . I am able to give them a real-world platform, a space where they feel safe and they can come and do a look, do whatever they were doing on Instagram in real life. And that is priceless, because on Instagram, there's no emotion. Real human interaction to me is now more important than ever: real people, real contact, seeing people's eyes and their energy, feeling each other. I really do think that is essential at this moment, because it has become so much about "How does this look on the internet? How does my Instagram look?" It's devastating.

KR: For you, personally, is there a difference between what you create for Instagram versus what you create in real life?

SB: Really, 99.9 percent of things you see on Instagram are what I'm doing to go to a live event. I've yet to do looks just for Instagram. What I think is interesting, and Instagram has helped with this, is that what I do—creating looks—is now considered an art. And I think that's where I'm also a pioneer, so to say. I'm getting this looked at as art, while it could just be fashion, it could just be someone in a dress, in heavy makeup. For most people, getting dressed is about "I have to wear this because I'm going there," or "This is what's in this season." What I do is so not about that. My body is my canvas, and I'm creating works of self-expression.

KR: Today, there are so many resources for discovering things, for broadening your horizons, but obviously that's all relatively new. So, I'd love to know, when you were growing up in Switzerland, what were your influences?

SB: I think I was influenced by the Swiss lifestyle. You've got to get up at seven, eight o'clock in the morning—maybe that's why I'm against the nine-to-five thing, because I was born in Switzerland with that base structure. There's the Alps, there's the valleys and it's very forbidding. The Alps stop anything from coming in, and you're in there and you're meant to be a certain way. And I guess I rebelled against that Swiss convention, which isn't exclusively Swiss: having the house, the white fence, the bank account, and the car and the kids. I think I grew up knowing that's not what I want.

KR: What was your family like?

SB: My parents were very open, very embracing. So, I learned all the things that are the basis of a human being: to be kind and not cruel, and give, and forgive. I learned that, and that we're all people—we're all the same. I grew up with that philosophy. So, I was lucky that I never had to be afraid of who I am or what I am. And they were stylish parents; they were always interested in how we looked, the whole family: my sister, my mother, my father, and me.

KR: So much of what you do is ephemeral; you create works that happen and then they're gone.

SB: It's definitely a one-night stand, yeah.

KR: Do you ever wish there was more permanence to what you do?

SB: Not really, no. But having said that, it's not a smart business; it would be good to have a product. *I'm* the product. But I like that when a party ends, people will leave with a memory. I like the idea of being a memory. It's like a love affair: that night was amazing, then it's gone, and you remember it. People are nostalgic about it. I think if you have something that keeps going the same way, it burns out. People get bored. I like that with each time, it's a new challenge.

KR: And with your looks, too, you essentially never repeat yourself.

SB: I get a lot of joy out of doing my looks; it's never a chore. To me, a chore would be to repeat the look. Which is funny, because a lot of people who are known for their style have a style that repeats. Like, Kim Kardashian is always just Kim Kardashian in another outfit—even Marilyn Monroe. My style is not having a style. I'm constantly going with what I feel, and that to me is real fun. I might be tired or feeling low, but I get turned on the minute I sit down and start doing my hair and makeup. It's an invention, saying, "Okay, we're going to do this, we're going to do that." I never get tired of it.

KR: Your style has evolved and [is] nuanced. When I look at pictures of you from the '80s, your looks are almost conventional compared to what you do today.

SB: In those days, it was more about something that people wouldn't wear or hadn't seen . . . more about the feeling of it. Then I was doing head-to-toe, a full look, and now it's more about mixing. I dress to the makeup, I'd say. Now, it's more about transformation. It's like Leigh Bowery—he painted a little here and there, then suddenly became this sculpture. I'm the same. I'm no Leigh Bowery, but I've become more and more creative with my own self. You know, I never just wear a wig from the store; I rarely just wear a dress as it was made. I always ask myself, "How can I make this something different from what it is? How can I make it mine?" If the hair is very Hollywood glamour, then I'll have the makeup be futuristic. If the outfit is very baroque, I'll have the hair be punk. I like to experiment. One new artist I'm working with made this dress out of plastic sculptures—amazing but a nightmare to put on. I couldn't deal with it, so I said, "Fuck it, I'll put it on my head." To me, fashion is one thing, but it's another art form to see a piece clothing and make it into something else, to make it your own. Back in the '70s, when I was in London, it was about dressing to be part of a scene . . . the punks, the rockers, the new romantics. Today, it's more about individualism.

KR: In a way, you've created your own scene.

SB: I've designed my life. I haven't designed that glass or that bag; I've designed a lifestyle, made a space for all these different things to coexist. I guess you could say I'm a designer of life.

KR: You've been a muse to so many designers and been instrumental in launching so many careers. Was there anyone in your life that was that kind of mentor?

Photo: Mike Ruiz

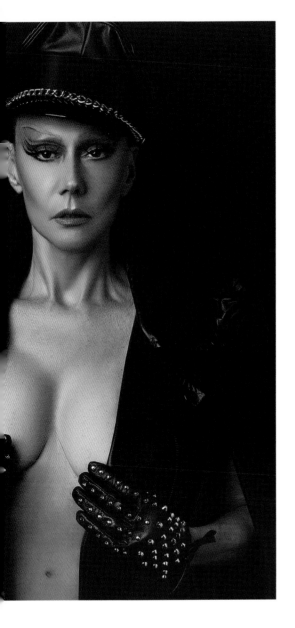

SB: There were two boyfriends. Paul Reeves, who I met in England, really saw the potential in me. There was a moment where I could have gone back to Switzerland, and he encouraged me to stay. He was incredibly creative himself. He had a store, Universal Witness, and every rock-and-roll person—from the Rolling Stones to David Bowie, you name it—went there. The other was Patrick Hughes, the artist. I moved to New York on Valentine's Day to be with him. Being here in New York with Patrick was when I really started to flourish. In London, I was just a part of things, taking it in, and here, I started to do my own thing. Other than that, the people I gave a head start to are actually my mentors. To see RuPaul on a go-go box at Savage and say to him, "You're a fucking star," he mentored me in a way. Leigh Bowery, Mathu Andersen, Zaldy, Galliano . . . there are too many. As much as I helped propel them, they were mentoring me by being in my life and letting me recognize their talents. They made me feel like, "Okay, I have the eye."

KR: From the beginning, you've been mixing and defying all of these kinds of groups. What do you think it is about you and your work that attracts all of these different people that, theoretically, are not supposed to like the same thing?

SB: It's probably one of the simplest answers: I embrace them all—the Brooklyn kids, the uptown ladies, the eccentrics, the regular guys from New Jersey, and everyone in between. With me, people know that they're going to be accepted—everyone's on the same level. It's a bit like when you go to the cinema and have to wear 3D glasses; everyone has to wear the glasses, and if you don't, everything is blurred. No matter who you are, if you're coming to one of my events, you're putting on the glasses—acceptance is the price of admission. Anything and everything goes. As humans, I think we all have a desire, deep down, to connect with one another, to be part of something. For some people, maybe I'm taking them out of their comfort zone, but I think even the most closed-minded people are curious. they're only closed-minded because they haven't been exposed. So, I create a place where all different cultures can be exposed to each other and step outside of whatever world they live in, or think they live in. That's what it's really about. ◈

ACKNOWLEDGMENTS

I'd first like to thank my friend Waleed Khairzada, my partner on this project from the very beginning, before we even had a publisher. His steadfast dedication and passion during the never-ending hours we spent working together made this book possible.

I want to thank my other partner Kareem Rashed, who helped realize this book, and worked on it across the board. Especially for all of his amazing help in organizing the interviews and writing the text for this book with me.

Thank you to Rodolphe Lachat for having the vision and birthing this book and to Regan Mies and the wonderful team at Abrams for all of your support throughout the process.

A massive thank you to the forever radiant RuPaul for writing the extremely thoughtful foreword to this book. I love you!

Thank you to my blood family David Barton for giving me the gift of motherhood, keeping me in shape from the moment we met, and for all of the fun and laughter we've shared over the years. To my beautiful son, both inside and out, Bailey Barton, thank you for keeping me grounded and honest.

My brother Andre and my sister Marlise, who are always there for me.

Deney Adam, thank you for your unwavering friendship, loyalty, and love.

I want to thank my vast chosen family of artists, performers, designers. Everyone who has danced, performed, turned a look, partied and carried on with me, whether it be for decades or just one night.

Thank you to Paul Reeves for everything you saw in me so early on. Your mentorship and encouragement of my talents have proved invaluable.

Thank you to Linda Powell for getting me my first job at a boutique in London and being a wonderful friend to this day.

Thank you to Patrick Hughes, whose love brought me across the pond to New York, the city I fell forever in love with.

Thank you to Michael Costiff for helping build the most beautiful showcases for my fashion businesses, and I cherish the many years of amazing friendship with you and your magical Gerlinde.

Thank you to Ty Bassett, who helped keep it together behind the scenes, which provided me the stability I needed to flourish on the dance floor.

Making this book has been a true labor of love that at times was very challenging for me. I could not have done it without the patience, encouragement, and assistance of the many wonderful people in my life. It is because of you that I was able to persist and make it to the end of this book's journey. You know who you are! I love you.

To all of the supremely talented photographers whose photos grace the pages of this book; if the legacy of Bartschland exists, it is because of your beautiful images: Tanner Abel, Jason Akira Somma, Ace Amir, Angel Anazco, Mathu Andersen, Peter Ashworth, Josef Astor, Michael Bailey-Gates, Andrea Barbiroli, Robert Bartholot, Sheyla Baykal, Stephen Blaise, Maxwell Brown, Michael Burk, Ryan Burke, Ben Chabanon, Jesse Chehak, Citizen Chris, Michael Costiff, Driu Crilly & Tiago Martel, Bill Cunningham, Wouter Deruytter, Nieto Dickens, Jeff Eason, Todd Eberle, Arthur Elgort, Michael Fazaerely, Santiago Felipe, Lisa Fiel, Jesse Frohman, Vito Fun, Cheryl Gorski, Jeffrey Clark Grossman, Torkil Gudnason, Michel Haddi, Michael Halsband, InFlux, Josef Jasso, Jeiroh, Kabuki, Steven Klein, Paola Kudacki, David LaChapelle, Marcus Leatherdale, Roxanne Lowit, Peter Lueders, Patrick McMullan, Steven Menendez, Fernando Milan, Jordan Millington, Mark Minton, Wade Muir, KC Mulcare, Francois Nars, Tony Notarberardino, Spencer Ostrander, Marco Ovando, Tim Palen, Tina Paul, Gazelle Paulo, Nasty Pig, Dustin Pittman, Ves Pitts, Matthew Placek, Ben Prince, Chantal Regnault, Rico & Michael, Kris Rox, Mike Ruiz, Lucien Samaha, Albert Sanchez, Norbert Schoerner, Sidewalkkilla, Sarah Silver, Rebecca Smeyne, SMLTD, Robin Souma, Tim Street-Porter, Miguel Villalobos, Gerry Visco, Megan Walschlager, Albert Watson, Bruce Weber, Wolfgang Wesner, Nina Westervelt, Mark Williams, and Pedro Zalba.

To those who helped me write and edit the text for this book, thank you for your generosity and thoughtfulness in helping me tell my story.

Thank you to Bob Bottle for contributing your many talents in the creation of this book.

Thank you for all your help, Mark Minton, Linux, David Tocci, Emmett Coleman, and John Granito.

Thank you to all of those who were part of helping me get my start in the world of fashion and nightlife, especially Hamish McAlpine, Peter Gatien, Vincent Crisci, Steven Greenberg, Julio Quiñones and Garry Pennington, Jonathan Madrigano and the Chelsea Hotel. I would not be where I am today without you.

Thank you to all of the club owners and employees I have worked with over the years, for providing homes for countless nights of uniting people on the dance floor. Thank you, Stephan Vacher, for thirteen fabulous years and counting.

Thank you to the endless number of people who have played a role in shaping Bartschland into the vibrant and love-filled community that it is today. This book is a tribute to you. Please forgive me if I was not able to include you in this book, as there simply were not enough pages.

Lastly, I would like to thank all who have ever attended one of my events, and you, the reader of this book.

I hope you are able to connect to and be inspired by everything that is Bartschland.

SUSANNE BARTSCH
PRESENTS

BA
RT
SCH
LA
ND

ISBN: 978-1-4197-6756-2
LCCN: 2022944664

Printed and bound in China
10 9 8 7 6 5 4 3 2 1

Cernunnos logo design: Mark Ryden
Book design: Benjamin Brard

Published in 2024 by Cernunnos, an imprint of ABRAMS.

Abrams books are available at special discounts when purchased
in quantity for premiums and promotions as well as fundraising or
educational use. Special editions can also be created to specification.
For details, contact specialsales@abramsbooks.com or the address below.

Abrams® is a registered trademark of Harry N. Abrams, Inc.

ABRAMS The Art of Books
195 Broadway, New York, NY 10007
abramsbooks.com

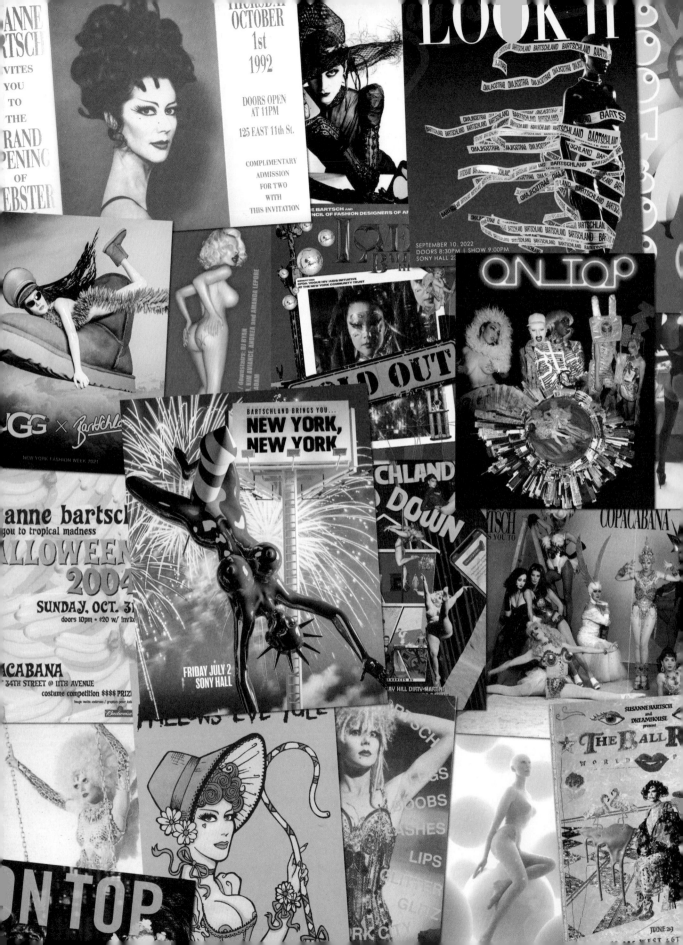